The Thief, the Cross and tł

PICTURING HISTORY

Series Editors
Peter Burke, Sander L. Gilman, Roy Porter, †Bob Scribner (1995–8)

In the same series

Health and Illness
Images of Difference
Sander L. Gilman

The Devil
A Mask without a Face
Luther Link

Reading Iconotexts
From Swift to the French Revolution
Peter Wagner

Men in Black
John Harvey

Dismembering the Male
Men's Bodies, Britain and the Great War
Joanna Bourke

Eyes of Love
The Gaze in English and French Painting
and Novels 1840–1900
Stephen Kern

The Destruction of Art
Iconoclasm and Vandalism since
the French Revolution
Dario Gamboni

The Feminine Ideal
Marianne Thesander

Maps and Politics
Jeremy Black

Trading Territories
Mapping the Early Modern World
Jerry Brotton

Picturing Empire
Photography and the Visualization of
the British Empire
James Ryan

Pictures and Visuality in Early Modern China
Craig Clunas

Mirror in Parchment
The Luttrell Psalter and the Making of Medieval England
Michael Camille

Landscape and Englishness
David Matless

The Thief, the Cross and the Wheel

Pain and the Spectacle of Punishment in Medieval and Renaissance Europe

Mitchell B. Merback

REAKTION BOOKS

For Felix, Theo and Alice . . . welcome

Published by Reaktion Books Ltd
11 Rathbone Place, London W1P 1DE, UK

First published 1999

Printed and bound in Great Britain by
Balding + Mansell Limited, Norwich

British Library Cataloguing in Publication Data:

Merback, Mitchell B.
 The thief, the cross and the wheel: pain and the spectacle of punishment
 in medieval and renaissance Europe. – (Picturing history)
 1. Art, Renaissance – Europe 2. Art, Medieval – Europe
 3. Punishment in art 4. Pain in art
 I. Title
 709.4

ISBN 1 86189 026 5

This book includes material reprinted with permission as follows: Michael Baxandall, *Painting and Experience in Fifteenth-Century Italy*, copyright © 1988 by Oxford University Press, reprinted by permission; Hans Belting, *Likeness and Presence*, copyright © 1994 by the University of Chicago Press; Harold Berman, *Law and Revolution*, copyright © 1983 by the President and Fellows of Harvard College, reprinted by permission of Harvard University Press; Jorge Luis Borges, *Jorge Luis Borges Selected Poems, 1923–1967*, copyright © 1968, 1969, 1970, 1971, 1972 by Jorge Luis Borges, Emece Editores, S.A. and Norman Thomas Di Giovanni, reprinted by permission of Delacorte Press/Seymour Lawrence, a division of Bantam Doubleday Dell Publishing Group, Inc.; Norman Bryson *et al.*, eds, *Visual Culture: Images and Interpretations*, copyright © 1994 by Wesleyan University, reprinted by permission of University Press of New England; Esther Cohen, *The Crossroads of Justice*, copyright © 1993 by Brill NV; Norbert Elias, *The Civilizing Process*, copyright © 1994 by Blackwell Publishers; Richard J. Evans, *Rituals in Retribution*, copyright © 1996 by Oxford University Press, reprinted by permission; Arlette Farge, *Fragile Lives*, copyright © 1993 by the President and Fellows of Harvard College, reprinted by permission of Harvard University Press; Richard Keickhefer, *Unquiet Souls*, copyright © 1984 by The University of Chicago Press; William Ian Miller, *The Anatomy of Disgust*, copyright © 1997 by the President and Fellows of Harvard College, reprinted by permission of Harvard University Press; Jürgen Moltmann, *The Crucified God*, English translation copyright © 1974 by SCM Press Ltd., reprinted by permission of HarperCollins Publishers Inc.; Elaine Scarry, *The Body in Pain*, copyright © 1985 by Oxford University Press, Inc.; R. W. Scribner, *For the Sake of Simple Folk*, copyright © 1981 by Cambridge University Press.

Contents

Preface 7

Introduction 11

1 ‘A Shameful Place’: The Rise of Calvary 41

2 The Two Thieves Crucified: Bodies, Weapons and
the Technologies of Pain 69

3 The Broken Body as Spectacle 101

4 Pain and Spectacle: Rituals of Punishment in
Late Medieval Europe 126

5 The Wheel: Symbol, Image, Screen 158

6 The Cross and the Wheel 198

7 Dysmas and Gestas: Model and Anti-model 218

8 Image and Spectacle in the Era of Art 266

Epilogue 304

References 311

Select Bibliography 339

Photographic Acknowledgements 344

Index 345

Preface

Juxtaposing the terms 'atrocity' and 'realism' creates an uncomfortable semantic friction and anticipates a painful revulsion. The outcome poses an ethical dilemma of the first order. In *Survival in Auschwitz*, Primo Levi attests that 'our language lacks words to express the offense, the demolition of a man'.[1] Direct depictions of human cruelty and destructiveness, bodily violation, pain, suffering and death are therefore among the most powerful representations that can circulate within a culture whose facility with images makes them possible in the first place. They provoke emotions ranging from fear and horror, through pity and guilt, to disgust and shame. A permanent danger attends every image of atrocious violence or suffering inside the public sphere, no matter how enlightened the intentions of those who place it there: historical horrors can become too familiar and tolerable, trivialized past the point of recovery, commodified, distorted into instruments of profit or pleasure. Economies of violence exist as much in the virtual worlds of images as in the social worlds of people, and images of atrocity now circulate with myriad other representations of violence. The danger occurs when specificities are lost; political charges are defused and diffused into a transcendent drama of human suffering, lifted above history. Anticipating such consequences, serious artists, writers, dramatists and film-makers have long sought out other methods by which to convey the actuality of unfathomable human pain and suffering. Like Claude Lanzmann's nine-hour film about the Holocaust, *Shoah*, they refuse accommodation to a situation in which, as the writer Terrence des Pres put it, 'what others suffer, we behold'.[2]

On a smaller scale, the same danger attends the publication of my study of the relationship between art and punishment in the late Middle Ages. Many of the images reproduced here either document or transcribe into fiction by various aesthetic means a range of corporal violations that were inflicted by some human beings upon others. For this reason alone they are atrocious. Furthermore, throughout the discussions I highlight questions of the *reception* of violent imagery,

and explore the kinds of visual habits and mental dispositions people in the Middle Ages developed to make those experiences not only tolerable but edifying. Modern scholars are more aware than ever of the danger that surrounds the historical treatment of events, practices, institutions and behaviours involving organized atrocity, the history of capital punishment perhaps most of all. Will the primary document, the eyewitness account of torture, be turned into just another titillating morsel for readers with sadistic inclinations?[3] This problem intensifies where the iconography of human destructiveness is so lavishly displayed. In sharing my explorations – and hence the images as well – with colleagues, family and friends, I have incurred enough perplexity about the 'source' of my 'interest' in such things to realize the importance of confronting critically this troubling phenomenon: 'What others suffer, we behold'. As much as my editors and I assume this risk, we trust that the serious treatment of the subject overall, coupled with my pointed remarks here, will serve to remind readers of the conundrum, and let each decide.

To say I've written this book with two audiences in mind, general readers and specialists, means only that I've left untouched many issues each group would have preferred I treat in greater detail. Although I've drawn from a wide range of sources, visual and verbal, quoted from authorities who would otherwise make strange bedfellows and adopted a range of methodological perspectives, I offer no formal statement of methodology as such, only a few scattered interpretive roadsigns. Although I am opposed to the death penalty, I have neither set aside space here to say exactly why nor envisioned the book as a historical argument for this position. There is no pretence here about speaking 'for the victims', but I would be pleased to learn if my historical observations about penality and visuality in history lend intellectual support to those who agitate for change. I will say that the need for change in my own country's penal institutions is urgent. With broadcasters now suing state governments for the right to televise executions, it may be only a matter of time before capital punishment once again becomes public, a form of spectacle. The legal precedent would bring us to a crossroads not only in the history of criminal justice but also in the evolution of sensibilities – a point at which a new, mediated spectacle of death would no longer arouse enough revulsion to fuel the necessary political challenges to state-sponsored killing.

This book would never have become even remotely possible without the labours of the many scholars and writers cited in these pages. My debt to them is enormous. Thanks are likewise due the numerous people who personally saw me through this project in one way or

another: for their inspiring examples and unimpeachable advice, Michael Camille and O. K. Werckmeister; for her close reading and perceptive criticisms of the drafts, Anne Harris; for their unerring professionalism, patience and trust, the editors and staff at Reaktion Books; for his consummate translations and uncanny nose for Thief miscellany, Keith Nightenhelser; for his lexical whimsies, Jon Kane; for kind assistance processing books, articles and photographs, Bizz Steele, Jeretta Reynolds and Gwen Bottoms; and for their continuous encouragement, my colleagues in the Art Department, Catherine Fruhan, Robert Kingsley, Martha Opdahl and David Herrold. Special thanks to my parents, for a lifetime of chances to do it all; and to my parents-in-law, the Cromes, for indispensable help managing the empire. I wish to acknowledge the financial support of DePauw University's Faculty Development Committee, the John and Janice Fisher Fellowship programme, and President Robert G. Bottoms's Discretionary Fund. For proudly resisting the clichés of the scholar's wife, and always knowing how to turn melancholy into high spirits, I thank Althea, who once again grew fecund and round as I processed words; and for helping me 'do dogs' on my 'pewter', my son, August Wolf. Without them this project would have been far too gloomy.

M. B. M.
Greencastle, Indiana
January 1999

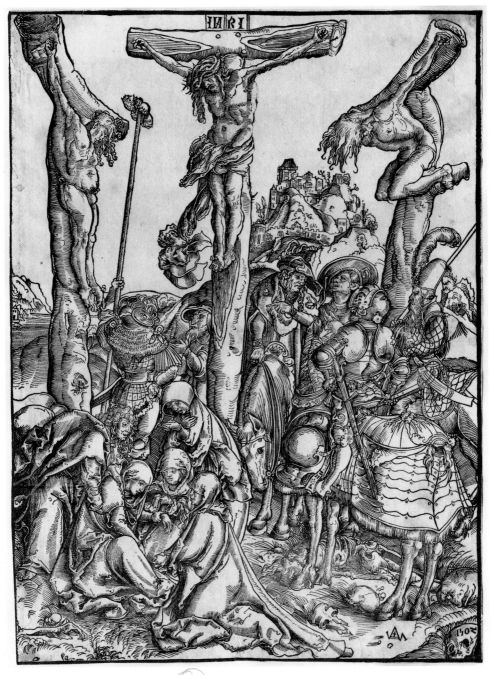

1 Lucas Cranach the Elder, *Calvary*, 1502, woodcut, 405 × 292 mm. Metropolitan Museum of Art, New York.

Introduction

The scene is a place of execution (illus. 1). Against a cloudless sky a steep mountain rises in the background, capped by a castle. Closer to us, on the narrow hilltop, tokens of death's presence lie strewn about. Human and animal skulls mingle. Half-hidden behind the legs of a knight's steed can be seen a rotting corpse lying on its back, its flesh still clinging to bone, an agonized howl stretched across its hairy head. Blank eyes in shrivelled sockets stare up into space, unnoticed by the mounted officials. Their attention is fixed instead on the condemned men suspended above them, nailed to timber crosses. In the centre hangs a gaunt figure, his head crowned with a thorny garland, and his arms stretched out, taut and cadaver-like. His body is motionless; only his loincloth moves, tossed by a passing wind. Above his head a plaque is inscribed with four letters: 'INRI'. Beside him are two other condemned men. The one on our left languishes in the same posture, peacefully asleep in death; but the second is painfully bent forward, straining in unbearable torpor against the nails that immobilize him. Affixed to a cross which is gnarled like an old, diseased tree, his whole body conforms to its twisted organic growth. His head is thrust forward and he seems to be still alive. Down below the mood is quiet: the mounted figures stare and point and wait; the mourners huddle in sympathy around a woman who has fainted.

The woodcut I'm describing was made by the German painter and printmaker Lucas Cranach the Elder, a native of Kronach, in Franconia, who lived and worked in the city of Wittenberg, in Saxony, before and during the years of the Reformation. Cranach produced the work early in his career, sometime during his journeyman's days (*Wanderjahre*) in Vienna, where he sought out the dynamic circle of humanist scholars, writers and artists centred on Conrad Celtis and the famed poet-physician – and confidant of the emperor – Dr Johannes Cuspinian.[1] Its date of 1502 is emblazoned on one of the discarded skulls in the lower right corner, and Cranach's mark, the initials LM ('Lucas Maler') interlinked in the form of an angular snake

over a cross, appears next to it. For its time, the woodblock was rather large (405 × 292 mm), suggesting that it was Cranach's intention to produce a Passion of Christ narrative that could rival the best-selling print series of his rival in Nuremberg, Albrecht Dürer, who published his *Apocalypse* woodcuts in 1498. Indeed, there are numerous debts to Dürer which scholars have long acknowledged.[2]

Despite the conscious effort I made in my description to suppress what I know of the woodcut's references to Christian history and legend, few readers will have mistaken that description, or Cranach's image, for anything other than the Crucifixion of Jesus Christ. As an iconographic theme, it has been the subject of countless representations in every conceivable medium, making it, perhaps, the most recognizable image in all of Western visual culture. In medieval art it ranks as the most prevalent theme and the central statement of Christian belief. A more conventional description, the kind a student of art history might encounter in a textbook or lecture, would probably have been more up-front about identifying the man in the centre as Jesus of Nazareth, Christ, the Crucified God. It would also have informed the student that the two men flanking him were the Two Thieves, unnamed criminals in whose company, according to all four Gospels, Christ suffered bitterly and died.[3] And, in a more detailed account, that same student would have learned the identities of the other figures whose names are established in legend: St John, the 'Beloved Disciple' and Evangelist; the Virgin Mary, Jesus's mother; the Holy Women or the Three Marys, including Mary Magdalene, the penitent ex-prostitute; and Stephaton, who proffered the vinegar-soaked sponge to the dying Jesus as he complained of thirst. He or she would then be encouraged to consider whom Cranach had in mind for his mounted officials in contemporary dress and armour: the Jewish high priests maybe, or Pontius Pilate himself?

Today the textual sources which lie behind the image and support these identifications are not, as they were for the people of Cranach's time, so much a part of the cultural capital each member of society possesses to a larger or smaller degree. Indeed, it may be because the traditional figures and motifs which belong to the scene, the theme's symbolic *code*, were so readily accessible, so firmly established in the minds of Cranach's audience, that he was able to do without most of the standard devices and cues that had once been routinely used to render the sacred narratives of late medieval art sacred and, to that end, legible to beholders. Notice, for example, the absence of haloes on either Christ or the other members of Christ's saintly entourage. In medieval painting haloes tended to appear as either flat circles of gold

surrounding the heads of the saintly or fine, radiating lines; they some-times looked like cumbersome discs mushrooming from the head. In all their forms, haloes were unmistakable signs of holiness. Yet as late medieval painters strove to reproduce, in the virtual spaces of their images, an impression of Nature's optical appearances, their inclusion grew increasingly contradictory to the goals of realist painting.

But that is not the principal reason we see no haloes, no fluttering angels with censers and chalices, no swooping devils preying on the departing souls of the dead, no dark skies or heavenly pyrotechnics, no hand of God the Father reaching down towards the abandoned Son. Cranach's story has unfolded only so far; the literally earth-shaking moment of Christ's death, and with it the promise of Resurrection, has been forestalled to assert something else. Implanted in the dense network of lines, which forces us to *read through* the image rather than absorb it at a glance, we find the hidden signifier: Christ's open mouth. For those with a knowledge of the codes, Cranach's narrative moment is ostensibly about the so-called 'Seven Words from the Cross', the seven last utterances of Christ before his death. But which one? Is he commanding Mary and John with the words, 'Woman, behold thy son!' and 'Behold thy mother!' (John 19: 26–7)? Or is he addressing the sponge-bearer with the pathetic cry, 'I thirst' (John 19: 28)? A provoca-tive exchange of gazes between Christ and the sponge-bearer suggests the latter. What is more important, however, is the way Cranach has so deliberately suspended the narrative of Christ's suffering in the irresolute moments before his saving death. Instead of the divine plan's fulfilment, we witness the prolongation of the penalty. Instead of Redemption and Triumph, we are urged to contemplate Mary's bitter emotional suffering, Christ's helpless cry, the pitiless response of the soldiers and the abject misery of the dead or dying Thieves.

The five years after 1500 were a period of intense activity and vaulting expectations for the promising young Cranach, who ultimately became court painter (*Hofmaler*) to the dukes of Saxony, the wealthiest citizen and mayor of Wittenberg, a close friend of Martin Luther, the scion of a family of painters and the progenitor of the so-called 'Danube School' of painting, which includes such prolific talents as Albrecht Altdorfer (see illus. 107) and Wolf Huber (see illus. 6). While still in Vienna the painter produced two study drawings in black and white chalk on a red-toned paper, now preserved in Berlin, each depicting a crucified Thief (illus. 7 , 8).[4] At first glance these are beautiful drawings, revelatory of Cranach's already considerable gifts for handling materials, gestural expression and the organic integration of figure and space. But the delicate treatment of visual form is belied by the painful severity of

the dislocations Cranach has devised. In the Thief turned to our left (illus. 7), one can sense the awful strain placed on the shoulder socket as gravity threatens to pull the body away from the immobilized arm, hooked over the crossbar (*patibulum*). That we can see the bottom of the right foot implies another dislocation, this time of the shin (the shiny welt on the left calf, emphasized by the rope's ligation, may denote the leg wounds mentioned in John's Gospel). In the second rendition (illus. 8), we see the left arm, stiff as a ramrod, thrusting towards the

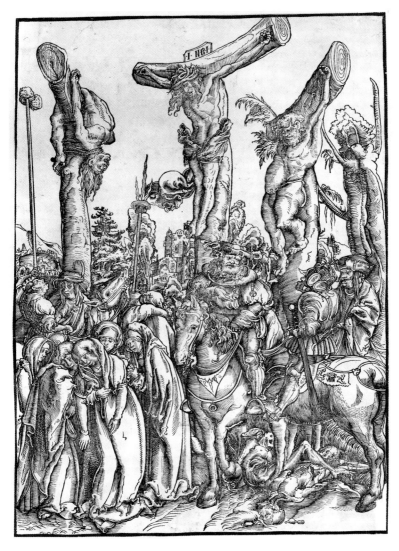

2 Lucas Cranach the Elder, *Calvary*, *c.* 1510–12, woodcut, 394 × 284 mm. Staatliche Museen zu Berlin – Preußischer Kulturbesitz (Kupferstichkabinett).

upper corner of the sheet, away from an otherwise slackening, ravaged body. One could say that it is here, half-hidden from view, in this shoulder socket where the torsioned arm connects to the upper body, that Cranach has concentrated the tormented energy of the figure. This shoulder, wedged against the front of the vertical beam of the cross (*stipes*), jams the upper body forwards despite the pull of the opposite arm back and over the crossbar; the thoracic cavity is thrust sideways, and the ribs assert themselves strongly from under the skin.

One decade later Cranach seized yet another opportunity to arrange the bodies of the Two Thieves on their crosses. Unsigned and undated but clearly attributable to the artist, this second woodcut version is only slightly smaller than the one dated 1502 (illus. 2). Again Christ hangs in his canonical cruciformity and the narrative has stalled in abjection. Three nails pierce his body and hold him fast to a rough-hewn timber cross. The only difference is that here, in keeping with his distaste for symmetry, Cranach turns the central cross slightly to our left, showing us a hint of the compositional gambit he realized fully in the famous Munich *Lamentation Beneath the Cross* (see illus. 100). Now the Thief to our right must cower in the shadow of Christ's cross; there, dejected but still alive, the fleshy rogue struggles against the gnarled wood of his own cross, while shoots from another tree creep out towards him. But most riveting of all is the image of the Thief to Christ's right, his body appallingly broken backwards over the cross-bar. On the opposite side of the vertical beam, Cranach nails down the victim's feet. Unleashing the powers of his brutal penal imagination, Cranach has immobilized the limbs with a ferocious combination of technical means, removing all trace of the body's resistance to the apparatus. At a stroke, the enterprising young humanist artist pushed his imagery to the outer limits of penal atrocity and delivered to his audience a sobering test of their capacity for horror.

In Cranach's early Crucifixion imagery we find an artist of a decisively 'proto-reformed' sensibility ready, it would seem, to parlay the grotesque realism of late Gothic art into an uncompromising vision of human death stripped of any transcendence, a kind of pictorial anticipation of Luther's *theologia crucis*, with its mystical call to suffering as the inescapable penalty for sin. No doubt infused by a brutal temperament, Cranach applies his considerable powers of observation and invention to the task of fixing our gaze upon the violation, if not demolition, of a human body. In doing so, he constructs a high-pitched rhetoric of violence that compels us towards a reality half-hidden behind the countless images to which we've been exposed in museums,

churches and homes: *the image of the Crucifixion depicts an instance of capital punishment*. And not just one possible penalty, but the supreme penalty, crucifixion (*crux*), the *summo supplicio* of Roman law. Flavius Josephus (d. after 93), who as adviser to the Roman emperor Titus witnessed its use by soldiers during the Jewish Wars of the first century, knowingly called it 'the most wretched of deaths', referring to the prolonged agony and ultimate disgrace it caused its victims (see Chapter 6). Even though neither Cranach nor any of his contemporaries could have witnessed the infliction of the penalty personally (it had been obsolete in the West since the late fourth century), his work renders its hideous scope of possibilities with the authority of someone who had. In a single image he shows us three alternative modes of crucifixion. Their aesthetic shock is cumulative. Together they emphatically remind us of crucifixion's surplus in the historical economy of state-sanctioned killing.

The idea that a Christian artist sought to emphasize the mundane, *penal* aspect of the biblical events on Golgotha, and in so doing assert that the Redeemer's death instantiated a vulgar and disgraceful form of *punishment*, may strike some pious readers today as misguided. It is an article of faith, and a cornerstone of Christian theology, that God the Father willingly sacrificed his only Son for the sake of a fallen and sinful humanity. Generations of schoolchildren have learned that Jesus humbly submitted to his death as the sacrificial Lamb, in effect offering himself, his own human flesh and blood, to rescue all believers from the clutches of Satan and eternal Death. The unalterably sacrificial logic of His Death has given the event not only its mythopoetic power but also its capacity, as a symbol, to fuel the sacramental rites of the Church. Prior to the twelfth century, medieval ecclesiastical art tended to confine the representation of the crucified to this symbolic conception. Rather than attempting to convey the historicity and actuality of the event, such images illuminated its eucharistic significance, or trumpeted its cosmogonic meaning with all the heavenly fanfare of a theophany.

Yet this same theology, at its roots, has not been able to do without the concrete, *historical* reality of Christ's shameful death on the Cross. 'For the preaching of the cross is to them that perish foolishness,' insists Paul in I Corinthians 1: 18, 'but unto us which are saved it is the power of God.' As a man of the first century, Paul knew his Greek auditors would be struck incredulous by the idea that a man whom the Romans had nailed to the 'fatal wood of the cross' (*crucis ligna feralia*) as a state criminal was to be worshipped as the Son of God.[5] Without faith, the paradoxical idea of the criminal-god, the holy scapegoat

who dies so that others may live, amounted to a sick delusion and a scandal.[6] 'But we preach Christ crucified,' Paul insisted, 'unto the Jews a stumbling block, and unto the Greeks foolishness' (I Corinthians 1:23). While some ancient Christian sects like the Gnostics hoped to remove the scandal of the Crucifixion by claiming that Jesus only *seemed* to be crucified (and therefore did not suffer physically at all), Paul realized that the highly offensive nature of the Cross had to be squarely faced if the 'Word of the Cross' was not to dissolve into meaninglessness. Thus he was adamant that Christians believe what others considered 'madness'. He performed the perfect inversion, according to Martin Hengel, transforming the 'folly' of the Cross into 'the death of the incarnate Son of God and Kyrios, proclaiming this event as the eschatological event of salvation for all men'. [7] Later the medieval Church, faced with its own dualistic heresies, maintained its stark insistence that it was a fully enfleshed, *human* Christ who died on the Cross (and from the sixth century onward the figure of a *man* hanging on the Cross replaced the symbolic image of the Lamb). Thus we can see how indispensable the *penal* character of the Crucifixion, together with the imagery devoted to it, is to this deep structure of Christian thought and devotional feeling.

It may rarely occur to those who debate the capital punishment question today that our attitudes towards the penalty of death, like the theories, institutions and practices that actualize it for us, culturally, socially and politically, are the outcome of a historical process extending over many centuries. Today we hold that religious perceptions have no place in the articulation and enactment of laws that protect and prosecute individuals in democratic, civil societies. And so we find our own rituals of judicial killing accordingly stripped of the sacred aura and magical trappings that once clung to them, leaving only a perplexing mixture of bureaucratic protocol, spiritual ministering, folklore and politics.[8] But that, too, is the result of long-term changes. Whatever traces remain of older religious perceptions belong not to the dim past of pagan sacrifice, as folklorists once thought, but rather to the Christian Middle Ages. When we look there we discover an era in which the interrelationship of criminal justice and religion was a fact of life beyond dispute. We find learned jurists enthralled by the rationalism of the neo-Roman law then being studied in the universities, yet beholden to theological precepts and para-religious practices rooted in popular culture and enshrined by custom. And we find, on the other side of the scaffold as it were, a popular audience for executions that experienced the performance of justice as an opportunity for cultic devotions, prayers and transactions with the community of the dead.

Chapter 4, centrally placed in this book, shows how deeply medieval punitive justice was rooted in a magico-religious conception of the world, and also how such a framework allowed for its smooth functioning as an assertion of political power and a tactic of social control. From the explicit iconic parallels drawn on the walls of courthouses between earthly and divine judgement to the elaborate measures taken to provide for the soul of the 'poor sinner' up to the very moment of death; to the detailed requirements for the position of the hanged man's body upon the gallows; to the widely held belief in the curative potency of the dead criminal's blood and body parts and the judicial paraphernalia that brought him, with a terrifying suddenness, 'from life to death' – all of this suggests that punishment operated as *both* a projection of the majesty of the law, the sovereign's power to monopolize violence, *and* a quasi-religious ritual in which the community at large ushered the condemned culprit into death and thus a new 'social' role. Crucial to both dimensions is the fact that the rituals of punishment in the later Middle Ages were intensely *visual*. Played out in public and before the collective gaze, the drama of state-sponsored death was a form of *spectacle*.

The temporal flow of everyday life in pre-industrial Europe was punctuated with spectacles of all kinds. By 'spectacle' (from the Latin *specto*, meaning 'to look at') we mean any 'specially prepared or arranged display of a more or less public nature (especially one on a large scale) forming an impressive or interesting show or entertainment',[9] in short, a *sight*, an event or performance which is set up and enacted mainly to be seen. In the later Middle Ages town-dwellers could witness in their lifetime princely or royal weddings or ceremonial entrances into the city known as advents; religious processions for different occasions and the religious dramas enacted during Passion Week or during the Feast of Corpus Christi; the signing of charters and treaties; popular festivals with their attendant entertainments; funerals of important persons; the saying of *Te Deum*s for victories or of masses after childbirth; and the public sentencing, processioning and execution of criminals. Not all but the most important of these events were ones for which crowds were invited by those in power, invited, according to Arlette Farge, to witness and thus legitimate power in all its aspects:

Called on to gather together . . . for such spectacular occasions, and obliged to follow the ups and downs of the body monarchial in all its joys, griefs or sorrows, crowds had a duty to mark, by their presence, the irreversible alliance binding them to the royal power. And even when they were not specifically

invited to a royal spectacle, the crowds showed a fondness for anything unusual that might be going on in the street, whether it was some kind of game or anything else out of the ordinary. [10]

All of this made up a rather full and enticing calendar for urban inhabitants across Europe.

To deepen our understanding of what penal spectacles showed their audiences, the word 'spectacle' must be extended beyond what is called, in theatrical parlance, the overall 'production'. It also encompasses the things shown, the 'person or thing exhibited to, or set before, the public gaze as an object either of curiosity or contempt, or of marvel and admiration'.[11] Many individual features of judicial proceedings, from the clothing of the judges at sentencing to the method of transporting the condemned to the gallows, the oratory of the *amende honorable*, the prayers and hymn-singing, and the executioner's performance, were spectacle, demanding the closest attention. But most of all it was the person of the prisoner, his or her body and his or her pain, that constituted a sign with the power to compel fascination.[12] Trembling, sweating, resisting, gesturing, crying, ejaculating blood, spilling its contents and then falling silent, the maimed body of the condemned spoke an arresting language of pain that spectators understood not as an unfortunate by-product of the performance of justice, but as a portentous source of information. For spectators, 'Nothing was considered unworthy of comment or lengthy interpretation, whether it was a tearful or effeminate face, a wild look . . . or perhaps angry gestures or pleas and imprecations.'[13]

For medieval people, the experience of *seeing and imagining* a body that was ravaged and bleeding from tortures inflicted upon it lay at the centre of a constellation of religious doctrines, beliefs and devotional practices. Meditative devotions to the Passion of Christ required a form of contemplative immersion in the grisly details of His affliction from one Station of the Cross to another. Legends of the glorious abjection of Christian martyrs played to the same fascinations. And since it was not uncommon to look upon the suffering convict as a pseudo-martyr, and thus Christ-like, physical pain at the scaffold stood within this very same constellation of beliefs and feelings. It was an ambivalent sign that could point one of two ways. The pain of a guilty malefactor who showed no remorse, refused confession or resisted altogether communicated to spectators the utter alienation of the soul from God; his visible sufferings revealed the criminal as a living *exemplum* of despair, since his last moments on earth were but a foretaste of hell's endless torments. But for the confessed criminal who took refuge in God's grace, admitted guilt (*culpa*), accepted penance,

prayed for forgiveness and made a good end – what medievals called the 'good death' (*bene moriendi*) – pain signalled purgation and expiation; though ugly to behold, this criminal's sufferings revealed the inner beauty of a soul that had made its peace with God. Having accepted communion and the prayers of the living, the suffering convict could play the role of the penitent martyr, eliciting strong feelings of sympathy, identification and especially compassion from the onlookers. In this way the spectacle of punishment shaped a different kind of social relationship, one grounded in the shared religious imperative towards compassion. This imperative, above all, forced each participant in the liturgy of execution to view the infliction of the penalty as cathartic, and the state as its legitimate agent. Just as characteristically late medieval devotional images such as the 'Man of Sorrows' (*imago pietatis*) isolated for the spectator the bloodied body of Christ, riveting the compassionate gaze upon wounds caused by human sin,[14] the spectacle of punishment fashioned a kind of living devotional image of pain for pious, contemplative immersion.

Under these circumstances, medieval people did not perceive the pain of the body as an alienating, isolating and stigmatizing power that banished its bearer beyond the pale of shared experience and meaning (as the efforts of modern torturers are calculated to do). Instead pain could be a powerful emblem of intersubjective experience; it actuated empathic bonds between people. Pain in the penitential spectacle is therefore not 'world-destroying', in the sense theorized in Elaine Scarry's brilliant essay on the structure of torture, but rather 'world-making'.[15] Suffering as spectacle could become, under these mental conditions and religious imperatives, a form of what anthropologists call *communitas*. Such intersubjective bonds seem to grow faster and deeper in periods of shared crisis: during the worst of the Black Death years (*c.* 1348–51), for example, when organized 'brotherhoods' of flagellants took their penitential spectacles to the towns and villages of Europe, and aroused in their audiences powerful mixed feelings of remorse, compassion and awe as they tortured themselves to avert God's wrath. At the same time, we must not mistake this religious imperative towards compassion for modern humanitarianism, whose goal is the cessation of suffering and the alleviation of pain. Late medieval religious culture, exemplified in the penitential pantomines and 'defiling practices' of mystics and ecstatics like Catherine of Siena, actively geared itself to the pursuit of pain as a positive force in spiritual, and thus human, affairs.[16] Aptly labelled *philopassianism* by the historian Esther Cohen, this late medieval attitude towards bodily pain and its magical, redemptive instrumentality is unique in the history of human

sensibilities.[17] Its perceptual point of departure resided in the salvific powers attributed to the suffering body of Christ (*corpus Christi*), made literally present for the worshipper in both the cult image and the consecrated host. And just as both of these power sources could be accessed through vision itself, so too could the magical potency of the criminal's body, once purified of sin's miasma, extend to the believer visually.[18]

If the role of the visual decisively separates pre-industrial from modern systems of capital punishment, how much more profoundly does it separate the medieval person's *experience* of the death penalty from our experience of its undisclosed modern counterpart? And it is precisely here, at the level of visual experience in history, that I will lodge my central claim about the imagery surveyed by this book. I will try to show how late medieval realist painters presented the sacred scene of the Crucifixion in terms of their own, but more importantly their *audience's*, experiences with criminal justice rituals. Both kinds of experience, one lived out collectively in the theatre of public punishment, the other enacted sometimes publicly, but often privately, before the Passion altarpiece (where the Crucifixion was typically central and defining), unfolded within the same mental boundaries, fell into the same perceptual schemata and were conditioned by the same social and cultural factors. Spectacle and art were dialectically interwoven in the fabric of late medieval life, and this book explores one, I believe pivotal, instance of their interaction, the expanded image of the Crucifixion known as 'Calvary'.

Chapter 1 explores the artistic development of Calvary as the imaginative centrepiece of late medieval devotions concerning the Passion, specifically the Franciscan practices of visual meditation. Calvary epitomized the rich scenographic re-creations of the holy places (*loca sancta*) into which beholders were encouraged to enter imaginatively. Chapters 2 and 3 account for the specificities of what some painters insisted we see once on Calvary: an apparently exotic penal procedure that nevertheless targeted the body in familiar ways. Through our own, at times uncomfortably close, examination of these details, we can attune our sensibilities to the *intervisual* dynamic between art and spectacle. If we find that the mutual dependency of art and spectacle is less easily discerned in the imagery of Christ's crucified body, which maintained for theological reasons a certain schematic constancy throughout medieval art, it is impossible to miss in the brutality that informed representations of Christ's 'shameful company', the Two Thieves.

*

The Two Thieves appear only briefly in the New Testament accounts of the Passion, though it is noteworthy that all four Gospels mention them.[19] Though second in canonical order, Mark's Gospel contains the oldest account of the Passion and is therefore the earliest text to tell us that there were two malefactors crucified with Christ, 'the one on his right hand, and the other on his left' (15: 27). Mark later mentions that Jesus suffered mockery from 'they that were crucified with him' (15: 32). Matthew follows suit with an equally minimal treatment (27: 38), describing the way they mocked him and 'cast the same in his teeth' (27: 44). In Luke their story receives its first elaboration when we hear of a conversation between Christ and the Thieves upon their crosses. One of them insolently demands, 'If thou be Christ, save thyself and us'; the other, however, 'rebuked him saying, Dost not thou fear God, seeing thou art in the same condemnation?' He continues to berate his counterpart, explaining with forgivable naïvety, 'And we indeed justly; for we receive the due reward of our deeds; but this man hath done nothing amiss' (23: 39-41). Luke's dialogue thereby represents the Two Thieves as anti-types, moral-spiritual opposites: one unrepentant for his misdeeds, blind to the significance of Jesus's death and scornful of His suffering; the other a model of repentance, whose last-minute conversion opens his eyes to Christ's divinity. 'And he said unto Jesus, Lord, remember me when thou comest into thy kingdom. And Jesus said unto him, Verily I say unto thee, Today shalt thou be with me in paradise' (23: 42–3).

So much of the Gospel accounts of the Passion are steeped in the prophetic imagery of the Old Testament that little doubt remains that certain motifs are literary devices intended to demonstrate the fulfilment of those prophecies. For all we know, the historical existence of the Thieves may be little more than a transposition of Isaiah's words: 'and he was numbered with the transgressors' (53: 12). Clearly, by the time we get to Luke, a good part of what the theologian Jürgen Moltmann calls the 'kernel of historical truth' about the Passion and death of Jesus has already been swept away. Each Passion narrative has a different emphasis and emotional pitch, and each bears a different theological import. Whereas the earlier Gospel of Mark relates the agonized death cry of Jesus, 'My God, why hast thou forsaken me?' (15: 34) and thereby emphasizes the bitterness of His death, Luke rejects the implacable desolation of this formula in favour of the confident utterance of the Jewish evening prayer, 'Father, into thy hands I commend my spirit' (23: 46), emphasizing that the work of salvation has concluded. Although the text and imagery of Christ abandoned on the Cross come from Psalm 22 and carry its scriptural authority,

Moltmann concludes, along with other scholars, that the more difficult reading of Mark, based on very ancient traditions, is probably closest to the historical reality.[20] Thus the presence of the Thieves alongside Christ, as attested by Mark and Matthew, may well be based on contemporary recollections, but this is much less likely in the case of the words and actions attributed to them in Luke. Luke's dialogical evocation of the Two Thieves as opposites, one damned and the other redeemed, must be understood instead in terms of the general optimism of the later accounts, with their emphasis on the Resurrection and the imminence of Christ's return. These writers, like Paul, treated the Crucifixion 'as the necessary precondition of his resurrection' and thereby maintained, for some 500 years, the 'unity of cross and resurrection' as a single paschal mystery.[21]

In the Greek tradition of the apocryphal Gospels the Thieves appear again, now, significantly, with bigger parts to play. The author of the fifth- or sixth-century *Gospel of Nicodemus*, sometimes called the *Acts of Pilate*, a text whose colourful embroideries were widely woven into medieval art, informs us of several interesting facts about the culprits. When Pilate personally decrees Jesus's conviction, we also hear, for the first time, their names: 'and let Dysmas and Gestas the two malefactors be crucified with thee'.[22] In all but one of the extant manuscripts bearing this text we are told that these men hung on opposite sides of Jesus in a certain fashion, 'Dysmas on the right and Gestas on the left'. By appealing to the symbolic sense of the right hand of God (*dextra*) as a place of honour and privilege and the left (*sinistra*) as a place of debasement and condemnation, the text's spatial polarity inaugurated a tradition in which Gestas is identified as the Impenitent (or Bad) Thief and Dysmas as the Penitent (Good) one who rebukes his counterpart in Luke. In the *Gospel of Nicodemus* the dialogue from Luke is reproduced verbatim, virtually sealing the antithetical identities once and for all. However, M. R. James, the English scholar who offered the first standard translation of the book, points out that one of the surviving manuscripts containing the legend places *Gestas* on the right and Dysmas on the left; and several works discussed in these pages show the name 'Gestas' inscribed near the Thief on Christ's right (see illus. 32, 38). Whether these are the outgrowths of a primitive literary tradition or the result of iconographic confusions or misappropriations is unclear; apparently unaware of the divergences in the visual record, James insists that the canonical view, which places Dysmas on the right side, prevailed.[23]

In another early text, called *The Story of Joseph of Arimathaea*, the author digresses upon the 'two condemned robbers sent from Jericho

to Pilate', and commits a fair number of lines to sketching the criminal careers of both men:

The first, Gestas, used to strip and murder wayfarers, hang up women by the feet and cut off their breasts, drink the blood of babes: he knew not God nor obeyed any law, but was violent from the beginning.

The other, Demas, was a Galilean who kept an inn; he despoiled the rich but did good to the poor, even burying them, like Tobit. He had committed robberies on the Jews, for he stole (plundered) the law itself at Jerusalem, and stripped the daughter of Caiaphas, who was a priestess of the sanctuary, and he took away even the mystic deposit of Solomon which had been deposited in the (holy) place.[24]

Gestas, the Bad Thief, is an irredeemable sociopath, while Demas (Dysmas), the Good Thief, becomes a people's outlaw, a heroic blasphemer against a bankrupt religious order, much like Christ himself. Further embellishments to the Good Thief's criminal biography appear in the Arabic *Gospel of the Infancy*, or *Evangelium arabicum*, where the Holy Family, fleeing into Egypt to escape Herod's wrath, meet up with the bandits Titus (Dysmas) and Dumachus (Gestas). Dazzled by the baby Jesus's beauty and moved to compassion, the Good Thief scuttles his own robber-band's plans to despoil (and kill) the helpless wanderers; in return, Jesus prophesies that in thirty years the two will be crucified on either side of him, and that Titus will see Paradise.[25]

At the Crucifixion, as narrated in *The Story of Joseph of Arimathaea*, each man delivers a strident speech on his own behalf, in effect shoring up his credentials as either recklessly wicked or good at heart. Gestas boasts about his evil deeds, assuring Jesus that, 'had I known thou wert king, I would have killed thee too'; he heaps mockery upon blasphemy, and does some teeth-gnashing too. Demas, 'seeing the divine grace of Jesus', asks for mercy and forgiveness for his sins, entreats Christ to protect his soul from the Devil's clutches (tantamount here to being cast 'into the lot of the Jews') and exults in the prospect of one day watching, from the heavenly kingdom, as the Twelve Tribes of Israel are judged and punished. Christ responds by promising him Paradise, adding the reassurance that 'the children of Abraham, Isaac, and Jacob, and Moses shall be cast out into the outer darkness'.[26]

At the heart of this crude anti-Jewish polemic lies the makings of a powerfully archetypal role for the Good Thief Dysmas. Since, according to Christ's own words, 'none of the former men [the Old Testament patriarchs] shall see paradise until I come the second time to judge the quick and the dead', the heavenly kingdom is initially left with one heir, Dysmas. Much of the rest of the story is in fact given over to playing out this remarkable notion. First, immediately before

he dies, Christ composes a letter to the archangels who stand guard before the 'doors of paradise', ordaining with solemn authority that 'he that is crucified with me [should enter in], receive remission of his sins for my sake, and being clothed with an incorruptible body enter in to paradise, and that he dwell there where no man *else* is ever able to dwell'. Accordingly, when Joseph of Arimathaea, the pseudonymous author of the legend, goes to seek the dead body of Christ, he finds the body of Dysmas missing (whereas the punished body of Gestas appears monstrous, 'like that of a dragon'). Later, after the Jews imprison the narrator, Jesus appears to him in a luminous vision 'with

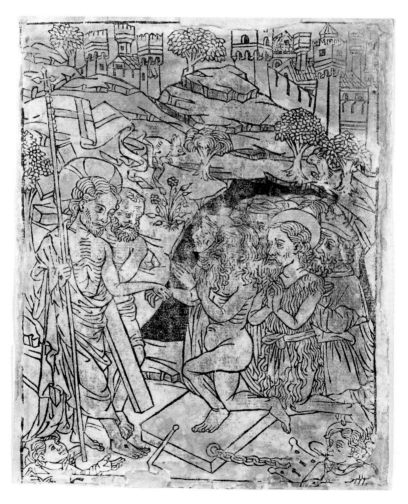

3 *Christ in Limbo*, German, 15th century, woodcut, 170×130 mm. Germanisches National museum, Nuremberg.

the thief on the right hand'; Christ transports him to Galilee, where they meet John the Apostle. In the end, the Thief has not only become the sole heir of Paradise but is now transfigured before the two witnesses into a mysterious emblem of 'things hidden', a majestic figure 'like a king in great might, clad with the cross'.[27] Other traditions likewise place Dysmas at the gates of heaven.[28]

Art history has yet to produce a study of the diverse *visual evidence* for a cult of the Good Thief, but such a cult undoubtedly existed, most strongly in the Baroque era ('St Dysmas' has never officially been canonized, however). What seems to have aroused the interest of pre-medieval Passion narrators was the exaltation of one who, like Christ, is condemned and executed as a criminal: he attains glory through humility and suffering, not despite but *because* of the fact that he shares his fate with the most ignominious and wicked of men. Indeed, his unlikely ascent to the very apex of blessedness reveals, with a polemical force that is hard to appreciate today, the superior redemptive power of Christ's Death on the Cross. 'Clad with the cross', he appears in Byzantine Last Judgement imagery outside the gates of Paradise; likewise he accompanies Christ in numerous examples of the pre-Resurrection Descent into Limbo (illus. 3). The promise of Paradise comprised the second of the so-called 'Seven Words from the Cross' (mentioned above), which became the basis of one of several types of serial meditations offered

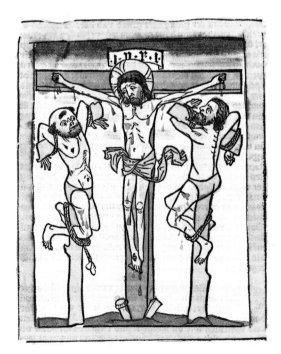

4 'Crucifixion with Two Thieves', woodcut from *Gaistliche vsslegung des lebens Jhesu Christi* (Ulm: Johann Zainer, 1480–85), fol. 123v. Germanisches Nationalmuseum, Nuremberg.

to lay people seeking spiritual improvement in the late Middle Ages. In a German edition of the tract *Gaistliche vsslegung des lebens Jhesu Christi* ('Spiritual Interpretation of the Life of Christ'), printed in Ulm between 1480 and 1485 and illustrated with woodcuts, the assymetry of the redemptive promise is dramatized by abstracting the three crucified from the hubbub of Calvary (illus. 4). Through image and word, the text assures the reader that no one, regardless of the enormity of their sins, will be denied forgiveness. It provides prayers that actively encourage the reader to *identify* with the Penitent Thief, who was redeemed and beatified at the critical 'hour of death' (*hora mortis*).[29]

Frequently and intensively, then, did the devotional literature and imagery of the era present the Good Thief as a model of spiritual conversion and the progenitor of the 'perfect penance', a spiritual goal towards which the mendicant orders in particular urged the laity. Chapter 7 examines the effervescent role of the Franciscans in the medieval Dysmas cult, and draws out the implications for the saint's intercessionary role as a patron of convicted criminals, and of the 'good death' in general – implications that extend to Passion iconography as well as to judicial spectacle, and inform the dialectic of beholding that traverses between them.

Several centuries had to elapse before Eastern icon painters and Western manuscript illuminators would take up the task of realizing pictorially the Thieves' antithetical criminal personae found in the Apocrypha. In early Christian art this idea was expressed simply, through gesture, as when the designer of early pilgrims' images turned both Thieves' heads to the right, so that the figure on Christ's right looks towards Him while his opposite looks away (see illus. 16). Most medieval makers of images, though not all, adhered to the traditional spatial symbolism of God's right and left hands to distinguish Dysmas from Gestas. In later medieval art, as the many examples on the following pages show, differing physiognomies, facial expressions, skin colour, clothing and even hair colour expressed and reinforced the contrast. The art historian Ruth Mellinkoff has called these motifs 'signs of otherness', for they marked the Thieves as infamous and, in the case of the Bad Thief, impious and wicked.[30] As condensations of both folkloric and learned stereotypes, these signs of infamy were important triggers for response. They comprised an integral part of the stock of quotidian references that northern European painters, in particular, used to contemporize their visions of the events on Calvary.

My focus in what follows, however, is different. I am less concerned with this surplus of defamatory markings than with the figurative

Gestalt to which they were attached: the image of the body in pain. What were the late medieval painter's primary strategies for visualizing the pain of crucifixion? With the possible exception of the Last Judgement, with its infinite array of infernal cruelties, no other iconographic theme gave medieval painters, over the long term, such a wealth of opportunities to develop a figurative language of pain than the Crucifixion. For beholders the penalty was at once exotic, because obsolete, and yet compellingly familiar. So how did painters invest their depictions of the *Thieves'* punishment – so different from Christ's – with such a sense of the familiar? How did they manipulate the 'look' of crucifixion and its effects on the body – what I'll call in Chapter 6 a *phenomenology of pain* – so that contemporary viewers might apprehend it more clearly and immediately? What cues for response lent the punished body in the sacred narrative *image* its gruesome palpability as *spectacle* for contemporary viewers?

From what's been said already, it will be clear that I regard the viewers' lived experience of spectacular pain inside the rituals of justice as a key framework for explanation and interpretation. Without sounding a methodological alarm, it is important here for me to point out my preference for the term 'framework' over 'context'. As Norman Bryson has cogently argued, a number of fallacies emerge whenever 'context' is taken as a fully determined, stable and reliable unity – a completed picture, so to speak, of contiguous social realities – and then juxtaposed with the 'text' (in our case the visual image) to establish a cause-and-effect relation.[31] It is easy to put faith in contexts. An important point of departure for my own work had been the belief that a medieval-judicial 'context' would help me understand the ferocious penal violence I saw in the visual narratives of the late Middle Ages, an era that loved to see itself reflected in the mirror of biblical history.

On one level this faith in 'context' was and is justified, since we can readily identify instances where a painter's recollections of a specific penal practice are inserted directly into the pictorial narrative. A straightforward example appears in the Calvary scene from a middle Rhenish Passion altarpiece of *c.* 1420, once in the St Peterskirche of Frankfurt and now preserved in the city's museum (illus. 9).[32] Here we see an executioner leading the condemned man, fettered in ropes, backwards up a ladder in precise emulation of the medieval method for hanging – the aim being to shove the victim from the ladder for a relatively slow death by strangulation (illus. 5). To my knowledge, the motif has no textual authority; neither the Gospels nor the Apocrypha nor contemporary Passion narratives describe it. But contemporary, secular illustrations of the same procedure do (see illus. 57, 75), and

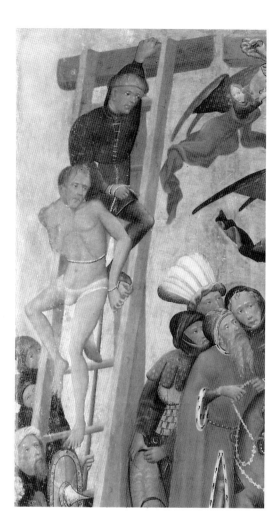

5 Detail of illus. 9, showing the Thief on Christ's right being pulled up a ladder.

they exist in sufficient numbers to assure us of the plausibility of our leap from context into 'text', that is, the imaginative spaces of Passion iconography. If we can hold at bay the deconstructionist's loquacious doubt about representation per se, the social context in such cases provides here a useful key for distilling out the procedures of observation, recording and transcribing from those that owe more to convention or even fantasy.

But where can interpretation go from here? The answer is, not far. Fascinating as these clear-cut transfers from social context to religious text are, we have succeeded only in identifying what Arthur Danto calls a 'manifestation' of a social reality inside the picture.[33] It is easy enough to offer an explanation (what hermeneutical philosophy calls *Erklärung*), but we have as yet fallen short of the interpretive task of

making sense of the idea we find embodied in the image, what Danto calls the artist's 'expression'. We have stopped short, in a word, of understanding (*Verstehen*). Broadly speaking, the problem with past scholarly approaches to 'judicial iconography', both within and outside of art history, is a surfeit of explanation and a shortfall of interpretation. Certain historical factors, to be sure, recommend that we view the reference to hanging in the St Peterskirche altar as a 'manifestation' of quotidian reality into the biblical narrative. As a maker of images, the guild-sanctioned master working around 1420 would not have been familiar with the advanced claims for poetic licence then being advanced in Italian humanist circles, claims that inaugurated the modern conception of 'art' and established the pre-eminence of the painter's aesthetic *idea* as a signifying presence in the work (see Chapter 8). Without the assurance that the painter self-consciously implanted an *idea* in the work, can we apply ourselves in good faith to the hermeneutical unravelling of its expressive purpose?

The Frankfurt master's departure from convention is apparent enough, but we can only guess at the motivation behind it. On the other hand, where artistic self-consciousness can be assumed (as is the case with most painters imbued with humanist ideals), the anachronistic superimposition of one judicial reality upon another can create tantalizing new conditions of interpretation – and experience – for the beholder. A pen and ink drawing of *c*. 1525 by the 'Danube' painter Wolf Huber (now in Cambridge) does this in several ways (illus. 6). Rotating the angle of view as Cranach and Altdorfer had done before him, Huber invests our perspective with an imperative towards self-consciousness as we gaze upon the pitiable lamentations beneath the Cross (the forest setting records the features outside Huber's native Feldkirche).[34] Seen in profile, the dead Christ hangs from the Cross, the sole focus of the mourners' gestures of desolation. Hovering above him, another figure hangs by the neck from the branch of a tree, evidently not one of the Thieves but the traitor Judas Iscariot, whose suicide, driven by remorse, often appears in scenographically complex, late medieval renditions of the Crucifixion. Huber seems to have eliminated the Thieves, or has he? Behind the hanging tree we see a hangman's ladder and, at its base, an executioner surveying his work; there is also an elevated wheel, loaded with human carrion. Huber's forest Calvary has become an infamous execution precinct, where all the vulgar penalties, past and present, mingle. We are led to wonder if the wheel perhaps holds Dysmas or Gestas, or if the apparent suicide is really one at all (the figure's arms appear to be cuffed behind the back). By playing with the codes of both biblical and judicial narratives,

6 Wolf Huber, *Calvary with Executed Criminals*, *c.* 1525, pen and ink drawing, 32 × 21.5 cm. Fitzwilliam Museum, Cambridge.

Huber conflates crucifixion with the vulgar penalties of his own day, re-envisioning Christ's death among Thieves as an utmost disgrace. Like Cranach, Huber strips the event of transcendence to plumb the depths of Christ's humanization, and to test our response to a death so disenchanted.

It is significant that we have no surviving altar panels to show that Huber ever *painted* such radically conflationary motifs for a patron. Unlike modern artists, whose drive to innovate can beget new visual codes that are beyond the perceptual or cognitive scope of their audience, but wind up moving them in a certain direction, medieval painters and sculptors had to collaborate closely with their audience's mental and visual habits, which they of course shared. What shaped these habits? To be sure, a network of experiences, among them the pictorial form of the sacred image, which was evolving at this time. Equally important, I think, was the experience of spectacle, which offered people in groups emotionally charged opportunities for a kind of collective simultaneous perception. Spectacles had to play to audience

sensibilities and, in particular, visual habits developed over the long term, but they also shaped them. And for this reason, I would argue that the 'context' I have chosen to recuperate as a framework for my interpretation, the theatre of criminal justice, with its attendant rituals, is no static context at all, but a dynamic sphere of social action, religious expectations and visual experience that was constantly being remade by the very human sensibilities it engaged with. It seems appropriate to ask: Might not the visual habits and modes of perception that were acted upon by the spectacle of bodily violation and pain have also been shaped by the experience of looking at pictures? Might not the inverse be true as well?

These are speculative questions, but if this is a valid way to pose the problem of *intervisual* communication and experience, we have taken the first step towards a *dialectical understanding* of the interrelatedness of spectacle and 'art'. Each sphere of perception, feeling and thought points the way back to the other. Spectatorship in each sphere conditions experience in the other, so that each serves as a text and context for the other. For these reasons, I believe it is vital, despite the methodological difficulty, to avoid isolating the 'history of art' from the history of spectatorship, since both streams are fed by, and in turn feed into, the main currents of visuality's history.

Most of these investigations lead outwards and back into this insight. In them I seek to trace the sociogenesis of a mode of visuality I call the 'medieval paradigm' and explore its simultaneous conditioning and exercising by images, religious devotion and judicial spectacle. In Chapter 8 I trace the beginnings of its slow dissolution, which culminated in the abolition of public executions in the nineteenth century; and in the Epilogue I consider the implications of its apparent return.

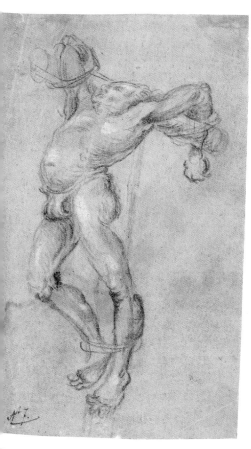

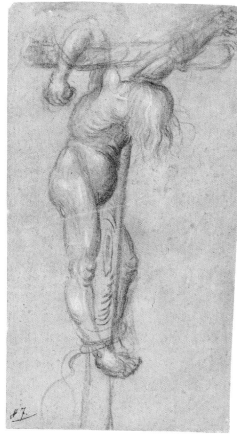

Lucas Cranach the Elder, *Thief on the Cross* (1), *c.* 1502, black and white chalk on red-toned paper, 21.5 × 12.8 cm. Staatliche Museen zu Berlin – Preußischer Kulturbesitz (Kupferstichkabinett).

8 Lucas Cranach the Elder, *Thief on the Cross* (2), *c.* 1502, black and white chalk on red-toned paper, 22.6 × 12.1 cm. Staatliche Museen zu Berlin – Preußischer Kulturbesitz (Kupferstichkabinett).

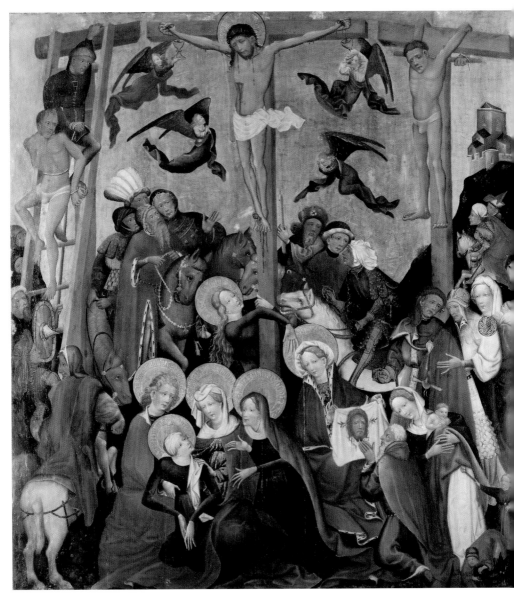

9 Middle Rhenish Master, *Passion Altarpiece*, *c.* 1420, 186.7 × 168.3 cm. Originally St Peterskirche, Frankfurt; now Historisches Museum, Frankfurt.

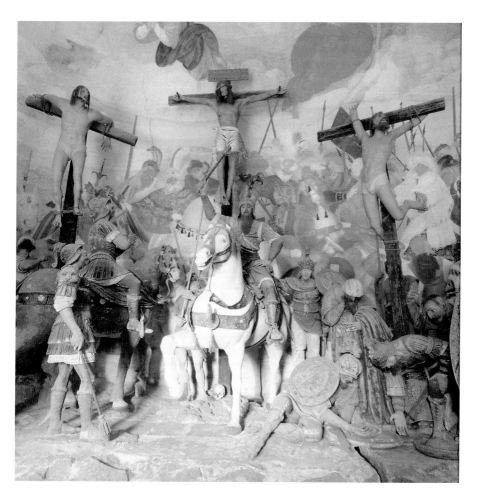

10 Gaudenzio Ferrari and workshop, *Calvary*, polychrome
sculpture with other media, from the Calvary chapel,
Sacro Monte, Varallo (Piedmont), 1520–28 (detail).

11 Ferrari and workshop, detail of *Calvary* showing the
Virgin Mary and the apostle John.

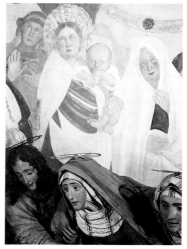

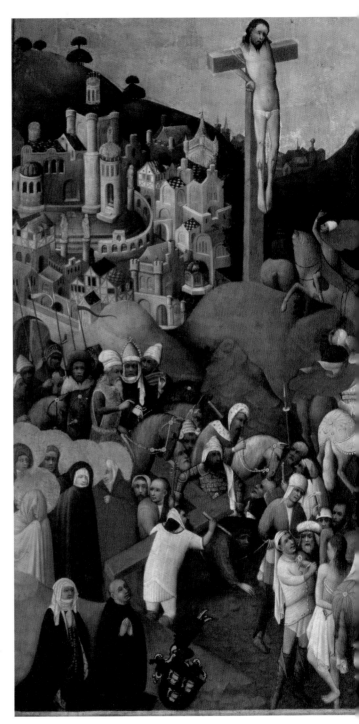

12 The Master of the
Wasservass Calvary,
*Calvary with Other Scenes
of the Passion* (the so-called
Wasservass Altar),
1420–30, painted oak
panel, 131 × 180 cm.
Wallraf-Richartz-
Museum, Cologne.

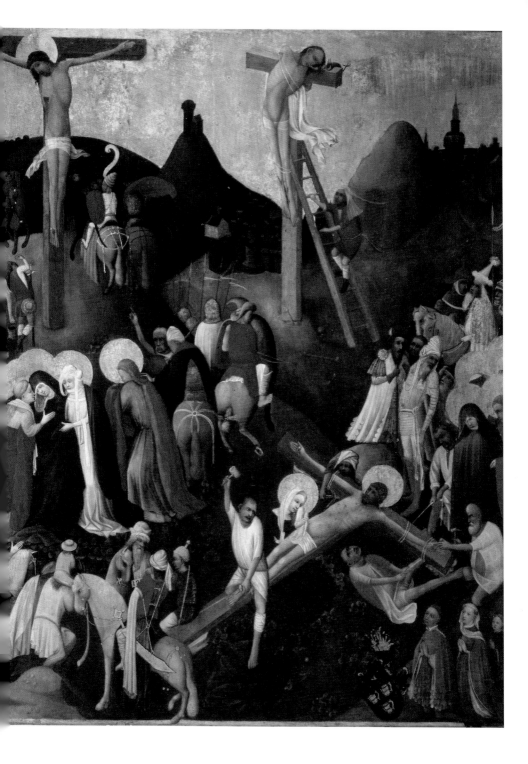

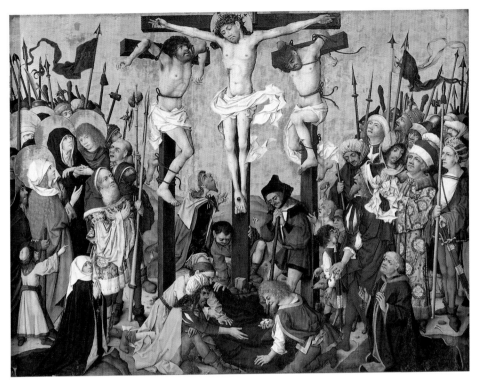

13 The Housebook Master, 'Calvary', central panel of the *Passion Altarpiece* (the so-called *Speyer Altar*), 1480–85, painted pine panels with gold ground, 130.5 × 173 cm. Augustinermuseum, Freiburg im Breisgau.

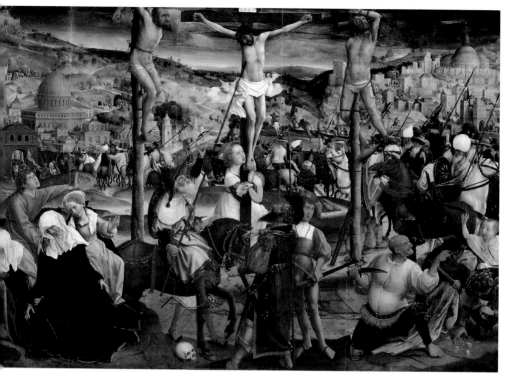

14 Jan Provoost, *Calvary*, early 16th century, oil on oak panel, 117 × 172 cm. Groeningemuseum, Bruges.

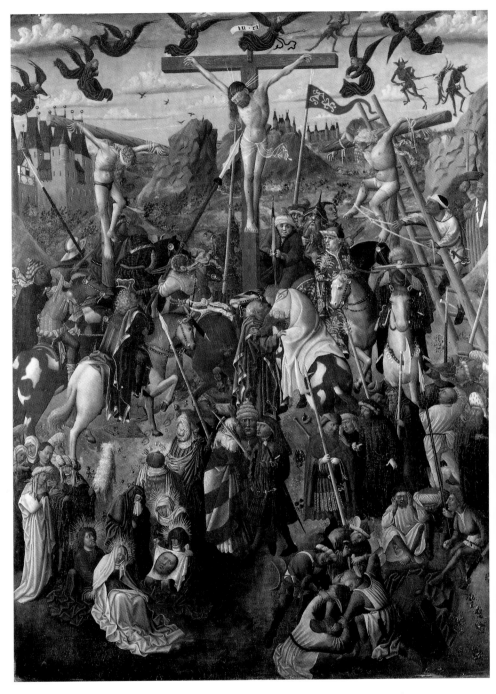

15 The Master of Benediktbeuren, *Calvary*, mid-15th century, painted pine panel, 170.5 × 126 cm.
Alte Pinakothek, Munich.

1 'A Shameful Place': The Rise of Calvary

> The pains of the Passion were fivefold. The first pain consisted
> in the shame of the Passion. For he bore it in a shameful place,
> Calvary being reserved for the punishment of criminals.
> JACOBUS DE VORAGINE, *Legenda Aurea* (*c.* 1260)[1]

Going to Calvary

Pilgrims and tourists who want to walk the *via crucis*, ascend Mount
Calvary and witness there the climax of Jesus's Passion, his agonizing
death on the Cross, can still, without going to Jerusalem, visit the well-
known pious simulation, the *Sacro Monte* (Holy Mountain), which
looms above the town of Varallo, in the Piedmont region of Italy (illus.
10). Conceived by an Observant (Franciscan) Friar, Bernardo Caimi,
in the old Milanese duchy as an accessible European substitute for the
perilous and expensive journey to the Holy Land – a painted inscrip-
tion there once claimed, 'so that those who cannot make the pilgrimage
see Jerusalem here'[2] – the project began in 1486, shortly after Caimi
received papal permission for the plan. In 1491 it opened to pilgrims,
with only the first three chapels ready for viewing. This makes Varallo
the oldest of the *sacri monti*, versions of which can be found in Spain,
Portugal, Germany, Brazil and elsewhere in Italy, each with its own
programme of sacred imagery.[3] The most dazzling of these multi-media
spectacles, Varallo is also the best loved and most widely studied.

Over the centuries of its growth, decline and modern recuperation,
the Sacro Monte has earned a reputation as a monument of 'popular'
art for two related reasons: because its founders built it as an elaborate
stage set for their missionary activities, first among them preaching;
and because the striking, often grotesque hyper-reality of its many
tableaux vivants, what one scholar calls its 'almost hallucinatory style',
fails to sit still inside any established art-historical categories.[4] Familiar
biblical scenes are enacted by hundreds of life-sized and lifelike poly-
chromed sculptures, replete with the stiff gestures, glass eyes, real

clothing, hairwigs and props (including stuffed horses at Calvary and seasonal fruits on the table of the Last Supper) which we often associate with religious kitsch (illus. 11). To cultivated tastes, the tableaux might appear more like a strange hybrid of folk theatre and wax museum than Renaissance Art. Yet we know that the work in all media represented there was in fact executed by some of the leading artists of the day. The spacious and turbulent Calvary scene, for example, was part of the statuary programme begun by the Lombard painter and sculptor Gaudenzio Ferrari – whose fame rested upon it for most of his career – in 1490, though it was not completed until about 100 years later by others.[5] Furthermore, the apparent pitch to 'popular' sensibilities which permeates the whole did not, as one historian notes, prevent Milanese aristocrats, various heads of state, Church officials and the celebrated humanists of the day from making the journey, praising its beauty and feeling moved by the devoutness of the scenes.[6]

In order to reach the building housing Gaudenzio's Calvary, visitors must first wend their way through 45 chapels (called *luoghi sancti*), each containing their own scenographic tableaux displayed behind iron or wooden grilles, through which one looks. Beginning with the Fall from Grace and the Annunciation, and climaxing in an expanded version of the Passion, over 600 statues and 4,000 painted figures greet the pilgrim.[7] To engage all the senses visitors physically ascend the mountain slope upon which the chapels are arranged (unlike modern theme-park visitors, whose effortless movement via monorail creates a kind of spectatorial distance which is compensated for by loud special effects). As they trod the simulated *via sacra*, medieval pilgrims would survey the holy places, perhaps pause to touch the sculptures (cuddling the Nativity's Baby Jesus, for instance), and listen to the precise descriptions of the Holy Land offered by the friars. Physical movement contributed to a feeling of being personally involved in the events. Once inside the Calvary chapel, visitors were surrounded by a dizzying array of carved and frescoed figures – in a sense, by other 'participants' in the Passion, whose postures, gestures, expressions and responses must have in turn elicited certain responses. They might also be urged by the friars to recite familiar prayers, or to immerse themselves in a deeply felt, affective contemplation of events. At the Sacro Monte, then, physical effort would have been not only rewarded but also, as George Kubler observes, required if the pilgrims were to approach the scenes with the proper mindset. The tour itself became a rite of passage undertaken, in all likelihood, by communities of fellow travellers, each of whom earned the privilege of witnessing the tragic and turbulent climax of Christ's Passion personally. Every exhausted

tourist knows how the hardships of a journey can, at unexpected moments, melt into moods of reverential awe and gratefulness for the things seen; here, at the summit, such an effect on sensibilities and pious feeling was no doubt calculated, its psychological impact sustained through exhortations and prayers, and its educational potential exploited to promote specifically Franciscan spiritual ideals (later it was used for explicitly anti-Lutheran purposes).[8]

Unlike medieval pilgrimage shrines, the Sacro Monte boasted no wonder-working relics, no miraculous images or saintly patrons – the attraction, like that of today's theme parks, was the very experience of moving through the simulation: 'The early *sacri monti*, from Varallo on, first answered the need for scenographic spaces shaped for human motion in sacred history.'[9] This 'New Jerusalem', as the Milanese Archbishop Carlo Borromeo called it, therefore became more than a sanctuary and more than a centre for Franciscan preaching; it served as a great conduit for channelling popular religious feeling into the empathic forms commensurate with Franciscan spirituality. And it did so by placing pilgrims in direct, imaginative contact with the people and events of the Passion.

Direct, imaginative contact with the people and events of the Passion. Here I must choose my words carefully. For surely biblical events were regarded by pious medieval Christians in the way we regard historical events today, as singular, unrepeatable occurrences. Personal experiences of these events therefore had to be achieved through the imagination; one simulated pilgrimage and the sense of place mentally. This was one of the primary goals of religious life in the so-called 'Franciscan Middle Ages'[10]: the training of the imagination for making interior pilgrimages to the Holy Places (*loca sancta*), especially Golgotha and the Lord's Sepulchre, the sites of the Passion. Perfected in the monasteries, visual meditation was disseminated to the laity primarily – at least in the three centuries prior to the Reformation – by the Franciscans and Dominicans, who cultivated it intensively themselves. But how exactly was the image-forming capacity of each person to be cultivated and used? As difficult as a human faculty like imagination is to study, we must consider what medieval people saw as its psychological dynamic and spiritual purpose if we are to understand the role it played in devotional practice. What did the first pious audiences at Varallo think they were *seeing* in Gaudenzio's re-creation of Calvary, and of what use was it to them?

Judging from the hyper-realism of the scene, one could begin by inferring that ordinary folk thought they were seeing accurate re-constructions of the biblical people and events. This might sound

condescending, but it is not unjustified. Caimi and his brethren were very explicit in their claims that Varallo was to be experienced as an accurate topographical reproduction of Jerusalem and its sites. In his sermons Caimi often referred to his personal knowledge of Jerusalem (for a time he was chief among the Franciscan caretakers of the Holy Sepulchre). Further, when reassuring his audience about his experience showing pilgrims in the East the real thing, he evidently gave free play to what Alessandro Nova calls the 'Franciscan obsession with numbers, dimensions and distances': the height of the True Cross, the shape and manufacture of the table of the Last Supper, the distance of Calvary from the city walls, etc.[11] Gaudenzio's attention to the minutest details in his sculptural renditions, the use of all types of material props and accoutrements to bring the scene on Calvary to life, accorded with and reinforced the friars' claims to accuracy.

However, when pilgrims stopped at the Observant church before ascending the Holy Mountain, we are told, they were diligently reminded that what they were going to be visiting were, in fact, *reproductions* of the Holy Land, and that the statues they were going to be seeing were *replicas* of the people and events of the Bible (not, of course, replicas of statues in Jerusalem, which never existed).[12] Why, then, did the friars keep their auditors aware of the simulated nature of the spectacle before them, but at the same time vaunt its unparalleled accuracy? Numerous inscriptions throughout the complex appear to claim authenticity for its features: outside the Lord's Sepulchre, for example, there is a stone that claims to be '*similar in every detail* to the stone slab which covers the tomb of Our Lord Jesus Christ in Jerusalem'.[13] Yet at the same time the friars were careful not to overstate their claims. The reasons behind this circumspection reveal much about the interconnections between pilgrimage, imagination, devotion and religious images in the later Middle Ages.

At Varallo the friars defined the line between reality and simulation because they sought, as the foundation of all their other educational goals, to train their audiences in the proper uses of the imagination and memory, not to furnish them with fixed images for easy recall. This may seem paradoxical in light of the specificity of detail which the spectator encounters at every 'station' – and modern visitors may well complain that 'nothing is left to the imagination'. But listen to what the Franciscan author of the popular devotional tract, the *Meditations on the Life of Christ*, advises in this key passage: 'For the sake of greater impressiveness I shall tell [the events of Christ's life] to you as they occurred or as they *might have occurred* according to the devout belief of the imagination and the varying interpretation of the mind.'[14] For

the Poor Clare (a Franciscan nun) for whom the guidebook was originally penned, the distinction between what 'occurred' and what 'might have occurred' is meant to be fluid and creative, not a dead end to interpretation. It was drawn to remind the meditator that the Evangelists, though the primary sources of information, do not tell all that Christians need to know about the Passion. 'There are still many other things Jesus did,' we read at the very end of John's Gospel, 'yet if they were written about in detail, I doubt there would be room enough in the entire world to hold the books to record them' (21: 25). What the Gospels did tell was, of course, unimpeachably truthful, but when it came to the specifics of Christ's suffering and death, Scripture was woefully sparse from the perspective of late medieval piety.[15] Details which they passed over in silence had to be furnished by the imagination – but for the lay person this could hardly be expected to happen unaided. To feed the growing appetite for detail, writers of Passion narratives like the *Meditations*, following the great Franciscan theologian Bonaventure (*d.* 1274), practised a form of biblical exegesis that F. P. Pickering famously described as a 'translation of ancient prophecies, metaphors, similes and symbols . . . into "history"'.[16] The result of their labours was a class of expanded, popular accounts of the Passion that focused the reader's imagination on the historicity and actuality of biblical events.

Devotional authors sought to compel their readers, as the friars did their peregrinating visitors to the Sacro Monte, to fuse within themselves the roles of spectator *and* participant in the Passion. Believers were to cultivate the mental power to witness the events with their own, spiritual sight, deploying fragments of experience gleaned from corporeal vision and whatever else might serve as a catalyst.

And then too you must shape in your mind some people, people well known to you, to represent for you the people involved in the Passion – the person of Jesus himself, of the Virgin, Saint Peter, Saint John the Evangelist, Saint Mary Magdalene, Anne, Caiaphas, Pilate, Judas and the others, every one of whom you will fashion in your mind.[17]

So advised the author of the *Zardino de Oration*, a spiritual guidebook published in Venice in 1454. Meditative practice meant learning to cast and direct the actors of one's inner Passion play in order to make their performances as absorbing as possible. The importance of such devotional ideals for grasping the character of later medieval imagination and image-making can hardly be underestimated. In tandem with them evolved a mutual dependence between the painter's and the spectator's efforts at visualization. One of the best formulations of this intervisual collaboration is Michael Baxandall's investigation of the 'period eye':

The painter was a professional visualizer of the holy stories. What we now easily forget is that each of his pious public was liable to be an amateur in the same line, practised in spiritual exercises that demanded a high level of visualization . . . The public mind was not a blank tablet on which the painters' representations of a story or person could impress themselves; it was an active institution of interior visualization with which every painter had to get along. In this respect the fifteenth-century experience of painting was not the painting we see now so much as a marriage between the painting and the beholder's previous visualizing activity on the same matter.[18]

The physical pilgrimage to the Holy Land or its European surro-gate, limited in time and space, was to be matched if not surpassed in the believer's lifetime by countless mental journeys, interior visualiza-tions of the personages, places and events which comprised the corpus of sacred narratives. Among these narratives, the story of the Passion demanded, and rewarded, the most intensive mental efforts at 'mystical witnessing'.

Many of the pictures illustrated in the following pages were expressly designed to facilitate such acts of 'mystical witnessing', but some also thematized the pilgrim's journey and explicitly showed the patron spectating within the spectacle itself. One such picture is the so-called *Wasservass Calvary*, now in Cologne, named after the patrician family who commissioned it from a city guild master sometime between 1420 and 1430 (illus. 12).[19] From an elevated perspective we look down upon a bustling stage set that encompasses several episodes of the Passion, a scenographic assemblage that must be 'read' and thus ex-perienced sequentially. Asked to wend our way visually through this three-dimensional map of the *loca sancta*, we find ourselves leaving behind Pilate's prison and the empty spaces of a candy-coloured Jerusalem (upper left); observing Christ stumble under the weight of the Cross as the judicial procession, headed by the Two Thieves in fetters, arrives at Calvary (lower left); following the dashing riders across the landscape to the place where grunting knaves stretch Christ's limbs and pound nails through his members; and then gazing upon the drama of the tortured men expiring on their crosses, which loom so large over the bone-strewn hilltop. Our specular peregrina-tions between scenes are spurred by the hectic activity of the riders, but also halted before each scene of torture by the rich blue robes of the Virgin, depicted three times and always prominent among the mourners. And in the lower corners we see the donors – the scion of the Wasservass family, Gerhard, and his wife, Bela, on the left; his son Godert and his first wife, Christine, on the right – kneeling next to their coats of arms. Pilgrims all, we enter into a special relationship

with our pictured counterparts. At the same time we look upo. Christ's tribulations, we look at them looking, praying and absorbing themselves in the thing seen, no doubt aware of their roles as privileged surrogates for our vicarious journey. We share their vision of event and place, but they have arrived physically where we only imagine ourselves to be.[20]

We could easily go further in exploring the dialectical interplay of subject and surrogate, presence and absence, place and imagination, voyage and vision, and add to these factors the later situation of the Wasservass panel in the family chapel in St Columba's Church, built by Godert before his death in 1464.[21] But the point I hoped to make is simple enough: an experiential continuum existed between artefacts as diverse as the Sacro Monte and the painted altar panel, because they both furnished a literalized space for the imagination's deployment. Each encouraged the pilgrim to think of Calvary, and *use* it, as one of the paradigmatic *loca sancta* in several senses simultaneously: as the physical setting for the unrepeatable events which transformed history; as the point of arrival for pilgrims desiring commemoration and communion with those events in their original setting; and as the *imaginative* setting for the interior pilgrimages which made up the ideal daily regimen of devotional meditations for the laity. From this perspective Gaudenzio Ferrari's veristic sculptural tableaux is nothing more – but also nothing less – than an extremely literal analogue to the everyday visualizations of the Passion that painters and patrons developed in concert with the visualizing activities of the other.

Jerusalem formed the centre of the symbolic geography of Christendom, and this made its geopolitical proximity or distance from the *Corpus Christianum* a matter of some urgency, if not anxiety. Calvary as spectacle, vision and image was always tangled up with the history of Calvary as place, and so the historical development of Crucifixion iconography in its changing forms and functions grew from, and often responded to, the institution of pilgrimage in *its* changing forms and functions. Varallo's situation shows us these entanglements. In 1453, some 30 years before Bernardo Caimi's plan was approved in Rome, the Ottoman Turks had succeeding in capturing Constantinople, an event that toppled the nearly 1,000-year-old Byzantine empire and shocked the Latin West. Caimi sensed that Palestine would soon be annexed, that the hopes of a continuing Christian presence in the Holy Land would be shattered, and that the tradition of pilgrimage there would be disrupted. He was right; by 1517 the Sultan Selim I had defeated the Mamluks and incorporated Palestine, Syria and Egypt into his empire. So the decision to build a

erusalem may look, at first, like an acquiescence to an
geopolitical reality. But it also can be understood as a
ertion of Jerusalem's central place in Christendom and the
y of its deliverance from 'pagan' hands. Franciscan promo-
tion of a Passion-based spirituality had always been bound up with
a zeal for preaching crusades, and both areas of activity seem to
have become more urgent as access to the Middle East was forcibly
restricted.[22] It is also noteworthy that the Sacro Monte appeared to
the public at a time when Protestant reformers in central Europe were
undermining the ideological foundations of pilgrimage *and crusade* as
Church-sponsored institutions. To emphasize Jerusalem now meant
to stake a definitively Roman claim to the threatened *loca sancta* beyond
Europe's borders. Caimi knew in whose rightful hands the *via sacra*
belonged. The topographical accuracy of the Sacro Monte ratified
Franciscan and thus papal authority in the Holy Land.

The contradictions are clear enough. Every effort to bring Calvary
as spectacle closer to the pious imagination had to be all the more
strenuous when Calvary *as place* withdrew further from Europe's
geopolitical grasp. As such, the construction of the Sacro Monte, as a
stridently Catholic monument, did not express a permanent distance
but echoed the call for a new crusade. The experiences provided by the
Sacro Monte, especially at this critical juncture for Christendom –
which turned out to be an end point, given that the Ottoman empire
would effectively control Palestine until 1918 – illustrate the deep
connections between the politics of pilgrimage, religious imagination
and the cultural logic of Calvary's visualization, in whatever media we
turn to. With such a long-term perspective, even one so cursorily
drawn, we can better grasp the modes of devotional response which
accrued around the Calvary image over time, and thus the meaning of
its distinctive motifs at certain points in that history.

Creating Calvary

Calvary is a toponym meaning 'place of skulls', and comes from the
word *calvarium*, used in the Latin Vulgate for the Hebrew word
golgōlet, or Golgotha (originally from the Aramaic *gûlgaltā*). In art-
historical parlance it denotes a type of elaborated or 'historiated'
Crucifixion, set into a landscape with an expanded, often quite dense,
cast of characters. Normally associated with the later Middle Ages,
the heydey of its popularity, the Calvary image contrasts with several
more simplified types of the Crucifixion, the most common of which
presents a triumvirate of the crucified Christ flanked by the sorrowing

Virgin and John the Apostle. *Calvary* therefore comprises but one species within the genus of the Crucifixion as a theme. It also exemplifies the kind of representation early Church authorities designated with the term *historia* (a story or narrative), to distinguish it from the cult image or *imago*, a portrayal of the 'likeness' (*eikon* in Greek) of a holy person, one that was suitable for veneration (*latreia*) in the case of saints or worship (*dulia*) in the case of Christ. Although controversies have always surrounded the form and function of the medieval cult image, representations of biblical history held the comparatively unassailable status of images that taught what Christians needed to know. As Pope Gregory the Great (590–604) famously explained to the iconoclastic Bishop Serenus of Marseilles, images instruct the unlettered, who 'read in them what they cannot read in books'.[23] As *historia*, then, the Calvary image alleges to show the actuality and temporal unfolding of the event, while its 'devotional' counterparts, like the three-person Crucifixion, take us to the symbolic heart of the action by lifting it away from narrative's flow; what German scholars call the *Andachtsbild* (devotional image) is therefore better suited for contemplative immersion and prayer. If only these distinctions held in practice! Art historians have slowly come to realize that narrative imagery could also provoke and sustain a 'devotional' response from medieval beholders. As my own investigations unfold, I too will try to show how fluid these categories were. For the time being, though, I want to let the basic distinction stand, since I contend that it is Calvary's *scenic* conception, above all, that sets it apart as a species from the devotional or symbolic representations. Its historical development, at least, needs to be explained as such.

For the earliest Christian communities in the still-pagan Roman empire, the odour of scandal that clung to the idea of the Crucified God meant that the possibility of picturing the Crucifixion, the climax of His paradoxical human sufferings, had to be deferred. Despite Paul's insistence that Christians 'preach Christ crucified', early Christian iconography could not bring itself to dwell on the sufferings of a human Jesus. Images in the early Church spoke in signs, coded images and allegories, stressing not the death but the Resurrection, and even here not in the descriptive language of *historia*, but only indirectly. Although some abbreviated narrative images exist from the earliest times, evidence of imagery dealing specifically with the Passion is lacking before the fourth century.

But from the era of the emperor Constantine onward, theology, liturgy and piety began to turn decisively towards the commemoration of the Passion.[24] Cults such as the one devoted to the Cross on

49

Golgotha probably existed earlier, but evidence for their practices is scanty. By this time Constantine had called the historic Church Council at Nicaea in 325 and had begun building commemorative churches (*memoria* and *martyria*) upon the acknowledged sites of the *loca sancta*, the most important being the famous rotunda surrounding the Holy Sepulchre in Jerusalem. In 451 the Church Council at Chalcedon established Jerusalem as the fifth patriarchate (after Rome, Antioch, Alexandria and Constantinople), further solidifying the tradition of imperial art. But in most cases imperial patronage could only ratify and give official sanction to what were well-established local traditions. Christians in fourth-century Jerusalem were already commemorating Christ's sufferings in liturgies celebrated at the historical sites of the Passion, and these celebrations attracted pilgrims from all over the empire who, for the first time, could see the sites whose names they had previously only heard and read about.[25] 'In the *loca sancta*, text met place in a confrontation systematically (i.e., liturgically) organized by the Jerusalem Church.'[26] Services appropriate for the occasion and place assisted the pilgrims in visualizing the 'historic' events and entering into their 'real presence' – that is, an immediate though imaginative sense of their actuality.

Scholars can't be sure how old the pilgrimage practices of retracing Christ's path along the topography of the *via crucis* and visualizing his deeds *in situ* are, but the new experiences were undoubtedly one of the early spurs to iconographic innovation. And it was surely Palestine, with its developed network of churches and monasteries centred on the *loca sancta*, that served as the natural *mise-en-scène* of these early images. Unlike the otherworldly art of the catacombs in far-off metropolitan cities like Rome, the new *ars sacra* of Palestine was rich in specific topographical references that connected images – and their viewers – to a concrete sense of place.[27]

One of the earliest surviving images of the Crucifixion can be found among a group of scenes dating to the later sixth century and painted on the underside of the sliding lid of a wooden box made to hold mementoes from the pilgrimage routes (illus. 16). The object is housed among the treasures of the Sancta Sanctorum in the Vatican. Whether or not the images on this functional icon reflect a lost monumental prototype,[28] they were surely meant to relate to the contents of the box. They present what amounts to a scenographic itemization of the relics collected in the course of the pilgrim's travels (also shown are the Nativity, Baptism, Resurrection and Ascension, each of which references a different location). Given this indexical function of relating image to place, we should pay close attention to the scenic devices that

16 *Crucifixion and Episodes from the Life of Christ*, Palestinian, 6th century, painted wooden box for pilgrim's mementoes of the Holy Land (the so-called 'Sancta Sanctorum Icon'), Museo Sacro Cristiana, Vatican City.

evoke Golgotha's terrain. Not only does the mountain vista unify the spatial setting for the figures, who can now interact with one another in convincing ways; it may also have helped the viewer/owner of the box to visualize the events *in situ*, when he or she was actually present at the holy sites, or even re-create the memory of the sites visited once departed. Here, then, is a remarkable document of early religious tourism, a finely crafted *souvenir*, acquired abroad, suitable not only for commemorating the journey and enshrining the miscellaneous relics of place collected along the way, but also for stimulating re-enactments of the physical journey's analogue, the interior pilgrimage of the imagination.

Several other motifs seen in the Sancta Sanctorum icon developed into standard elements in later renditions. Christ and the Thieves, noticeably larger than the people on the ground, together form a triumvirate of figures, horizontally co-ordinated, with arms out-stretched towards one another. But this is where the visual associations between the three figures end. As in several other surviving images made as souvenirs for pilgrims (see illus. 26, 27), the Thieves are suspended in front of short, slender crosses pegged into small hillocks, and both look to our right. All of their limbs, like those of Christ, are

51

tacked on to the wood with nails (these technical features are discussed in Chapter 2). But Christ stands on a footrest (called a *suppedenaeum*), a device which, despite its archaeological improbability, asserts a singular holiness and majesty, matched only by the sleeveless purple tunic, the royal *colobium*, also symbolic of Christ's majesty. His bearded head, a 'Semitic' type which Hans Belting thinks may have been modelled on a now-lost portrait icon of some fame,[29] is crowned with a nimbus, whereas the clean-shaven faces of the Thieves are not.

Other indispensable participants in the Passion appear here too. Mary and John, tiny figures burdened with oversized nimbi, take up positions and assume roles that were by this time fixed. Together they stand for the community of believers, the *Corpus Christianum*, the mystical body of the Church. Flanking the central cross are also the soldier, later identified as St Longinus, whose lance-thrust produced the miraculous gush of blood and water (John 19: 34), and the sponge-bearer (later named Stephaton), who offered Christ vinegar when he complained of thirst (Matthew 27: 48; Mark 15: 36; John 19: 29). Because only the Gospel of John tells the story of the lance-thrust, it is tempting to see this image, along with its rough contemporary in the Syrian manuscript known as the *Rabbula Gospels* (illus. 17), as an 'illustration' of the Passion narrative found there. Other visual evidence – such as the slight turn of Christ's head to his right, which Gertrud Schiller sees as illustrative of His instructions to His mother to 'Behold thy son!' and to John to 'Behold thy mother!' – can be made to fall into interpretive place if John's Gospel is taken as a source for the manuscript image.[30]

In one pivotal respect, however, the *Rabbula Gospels* image denies the text any straightforward authority over it: when the soldier pierces Christ with the lance in John's account, Christ had already expired (19: 30), but in neither of these historiated Crucifixions is he represented as dead. The appearance of a group of actions captured in *statu nascendi*, in the moment of their happening,[31] is therefore contradicted by the text they allegedly illustrate. Despite the unprecedented elaboration of narrative detail and the specification of place each image provides, they unequivocally refuse to lead us to the moment of death itself; and without this tragic element the actuality and historicity of the events depicted – the lance-thrust especially – fall away.

Should we read this only negatively, as a painter coming up short against the difficult demands of a text, or can we see the decision to depict Christ with eyes open as a positive choice? When we realize that the *coup de lance* is steeped in the imagery of the Old Testament,[32] our attitude towards the apparent contradiction between the artist's visual

evocation of continuing life and the text's narration of death must change. Theologians interpreted the double stream of water and blood in terms of the paradoxical double reality of Christ as both God and man: the water recalled the divine life made possible by the baptism, and the blood the human nature which Christ shed in experiencing human death. Augustine of Hippo saw the wound in Christ's heart as a door of life whose opening allowed the sacraments of the Church to pour outwards to the faithful: blood for the forgiveness of sins, water to cleanse Original Sin.[33] So the *coup de lance* is a symbol, or, to be more precise, it is a representation of a symbolic action that reveals God – theophany – and thus asserts a vital point of dogma.

This reading is fine from the perspective of iconology, where what

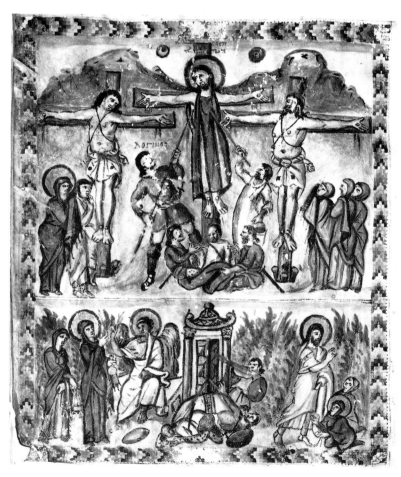

17 *Crucifixion*, illuminated page from the *Rabbula Gospels*, Syriac, AD 586, 33 × 26.7 cm. Florence, Biblioteca Medicea-Laurenziana, Cod. Pluteus I, 56, fol. 13r.

matters is the doctrinal content of the image, its approximation to contemporary theological pronouncements on a fundamental article of faith. Every visual element in the Crucifixion image is a symbol that must be harnessed to a system of antitheses for its meaning to be fully realized. In their symmetrical placement on either side of the Cross, these symbols unfold the double nature of Christ: Mary and John, Longinus and Stephaton, sun and moon, and, among others, the Two Thieves.[34] But compelling as this theological interpretation may be, the symbolic plentitude it promotes can be deceiving, since it can manifest itself only to those, past or present, with an exegetical mastery of the text. Herein lies the difference that, in all likelihood, existed between the viewer of the Sancta Sanctorum icon and the Crucifixion in the *Rabbula Gospels*. Though the former can be read in precisely the same symbolic terms as the latter, and refuses equally the onus of having to deal with the paradoxical idea of the dead god, its reception was most likely informed by the psychological requirements of Passion pilgrimage and devotion. Despite their incommensurability with the biblical text, the earliest historiated Crucifixion images worked primarily to transform the viewer into a mystical witness and a participant who enters into the action depicted and, in doing so, activates their symbolic meaning. Though these early images, especially the *Rabbula Gospels* miniature, are no doubt theologically complex, perhaps the missing piece in the iconographic puzzle, the visualization of Christ's actual death on the Cross, was the very thing to be provided by the pilgrim's imagination.

Death on Calvary

> Listen while you tremble before him on whose account the
> earth trembles:
> He that suspended the earth was himself suspended.
> He that fixed the heavens was fixed [with nails].
> He that supported the earth was supported on a tree.
> The Master was exposed to shame,
> God put to death![35]

The seventh and eighth centuries were a time of political crisis, cultural confrontation and intense theological controversy in the Greek-speaking East. Christian sects continued to proliferate in the Byzantine provinces, where they mingled with Jewish, Zoroastrian and Manichaean religious ideas and often evolved into heresy outside the centres of orthodoxy. Islamic conquest had exploded out of Arabia in the mid-seventh century

and now not only presented a military challenge to Byzantium but also stood by its patent refusal to accept the divinity of Christ and the reality of the Crucifixion. Finally, by the second decade of the eighth century, prompted as much by the loss of territories to the Arabs as by theological paranoia about the idolatry lurking behind every instance of image-veneration, an orthodox ban on all religious images – Iconoclasm – became the official policy of the Byzantine state under the emperor Leo III in 726. Each manifestation of crisis posed its own, peculiar challenge to the orthodoxy of images. These challenges were met energetically by monastic leaders like Theodore of Studion, Anastasius of Sinai and John of Damascus, who saw the defence of images as a bulwark against heresy. As a result of their ideas and writings, new iconographic elements with polemical implications were injected into the Crucifixion image (among other themes), transforming it profoundly in the process. These changes were to have a tremendous impact on later developments in the Western iconography of the Passion when Eastern icons began appearing in Europe centuries later.

In the monastery of St Catherine at Mount Sinai in Egypt there are preserved a group of three remarkable icons of the Crucifixion, each exhibiting different aspects of this sea change in Passion iconography. The earliest of the three panels dates from the mid-eighth century and stands, in our present state of knowledge, as a repository of several iconographic firsts (illus. 18).[36] Set against a dark blue-black ground that effectively cancels any deeper view, the main figures press up towards the picture plane in a dramatically flattened space. Landscape elements have been reduced, leaving only a few cubic rock formations to suggest Golgotha's desolate terrain, but their isolation makes them look more like artificial props on a spotlit stage. Vividly rendered Greek inscriptions identify most of the protagonists. For the first time we are informed, in apparent contradiction to the literary tradition stemming from the *Gospel of Nicodemus* (see Introduction), that it is the Thief 'Gestas' who appears at Christ's right hand and 'Dysmas' at his left (though all that remains of the latter is an elbow, the end of the *patibulum* [crossbar] and half an inscription).

There is a formality and didactic quality to this image which must be understood in terms of its conflicted historical situation. Designers of icons like this one, produced in the wake of the iconoclastic controversies, were involved in profoundly risky ventures considering the paradoxical nature of the orthodoxy they strove to make visible. Thus it seems to have been the strategic intent of the designer to use inscriptions, as well as the dark background, to heighten the legibility, and thus the theological specificity, of what the image shows. Because what

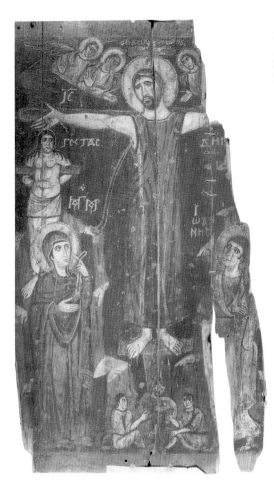

18 *Crucifixion*, icon from the Monastery of St Catherine, Mount Sinai, Byzantine, mid–8th century, tempera on panels, 46.4 × 25.5 cm.

it also shows, for the first time, is Christ suffering and dead on the Cross (*Christus patiens*). Eyes are closed and the head, adorned with a slender filet studded with three small stars, meant to depict the Crown of Thorns (the first known instance of this motif), tilts only slightly to one side. Rivulets of blood flow from all wounds that are still visible and, though Longinus is nowhere to be seen, the wound in Christ's side pumps out two thin streams, one red and one white, which strike the rock alongside Gestas and drip down towards Mary. At the very top of the panel, a small squadron of angels – four originally – descends upon the scene, calling attention to the act of sacrifice with gestures and expressions of lamentation.

According to the art historian Hans Belting, the theme of the Crucifixion was an especially topical one in the early Byzantine period, since it helped theologians distinguish the various positions on the

question of the person of Christ, and the debate concerning who exactly died on the Cross.[37] Was it the man Jesus, God or the divine Logos? What exactly happened at the moment of death? Did Jesus's soul depart from his body, and if so was this a mortal soul or a divine one? Common to the thinking of some heretical groups was the notion that it was the divine Logos that had suffered and died, not Christ's human body.[38] Such notions assailed the central mystery of the Incarnation and thereby threatened the delicate balance orthodox theologians needed to strike between the two natures of Christ. In arguing against the Iconoclasts, who denied the capacity for images to encompass the uncircumscribable nature of Christ's divinity, or even the Muslims, whose position was often likened to that of the Monophysite heretics – though it was more than likely misunderstood or distorted by its opponents – the orthodox maintained the emphasis on Christ's humanity. And nowhere was his humanity more powerfully demonstrated than in the corporeal reality of his suffering and death on the Cross.

Although European painters could not have grasped the full liturgical significance of the Eastern Crucifixion, with its charged image of the dead Christ, the poetic Greek emphasis on Christ's suffering humanity, as well as the startling 'psychological realism' of its address to the viewer (expressed in Melito of Sardis's Easter homily quoted above), found fertile soil in the West. In several ways the ground had long been prepared. In the ninth century Carolingian theologians debated the 'identity' of the sacraments, and those who championed the idea of the real presence of Christ's *historical* body in the consecrated host and eucharistic wine won the day. By the tenth century, at least, sculptors in the West had ventured their own version of the dead Christ in the form of crucifixes carved in the round, monumental images that dominated the altar area of churches. More decisive, however, were the profound changes in monastic devotions sparked by the writings and sermons of St Anselm, the archbishop of Canterbury (*d.* 1109) and St Bernard, the Cistercian abbot of Clairvaux (*d.* 1153), among others. Diverting attention away from the traditional cults of saints, these theologians fostered a new type of *affective* piety and mysticism focused on Christ and the Virgin, whose co-suffering during the Passion became, in their hands, the leitmotif of the era's deeply emotional spirituality. Scholars speak of a line of descent connecting the ideas and influence of Anselm and Bernard to the personalized mysticism of St Francis and, in turn, Bonaventure (see Chapter 7). This new, affective theology, which sought for a transformation of the soul through compassionate absorption in

the sufferings of Christ and the Virgin, helped awaken a positive fascination with the Eastern cult image, with its rich psychological realism and venerable iconography.

A watershed at the opening of the thirteenth century made this trend irreversible: as a result of the inglorious sack of Constantinople by the armies of the Fourth Crusade in April 1204, numerous icons were looted from imperial treasuries and brought to the West, appearing first in Italy and then throughout Europe, where they became models for local cult images and new genres of devotional art based on them.[39] It is therefore no exaggeration to say that a new era in the history of the Crucifixion image, and image-making in general, opened with the forced expatriation of these Eastern images. Western interest in the historical sites and scenography of the Passion had already been invigorated by the first Crusade, and the establishment of a Latin kingdom in Jerusalem provided for the reopening of old pilgrimage routes. Geopolitically, Calvary was coming closer again. But it was primarily the profound changes in piety – pioneered by the mendicant orders and practised by their lay offshoots, the confraternities – that created novel situations of devotional use for images and, in turn, inspired European painters to adopt, combine, revise and in some instances even reject the authoritative formulas of the Eastern icon. Ironically, though, it was these same devotional practices, centred on the Passion – most of them refractions of the Franciscan cult of the Crucified – which eventually drove European artists to abandon the Eastern pictorial conventions. One of these conventions was the antithetical pairing of figures around the base of the Cross. Once this symbolic and schematic straitjacket was removed, new motifs could proliferate and fulfil the growing appetite for narrative detail, an appetite simultaneously fed and whetted by the growing body of devotional literature exemplified by popular Gospel harmonies like the *Meditations on the Life of Christ*.

A marble relief scene, carved for the pulpit of Siena Cathedral between 1265 and 1268 by Nicola and Giovanni Pisano, capitalized strongly on this break with Byzantine schematism (illus. 19). The Pisanos pack their auxiliary figures into nearly every available space beside the cross, an effect which heats up the emotional intensity without, to the sculptors' credit, overpowering the individual characters, all sensitively carved. Mary swoons into the arms of another woman, overcome with grief; John stands alone and desolate, weeping and dabbing the tears from his eyes with his robe; other characters, like Longinus, Stephaton and the converted Centurion, converge on the Cross and eye the dying man with deep interest and wonder. Also

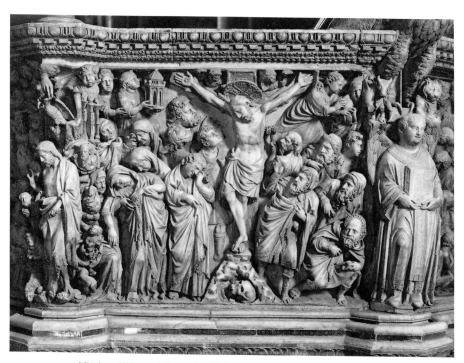

19 Nicola and Giovanni Pisano, *Crucifixion*, marble relief on a pulpit, 1265–8. Cathedral, Siena.

included, and cast into dramatic roles, are the female allegorical figures representing the Church (Ecclesia) and the Synagogue (Synagoga), an antithetical pair long established in Crucifixion iconography to announce the historic transition from the Old Dispensation to the New; in the upper left we see Ecclesia, who carries a self-referencing architectural model, escorted upon the scene by one angel, while another angel shoves the dejected Synagoga off-stage on the opposite side.

The Pisanos omit a number of other motifs that were generally included in post-Carolingian manuscripts, evidently in response to the pulpit's compositional constraints. We see neither the soldiers gambling for Christ's mantle, nor the Two Thieves, nor the *tortores* or 'men with clubs' (the Thieves do appear in Giovanni's *Crucifixion* for the pulpit at Sant'Andrea in Pistoia of 1301).[40] These absences diminish the scenographic potential of the Siena relief, even with its unprecedented deployment of figures. Furthermore the actual spaces and terrain of Calvary are given only abbreviated form; we see just a pyramid of rutted earth where the Cross is planted, its womb-like chamber revealing the skull of Adam, believed buried under Golgotha (and apparently shown to pilgrims well into the fifteenth century!).

Although nothing like the Siena pulpit had ever been conceived for the Crucifixion image in the West before the thirteenth century, the Pisanos' treatment – their juxtaposition of allegorical figures with human actors, the reduction of landscape, the omission of the Thieves – still left a great deal of room for scenographic innovation. This challenge was taken up by fresco painters, whose elaborations of the Passion cycle in the first half of the fourteenth century set the aesthetic stage for all later medieval developments in the Calvary image. A paradigm of the new compositional venture – one which also takes us into the nerve centre, as it were, of the religious consciousness behind these innovations – is the large fresco painted between 1316 and 1319 by Pietro Lorenzetti for the lower church of San Francesco in Assisi (illus. 20).[41] Despite the damage the fresco has suffered in the past (earthquakes in 1997 threatened the entire church), many of the individual figures and anecdotes can still be appreciated. Careful attention has been lavished on the gestures, facial expressions and costumes of the Calvary crowd, especially the pageant-like tournament of knights, who reappear in proud regional variations wherever later painters employed the motif.

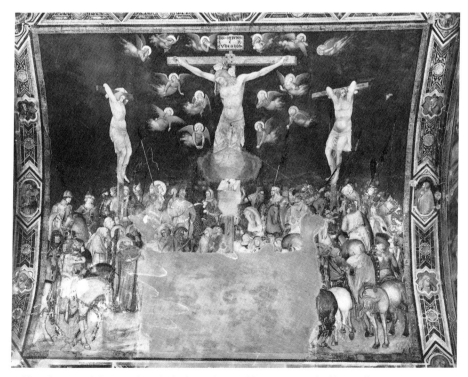

20 Pietro Lorenzetti, *Calvary*, fresco in the lower church of San Francesco, Assisi, *c.* 1316–19.

But the real drama is in the air: soaring above the heads of the crowd, amid a swarm of wildly expressive, mourning angels, the three crucified, clad in loincloths, are boldly spotlit against the deep lapis lazuli background. In photographs Lorenzetti's Christ appears somewhat larger than the Thieves, but this is the result of a spatial device the painter has used, in the absence of a worked-out perspective or landscape, to show that the Thieves' crosses are planted further in the background. His portrayal of the Thieves is likewise indicative of both his naturalistic strivings and his concern to re-create biblical history: the malefactors are distinguished not only from Christ but from one another in significant and expressive ways. Whereas the figure on Christ's right, a clean-shaven young man, hangs from his cross, asleep in death, his head tilted down to mirror Christ's, his opposite, a bearded figure, turns his head away from the central cross, a gesture that enacts his symbolic blindness to Jesus's divinity. Consistent with John's Gospel, he remains alive while the *tortores* hack away at his legs; his muscular body tenses in response to the punishment. Sanctity is thus accorded only to the convict on Christ's right, whose halo identifies him as the Penitent Thief. Their asymmetry is confirmed elsewhere in the church. In the fourteenth-century Magdalene Chapel Dysmas appears in his own standing portrait (see illus. 88), grouped among other famous penitents whose lives furnished Franciscan authors with a useful template for the spiritual biography of their beloved founder, the *Poverello* of Assisi, whose *imago* suffuses the entire edifice.

Crystallizing Calvary

> Rest in the cross – with Christ crucified. Delight in Christ crucified; delight in suffering. Be a glutton for abuse – for Christ crucified. Let your heart and soul be grafted into the tree of the most holy cross – with Christ crucified. Make his wounds your home.[42]

In the first decades of the fourteenth century paradigmatic works by the leading Italian masters of the *duecento* and *trecento* were assimilated by northern European artists through a variety of means. Regions that bordered northern Italy directly, like the mountainous Tyrol of Austria, became corridors for Italian styles to enter into German-speaking regions. Alternately, in centres like the Holy Roman Emperor Karl IV's Prague, a faddish interest in things Italian, borne of political contacts with north Italy (Bologna in particular) and the papal court at Avignon, demanded the importation of Italian artisans and a synthesis

of their work with regional idioms by the top court painters (see illus. 42).[43] Then there were cosmopolitan artists like the Parisian illuminator Jean Pucelle, who worked for royal patrons and no doubt visited Italy at their expense; such masters were able to absorb Italian innovations directly into their art through observation without, however, slavishly imitating them (see illus. 28). In the first half of the fourteenth century, many centres of northern European art, which were, in contrast to Italy, still beholden to aristocratic patronage networks, became so well interconnected that art historians have dubbed the advanced, courtly art of this period the 'International Style'. But diffusion and reception, absorption and adaptation are complicated processes involving producers in all media in a range of social settings. There is no simple way of charting influences and mapping developments.

After 1400 painters in Germany were encountering the courtly style mainly through Bohemia; but in the course of the fourteenth century it was the economically and politically powerful cities of the lower Rhine, especially Cologne, that were its most fertile ground. An early paradigm of the International Style in this region is the so-called *Wehrden Altar*, painted *c*. 1350 (illus. 21).[44] Its debts to Italian art become obvious at a glance: from the Lorenzetti frescoes (or some contiguous tradition) come the sorrowful gestures of the angels and the 'hooked arm' position for the Two Thieves (see Chapter 2); from Duccio's *Maestà* altarpiece in Siena (or, again, some similar source) comes the body of the crucified Christ, the so-called 'three-nail type', dramatized by the placement of the right foot over the left (see illus. 29).[45] The Rhenish painter also appears to have borrowed the broadly muscular nude torso of Lorenzetti's Impenitent Thief for *both* of his Thieves, who exhibit identical facial types, the same tilt of the head and, perhaps most ingeniously, a striking stereoisomerism of their bodies. Yet the parallel tilting of heads also differentiates them, since it makes one nod towards Christ and the other away. The refined elegance associated with the International Style infuses both the courtly figure of the Good Centurion, shown in contemporary garb, and the mourning family of Christ, shown in a generic 'biblical' attire, so much so that the work was once attributed to the workshop of Jean Pucelle![46]

In fifteenth-century Germany, where political power was vastly decentralized compared to France or England, regional 'schools' of painting developed according to their relative distance from the centres of advanced realist painting in the Burgundian Netherlands. Two Calvaries from two distinct regions in the German empire will suffice here to highlight the defining conceptions of the theme prior to the

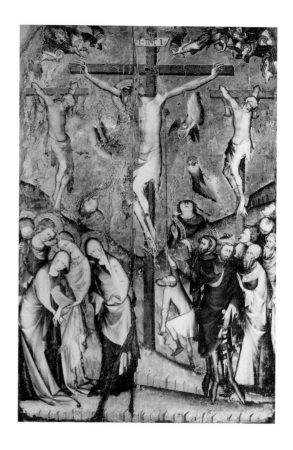

21 Rhenish Master (French?), *Calvary* (the so-called *Wehrden Altar*), *c.* 1350, painted panel, 169 × 111 cm. Wallraf-Richartz-Museum, Cologne.

Reformation. One is the so-called *Speyer Altar*, a folding Passion polyptych, with its different parts now divided among various museums, painted late in the fifteenth century by the middle Rhenish painter known as the Housebook Master (illus. 13).[47] The other, by an unknown Bavarian master, was painted for the monastery at Benediktbeuren shortly before the middle of the century, a decade or so before the Housebook Master's polyptych, and also must have been part of a larger group of panels (illus. 15).[48] Clearly now, in each work, the figures on Calvary are no longer symbols but are conceived and rendered, with all the pictorial illusionism at the painter's disposal, as real human beings participating in a real event, smitten by real pain and grief, responding to one another in spontaneous ways. Even greater attention is lavished on the better-known characters, like the Virgin Mary, John and Mary Magdalene, who is shown wailing at the foot of the Cross. They appear as compelling dramatis personae in a frozen Passion play. Figures are packed closer together, increasing the tumult and excitement of the event. As the Benediktbeuren Master's work in particular reveals,

the scenography of Calvary expanded rapidly in the course of the fifteenth century. Each new motif became an expressive vehicle through which the painter could coax the viewer into contemplative immersion in the unfolding action and the individual characters. Expressive faces and gestures, sympathetic interactions between the mourners, the shuffling and jockeying of witnesses and gawkers, parents and children, gloating bailiffs and posturing magistrates, the grotesque ugliness of the tormentors, the richly described costume, the cruelty of the executioner's work – all these elements were intended to wrap the devotional viewer in a virtual world of phenomenal detail.

Lest we assume that this surplus of anecdote cluttered the viewer's imagination, we should recall that these pictorial worlds, like their scenographic equivalents in the life-sized simulations of the Sacro Monte at Varallo, were intended to stimulate the imaginative appetite, not satisfy it. With more to see, there is also, in theory, more to imagine *as it could have happened*. New demands are being placed upon the viewer, who must not only encompass mentally the wealth of detail and action at the moment of highest suspense, but also place him- or herself – as a witness *and* participant – within its subsequent unfolding. For those who might forgo this act of pious self-projection, the Benediktbeuren Master has placed us on red alert that it is *me* who are personally involved, that it is *our* sinfulness which necessitates the 'ongoing Passion' of Christ: two of the mounted men on the right side of the painting, one just below the struggling body of the Impenitent Thief, aim their weapons directly at us (illus. 22). Are they there to elicit, by force of arms as it were, our guilt by association in Christ's torture, as Bonaventure had done in the *Tree of Life*: 'And you, lost man, the cause of all this confusion and sorrow, how is it that you do not break down and weep?'[49] To my knowledge this militant audience-address motif is unique in Passion iconography, but the sentiment it secures, and then polices, is wholly characteristic of the guilt complexes of late medieval piety. This is at once an art of commemoration, edification and antagonism.

Eventually the kinds of theatrical and scenographic embellishment discussed above demanded that figures be set in landscapes of more convincing depth and scope. The Benediktbeuren Master deploys his figures in just such a deep landscape, exploiting the genre's potential to link the actions of individual figures in a coherent space. In the distance are several German castles (*Schloß*), unabashedly posing as contemporized stand-ins for Jerusalem's topography. Also, in a bold reversal of optical perspective, the painter has made the figure groups in the foreground appear smaller than those set deeper into the land-

22 Detail of illus. 15,
showing a horseman
aiming an arrow towards
the viewer.

scape. The visual centre of the picture therefore bulges out towards us
with a hallucinatory insistence; the landscape recedes back sharply, and
attention is riveted on the dense and busy horse and rider groups. For
the viewer the crunch below the crosses can be relieved only by looking
up to the figures upon them, suspended above the crowd in the same
thin air inhabited by swooping red angels and battling devils.

On the other hand, the Housebook Master – an artist demonstrably
capable of handling landscape – chooses to occlude the view into depth
with gold ground. This old-fashioned choice was doubtlessly specified
by the patrons in accord with the work's functional siting as an altar.
Denied an extended space for the imagination's free wandering, the
viewer must confront each character on the shallow 'stage' intimately
and personally, much as one might approach the literal presence of the
holy person in a bona fide cult image. We immerse ourselves in the
spectacle from our place outside it; meanwhile, the kneeling donors,
transported to Calvary with rosaries in hand, do likewise from their
privileged place inside.

Rhineland painters like the Housebook Master, working in fairly
close proximity to the orbit of Burgundian court culture, were deeply
indebted to the artistic achievements of the Netherlands (medieval

Flanders and Brabant). There, masters like Robert Campin (see illus. 39, 74), Jan van Eyck and Roger van der Weyden built upon the heritage of late medieval book illumination to forge an illusionistic art which combined, as Erwin Panofsky famously wrote, 'two infinites', one miscroscopic and the other telescopic.[50] Though Panofsky was talking specifically about van Eyck, it was ultimately through Roger's influence – and Campin's work mediated by Roger – that the achievements of Flemish painting were transmitted to the German painters discussed in the following chapters. What is paradoxical in the northern mode of painting is that, at the very time the painter was conjuring away his materials themselves by his masterly execution, the vision itself became more palpable to the imagination, more material. In conformity with the widespread pursuit of visions and visionary experience, among not only monks and mystics but princely and bourgeois patrons as well, the image finally appears less like a product of the painter's skill and more like a projection of the mind's eye itself.[51]

This crystalline, visionary conception of the pictorial field culminates in the work of artists like the Fleming Jan Provoost, a prominent member of the Bruges painters' guild, whose cosmic rendition of *Calvary* is now preserved in the museum in that city (illus. 14).[52] Provoost's skilfully constructed landscape furnishes the imagination with a virtually infinite space for its deployment. Realist scenic devices like the 'architectural portraits' of recognizably 'Eastern' buildings – the domed octagonal building on the left reproduces with fair accuracy the famous Muslim shrine known as the Dome of the Rock – are designed to evoke, in true Franciscan fashion, the sacred topography of Jerusalem down to the last detail. With the utmost skill, Provoost conjures away his material surface – oil paint – into light and air, leaving only the crystalline vision, clearer than any the mind's eye could conjure.

Conclusion

By the middle of the troubled fourteenth century, in all of the major centres of European art, Calvary stood as the standard formula for Passion sequences on church walls and altarpieces (though less so in devotional woodcuts and engravings, where the three-person Crucifixion seems to have dominated). Calvaries survive from all the major regional traditions of northern Europe, and practically all of the major masters of late Gothic and the so-called 'Northern Renaissance' left to posterity at least one rendition of the scene. Clearly, then, by 1400 it had become one of those themes that every painter had to know how to

treat 'in the customary manner', though of course painters were left with the same discretion that extended to other themes.[53] However, our understanding of Calvary's blossoming cannot be confined to art-historical reasoning alone. If it were, we could easily overlook, as many scholars have done, the terrifying brutality of what the image shows: the triple execution of Christ and the Two Thieves, a spectacle of pain which the greater talents refused to soften. As image and visionary spectacle, Calvary came into its own amidst the turbulence of a century rocked by crises and catastrophes and violences of every sort: famines, plague, wars, pogroms, peasant revolts, the schism of the Church – the litany of misfortunes is a familiar one. It was a time when religious consciousness responded to a multitude of social pressures, veering between serenity and shock, craving at once the sweet music of heaven and the stench and horror of Calvary.

In a general way, we know Calvary's virtual spaces were the preserve of an intensely private piety, nurtured in the monasteries and convents, which derived 'spiritual refreshment', as the famous German Dominican Heinrich Suso called it, from contemplation of Christ's tortures.[54] But the charismatic dimension of late medieval piety, exemplified at its extremes by the penitential pantomimes of the Passion undertaken by saints and mystics like Margaret of Ypres (*d.* 1237), Catherine of Siena and Suso – who, for example, nailed a wooden cross to his back – yields only a small part of the story. For ordinary people the era was one of mass pilgrimages, multiplying miracles, the institution of new feasts, the organization of new cults and processional rites, and the dissemination of devotional literature to a growing reading public – these were all manifestations of an intensifying religious life that combined, as Bernd Moeller put it, 'a trend towards massiveness, towards wild and, wherever possible, violent excitement, an inclination to simplify and vulgarize the holy' with 'a tender individualism, a propensity for quiet inwardness and devout simplicity'.[55]

A dynamic urban bourgeoisie, then in the process of wresting greater control over both their worldly affairs and spirituality, sought ways to bridge the gap between the rigors of secular life and the monastic-ascetic ideal of fashioning one's life into a true fellowship with the suffering Christ. Franciscan spirituality in particular 'enabled the laity to merge personal history with salvation history through an established meditative tradition, in a manner previously limited to those who led monastic lives'.[56] Through their active patronage of the winged altarpiece, and their desire to see in it sacred history updated in all its incidentals, the urban ruling classes, perhaps above all, decisively shaped Calvary's history. From them it fell to the painter to transpose

biblical stories into a stunning 'omnitemporal present', a virtual world of vivid, quotidian detail that ensured the devotional allure of the vision for a class rapidly acculturating itself to a conflation of material and spiritual values.

In the next two chapters we will move closer to that sphere of social and cultural action from which late medieval painters drew as they strove to assimilate sacred history to everyday reality: the rituals of punitive justice (*iustitia*). Searching out the transferences from spectacle to image means we need a clear grasp of how to separate convention from innovation, and so in what follows we will revisit the story of Calvary's late medieval development told here, but this time with an eye to the changing modes of torture unleashed on the bodies of the Two Thieves. We will see why, when pious lay people undertook the mental journey to Calvary, and struggled to fashion the dramatis personae of the Passion out of the fragments of their own lived experience, their participation as spectators in the theatre of judicial punishment was so important. 'And then too you must shape in your mind,' urged the author of the *Zardino de Oration*, 'some people, people well known to you, to represent for you the people involved in the Passion.' Who better to play the role of the Good Thief Dysmas or the Bad Thief Gestas than the poor culprit hanging from the gallows or broken upon the wheel? What better model could be found for the Two Thieves, whose violent deaths painters sought to present as startling *images* of redemption and abjection, than the very criminals whose deaths authorities had fashioned into a *spectacle* of violent death, in which redemption always teetered – instructively – on the brink of its opposite?

2 The Two Thieves Crucified: Bodies, Weapons and the Technologies of Pain

> I cannot conceptualize infinite pain without thinking of whips and scorpions, hot irons and other people.
>
> MICHAEL WALZER, *Just and Unjust Wars* (1977)[1]

Bodies canonical and otherwise

The Passion narratives of Matthew, Mark, Luke and John offer no information whatever regarding the technical details of Jesus's capital punishment, let alone that of the Two Thieves. One word, *crucifixerunt* ('they crucified [him]'), stands in for a penal procedure which, as we know from non-Christian sources and archaeological research, was enormously varied in its applications and techniques (see Chapter 6). At face value, then, Scripture offered the medieval painter no clear guidelines for re-creating the particulars of crucifixion for his scenes of Calvary. Accordingly, we must look elsewhere for explanations as to how the penal mechanics and sacred physiognomics of Jesus's *cruciformity* became standardized, and resistant to change, to the extent that they did. It is no small problem. Although significant variations exist worldwide – attesting in some cases to the strength of regional and ethnic traditions, in others to the openness of Christian communities to reworkings of older types by respected image-makers – when we turn to the late Middle Ages, we see in country after country, from one image to another, the crucified body of Christ hangs in a more or less standardized manner: dead upon the Cross, Jesus's head is slung to one side, typically our left; his torso is naked and upright, sometimes slightly arched. More or less subtle variations appear in the positioning of the Holy Limbs: arms are outstretched either to conform to the horizontal line of the *patibulum* (crossbar) or, with shoulders dipping below it, form a Y-shape; legs extend down, knees slightly or severely bent, sometimes to meet the *suppedenaeum* (footrest), sometimes nailed to the *stipes* of the cross (vertical beam) individually or with the right foot overlapping the left (the 'three-nail type');[2] in some instances the

lower body conforms to the *stipes*, whereas in others it curves down in a gentle *contrapposto* or angles into a stronger zigzag superimposed upon it.

Granting these variations, artistic presentations of the body of the crucified Christ nevertheless obey some very strict conventions. A long-term view tells us that traditional forms, constrained and made *canonical* by tough theological imperatives, wended their way through centuries of Christian art and across vast stretches of geographical space. Such a strictness appears in bolder relief when we distil out from our (present) consideration that great wealth of motifs having to do with the abuses and injuries inflicted upon the *surface* of Christ's body: bloodied bruises from the blows delivered by Pilate's soldiers and lacerations from their scourging; subcutaneous welts from the thorns placed on his head; stretched and torn puncture wounds in both hands and feet; and the gaping, gushing wound left in his side from Longinus's lance thrust. All of these violations, and the overwhelming pathos which they revealed in Christ's suffering for humanity, were developed as topoi in the devotional literature of the later Middle Ages. Familiar Old Testament imagery, especially from Isaiah, was mined by authors like Bonaventure and transformed into literal descriptions of Christ's afflictions. Repeatedly the body of Christ is scourged and beaten, draining it of blood and littering it with sores – becoming in these instances the 'leper' of Isaiah (*quasi leprosum*).[3] For these authors and their audiences, the narrative embroideries did more than satisfy a curiosity unappeased by the cautious Gospel accounts. As Christ suffers 'from the sole of his foot to the top of his head' (Isaiah 1: 6) he also appears to fulfil prophecy, uniting Old and New Testaments into a harmonious unfolding of the divine will.

Many late medieval artists approximated these grisly violations with the unerring eye of a forensic pathologist. One need only recall the grotesque, lacerated carcass Matthias Grünewald created for the famous *Isenheim Altar*, now in Colmar, to appreciate the painter's determination to make every wound unbearably visible to the devotional gaze. Frequently enough such 'Gothic horrors' appear in narrative imagery, but outside the realm of narrative action, in the contemplative spaces of patently *devotional* images (*Andachtsbilder*), those gruesome dissections of Christ's bodily pain exerted an antagonistic pressure upon the mind of the beholder that veered towards the unbearable. A small panel of *Christ on the Cross*, painted by an Upper German painter in the first decades of the sixteenth century and now in Cologne, combines an implacable display of torture's aftermath with a number of unusual motifs that are probably attributable to the peculiarities of

the patron's devotional agenda (illus. 23).[4] The stark nakedness that reveals the otherwise masculine figure as unsexed (what Leo Steinberg calls 'Christ's immaculate body');[5] the legs crossed so drastically that they can be nailed individually to the fantastic *suppedenaeum*; the expression of pain still etched upon the face of the dead man; the double encircling of the body with ropes that provide no means of support – all these features gain in antagonistic power by the isolation of the figure by light and the absence of other actors, the close quarters of the picture space and the prominently displayed tokens of Calvary's desolation and infamy.

When we are attentive to such details, the imagery of the Crucified may appear complex and variable. Yet neither the modifications seen here nor those found in Grünewald's powerfully original conception affect the fundamental bodily *Gestalt*, the basic way the dead Christ hangs on the Cross. The same can even be said with regard to the two alternate ways of *affixing* Christ to the Cross put forward in devotional

23 *Christ on the Cross*, Upper German, first third of the 16th century, limewood panel, 42.8 × 28.3 cm (with original frame). Kunstgewerbemuseum, Cologne.

handbooks like the *Meditations* as possibilities for visualization. In both cases the pain of torture emphasized is that of stretching; in neither one is any significant latitude offered to the meditator for reimagining the basic conformation of the crucified body once upon the Cross.[6]

Such variability easily escapes our notice when seen next to the bodies of the Two Thieves, which are often spectacularly bent, twisted, folded and broken around the *patibulum* and *stipes*. Painters were quite deliberate – and often emphatically so – in distinguishing the punishment inflicted upon Christ from that of the Thieves (even if we discount for now the *crurifragium*, or breaking of legs, reported in John's Gospel, since it was inflicted only after crucifixion proper, and ostensibly only under the circumstances created by the oncoming Sabbath; see Chapter 3). Whereas Christ so often hangs placid and impassive, asleep in death, the Thieves kick, pull, strain and sometimes thrash in painful torpor against the ropes which bind them (or to avoid the blows of the executioner). Even in death their bodies remain full of turbulent energy next to the quiescent Christ.

One could say, then, that artists concentrated their efforts on differentiating the punishment of the Thieves from that of Christ precisely here, where the unique torments of Christ concluded and those of the Thieves began. Reading the Gospel narratives one is led to believe that the three executed men suffered the same penalty under Pontius Pilate that fateful day. Many painters – for example the Sienese master Duccio (see illus. 29) – aligned themselves with an iconographic tradition that took literally the absence of difference in Scripture; they show the Thieves nailed and hanging in the same manner as Christ. But the majority of later medieval artists would have us understand it rather differently: Christ was crucified *this way*, the Thieves *that way*.

In what follows I want to focus attention on a set of interrelated motifs whose signifying power extended above and beyond the traditional antithesis of good and bad, penitent and impenitent, that informs most discussions of the Thieves' symbolism. There are, in my view, four motifs whose combination could lead the viewer to the inescapable conclusion that the Thieves' punishment was something different, something *other* than Christ's. They are the shape of the crosses and the character of their manufacture; the conformation of the crucified bodies juxtaposed against the crosses; the technical means of fixing the bodies to the crosses; and the explicit depiction of wounds. Observing the changing ways painters and print-makers unified these four motifs into convincing rhetorical demonstrations of crucifixion's effects upon

the body will allow us to mark the infiltration of the real, the smuggling in of contemporary judicial elements, where and when it occurs in Passion iconography.

A lively engraving by the Flemish Master I. A. M. von Zwolle, produced sometime in the last quarter of the fifteenth century, exemplifies the combinatory logic used by many artists in the Low Countries, France and Germany during this same period (illus. 24). As a cultural centre, the northern Netherlandish city of Zwolle was within the mainstream not only of advanced naturalistic art – manifest in the quality of this work and in the borrowing of Roger van der Weyden's figure of John, quoted from the renowned *Deposition* altar in Madrid – but also of advanced lay spirituality, being home to numerous houses of the *devotio moderna*, revivalist, semi-monastic communities known as the Brothers (and Sisters) of the Common Life. These two facets of the religious environment in which the print was designed, printed and sold may be related. Compatible with, and expressive of, the humble, disciplined spirituality of the *devotio moderna* is the mood conveyed in the expressions of both Christ and the mourners; it is also determined by the choice of narrative moment. Rather than depicting the high suspense of Christ's death or the *coup de lance*, the engraver pursues the lingering aftermath of death, when action begins to subside and emotional space opens for the profoundest displays of compassion, quiet pathos and sorrow.

Master I. A. M.'s figure of Christ, positioned directly along the picture's central axis, though somewhat diminutive, shows nothing surprising: he hangs symmetrically upon a thick, well-carpentered timber cross, fastened with three nails, one for each hand, one piercing both feet, which overlap according to a long-established convention. A wispy loincloth covers enough flesh to protect against immodesty but reveals enough to convey the paradoxical idea of His nakedness, its shame and triumph. Both Thieves, in contrast, are suspended from organic 'tree' crosses that are fashioned from knotty beams of unworked timber. Instead of nails they are fastened in place with thin ropes that loop around elbows and forearms and pull ankles and shins hard against the wood. The attachment of body to apparatus appears almost playful, and the bodies hang free of the apparatus in striking, asymmetrical positions: the figure on Christ's left careens forwards, his arms yanked back over his head; his counterpart kicks backwards and twists sideways, the weight of his body stretching shoulder sockets and compressing immobilized shins. Adding to the brutality of these contortions are the wedge-shaped gashes along their shins, wounds struck painfully close to the points of ligation.

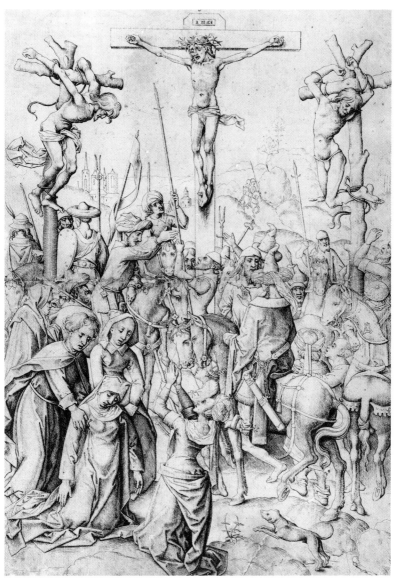

24 Master I. A. M. von Zwolle, *Calvary with Riders*, 1480, engraving, 358 × 348 mm. British Museum, London.

All four motifs contribute something of their own valency charge to visual distinctions that were always – either by textual authority or sheer force of tradition – writ large across the triad of the executed on Calvary. To some extent each of them might be read allegorically or typologically, especially if a given viewer's education inclined her or him to do so. For example, the different cross types might be read in

terms of the antithetical arboreal symbolism, employed by numerous medieval writers, that linked the wood of the True Cross to that of the paradisaical Tree of Life, and those of the Thieves to the forbidden Tree of Knowledge of Good and Evil.[7] Such idealized theological readings of these and other symbols, however, carry us away from visible features that were, for ordinary people, accessible, concrete and immediate to perception. I therefore want to be circumspect about the *relevance* of such deep symbolisms to the generally *untheological* lay piety of the fifteenth century – a piety the fifteenth-century theologian Nicholas of Cusa called *docta ignorantia*, or 'learned ignorance', and which he championed as more profound than its learned counterpart.[8] We can fruitfully explore these four motifs together in what I will call their *phenomenological* interrelation and interaction. In so doing we can come closer to that mode of visual perception exercised and refined in the techniques of imaginative devotions, techniques which religiously minded lay people cultivated under the guidance of spiritual leaders like Geert Groote, whose teachings inspired the *devotio moderna*, and Thomas à Kempis, a member of the Windesheim congregation at Mount St Agnes (near Zwolle), whose devotional treatise, the *Imitation of Christ*, in many ways exemplifies the self-denying, contemplative spirituality of the era. To eschew the symbolic here is not to deny it; only to hold it in suspension long enough to bring our understanding in line with the mainstream of lay religious consciousness, the experiential ground out of which such visualizations were enacted and such meanings constructed in everyday life.

We also come closer to the modes of feeling and structures of thought that lent the *spectacle* of the body-in-pain its potent, signifying charge. Late medieval audiences were well attuned to the visible indices of bodily pain in both art and spectacle. When painters rendered the specifics of historical punishments – the violation of the body by weapons, human agency and non-human forces – they made certain that specific aspects of the penal procedure's technical effects would render pain inescapably *visible* for beholders. We are shown what a given technique – and the executioner who discharges it – does to the body and, in the special case of crucifixion, what the technique makes the body do to itself. Master I. A. M.'s Thieves do not simply hang from their crosses, neatly conforming to the shape, but struggle in painful torpor against the binding cords, refusing to bend to the will of the apparatus. These staged battles between victim and apparatus, body and weapon, form the primary *Gestalt*, the element of experiential immediacy, in these images, and give them their sometimes unbearable palpability.

In *The Body in Pain*, Elaine Scarry has trenchantly explored how the image of the weapon 'can lift pain and its attributes out of the body and make them visible'. Injury and pain are the weapon's *raison d'être*, and it therefore seems to contain them within its very structure. One suspects that among the perceptual powers medieval people possessed was a knack for '*recognizing* pain *in* the weapon. . .'[9] Weapons could actively desire their victims, as when, by popular reckoning, the executioner's broadsword quivered in anticipation whenever a capital crime was committed. Conversely, pain could reside *in* the weapon long after the fact of wounding. The fourteenth-century mystic Margery Kempe once wrote of the 'boisterous nail' as though the anguished cries of the Saviour could be heard merely by contemplating it.[10] Thus, in a sense, each weapon 'speaks' the pain it will cause. Michael Walzer's epigraph to this chapter, a revelation of his inability to imagine pain in the absence of the weapon or agency, suggests an enduring human identification of weapon and wound that borders on the primal.

The intensity of this imaginative relationship between technique and pain may therefore not be so difficult for us to appreciate today – American popular culture is no stranger to the fetishistic display of weapons. But to devout Christians in the Middle Ages, the weapons found in the Passion narrative, verbal or visual, were always imbued with a powerful inverted logic. The instruments used to chastise and murder Christ become the very weapons with which he vanquished Death and Satan: the Passion relics known as the *Arma Christi*. From the mid-thirteenth century onwards, the *Arma Christi* play an increasingly important part in devotion to the Passion; their ongoing reproduction and promotion as indulgenced images ensured that the image of the weapon would become something of a devotional fetish. In their cult images, each of the important martyr-saints pose proudly with the devices of their demolition, and much Passion iconography positively bristles with weaponry. As I will show in the last section of this chapter, cultic interest extended not only to the mythical weapons of Christian legend but also to the otherwise ordinary tools of the executioner's trade. Within the magical purview of popular perception, weapons that had come into contact with the executed person, the hangman's rope in particular, were charged with special powers, making them the dialectical other-image of the charmed *Arma Christi*. Valued as relics and amulets in their own right, their magical potency stemmed from their intimate contact with the surfaces and substances of the punished – hence purified – body.

How, then, did ropes come to be the featured mode of affixing the bodies of the crucified Thieves to their crosses? Are we dealing here

with a simple convention, established in an earlier tradition and maintained thereafter? Given the ongoing topicality of Christ's wounds to medieval theology, should we expect to find some corresponding discussion of how the Thieves were tortured? Do the varied motifs of their rough suspension from their crosses possess some kernel of historical reality that connects medieval art to Roman crucifixion's actuality? These questions can not be separated from the question of why, in the visual traditions of medieval art, Christ is overwhelmingly – *canonically* – crucified with nails.

Nails and ropes

For medieval theology as for modern archaeology, one of the more infuriating omissions from the Evangelists' accounts of the Crucifixion was the question of whether the historical Jesus was affixed to the Cross with nails or ropes. The North African rhetorician Tertullian (*c.* 200) seemed certain enough to speak of the killing of Christ *nervos suffigendo clavis*.[11] In the early fourth century the Christian apologist Lactantius (d. *c.* 320) quotes a response in Greek given by the oracle, the Milesian Apollo, when asked whether Jesus was a good man: the oracle declared that Jesus endured a bitter death 'with nails and pointed stakes', making no mention of ropes.[12] Bishop Hilary of Poitiers (*c.* 350) expressed some uncertainty, claiming that Christ had been affixed to the Cross with nails *and* ropes. However, both Jerome and Augustine were convinced it had been carried out exclusively with nails. According to the philologist F. P. Pickering, patristic authorities based their inference about Christ's actual nailing from the combined evidence of two key biblical texts other than the Passion narratives.[13] Psalm 22, which was mined extensively by the Gospel writers – Christ's lament on the Cross, 'My God, my God, why hast thou forsaken me?' derives from it – contains one of the founding phrases: 'the assembly of the wicked have enclosed me: they pierced my hands and my feet' (Psalms 22: 16). The other is found in the New Testament story of the Apostle Thomas's doubt, expressed to his comrades with the demand that, 'Except I shall see in his hands the print of the nails, and put my finger into the print of the nails, and thrust my hand into his side, I will not believe' (John 20: 25).

For most theologians up until the fifteenth century, this evidence, and the pronouncement of major authorities like Augustine, settled the issue. But the Church had other more compelling reason to insist on nails over ropes: the redemptive power of Christ's blood, shed on Calvary and commemorated in the eucharistic rites of the Mass.

Medieval theology was deeply imbued with a sacramental logic that demanded Christ's blood flow profusely, washing sinners clean in a 'fountain' of sacrificial blood.[14] Atonement for sin, the ratification of the new covenant, could be accomplished only by this shedding of His blood. It followed that, in the literally earth-shattering, history-transforming moment of Christ's death on the Cross (rather than, say, the sundry tortures and humiliations leading up to his death), only nails could produce the requisite flow. Such a strong theological underpinning made the use of nails a non-negotiable topos in medieval texts and images dealing with the Passion. It nourished the early Church's sacramental rites and later argued the medieval Church's claims to sacramental hegemony in the face of challenges from heresy and secularizing trends.

As the theological insistence on nails became more tenacious and conceptually entrenched, artists must have laboured under a fair amount of critical scrutiny when working on the Crucifixion. Hemmed in by the theological demand for blood, they were not free to imagine the technical procedures of *Jesus*'s Crucifixion and its effects on His body. The earliest Western representations of the Passion, like that on the carved wooden doors at Santa Sabina in Rome (illus. 25), in their reluctance even to show Christ's body attached to the Cross, nevertheless include nails, shown as small buttons affixed to the fingers of the three standing figures. In the entire history of images there are known but a few examples where Christ is held fast to the Cross with ropes.[15] In principle no such theological requirement existed for the Thieves' crucifixion, so artists' efforts were not circumscribed in this area. Most medieval writers who recounted the Passion, whoever their intended audience, mention the Thieves, but none to my knowledge dwell on the details of their punishment. From such a dearth of learned commentary we may infer how unimportant the issue must have been to the authorities. For the theologian Joseph Hewitt the issue was plain: 'No one is saved by their blood.'[16]

Yet the creators of the *visual* traditions had, perforce, to make some decisions one way or another, and both options were explored, producing a wide range of variations. Among the earliest Eastern Christian images are a number of small phials, or ampullae, adorned with linear relief images, dated to the later sixth century and now preserved in the Cathedral of Monza in Italy (illus. 26, 27).[17] These objects were probably, like the Sancta Sanctorum icon discussed in Chapter 1 (see illus. 16), made in local Palestinian workshops and sold to pilgrims as mementoes of their travels in the Holy Land. The designer of our first example (see illus. 26) sought to realize specific references in the

25 *Christ and the Two Thieves*, Early Christian, *c.* AD 430–35, carved cypress panel from the doors of the Basilica of Santa Sabina, Rome.

Gospels, and so includes Mary, who stands at the far left wringing her hands in grief, John, who stands on the opposite side, book in hand, gesturing towards the central figures as if addressing the viewer, and the three women at the Sepulchre beneath (the actual proximity of the Sepulchre and Golgotha as *loca sancta* is reflected in their close juxtaposition).[18] Still reluctant to show Christ literally crucified, however, the artist substitutes an image of a tall, leaf-covered 'palm cross', surmounted by a medallion portrait of the Holy Face. This may record the appearance of a large memorial cross erected by the emperor Constantine on Golgotha.[19] Pilgrims kneel in worship at the base of this composite icon, recollecting the early veneration of the Cross and perhaps also the devotions of the pilgrims who purchased the ampullae.

Flanking the abstract Cross are two very concretely crucified Thieves. Clad only in loincloths, each full-length figure is presented with arms outstretched and heads turned to the right. Each is affixed in the same manner to a slender cross, which is more like a stake, hardly visible behind the body: hands are nailed and legs are bound with ropes around the ankles. Taken together with the other extant ampullae, we find three different methods for depicting the Thieves' punishment current in Palestinian art; a second variation shows the Thieves bound

26 *Crucifixion with Palm Cross*, relief on lead ampulla, Palestinian, end of the 6th century, Cathedral of Monza, Collegiate Treasury, ampulla no. 10.

27 *Crucifixion*, relief on lead ampulla, Palestinian, end of the 6th century, Cathedral of Monza, Collegiate Treasury, ampulla no. 13.

with ropes at the feet and hands, which point outward, while a third shows their arms pulled back over the *patibulum* (though it is not easily visible) and hands tied behind their backs by a cord which stretches around their waists (see illus. 27).[20]

Art historians have been consistently impressed by the variety and seemingly realistic detail lavished on these small images. Kurt Weitzmann sees each type harkening back to different prototypes, while Gertrud Schiller claims that these three forms realistically reflect the methods of execution used at the time (given that the actual punitive use of crucifixion had been abolished by the sixth century, however, her claim is unsupportable).[21] But it is not difficult to comprehend how, in the wake of crucifixion's quickening obsolescence, traditional information about such fascinating penal particulars may have lived on in collective memory, especially in Palestine itself. Do any of the Thief types preserved on the ampullae reveal Moltmann's 'kernel of historical truth', a reality that is denied to the crucified Christ?

Very little direct, anthropological evidence exists for Roman penal practices, and only some of it can confirm what the patristic authors inferred, and needed to assert, from their biblical explorations about the use of nails. It has long been commonly thought that crucifixion in the ancient world was generally, though not exclusively, carried out with nails driven through both arms and feet. However, binding with

80

ropes appears to have been used, more often for the arms alone.[22] Techniques seem to have varied widely, and were more often determined by mundane factors, like the time and the human labour power available to the executioners, than on any overarching symbolic intent or legal requirements. In short, though it is highly likely that both Christ and the Thieves were crucified with nails, it is impossible to make any pronouncements one way or another. The Jewish historian Josephus, witness to the siege of Jerusalem in 70 CE, tells the story of three friends who, in his absence, were taken prisoner by the Romans and crucified. Upon his return he went immediately to Titus and obtained their pardon, allowing them to be taken down from their crosses before they died. Of the three men, doctors were able to restore only the one who had been bound with ropes instead of affixed with nails. As the surgeon Pierre Barbet notes, 'One can see that a variation in the method of crucifixion could effect the length of time which it took to cause death. Those who were bound with ropes, says Josephus, died less rapidly than those who were nailed, and could be more easily revived.'[23] Time, as a general element of torture, was integral to the somatic phenomenology of the cross as a punishment (a subject to which we will return in Chapter 6).

Nails appear just as frequently in the Eastern Christian art of the sixth century; recall that the Sancta Sanctorum icon (see illus. 16) and its manuscript relative, the Crucifixion painting in the *Rabbula Gospels* (see illus. 17), both show the Thieves in the manner of the first ampulla type: arms outstretched, pierced by nails in both hands and feet (interestingly, though, the manuscript painter shows ropes crossing over their chests). Further, if nailing was in fact the current mode in Roman Jerusalem during the first century, there is some credibility to the notion that the Synoptists would have seen no particular point in mentioning it. Of course, their silence on this technical matter is part and parcel of their extremely cautious approach to the whole matter of crucifixion. The vulgarity and atrociousness of the penalty, though destined to become the linchpin of Paul's 'message of the Cross', nevertheless made it as much a scandal for the still-Jewish Evangelists as it was for their pagan contemporaries.

In his exploration of the eighth-century Crucifixion icon at Mount Sinai, introduced in Chapter 1 (see illus. 18), Weitzmann observed that while the figures of Mary and John were conventionalized according to a well-established pattern, the position used for the Thieves compared to the third type found on the ampullae: arms hooked over the cross bar and hands fettered behind the back.[24] Indeed, for the first time in the visual record we can see clearly the relationship of the arms to the

patibulum, a model for the Thieves' crucifixion that would eventually gain an authoritative primacy in both the Greek and the Latin worlds. I am calling it the 'hooked arm' type. In the Mount Sinai icon the arms of the only remaining Thief are pulled back over the crossbar, now clearly visible, and the hands are hidden from view, most likely to suggest their being cuffed, with ropes, behind the back. Barely visible behind Mary are the ropes that bind his ankles to the *stipes*. But the painter has done nothing to indicate any strain upon the crucified body in this position – the figure clings effortlessly to his diminutive plank of wood as he gazes attentively, it seems, into the gushing wound under Christ's arm.

Such treatments as this served important visual and symbolic functions in the early historiated Crucifixion. Recall that these very legible images, produced in a religious milieu of controversy and polemic, became highly sensitized conduits of orthodox theological assertion. Whether or not the artist understood the physical effects of the punishment he was rendering, he configures the Thief's body to differentiate it from Christ's, hence underlining the singularity of His death: pierced with nails. The need to make such distinctions was urgent and ongoing. In 1054 a Roman delegation to Constantinople, led by the papal legate Cardinal Humbert of Silva Candida, voiced its strenuous objections to the Eastern image of the crucified then common in Greek art (the calculated failure of the meeting ended in the delivery of a papal bull of excommunication and the historic schism between Greek Orthodox and Roman Catholic Churches). Humbert railed: 'How can you nail a dying man [*hominis morituri imaginem*] to the Cross of Christ in such a way that any Antichrist may take Jesus's place on the Cross and seek to be worshipped, as though he were God.' Though this statement has conventionally been interpreted as a polemic against the theological illegitimacy of the Byzantine image of the suffering, *dead* Christ (*Christus patiens*), and thus a support of the Western tradition of showing Christ alive and triumphant on the Cross (*Christus triumphans*),[25] one wonders whether Humbert's evocation of dead, idolatry-inspiring impostors nailed to crosses like Christ's may not also have provided a tacit imperative that ropes be used for the Two Thieves in canonical images. If this is the case, we can see how the painter's inclusion of the Thieves, so important to the scenographic elaboration *and* symbolism of the image, may have at one time been an iconographic venture fraught with risk. Better to clarify matters by distinguishing two distinct methods for affixing the body to the apparatus. Thus in more or less strenuous ways, the variations we've seen in the icons, the ampullae and the *Rabbula Gospels* manuscript – in concert with other motifs like

those of dress – all guard against the heterodox possibility of mistaken identities and misdirected worship.

But these historical considerations do not force us to view the binding of arms with ropes strictly as an artficial device – a convention – either. Perhaps it was, after all, the image of the Thieves, rather than that of Christ, that conserved the historical memory of Roman methods of crucifixion, the archaeological truth as it were. Early theology did not have a special sacramental or liturgical role for the Thieves, and thus no doctrinal preconditions would have interfered with the transmission of living memories, images or ideas of 'how it happened'. Accurate or not, the types that evolved in early Christian and Byzantine art did attain the status of conventions in that they continued to be obeyed long after the historical memory of crucifixion's real appearance had faded for both the makers and users of images.

Hooked arms

Seventy-five years before Cardinal Humbert's divisive reproach in Constantinople, a Spanish illuminator, working in the scriptorium at the monastery of San Salvador de Tábara in the kingdom of León, completed a beautiful *Crucifixion* page, showing the crucified pierced and bleeding, stricken by the lance-thrust, and yet alive (illus. 38). Tábara most likely housed monks and nuns, a possibility suggested by the book's colophon, which names a certain Ende as the illuminator with the word *depintrix*, denoting a female painter. The colophon also tells the reader that 'the book was successfully completed on Friday 6 July . . . The year was 975.' The manuscript survives in the collection of Girona Cathedral, and is one of numerous illuminated books based on the Spanish abbot Beatus of Lièbana's (d. 798) commentaries on the Apocalypse of St John. Remarkable for its introduction of Passion subjects not found otherwise on the Peninsula and for the extent of its Islamic influences, the book is a paradigm for Thief iconography as provocative as it is puzzling.[26]

Against a deep, mottled blue background, the illuminator has set her figures – boldly coloured line drawings, flattened against the page – into a tightly organized, abstract composition. Besides Christ and the Two Thieves, there are Longinus, Stephaton and the *tortores* to round out a short cast of characters. They are interspersed in a carefully choreographed field with numerous inscriptions and symbols: angels flitter around the Cross and swing censers, a demon awaits the flight of the Bad Thief's soul and allegorical figures of Sol (sun) and Luna (moon) perch upon the arms of the Cross and gesture as if in disputation.

Below we see a pedimented sarcophagus, the side of which opens to reveal the shrouded corpse of Adam, who was, according to ancient tradition, believed buried directly under the Cross on Calvary. The name, *Adam*, appears on the tomb and astride Longinus's feet are the words which specify place: *Calvari locus ubi DNS crucifixus est* (Calvary the place where the Lord was crucified).[27] Thus for the monastic viewer of this compact assertion of theological truths (the first New Testament subject in the book to receive full-page treatment), the sacramental significance of the event could not be mistaken: the *living* Christ is bleeding profusely from wounds in both hands and feet; and beneath the feet a symbolic chalice collects the flow. His body has been pierced with nails, a fact that the inscription under Christ's arms – *Fixuras Clavorum* (the places of the nails) – makes clear.

Inscriptions also name the two smaller figures on either side: *Gestas* at Christ's right, *Limacs* (a corruption of Dysmas) at his left. These identities are consistent with those given in the Mount Sinai icon (see illus. 18) and appear also in the late ninth-century Gospel Book in

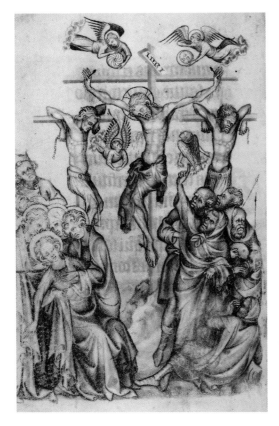

28 Jean Pucelle, *Crucifixion*, from a book of hours for Jeanne d'Evreux, *c.* 1325–8, painted vellum, 8.9 × 6.2 cm. New York, Metropolitan Museum of Art, Cloisters Collection, Ms 54.1.2, fol. 68v.

Angers, for which Syrian sources have been proposed.[28] But they run counter to the prevailing identifications found in the apocryphal tradition and most medieval accounts, where Dysmas is the Good Thief and Gestas his opposite (see Introduction). Be that as it may, the presence here of an angel above 'Gestas' and a demon above 'Limacs', a rare motif in Western art at this time, allows no mistake to be made about who is redeemed and who is damned. Both figures also appear in the hooked-arm pose familiar from Byzantine icons and traceable back to the pilgrim art of Palestine. Here, however, the painter seems less sure about the forces at work on the body, or the real purposes of technical details like the ropes, than even her Byzantine predecessor. Ropes wrap around the *stipes* at ankle level, passing over one leg and under another; their tethers are held in opposite hands of the men with clubs, who in an unusual variation of this motif tug on them, manipulating the legs they are about to break. Two nails appear in the feet of the Thief on Christ's left, but produce no stream of blood.

Whether or not these hooked-arm Thieves were copied from an Eastern prototype, as Schiller suggests, it is clearly their era – the tenth century – that marks their full emergence into European painting (in the north they prevail in the manuscript illumination of the Ottonians, whose political and cultural contacts with Byzantium were extensive).[29] Once established, the hooked-arm type and ropes held sway – without totally eclipsing nails as an alternative – well into the high Middle Ages, as we'll shortly see. Up until this time it may have simply been the weight of tradition, the authority of the models, that forced the hooked arm type, and ropes, to predominate. But once Gothic painters in the late thirteenth and early fourteenth centuries began developing their illusionistic skills, and taking seriously the scenographic challenge of the multi-figured Calvary image, the reasons for employing it appear to shift.

The international terms of this shift can be glimpsed in a long-acknowledged instance of a trans-Alpine reception. Its trace is the *Crucifixion* page of the small prayerbook, called a Book of Hours (*livre d'heures*), painted *c*. 1325 for the Queen of France, Jeanne d'Evreux, by the Parisian master illuminator Jean Pucelle (illus. 28). The manuscript can be seen in the Cloisters Collection in New York. Pucelle's knowledge of Italian art is well documented, and art historians have long recognized in Pucelle's miniature several direct quotations from the renowned *Maestà* altarpiece, painted by Duccio between 1308 and 1311 for Siena Cathedral's high altar (illus. 29). As one of the outstanding masters of the Sienese *trecento*, Duccio was well versed in Byzantine art; though no exact prototype has been discovered, it seems

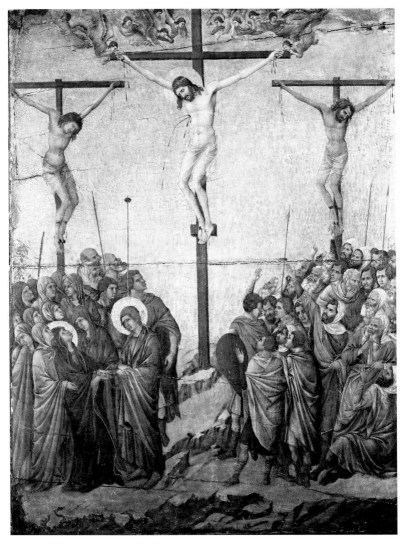

29 Duccio di Buoninsegna, *Calvary*, painted panel from the rear of the *Maèsta*, 1308–11, Duomo, Siena.

that a Byzantine manuscript containing an extensive cycle of Christ's life served as the model for Duccio's 44-scene sequence on the altar's back face.[30] But he rejected, for reasons we can only surmise, the hooked-arm type prevalent in Byzantine manuscript painting and, following it, Ottonian art. Instead of distinguishing his Thieves from the central figure of Christ, he assimilates their body-image to His, piercing their hands and feet with nails, then leaves it to the viewer to scout out the remaining, and more subtle, marks of difference. But Pucelle, in adapting and modifying the main outlines of Duccio's

composition, rejects the latter's conception of the Thieves, and opts instead for the hooked-arm type. Why?

One possibility is that Pucelle was affirming, or clinging to, a distinctly northern tradition for this type, conceivably transmitted from Ottonian sources to French or English ateliers. Exemplary in this regard, and testifying to the pre-eminence of the type in thirteenth-century art, is the Crucifixion miniature in an outstanding northern French *Picture-Book of the Lives of Christ and the Saints*, produced for a Cistercian nun identified only as 'Madame Marie' and now in Paris (illus. 30).[31] Here the Thieves rehearse the grammar of the Mount Sinai icon and its Ottonian counterparts almost verbatim. A second possibility is that Pucelle turned to a rival source in contemporary Italian art, one which, like Pietro Lorenzetti's earlier frescoes in Assisi (see illus. 20), employed a variation on the hooked-arm type (though the hidden hands of Lorenzetti's Thieves are in fact bleeding). Pucelle's modification of the type in fact recommends this reading: notice that he runs the *patibulum* underneath the inner elbow and bicep rather than under the armpit; similarly, in Lorenzetti's conception the Thieves'

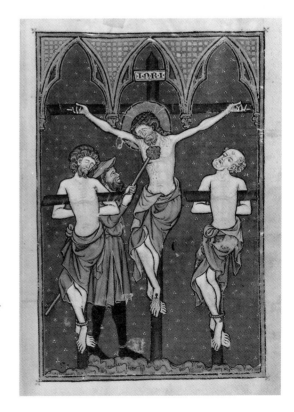

30 'Crucifixion', illuminated page from *Picture Book of the Lives of Christ and the Saints*, north-eastern French, 1268–98, 18.5 × 13 cm. Paris, Bibliothèque Nationale, nouv. acq. fr. 16251, fol. 38r.

forearms are stretched painfully over the top of the crossbar. Since the frescoes predate Pucelle's prayerbook, we can entertain the possibility of a direct influence; and it is more than possible that other Italian artists had already modified the hooked-arm type into this 'hooked-elbow' variation. Most important is the fact that Pucelle, a northern artist at the forefront of International Style naturalism, chose to pursue this type, with its roots in Byzantine and Ottonian art, in defiance of the Duccio model.

By the mid-fourteenth century, most painters in the northern countries were choosing ropes, and some variation of the hooked-arm type, for their portrayals of the Two Thieves. The international prestige of the Parisian ateliers and French culture in general ensured that its models would be warmly welcomed in burgeoning artistic centres like the kingdom of Bohemia (see illus. 42), which later transmitted so much to Austria, and east and south Germany; the Rhineland around Cologne (see illus. 21), which carried French and, later, Netherlandish naturalism into northern Germany; and Westphalia, opposite Cologne, along the Rhine. Often the most decisive points of entrance for these models were monumental wall paintings, like the one adorning the Predigerkirche in Erfurt.[32]

A luminous Passion altarpiece from the Westphalian town of Osnabrück, painted in the last quarter of the fourteenth century, gathers together several strands of influence, and gives us a glimpse of the point from which many of the fifteenth-century works took off (illus. 31).[33] Eschewing a straightforward treatment of the narrative in favour of a deeper pathos, the painter seems intent on capturing the precise moment of death: the souls of the dying Thieves are claimed by angels and demons, while Christ, already wounded in the side, gazes in sorrow at his grieving mother. Amplifying this dire sense of the moment, and suddenly prominent among the witnesses, is the so-called Good Centurion, shown here accoutred in fine armour. As he points towards Christ, a banderole, or speech scroll, unfurls upwards to read, 'Truly this was the Son of God' (Matthew 27: 54). Gold ground limits the sense of space here and across the altarpiece's many lively scenes, helping to focus attention on the figures and their actions.

Several new features, some of them rather curious, accompany the crucifixions of the Thieves. Though both figures are conceived in terms of the hooked-arm variation we saw earlier, the visible index of pain produced by this contortive pose has now been ratcheted up. Not only are the arms forcibly hooked around the crosses; now forearms are grievously pulled around to the front and locked in place by being tied to a straight rod or bar, which runs across their chests, parallel to the

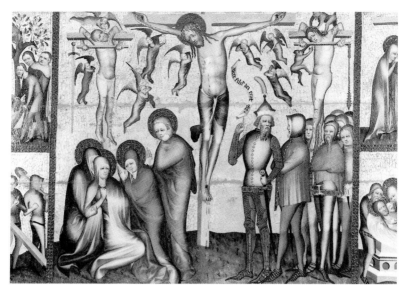

31 The Netze Master, central panel of the *Passion Altarpiece*, originally from Osnabrück (Westphalia), *c*. 1370–90, painted oak panels, 118 × 148 cm. Wallraf-Richartz-Museum, Cologne.

patibulum (Pucelle hinted at such a device, barely visible *behind* the torsos). Although the device appears to be peculiar to Westphalian art, contrary to the perception of one recent scholar, it is not always integrated structurally with the cross as a 'second lower horizontal bar', but often works in conjunction with ropes as some kind of independent device for securing the hands.[34] Though I will return to this motif at the end of the chapter, for now I think what we are seeing is an attempt to clarify, in visual terms, the feasibility of this new contraption for the arrangement of the arms and upper body. The painter, as many would do after him, has taken a liberty with the tradition of the *crurifragium*, by definition a breaking of legs, and wounded the *arms* as well. Has the painter reasoned to himself that only by fracturing the upper arms could the requisite deformation be plausibly depicted? Recall that a similar solution was employed by the Rhenish master of the *Wehrden Altar* of *c*. 1350 (see illus. 21), who brought the hands forwards from behind the *patibulum*, tied them off to a rope which stretched across the chest (and perilously close to the windpipe!) and added discreet, bleeding gashes to the forearms. How revealing of a new, realist attitude towards the visual specificity of penal technologies, their effects on the body and thus their impact on the viewer, is this small change in the equipmental aspect of the Thieves' crucifixion.

Another variant can be seen in a monumental work by the great Westphalian master Conrad von Soest, the *Niederwildungen Altarpiece*

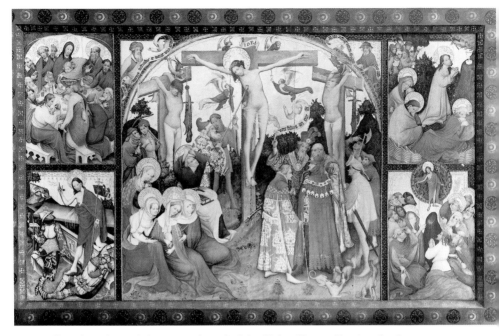

32 Conrad von Soest, *Calvary*, central panel of the *Niederwildungen Altarpiece*, dated 1403, oak panel with tempera and gold leaf, 188.4 × 305.4 cm. Evangelische Stadtkirche St Nikolaus, Bad Wildungen.

completed in 1403 (illus. 32). In many respects von Soest's art defines the cutting edge of late medieval *realist* painting in Germany around 1400.[35] And this huge altarpiece, which extends with its wings open to a total width of over 6 metres, could be considered the *magnum opus* of the master from Dortmund (itself one of the most powerful Westphalian cities in the Hanseatic League). So enchantingly well drawn and richly described are the costumes, terrain, foliage and minor characters (human and animal), so festive are the colours and overall sense of pattern, that it is tempting to agree with Charles Cuttler that 'the Crucifixion itself appears almost an afterthought'.[36] But von Soest has carefully co-ordinated the three crosses with one another and the surrounding groups; those of the Thieves he set obliquely to harmonize more easily with the arched frame through which we view the scene. The figures of the crucified are anything but an afterthought. Soest's Christ curves gracefully yet seems to withdraw from the lance-thrust with a reflexive shudder, as an amoeba might skirt away from an electric probe.[37] The Thieves hang stiffly from beams emblazoned with their names, *jasmus* (a.k.a. 'Gestas') on Christ's right, *dismas* on his left, the same counter-textual switching of names seen in both the Mount Sinai icon (see illus. 18) and the Girona

Beatus manuscript (see illus. 38). And, as in the Beatus page, where an angel claims the soul of Gestas and a devil that of Dysmas, Soest positions the redeemed Thief at Christ's right hand and the damned at His left, in recognition of the spatial polarity and its meaning.[38] He employs the hooked-elbow posture and binds the hands to a rod, as his Westphalian predecessor had in the Osnabrück altar; but he also keeps the stick practically hidden behind the cross, as Pucelle had. Furthermore Soest has refrained from wounding the forearms, and depicts instead what seem like a dislocation of the shoulders and an extreme stretching of the upper arms.

Some users of nails

The majority of the painters surveyed in this book employed ropes to fetter their Thieves – but not all. Duccio's paradigmatic composition in Siena, showing the Thieves nailed in conformity with Christ, is the first developed Calvary to remind us that an alternative tradition persisted; and other artists can easily be found in every national tradition who adopted this motif. Were those painters who adopted nails simply following the only tradition they knew, or did they reject ropes consciously, guided by some impulse or another? Though no clear answer can be gleaned from past scholarship, and none can be offered here, some further inferences can be made through a comparison of two works created in the same year, 1477. One of these, now in Augsburg, shows them affixed with nails (illus. 33), the second, in Cologne, shows the Thieves bound with ropes (illus. 34). What makes the comparison tantalizing is that both works are by the same hand, the eponymous Augsburg painter known as the 'Master of 1477'.[39]

One can't but be struck by the agitated, mid-air ballet which the painter has orchestrated in the Augsburg panel. He has concocted a number of rather cruel ways to turn his human figures into grotesque marionettes, capable of only the most painful, wooden movements. Both men are nailed through the hands to the top of the *patibulum*, producing a ghoulish stereoisomerism of the two bodies which contrasts strongly with the central figure. The hands of the Good Thief (identified by an angel taking flight with his soul) are nailed with their palms facing down, forcing the upper body forwards, away from the cross. Not content with this cruelty, the painter has affixed the arms so close together as to prevent them from stretching outwards like those of the two other crucified men; as if trying to squirm out of this impossible position, the man has pivoted around on the nail holes in his hands, throwing the body off axis with the cross (and perhaps also dislocating

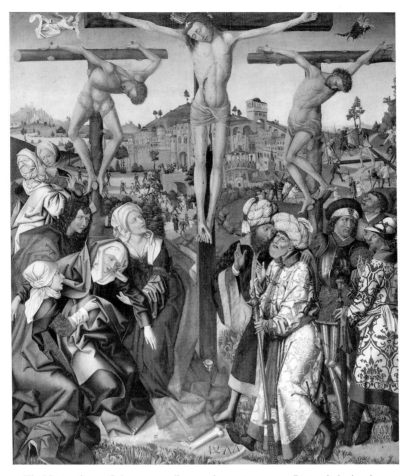

33 The Master of 1477, *Calvary*, 1477, oil on panel, 142.7 × 121.2 cm. Staatsgalerie, Augsburg.

the left arm, which is now crooked backwards). And because the feet are nailed down to the *stipes*, the whole upper torso, shoulders and head have nowhere to go but forwards and down, practically inverting the head. Meanwhile, the Bad Thief has had his left hand nailed to the cross *palm facing up*, which causes a harrowing torsion in the whole arm; this in turn effects a violent turn of the whole torso, as if the dead man were still struggling to relieve the pressure on his arm. Each figure is captured in the aftermath of a futile struggle against the contorted immobility of their own bodies. By contrast, the cross of Jesus seems a place of peace and repose.

In the Cologne panel (see illus. 34) the painter evinces the same kind of macabre fascination with the distortion of limbs. In the figure of the Thief to Christ's left he demonstrates his familiarity with the hooked-

arm type, but also reproduces the diamond-form configuration of the legs used in the Augsburg panel. The more terrifying depiction, however, is reserved for the Thief to Christ's right: though he has managed to work his legs free in an effort to escape, his shoulders and neck are jammed up against the underside of the *patibulum*, while his arms entwine the beam like a vine (see illus. 43). His rebellious struggle against death, the darkening of his face and the rotation of his cross away from Christ suggest that he is the Impenitent Thief, despite his position on the right (*dextra*) side, normally assigned to the Good.

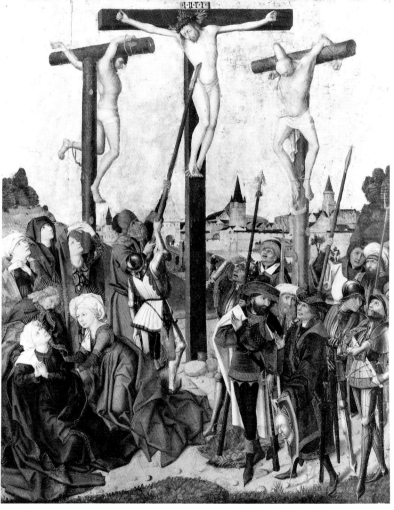

34 The Master of 1477, *Calvary*, 1477, oil on spruce panel, 151 × 118 cm. Wallraf-Richartz-Museum, Cologne.

This is but one apparent violation of a spatial code scholars have long considered to be, as Erwin Panofsky put it, a 'universally accepted symbolism' (see Chapter 7).

So here we have a daring figure painter, keenly aware of the expressive – and antagonistic – possibilities available to him by the use of nails and ropes. Perhaps his choice was determined by the patron's preference, or the setting for which each was produced (a *Last Judgement* is preserved on the Cologne panel's reverse); both panels show the Thieves' legs neither broken, bloodied nor even bruised, a fairly serious deviation from Scripture that may lead us to question the extent of the painter's iconographic knowledge. Finally, it is worth noting that each holds us to a different narrative moment: the Cologne panel focuses on

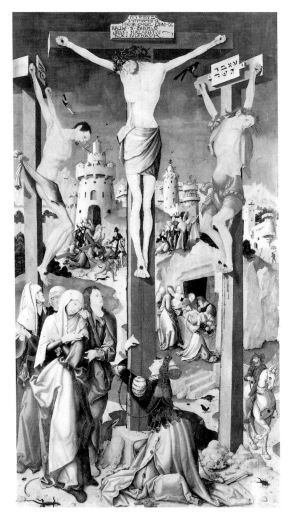

35 Jörg Ratgeb, *Crucifixion*, central panel from the *Herrenberger Altar*, c. 1510, oil and tempera on spruce panel, 262 × 142.5 cm. Staatsgalerie, Stuttgart.

the lance-thrust, while the Augsburg panel depicts the lingering aftermath of death for all three victims. But it is hard to know which, if any, of these issues connects with the rivalry between ropes and nails.

It was a similar moment of contemplative immersion in the abjection of Christ's death that the enigmatic Stuttgart painter Jörg Ratgeb chose for the stunning *Crucifixion* scene of his *magnum opus*, the *Herrenberger Altar* of *c*. 1510, now in the city's museum (illus. 35).[40] Lost now are the sculpted shrines that once filled the middle 'body' (*corpus*) of the retable and its lower portion (*sarg*) as well; a condensed Passion sequence once unfolded across the inner wings when opened, concluding with a resplendent *Resurrection*. An exploration of the minute details and robust symbolism of the altar, which for Otto Benesch showed a 'strong inclination for the biblical primitivism of the poor peasants and artisans',[41] would unfortunately take us too far afield. However, it is fascinating to note the fate of the famously folksy, expressive and evidently subversive painter: for his apparent political support of the peasant insurgents of 1525–6, Ratgeb was executed in Pforzheim by being drawn and quartered! Perhaps it is only with this retrospective knowledge that the political terror of Roman crucifixion, as a half-concealed actuality behind all Crucifixion iconography, seems to erupt so starkly to the surface in Ratgeb's conception. For him the use of nails entails no diminution of crucifixion's hideous squalor, though he too, for reasons we can only guess at, leaves the otherwise horrible, carcass-like bodies of the Thieves unbroken at the legs.

Sighting the weapon: Inversion and magic

We saw earlier that Westphalian painters, including the magisterial Conrad von Soest, hooked the arms of their Thieves over the *patibulum* and secured them in place – in some instances wedged against the body – with a short rod. How, when and why the device entered this regional tradition can only be conjectured. Numerous other Westphalian works display it, and variations appear in roughly contemporary works by middle Rhenish painters (see illus. 9); and in one of these, the central panel of the *Idar-Oberstein Altar*, we can even see the rods passing through holes bored in the *stipes*.[42] Scholarship has unearthed no textual authority for the device; no penal techniques peculiar to the region have been discerned to help explain it; and, to my knowledge, its function cannot be illuminated by the visual record of European criminal-justice history. Bridget Corley suspects that the rod was carried over from contemporary religious theatre, where it may have served as an actor's prop.[43] From the perspective we've been developing

here, it may have been intended to solve the problem of where and how to secure the hands once the arms had been stretched around the *patibulum*. However, most other artists employing the hooked-arm type, as we've seen already, had no need of it.

Still, both the Osnabrück and Niederwildungen altarpieces contain oblique clues as to its *imagined* meaning, if not its precise function. In both cases, where the stick appears it is visually associated with a variety of other weapons used by the executioner, which are shown hanging from the Thieves' crossbeams. In the Osnabrück altar a sword adorns the cross of the Good Thief (illus. 36), a mace that of the Bad Thief; contrasting with this arrangement, Soest places both a sword and a club next to his 'Good Thief' Gestas (illus. 37), a sword and an axe on the cross of Dysmas. Could it be that these weapons are standing in, metonymically, for the executioners who have carried out their duties and have now withdrawn from the scene? Many medieval artists freely interpreted the *tortores* of John's Gospel not only as the 'men with clubs', as iconographic convention had it, but also as the men with hatchets, halberds, sticks, metal bars, etc.[44]

A more compelling interpretation is possible if we consider that the weapons displayed were intended to be seen as attributes of the

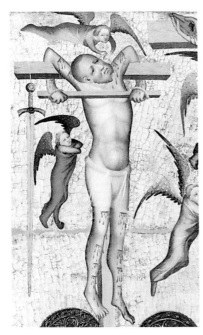

36 Detail of illus. 31, showing the Thief on Christ's right.

37 Detail of illus. 32, showing the Thief on Christ's right.

condemned Thieves themselves, who in legend were not simple thieves but murderers as well (medieval jurists would have regarded their crime as a form of aggravated theft, and this warranted death). Spectacular juxtapositions of executed criminals with their murder weapons were in fact decreed by early modern judges. In Amsterdam in 1660, when a man was tried and convicted of killing another – for money – with an iron spade, the executioner was ordered to hit him twice with the same spade and then garrotte him. Alongside his exposed corpse was displayed the weapon used in both the original crime and his execution.[45] Its public display evoked both the infamy of the malefactor's deed and the restoration of order through justice, which also entailed his elimination. The exhibition of weapons on the cross-arms of the Westphalian Thieves may partake of the same ambivalent, if not inverted, logic: a criminal's tools, made more infamous by their contact with the 'gallows', are turned against him to become symbols of justice's triumph and to demonstrate the cancellation of the 'bad death'. A similar logic underlay the cultic veneration of the *Arma Christi*: the same instruments of obloquy used against Christ by his criminal persecutors He forged into weapons of cosmic triumph over Death and the Devil. Such a logic of inversion may have captivated the medieval imagination in the sight of *both* kinds of weapons, sacred and judicial, but it does not, of course, *explain* the presence of the Westphalian 'binding rod' in these pictures. Instead it lets us know that responses to the sight of weapons and other paraphernalia associated with executions were complex, sometimes ambivalent and often highly charged.

Another factor in the capacity of the weapon-image to compel and focus the imagination, and to make it enter into chains of association, was the popular belief in the amuletic powers of objects associated with the dead, and in particular with persons who had died suddenly. Even the simplest objects, depending on their provenance, could possess magical powers. Like the various parts of the executed criminal's body, particularly the fresh-spilt blood, the technical paraphernalia of executions were eagerly sought after for their curative powers (to ensure availability there appears even to have been a lucrative black market, run by executioners, who were also part-time folk healers). All such objects were regarded, in short, as magical relics. When the German folklorist Gustav Radbruch related these beliefs to the popular conception of the condemned person as a kind of martyr, one who is made holy by the extent of his suffering, he writes with calculated derision: 'The magical effect ascribed to his [the convict's] thumb, his blood, the rope with which he had been hanged, and the mandrake root that grew beneath the

gallows fed by his humours, signify a superstitious degeneration in the veneration of relics.'[46]

The sanctioned prototype for this kind of quasi-religious weapon-veneration were of course, the *Arma Christi*. As relics of the Passion, the *Arma Christi* were archetypal *brandea* (a class of relics, distinct from bodily remains, that came into direct contact with the holy person). Christ's nails, their number set canonically at three, were central to this catalogue of holy weapons. But was it only their Christian meaning that gave the *Arma Christi*, and in turn the paraphernalia of judicial violence, their power?

Medieval ecclesiastical authorities, in an effort to rationalize every material prop for devotion, may have thought so; but we also have another perspective to consider, that of the majority. In the minds of many, the dividing line between canonically legitimate relics and those amulets which could be obtained near the site of ordinary executions may have been thin indeed, since a common notion lay behind both 'historical' and contemporary penal relics. If the paraphernalia of executions were invested with magical powers, it was because they had come into contact with a healthy human body (one that was free of disease and thus vital), at the moment of its sudden death by un-natural causes. They were therefore thought to absorb its powers.[47] These powers could then be transferred to the sufferers of certain diseases, notably epilepsy, known since antiquity as the 'sacred disease'. The presence of epileptics at medieval and early modern execu-tions is widely attested. Richard Evans explains the basis of these beliefs:

Sudden death cut off people before their time, and lent potency to those parts of their body – the fingernails and toenails and hair – that appeared to carry on growing after death, as well as to the blood itself, the life-force which con-tinued to flow for some time after the execution had taken place. Moreover, these relics were especially holy, since they belonged to people who had died a good death, left the world in a state of repentance and grace, and it was generally assumed, had gone straight to heaven.[48]

Pre-Christian sources corroborate the notion that instruments of execution *in general* – not just those associated with otherwise holy people – were thought to possess this power, and that they could be used either as amulets (natural magic) or as vehicles for sorcery (demonic or black magic). When the Roman poet Lucan (d. 65 CE) described the obscene foraging in cemeteries undertaken by the Thessalian witch Erichtho for her magical practices, he notes that among the bizarre things she sought was iron (literally, steel) that had been driven into hands (*insertum manibus chalybem*). According to

Joseph Hewitt, 'The magic of the iron, and more precisely the nail, is enhanced if it has been used in a crucifixion.'[49] And among the different types of magical paraphernalia mentioned by Pliny the Elder in his encyclopedic *Historia Naturalis* are *spartum e cruce* (a rope or halter that has been used for the crucifixion).[50] This is not only interesting evidence for the attribution of magical powers to judicial paraphernalia in earlier times, but further confirmation that ropes as well as nails were used in Roman crucifixions.

Far from being 'superstitious degenerations' of a more exalted form of religious veneration, the magical, specifically curative, power of the dead criminal's body was recognized by no less an authority than Paracelsus, who complained, 'If physicians and other men only knew what could be done with this mummy and what it could be good for, no malefactor would remain on the gallows or the wheel for longer than three days, but, were this at all possible, would be taken away.' The good doctor, learned in astrology, apparently believed that the bodies of those condemned to hanging or display on the wheel were exposed to the effects of the sun and moon as it shone on them and were therefore 'mightily impregnated and influenced' by the stars.[51] Taken together with numerous other instances from medieval and post-medieval European criminal-justice history and folklore, these examples suggest the embeddedness of such beliefs in long-term mental structures shared by all classes in medieval society. They caution us about dismissing as minor details the technical implements medieval painters so carefully depicted in their riveting representations of unnatural death.

Conclusion

In the foregoing we have seen that painters who deployed variations of the hooked-arm type were often adapting and developing older models for the crucified Thieves. As an iconographic 'motif', the pose and its attendant features have a long and rich history. But because it evolved independently of any dogmatic interpretations or theological prescriptions, the pose was one that could be easily adapted to a variety of narrative strategies and expressive needs. Unfettered, as it were, from theological control, the hooked-arm Thief served the painter as a protean shape from which he could launch his own explorations of the body in pain. Whatever degree of 'historical realism' it might have represented for painters, patrons and other beholders, the use of ropes opened up a range of possibilities for expressing physical agony through violent movements and dislocations.

Thus the real power of these images presupposes, it seems to me, a tacit departure from an over-reliance on 'models', and a decisive step towards fashioning the tormented figures into dramatis personae that could compel fascination in the complex, realist scenography of Calvary. Not long after ropes became ensconced in late medieval painting, they tempted image-makers towards the articulation of an entirely new language of posture and gesture for the body in pain. They gave painters the freedom now to rewrite the *rhetoric* of crucifixion's violence in the realist terms of specific penal techniques. Seen in this way, ropes and nails represent more than competing means of affixing bodies to crosses; as the technological keys to the total torture, a whole set of effects aimed at the body, they each operate as a synechdoche for two quite different versions of what was supposed to be the same punishment. Offering the devotional spectator this kind of variety was, as we saw previously, a critical strategy for helping lay people foster a deeper personal involvement with the events of the Passion. Similar realist strategies, aimed at sparking the same personalized response, are writ large across the devotional literature of the era, though I hasten to repeat that, to the best of my knowledge, none of the well-known Passion tracts of the later Middle Ages include penological details about the crucifixion of the Thieves. That was left to the painters.

In late medieval art, so historically remote from ancient penal methods and the cultural memory of them, the use of ropes facilitated certain kinds of expressive solutions to the problem of how to make the pain of death undeniably *visible*. We will see the gruesome outcome in the next chapter. Yet in non-narrative works such as the upper German *Christ on the Cross* with which we began this chapter (see illus. 23), ropes could be used for Christ's Crucifixion so long as they were not seen as functional elements in the penal technique. Rather, they operate as thick references to His humiliating debasement as a criminal and prisoner throughout the Passion.[52] Though rare, ropes similarly lashed around the body appear as more or less convincing functional supports *for the Thieves* in both early Christian art (see illus. 17) and then again in later medieval and Renaissance art in Germany (see illus. 118).[53] As signs of criminality, ropes therefore contrasted strongly with the nails, which were also Passion relics. Yet we have already seen that ropes had a judicial and magical reality quite independent of sacred art's traditional stock of motifs and its rhetorics of violence; it may be for this reason that their depiction opened the field of vision and feeling to such a broad range of significations. From the point of view of a 'social iconography' of later medieval art, we might call this process the *infiltration of the rhetorical by the real*.

3 The Broken Body as Spectacle

Something pre-social seems to link us to a strong sense of disgust
and horror at the prospect of a body that doesn't quite look like
one, either grotesquely deformed by accident or disorganized by
mayhem.

WILLIAM IAN MILLER, *The Anatomy of Disgust* (1997)[1]

Dislocations and improvisations

For the late medieval painter, working to forge a realist language out
of the idioms of country and region, and in conversation, to a greater
or lesser degree, with modish court styles, the figure of the crucified
Thief presented a unique aesthetic challenge. As we've seen, conven-
tional types for these figures were well disseminated through *trecento*
art, International Style painting and their satellites in the north; the
most widespread of these, by 1400, was certainly the hooked-arm
type. For painters who sought to push their art beyond convention,
the crucifixion of the Thieves presented an opportunity for the free
deployment of their inventive powers, since no significant theological
constraints were in force. Out of this dialectic of freedom and con-
straint were to come a panoply of wildly distorted figures whose gestural
language spoke directly of pain and, by extension, of the antithetical
states embodied in the Two Thieves: penitence and impenitence, re-
demption and damnation, sanctification and defamation. To modern
eyes, this language of pain is often articulated in terms so explicit
as to veer towards the disgusting and atrocious, surpassing perhaps
our ability to *see* what's going on at all.[2] Was it thus for the medieval
viewer?

I regard it as a principle of the history of human sensibilities that in
no culture is the capacity for experiencing violence, or intensely violent
imagery, unlimited. Thus we should not think it so for the 'rude and
barbaric' Middle Ages. Despite what many historians have said about
the medieval 'coarseness of attitudes', the 'familiarity with death' or

the 'uncivilized disregard' for public displays of bodily functions, there is evidence that later medieval people could experience disgust and revulsion over extremes of actual or represented violence. In the very text that helped popularize lay contemplation of the grisly details of Christ's torture during the Passion, the late-thirteenth-century *Meditations on the Life of Christ*, one finds an entreaty to the reader 'not [to] be repelled by those things that our lord Jesus did not hesitate to bear'.[3] Without an audience capable of experiencing disgust, disgusting imagery is robbed of its antagonistic power. And without this power it can have no meaningful cultural purpose (equally culturally meaningless would be imagery that was so out of line with sensibilities that spectators could not even bear to look at it, making its violence practically invisible). Cultivating compassion as a spiritual virtue and understanding that Christ's agonies begin and end with human sinfulness, one's *own* sinfulness, medieval devotional viewers no doubt understood the value of disciplining themselves, during meditation, to face the sickening spectacle of His torments squarely, to gaze upon them with a stoutness of heart, and even to seek solace and 'refreshment' in them. 'What can be so effective a cure for the wound of conscience and so purifying to keenness of mind,' asks the Cistercian abbot Bernard of Clairvaux in a sermon, 'as steady meditation on the wounds of Christ?'[4] Did the same viewers likewise make the effort to endure, as a cultivation of their own spiritual virtue, the shockingly 'disorganized' bodies of the Thieves? In Chapter 7, I suggest that this was the case, and that the acknowledged cultural purpose of their image was to provide just such a chastening, if not openly antagonistic, experience.

Where, then, in the long playing field of possibilities between tame conventionalism and ultimate abjection, between the fully legible body and the one which disintegrates before our vision, surpassing the *sensible* person's capacity for horror – where did the visualizations of painter and spectator meet? Was the skilled *lay* visualizer of the Passion already keen on generating such terrible spectacles for his or her own private meditations? Or did the lack of textual direction available to the pious lay person on this matter demand that the painter use his art to urge spectators towards ever crueller torments for the Thieves? Would not the ambitious painter have learned to exploit his audience's fascination with the body-in-pain, to keep their attention riveted upon the figure by crafting it with the utmost care – calibrating its effects, so to speak, against their capacity to visualize such things at all? Compared to his literary counterparts, the late medieval painter, as we know, was eloquent and precise about the punishment of the Two Thieves.

If the iconography of pain presented a special artistic challenge, one in which audience sensibilities had to be gauged and met at the extreme limits of apprehension, there was also a professional opportunity for the late medieval, guild-sanctioned master. To grasp fully the mental conditions under which such men worked would require reviewing the changing social status and self-definition of the professional painter in northern Europe. For the moment we can imagine these mostly provincial, mostly ambitious men, casting their nets widely in search of compelling models to adapt, revise and recombine, looking for new ways to make a convincing (and disgusting) display of the crucified body, and deploying all the auxiliary motives associated with it: crosses of varying shapes and sizes; ropes, nails and other technical parapher-nalia they chose to assemble around the suspended figure (recall the weapons in Westphalian art); facial expressions, clothing, hair and, above all, the horrendous, often gaping wounds on legs and arms, our present concern in this chapter. Committed as they were to providing their patrons, and their local audiences, with a stimulating and edifying visualization of how the three different executions on Calvary *may have happened*, the enterprising professional painter surely hoped to leave his own mark, so to speak, upon the bodies of Christ's 'shameful company'.

Indeed, as the fifteenth century speeded towards its irresolute end, as the 'medieval consensus' fell under the disintegrating advance of new ideas powered by the printing press, painters in the north, espe-cially in the German-speaking territories, applied themselves with ever greater stringency to the task of arranging the dislocated limbs of the Thieves on, around and over their crosses in the cruellest fashion possible. One even gets the feeling that these men staged their own penal atrocities competitively. Painters worked in a milieu of escalating artistic self-consciousness and self-importance, and 'showed an in-creasing self-awareness that a major altarpiece could serve a broader role in establishing their credentials as producers of great "works"'.5 As more and more painters sought aesthetic inspiration from Italy and, in doing so, cemented alliances of mutual respect with circles of humanist scholars and poets – the twin defining features of 'Northern Renaissance' aesthetics – they had to find ways to make good their claims to being more than just superb craftsmen; they had to assert that their practice was more than what the word *arte* traditionally denoted: skill. Such an extension of the artisan's practice into the improvisa-tional can be seen in terms of both the self-distinction it brought the maker and the prestige it brought the ever competitive guilds. In this sense it is an important precursor of the Renaissance ideals of *inventio*

and *fantasia* (see Chapter 8), but it is not, at this time and in this part of Europe, the same thing. Not until Albrecht Dürer's highly self-conscious presentation of the artistic self, undertaken within the burgeoning élite humanist culture of early-sixteenth-century southern Germany, did northern European artists learn to pose the question of their own poetic powers. If late medieval artists were using their image-forming powers in roughly analogous ways, it was still, primarily, in the service of the cult image, for the sake of its devotional usefulness and appeal.

One of the aims of this and the following chapters, then, is to show how an emergent professional and aesthetic practice, leading towards a synthesis of observation and improvisation, but still bound in significant ways to established models, led artists *away* from these models, and compelled them to seek new ways to convey the *reality* of crucifixion to an audience for whom it was a distant, and even exotic, form of punishment. Consciously or not, painters learned how to match the pictorial experience of these penal horrors with the judicial realities with which they lived, to make one resonate with the other. 'The power of realism in art,' writes the critic Leon Wieseltier, 'is owed to the continuity between the world which it makes and the world in which, and for which, it is made.'[6] Later medieval devotional art demanded such a continuity, and compelled the painter to imbue his 'rhetorics' of violence with all the appurtenances of *the real*. Meanwhile, devotional culture urged those pursuing a spiritual path into Christ's dire sufferings to seek for themselves such a continuity between past and present; it compelled the *spectator* to visualize every detail of the Passion in terms of what he or she knew most intimately – in other words, to imbue his or her own imaginary violence with all the forcefulness of the real. In what follows here and in the rest of this book, I hope to develop this idea of an experiential continuity between these three key spheres of experience: the sacred image, with its realist treatment of atrocious punishment; private devotion, with its peculiar mode of meditative visualization, responsive to the antagonizing directives of an art and literature designed for its cultivation; and a public sphere of ritual action and collective piety, where many of the perceptions and feelings aroused by devotional art were channelled and expressed: the contemporary spectacle of pain, penance, expiation and redemption that the late Middle Ages called justice (*iustitia*).

38 'Crucifixion', Kingdom of Léon, probably Tábara monastery, AD 975, illuminated page from Beatus of Lièbana's commentaries on the Apocalypse, tempera on parchment, 40 × 26 cm. Girona, Museu de la Catedral, ACG Ms. 1, fol. 16v.

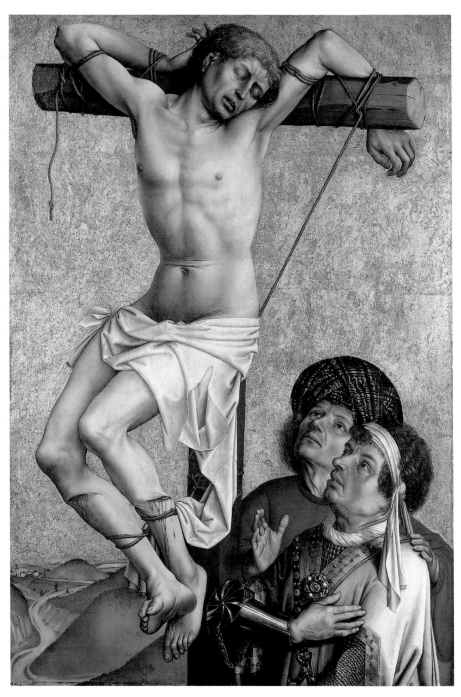

39 Robert Campin (The Master of Flémalle), *Thief on a Cross*, fragment of an altar wing, *c*. 1428–30, oil on oak, 133 × 92.5 cm. Städelsches Kunstinstitut, Frankfurt.

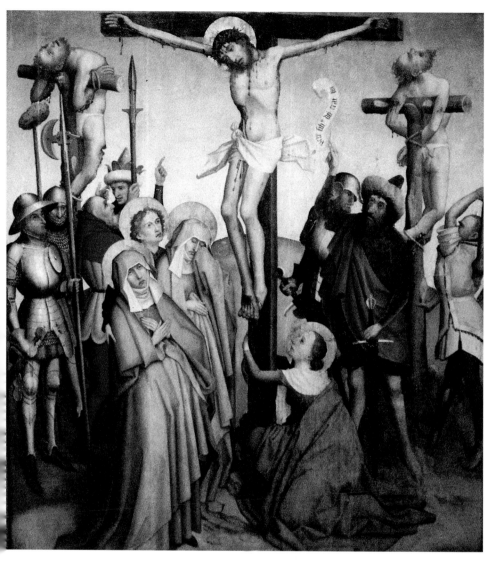

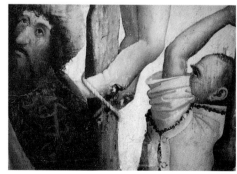

40 The Master of the Sterzinger Altarwings,
Crucifixion, exterior of a *Flügelaltar*, mid-15th
century, painted pine panel, 156.5 × 142 cm.
Staatliche Kunsthalle, Karlsruhe.

41 Detail of illus. 40, showing the legs of
the Thief on Christ's left and an executioner
with a club.

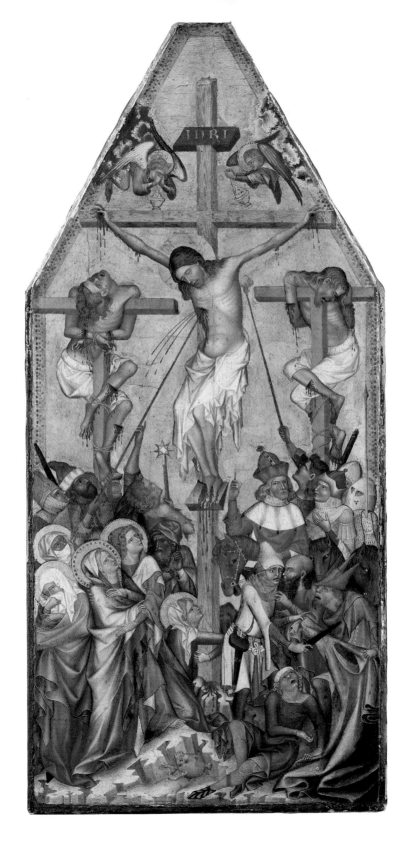

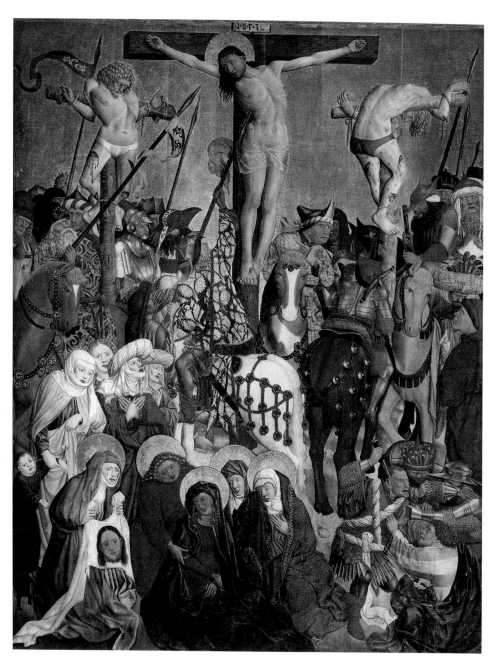

42 Bohemian Master, *Calvary*, central panel of an altarpiece (the so-called 'Kaufmann Cruci-fixion'), *c*. 1360, painted panel transferred to canvas over panel, 67 × 29.5 cm. Staatliche Museen zu Berlin – Preußischer Kulturbesitz (Gemäldegalerie) (OPPOSITE).

43 The Master of the Munich Domkreuzigung, *Calvary*, Upper Bavarian, mid-15th century, painted panel. Frauenkirche, Munich (ABOVE).

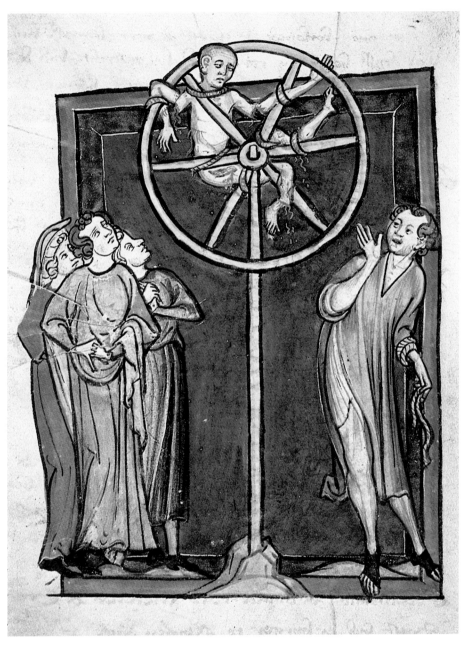

44 Mutilated criminal elevated on a wheel, from the so-called *Book of Numquam*, tempera on parchment, 13th/14th century. Cathedral Library, Soest.

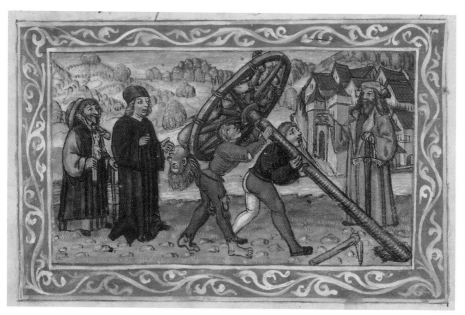

45 Diebold Schilling, Setting up the wheel with the murderer Duckeli in 1492, fol. 218v. from *Luzerner Chronik* (1509–13), 20 × 12.6 cm. Zentralbibliothek, Lucerne.

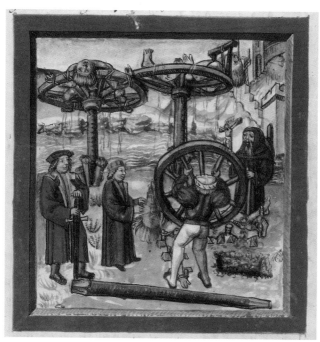

46 Diebold Schilling, Execution by wheel with mutilated criminals on elevated wheels, fol. 280r. from *Luzerner Chronik* (1509–13), 17.6 × 18.6 cm. Zentral-bibliothek, Lucerne.

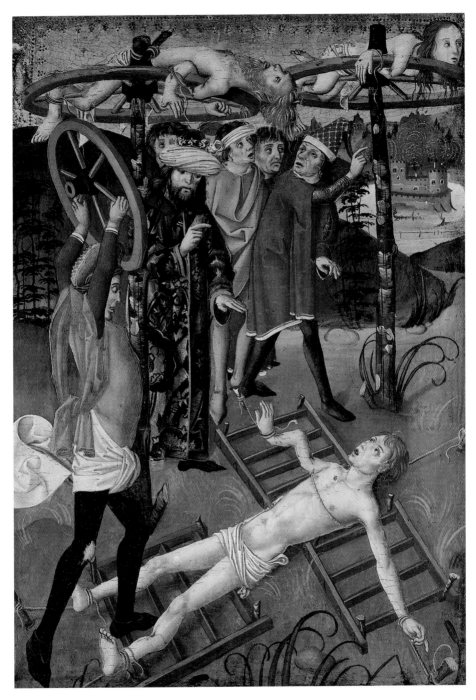

47 Circle of the Master of the Martyrdom of the Apostles, *Saints Felix, Regula and Exuperantius Broken with the Wheel*, Austrian or Hungarian, *c.* 1480, tempera on pine panel, 72.5 × 50.5 cm. Keresztény Múzeum, Esztergom, Hungary.

Each distinct 'type' for the crucified Thief in northern European art displays a set of technical effects that distinguishes it from its relatives; each directs an anxious perception to the terrors of 'crucifixion' according to its own, distinct phenomenology of pain. And within each mode of body-demolition, each set of effects, a special place was reserved for the graphic depiction of wounds.

Images of wounds may be the paradigmatic generators of horror, and perhaps also disgust, because of the way they locate perception at the pulsing boundaries of the body. Once a wound appears before our eyes, it is as if a fault line has opened up across the body's topography, one that threatens to tear open ever wider expanses of the body's hidden interior. We seem to sense, in that 'pre-social' way evoked by Miller in his epigraph for this chapter, 'the inappropriateness of destroying the integrity of the body's seal'.[7] Instinctively we fear the dissolution of that literally vital distinction between interior and exterior. Extend the wound far enough beyond its already unstable boundaries and the body, as an organic whole, threatens to disappear. In the course of my public lectures, which have included these images, it has become clear to me just how profoundly the 'civilizing process' has made the sight of serious wounds unbearable to all but a few. The sight of an opened body delivers an inchoate shock, and causes such sympathetic perceptions of pain, because the wounded body of our vision somehow ceases to be *that* body and becomes, in an uncanny way, *our* body as well. For Julia Kristeva the wound is profoundly disquieting because – like that 'utmost of abjection', the corpse – it '*show[s] me* what I permanently thrust aside in order to live'.[8] When the wound is transformed into spectacle, we glimpse in it our own future disarray.

With a macabre virtuosity unmatched in the history of art, numerous late medieval painters applied their illusionistic skills to the problem of creating wounds whose severity and gruesomeness could expose the perviousness of the body and, for that reason, attract the spectator's gaze like powerful magnets. In the work of the great Flemish 'primitive' Robert Campin (a.k.a. the Master of Flémalle), we find a far more rigorous attempt to come to terms with the grisly leg wounds, the result of the Roman *crurifragium*, than any artist who worked before him. And more effectively than any painter of his generation, Campin grounded his 'study' of the fractured limbs in direct observation. That, at least, was the conclusion of the historian of medicine Robert

Herrlinger, who in a 1953 article placed Campin's famous Thief fragment, now in Frankfurt, on the examination table (illus. 39).[9] Under Herrlinger's scientific gaze, Campin's near-photographic rendering of the human body revealed an astonishing exactitude. That the Tournai master's 'anatomical-surgical' rendering of the entire figure reminded him of modern anatomy manuals only underscored the historic importance he attached to Campin's achievement: more than 100 years had to elapse, he tells us, before its equivalent could be found in any European medical handbooks.[10]

Exceptionally large for its original time and place, the present painting in Frankfurt is but a fragment of a once larger altar panel that showed the Thief set in a rolling landscape, attended by two spectators standing on the ground (now visible only as bust portraits); this panel in turn most likely formed the right wing of a large altarpiece of the *Descent from the Cross*, the general appearance of which can be discerned from a copy now in Liverpool.[11] The figure languishes uneasily on the cross. Arms are bent back in two separate but equally well-described positions, and are lashed down brutally to the neatly carpentered beams: the left arm stretches up to hook over the *patibulum*, effecting what appears to be a dislocation in the elbow and leaving the hand to dangle; the right upper arm splays away from the torso but is severely locked back, the shoulder perhaps disjointed, and the wrist is tied down to the beam. Rotating like a fleshly swastika, the resulting configuration has a geometric logic that may have its source in older variations on the hooked-arm type. Combined with the tense, tormented facial features, the figure appears as a kind of disjointed, judicial analogue to the drunken sleeping satyr of Hellenistic art. Campin's soft modelling creates a plastic sense of flesh so evocative that it compelled his greatest pupil, Roger van der Weyden, to adapt its features for the Christ figure in his famous *Deposition* altarpiece in Madrid.

Of pointed interest to Herrlinger were the representations of the broken bones in the lower legs (illus. 48). Once again, the accuracy impressed him: he identified fractures in the tibia (commonly called the shinbone) and fibula of both legs, remarked on the manner in which the dislocation causes the skin to stretch in tight folds over the front edge of the tibia, and noted the indentations in the skin caused by the tightened ligatures beneath the wounds.[12] There couldn't be any doubt that Campin had based these details on careful observation of an unclothed human body, presumably a corpse. But neither he nor any other Flemish artist of his generation is likely to have brought corpses into the studio for observation or dissection. We know of no such anatomical investigations *by artists*, north or south of the Alps,

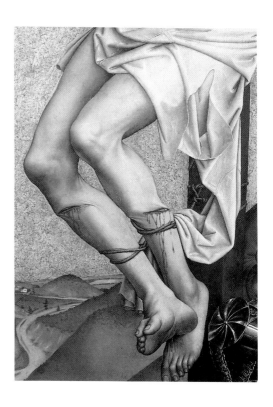

48 Detail of illus. 39, showing the fractured legs of a Thief.

until about 70 years later, when Leonardo da Vinci ventured into this high-stakes arena, touching off a period of fruitful collaboration between artists and medical doctors during the *cinquecento* that resulted in a 'revolution in the science of anatomy'.[13] Rather than using collected anatomical specimens, which at first were always the bodies of executed persons who had been denied burial,[14] Campin's studies would necessarily have been focused on the bodies of judicial victims *still displayed on the gallows*. For Herrlinger, the pallid hue of the skin – as well as the curious fact that the overtight ligatures cut into 'bloodless, dead flesh' – could not be mistaken for anything but the body of a hanging victim.[15] In his eyes, Campin had successfully parlayed a common, observable sight, an everyday experience, into a masterpiece of anatomical truth-to-nature.

However, several related aspects of Herrlinger's analysis don't quite add up. In the first place, he believes that the leg wounds shown by Campin were caused by a blow from a sword. Second, he casually assumes that the dead convict who offered his body to Campin's proto-scientific gaze was a hanging victim (*Gehenkter*),[16] ignoring the fact that hanging was not the only punishment in the medieval repertoire that included public exposure as a post-mortem indignity. Why would

a medieval hanging victim, who died from slow strangulation, have such wounds inflicted on his legs at all? Ironically, the seed of a better explanation can be found embedded in Herrlinger's observations and analysis. When he attributes the appearance of the wound to a blow from a sword, he means that the dislocations in the tibia and fibula were also the result of this blow. He does not consider that the disjointing of the leg may have been caused instead by bodily movements made, or external pressures applied, after the blows had been struck. Yet this possibility may well be precisely the thing Campin wants to trigger, and it is a surprisingly good match with what we know of the pathophysiology of Roman crucifixion. Several further comparisons will help make this clearer.

In a mid-fifteenth-century panel, now in Karlsruhe, by the painter known as the Master of the Sterzinger Altarwings, macabre virtuosity with wounding reaches an unbearable surplus (illus. 40).[17] This Ulmish painter, who worked with the sculptor Hans Multscher and was well acquainted with the art of Roger van der Weyden (the mourning figure dabbing her eyes with her robe is lifted from Roger's *Calvary Triptych* in Vienna), was certainly one of the century's greatest judicial voyeurs. Playing across the boundaries separating one Thief type from another, he shows the Good Thief arching back, with forearms savagely broken close to the elbows, locked around and tied down to the *patibulum* (illus. 49). His counterpart also has the *patibulum* shoved up under his armpits, but cannot arch back since his wrists are tied to the *stipes* behind his back. Both Christ and the Good Thief wear expressions of death: for Christ it is the impassive stare of the corpse; for the Good Thief it is the delirium of the torture victim. Only the Impenitent Thief endures, howling in pain as an executioner mercilessly batters his body (illus. 41). By angling the Thieves' crosses away from us, the Sterzing Master creates a semi-profile view from behind, one which objectifies the wounds and makes them maximally visible (we see most of them in profile). The worst of them appear as grotesque crimson mouths, surrounded by massive purple-blue contusions, gaping open to show splintered bones that look like jagged teeth. The compound fractures just above the ligatures are bad enough to disjoint the leg bone and cause it to 'hinge' outwards.

Equally chilling are the wounds described in the sprawling *Calvary* altarpiece painted between 1460 and 1470 by the so-called Kempten Master, who hailed from the Allgau region of Bavaria (illus. 50).[18] Again we are faced with mouth-like openings into the body's interior, drooling blood and filled with shattered bone, as if trying to speak. And again in the most visible instances the artist has conveyed the

49 Detail of illus. 40, showing the Thief on Christ's right.

anatomical specificity of a compound fracture that is bad enough to disjoint the limb at the bone's midpoint (illus. 51). Unlike the Sterzing Master, who pictures the club-wielding executioner as the human agent behind these demolitions, the Kempten Master has withdrawn the executioners from the scene, leaving only the wounds as a visible index of their presence. Did this artist assume that the spectator would fill in the missing characters, the so-called 'men with clubs' (*tortores*)? And if so, would they come armed with their traditional clubs or brandish alternatives – sticks, maces, hatchets, swords – in the way numerous other painters and illuminators had envisioned them? What specific form of butchery, what 'technique', has caused these horrendous gashes? How did both of these artists cue their audiences towards a comprehension of the pain they make so palpably visible? How did the infliction of wounds fit in with the rest of the torture? Was it simply an added cruelty for the Thieves (in contrast to Christ), did it contribute to their deaths, or was it the cause of death itself?

John's Gospel tells us that, after the Crucifixion, the Jews clamoured for the removal of the dead bodies from Golgotha before the onset of

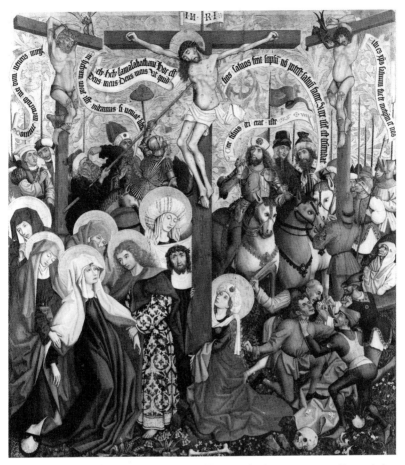

50 The Kempten Master, *Calvary*, 1460–70, oil on panel, 165.5 × 140.5 cm. Germanisches Nationalmuseum, Nuremberg.

the Sabbath. Since none of the three condemned men had yet died, however, they insisted that their legs be broken. Thereupon Pilate dispatched soldiers to do the job (19: 31–2). Of the few patristic authors to comment on this episode, Origen (d. 253/4) writes that this was carried out 'according to the Roman custom',[19] by which he apparently meant a procedure called the *crurifragium*. According to Pierre Barbet, whose 'Passion according to the surgeon' has done much to illuminate the patho-physiology of crucifixion, the Gospel writers would have known how effective this technique was in hastening the deaths of crucified men. In breaking the legs of the crucified, one removes what has become, in the course of the torture, the primary support for the suspended and immobilized body. Barbet explains:

After crucifixion [proper] . . . the body sagged, and dropped to a considerable extent, while at the same time the knees became more bent. The victim could then use his two feet, which were fixed to the *stipes*, as a fulcrum, so as to lift his body and bring his arms, which the general sagging would have dropped by an angle of about 65°, back to the horizontal. The dragging on the hands would then be greatly reduced; the cramps would be lessened and the asphyxia [caused by the inability of the lungs to properly expel air and thus exchange gases] would disappear for the moment, through the renewal of the respiratory movements . . . Then, the fatigue of the lower limbs would supervene, which would force the crucified to drop again, and bring on a fresh attack of asphyxia. The whole agony was thus spent in an alternation of sagging and then of straightening the body, of asphyxia and of respiration.[20]

Finally, in Barbet's opinion, the average victim of Roman crucifixion died not from loss of blood, thirst, starvation, fatty pulmonary embolisms or a cardiac arrest (all of which have had their diagnostic champions), but from asphyxiation. In John's Gospel Christ expires before the soldiers reach Calvary, and is therefore spared the *crurifragium* (though the exemption has a significance beyond this straightforward narrative logic, as I'll explain).

Barbet's account can help us reconstruct one level of intentionality behind the wound images served up by provincial painters like the

51 Detail of illus. 50, showing the Thief on Christ's right.

Kempten and Sterzing Masters, and by urbane masters like Campin. But it also exposes the limits of their 'archaeological' grasp of the penalty. Of all of the wounds found in their work, those which open up in front of a fracture severely enough to 'unhinge' the bone are the most deliberately rendered, and the hardest to look at. So let us take a closer look. If, consistent with the narrative logic of the Gospel, the fracturing blow was delivered in the midst of the up–down struggle described by Barbet, the weight of the exhausted upper body would, in fact, 'hinge out' the leg at the precise point of the fracture (and perhaps also tear open the wound still further). This is what we see. However, this reading is thrown into doubt in the case of the Kempten Thieves, whose upper bodies are not suspended in Christ's canonical pose, with arms outstretched and affixed to the cross at the furthest points of extension – yet this is the conformation assumed in Barbet's description. Rather, their arms are woven up, around and over the *patibulum* and tied down tightly with ropes. Such an immobilization of the upper body would not, strictly speaking, abandon the body to gravity's force, the precondition for the 'hinging out' of the broken limbs. What else, then, could have caused this kind of wound? Could the decisive blow in these cases have come *from behind*, fracturing the bone and pushing it through the other side of the limb? What other penal procedure could provide the model for this? And how might we have to reimagine the sequence of events in the biblical story of the breaking of legs in order to account for such a possibility?

The accuracy of Herrlinger's physiological understanding of Roman crucifixion is not really at issue here. Nor is how well Campin's understanding matches up against a modern, 'archaeological' grasp of these things. As a maker of sacred images, Campin's practice was directed towards neither reconstructing the patho-physiology of Roman crucifixion nor producing an optical recording of what he saw suspended on the gallows. His practice demanded instead that he confront the viewer with an image whose rhetorical power depended on its oscillation between past and present, partaking of both but committed to neither. In Campin the real infiltrates the rhetorical to the extent that wounds are not only shocking but shockingly *familiar*. The visual habits and devotional practices of his bourgeois audience would have compelled him, as Herrlinger rightly sensed, to draw upon that 'everyday lived experience' that included the sight of punished malefactors exposed to public view; but he also had the much harder job of reconciling that familiarity with a peculiarly medieval commitment to what the biblical story actually told. The anatomical accuracy of Campin's wounds are enough to convince us that he didn't just make them up (as one might

suspect of the cartoony Kempten Master). So where, if not upon the body of a hanging victim, could he have observed compound fractures? Are we looking at a seamless montage of elements taken from different sources? Or has Campin approximated his vision of the tortured Thief to a rather different instance of the broken body as spectacle?

Text and image: The Thief on the wheel

Whether or not the infliction of the *crurifragium* was, as has sometimes been thought, an expression of mercy, a death blow that spared the crucified hours of further agony, the overriding concern made plain in John's Gospel was the hastening of the men's deaths so their bodies would not remain on view during the Sabbath. Even this narrative rationale may be, symbolically speaking, beside the point. For the Gospel writer is quite deliberate about the typological spin he wants to give the incident. Christ is dead, so is spared the vicious assault; like the Paschal lamb of old, we read, 'a bone of [Christ] shall not be broken' (John 19: 36).[21] Only the Thieves are *literally* broken, and we can see in this simple denial – the only piece of technical description in the Gospels that lets us know that the torture imposed on the Thieves was different from that of Christ – what amounted to a decisive cue for later medieval artists. Many painters, as we've seen throughout the preceding chapters, simply go about the business of 'illustrating' the episode or its bloody outcome in straightforward terms, perhaps confident that they were reconstructing the historical reality of Roman crucifixion, or at least being true to Scripture's authority. Other painters, however, take a different approach, and seem to perceive in that account of the breaking of bones a dim prototype for a judicial procedure that was familiar to them. In the Gospels the legs of the Thieves are broken *after* the fact of their crucifixion – technically speaking, *after* they were already affixed to the crosses. But the fractures and dislocations of the body visible in several important works reveal something different.

One of the pivotal works in the development of the multi-figured Calvary image in northern Europe is a gabled panel from the kingdom of Bohemia (modern Czechoslovakia), painted *c.* 1360 and now in Berlin (illus. 42).[22] Its small size suggests that this was not a high altar but probably a domestic altar for a princely patron. Artists active at the court of the Holy Roman Emperor Karl IV were well acquainted with the *trecento* art that was then in vogue, and some authors have perceived the influence of Bolognese illumination in the composition; the same design reappears later in Bohemian art, this time in a missal, completed

in 1409 for the Archbishop of Prague Zbinko von Hasenburg and now in Vienna.[23]

In the Berlin panel the Thieves are shown in states of wretched dislocation that involve every bodily member. Taking the hooked-arm type to a terrifying extreme, the painter levers every arm over the *patibulum*, twisting them down and locking them in place behind the figures' backs, where they are cuffed with ropes. Enough anatomical descriptiveness is in force to make the perception of crunching dislocations in the shoulders inescapable. Horror is unrelieved as our gaze traces the serpentine line of the torsos down to the legs, which are broken and bent around the *stipes* and tied down to it. It is the legs, above all, which lend an abstract, geometrical quality to the arrangements; each figure is a mutilated zigzag and, but for the symbolic craning of necks, one up, one down, a rough stereoisomerism unites the two figures. Visually the twisting of their bodies, fused to the apparatus, retains a sense of dynamism which suggests life not yet extinguished, as if the two men were still straining against the agonizing immobility of their own shattered bodies.

Broken, dislocated, twisted, bent and levered around the beams of the cross, held down with tight ligatures – the limbs of the Thieves are forced to obey the dictates of the painter, who in turn seeks to convince us, with all the skill available to him, of the anatomical plausibility of these gruesome punitive contortions. To do so, the painter hints broadly at the infliction of a procedure in which the limbs in question must *first* be broken, or dislocated, in order for them to be twisted and affixed in this manner. As visual description, this in itself recalls the procedure of 'the wheel' (*das Rad*), in which the body is laid out on the ground, broken limb by limb with a large cartwheel and then 'braided' through the spokes of another wheel (see Chapter 5). Also evocative of this procedure is something we see in numerous other examples: the painter has extended the biblical assault on the victims' legs to include the arms as well, which bleed profusely from savage wounds. Because they are exposed to view, the arms of the Bad Thief (to Christ's right in the Bohemian panel) are where the painter makes explicit the penal function of the fracture that appears precisely mid-way along the axis of the bone: it becomes a fulcrum for pivoting the arm around the *patibulum* and behind the back. Likewise, the left leg of the Good Thief is fractured right where it crosses over the *stipes*, and the resulting dislocation allows us to see the foot from the *bottom* instead of in profile (see illus. 7). The same determination to entwine the broken body around the cross is manifest in a panel made between 1450 and 1455 for the high altar of the Reglerkirche in Erfurt, and now in Karlsruhe

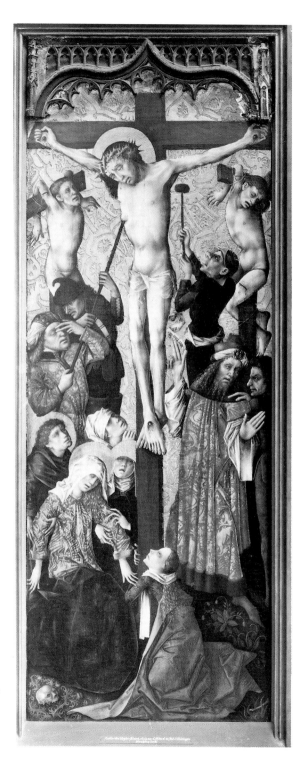

52 The Master of
the Regler Altar,
Crucifixion, *c.* 1450–55,
painted pine panel,
159.5 × 58 cm.
Staatliche Kunsthalle,
Karlsruhe.

(illus. 52).[24] Here it is the Bad Thief only who is pretzeled around the cross; slender gashes, surrounded by blue-purple contusions, appear on the thigh and the upper arms.

In south German and Austrian painting of the fifteenth century – both regions strongly influenced by Bohemia and cross-fertilized with one another – dramatic changes in the positional and gestural dynamics of 'crucifixion' produced even more stunning simulations of the wheel's fusion of body and apparatus. A number of works from this region are discussed in Chapter 5, but for the moment we can confine ourselves to one. In the Baroque Church of Our Lady in Munich (the Frauenkirche) hangs the central panel of what was once a larger, fifteenth-century Passion altarpiece, whose eponymous maker is known as the Master of the Munich Domkreuzigung (illus. 43).[25] Certainly one of the most accomplished representatives of the painters' guild in Munich, he capitalized on the stylistic advances of his (probably older) contemporary, the Master of Benediktbeuren (see illus. 15). From behind we see the body of the Bad Thief crunched forwards over the *patibulum* and therefore turned as if banished from the company of the living. Improvising, it seems, the artist has modified both the hooked-arm pose, in which the *patibulum* normally presses against the back or shoulder-blades, and what I call the arched-back pose, in which the figure bends backwards over the top of the cross (the latter is also discussed in Chapter 5).[26] Other visible signs of the condemned man's infamy, especially the leprous sores which pockmark the body, give validation to the painter's decision to subject the figure to the harshest tortures imaginable. In every detail the Munich painter's figure supersedes the Gospel account, producing a surplus disfigurement that obviates any textual reference. Instead, the painter transposes the familiar technique of 'braiding' the broken body around and through the spokes of the wheel upon the 'crucified' Thief.

Conclusion

The two art historians who have written substantively about the relationships between art and punishment, Samuel Edgerton Jr, in *Pictures and Punishment*, and Lionello Puppi in *Torment in Art*, both recognized the similarity between certain images of the Thieves, broken on their crosses, in varying states of dislocation, and the grisly outcome of the medieval torture of 'the wheel'. And it is significant that, as scholars of Italian art, their responses were provoked exclusively by the works of *northern* European painters, not their Italian counterparts.[27] I point out their agreement less as a way of logging a historiographic footnote, or

to acknowledge the scholarly debt that it is, than to underscore the temporal and regional parameters of our theme: a specific mode of aesthetic and imaginative assimilation of spectacle and the spectacular, to pictures and the pictorial.

In the 'hot-house atmosphere' of Bohemian painting,[28] as well as in Austrian and south German art in general, for about a century and a half, painters connected the Thief's hideous abjection on the cross to that of the condemned criminal broken on the wheel (illus. 44). But they did so, as I've stressed, in a manner that forces us to rethink the language we use to analyse that connection. To say that the imagery of the Thieves' punishment 'derives from', 'refers to' or 'recalls' contemporary procedures like the wheel is not only simplistic; it leaves us bereft of an understanding of how such derivations, references and recollections affected beholders. What made this imagery so compelling for medieval viewers was precisely the way it *served* the workings of the imagination: its realism stimulated the viewer's own powers of visualization without supplanting them, and therefore presented itself as a model for the viewer's synthetic assimilation of past to present, sacred history to familiar reality. It succeeded as realist religious art not when it finally approximated itself to an optical reality against which the viewer might then in turn test it, but rather when it insinuated itself into the beholder's perceptual frames as a model upon which pious imagination-work could be patterned.

Up until now I have taken it for granted that the spectacle of punishment, and in particular the *sight* of the body-in-pain, held a special place in the perceptual world of medieval people, that it had the power to focus the gaze and compel fascination in a way few other sights could. But to account for this fully we need to understand the conditions under which pain became spectacle, and that means a more detailed description of the late medieval paradigm of punitive justice.

4 Pain and Spectacle: Rituals of Punishment in Late Medieval Europe

Now reflect and suffer patiently
The punishments you justly have deserved.
Be like the thief who died on the cross,
And who came to heaven by true repentance.
Love beckons you, and mercy takes you,
O now end the last circle of life
Now, that heaven and time still favour you.
See, the bloody judgement is executed now.
Ye idlers! who steal the fruits of hope,
From God, the world, the days and yourself,
See this blood, understand its teachings:
Learn to fear and venerate justice.
Moral sermon for the execution of a thief in Munich, 1771[1]

Popular fascination with the fate of criminals executed by the state has been a persistent feature in the history of capital punishment in the West, though the cultural logic of this fascination changes from era to era. In the clichéd macabre of the verses above, penned in the late eighteenth century and sold on the street in the form of cheap, printed broadsheets, we can perhaps recognize a precursor to our own unending appetite for pre-packaged horror: juicy morsels of transgression, crime, confession and punishment concealing brittle pits of morality, consumed in the safety of theatres and bedrooms. Then as now, the moralizing sermon pulls no punches in issuing its timeless warning: *memento mori*, remember death. 'Untiringly connecting death and crime, sin and punishment,' writes Jean Delumeau, the moralizing sermon 'seems confirmed by facts, and this confirmation feeds and thus fills it with a stronger force. It speaks of fear to people who are afraid and, finally, it speaks their own fear.'[2] As the heirs to a distinctly Western 'guilt-culture' forged in the Middle Ages, it is no wonder that the symptoms of our individual death anxieties appear as a kind of social bulimia whose pleasure, and irritant, is the contemporary folklore of crime and punishment.

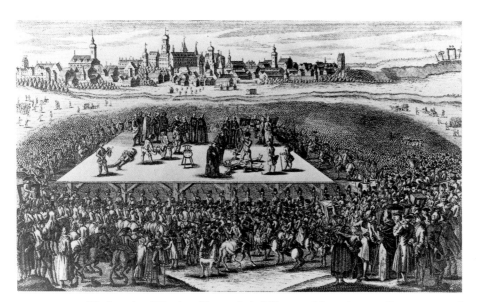

53 *The Execution of Matthaus Klostermaier in Dillingen on 6 September 1771*, German, engraved broadsheet. Mittelalterliches Kriminalmuseum, Rothenburg ob der Tauber.

That, anyway, is a view from the present. Looked at from the other side of the historical divide, from the Middle Ages, the eighteenth-century 'moral speech' (*Moralrede*) over the death of a thief speaks to a drawn-out process of decline and transformation, one which ultimately brought to a close the long era of justice done before the public gaze. When moral speeches and 'farewell songs' (*Abschiedslieder*) came into their own as a form of 'execution literature', complemented by a robust, comic-strip imagery of crime and punishment, crowds at executions had already begun accommodating themselves to the various forms of mediation mandated by the security needs of the state. A reconfiguration of the spatial relations between actors and audience, like the stepped-up presence of armed militias, distanced spectators physically from the scaffold and thus psychologically from the humanity of the suffering convict (illus. 53). New mediations such as these were instruments for social and political control in the hands of absolutist regimes. They corresponded to a strong determination, on the part of authorities, to repress the religious and para-religious (i.e. magical) elements of public punishments, elements that often elicited a troubling sympathy for the condemned and posed a threat to public order. One anonymous pamphleteer in the eighteenth century, imbued with the latest thinking, complained:

The ultimate purpose of public punishment is largely frustrated if the malefactor dies in circumstances that arouse a kind of admiration and respect

. . . An infanticidal woman clothed and adorned purely in white, going joyfully to her spiritual wedding accompanied by the preacher, is a very dangerous sight for other people in the conduct of their daily life. And a murderer going to his death accompanied by sighs, prayers, and admonitions of the preacher, and by singing of inspiring funeral hymns, often has the deleterious effect of causing weak and melancholy natures to desire for themselves a form of extinction which, as they think, allows them to meet their end more peacefully, indeed, more joyfully, than on their death-bed after a long illness.[3]

Collective emotional response in the penal theatre, which as we will see was so integral to the medieval ceremonies of death, thus came under attack as antithetical to the rational purpose of public punishment, which was the maintenance of law and order through public education (and only incidentally the elimination of the offender). Although its juridical roots are older, the concept of 'deterrence' became the jewel in the crown of utilitarian theories of punishment and the bedrock of absolutist state penal policy. As another pamphleteer wrote: 'Terror and repugnance, in accordance with the purposes of criminal justice, are the only emotions which the sight of a malefactor being led to the bloody scaffold should arouse in the spectator's heart.'[4] All of the religious and magical elements that enlightened monarchs like Prussia's Frederick II wished to expunge from the ceremonies of death were of late medieval provenance.

Much of the present chapter is concerned with what I take to be one of the defining features of this Christianized, late medieval 'paradigm' of punitive justice, namely, a distinctive mode of *judicial spectatorship*, fretted with the visual habits and devotional attitudes unique to this period. When late medieval spectators focused a rapt eye upon the pain-stricken body of the 'poor sinner under sentence of death' (*Armesünder*), what exactly did they see? What moral and religious attitudes to the suffering of the condemned man or woman informed their perception of the body's sign language of pain? What perceptual possibilities, and what devotional opportunities, did the body-in-pain present to spectators? What other visual cues or symbols were aimed at spectators in the dramaturgical elaboration of the death ceremony? Who controlled the deployment of that symbolism? These questions form a bridge to the art-historical questions with which this book is also concerned. Once addressed, not only will we be in a better position to think about the 'penal imagination' underlying the iconography of the Passion in late medieval art and responses to it. We will also be addressing, simultaneously as it were, the converse question: how and to what extent did experiences with the imagery of martyrdom and its archetype, the Crucifixion, condition response at the scaffold? What

was, in short, the lived connection between art and spectacle that made it so important for each kingdom of *imagery* to reflect the other?

Unlike most histories of punishment, then, my condensed account is weighted towards issues of audience participation in, and response to, the rituals and spectacle of punishment. On one level this serves as a social and cultural 'context' for the penal iconography of the Two Thieves; but my intention is to go beyond the cause and effect juxtapositions of (social) 'context' and (visual) 'text' in order to explore a reciprocal logic, embedded in medieval visuality, that made art and spectacle dialectical halves of the same experiential mode. We can usefully characterize this logic of response, borrowing a term from Hans Robert Jauss, as a 'horizon of expectations', and extend our litany of questions. How did a distinctly late medieval horizon of expectations raise compassion for the suffering martyr-criminal nearly to the status of a cultic obligation? What beliefs and perceptions transformed the blood of ordinary thieves into a quasi-sacramental substance with the power to heal? What attitudes allowed the reeking scaffold to become a surrogate altar and a place of veneration? To grasp the logic of the whole we must trace a continuum through and between spheres of life that modernity has proclaimed separate: religious devotion, public spectacle, punitive justice and art (to use our modern terms). A common denominator for them all is a preoccupation with the pain of the body, its powers, opportunities and dangers.

Law, jurisprudence and criminal justice

A good starting point for understanding late medieval law is historian Esther Cohen's characterization of it as 'a cultural crossroads, an intersection of perceptual trends'. Far from being a discreet, professional field of knowledge and practice as it is today, jurisprudence in the late Middle Ages gathered into itself philosophy, theology, numerous sciences and pseudo-sciences (anatomy, zoology, astrology), literature and folklore.[5] Medieval doctors of law, like their theological counterparts, devoted themselves to synthesizing two separate, and often contradictory, modes of thought; in their case these were customary law and Roman law (the latter transmitted in the famous code of the Byzantine emperor Justinian). Customary law was practical law; it derived its authority 'from long, consistent usage'.[6] Until the eleventh century, customary jurists had only limited need of Roman law, but by the century's end the situation was changing rapidly. A movement launched by the reforming pope Gregory VII, designed to assert papal political and legal supremacy over the entire Church and to check

secular control over clerical appointments (the Investiture Controversy), not only spurred the Church to develop its own legal system but also led Europe's monarchs in turn to a historic realization: that the maintenance of royal prerogatives over local affairs would henceforth require a wider and tighter grip over legal jurisdictions. Customary law was sadly inadequate for the task, so hand in hand with the process of state-building went the consolidation of legal institutions. 'Each of the peoples of Europe,' explains Harold Berman, 'had its own rather complex legal *order*. But none had a legal *system*, in the sense of a consciously articulated and systematized structure of legal institutions clearly differentiated from other social institutions and cultivated by a corps of persons specially trained for that task.'[7] New legal systems were developed first for the Church (canon law) and then for secular political orders – often in competition with the former. Thus canon law, royal law, feudal and manorial law, and eventually mercantile law and urban law all evolved their own courts, their own bodies of legislation, their own class of professional jurists, their own 'scientific' legal literature and curricula in the universities (schools of neo-Roman law were founded at Ravenna, Bologna and Pavia).

In England, France and the Italian states, the twelfth century witnessed a rapid transformation of legal structures. Not so in Germany and the Netherlands, where 'a bewildering profusion of overlapping customary law jurisdictions prevailed'.[8] From Pope Gregory to the Reformation, German jurists vascillated between a tenacious preservation of Germanic folk-law and a grudging admission of neo-Roman law.[9] Even after Roman law was formally introduced into Germany with the institution of an Imperial Court of Justice (*Reichskammergericht*) by the emperor Maximilian I in 1495, urban communities and other political entities continued to write their own codes (*Gerichtsordnung*). The electoral state of Brandenburg, for instance, printed its own law codes in 1516, about one year after the politically ambitious Albrecht of Brandenburg obtained his third and most powerful ecclesiastical office, the archbishopric of Mainz (illus. 54).[10] For illustrations the printer employed woodcuts previously designed by Wolfgang Katzheimer for the well-known Bamberg ordinances, published several years earlier (see illus. 63). The multiplicity of laws in Germany continued into the sixteenth century. Even the Holy Roman Emperor Charles V's code, promulgated at the diet of Ratisbon in 1532 and known as the *Constitutio Criminalis Carolina*, did not succeed in establishing a single criminal law code throughout the land.[11]

Despite the multiplicity of sources, theories and overlapping jurisdictions, a relatively straightforward conception of secular – particularly

54 Wolfgang Katzheimer, Instruments of torture, woodcut on the title page of *Brandenburgische Halsgerichtordnung* (Nuremberg: Jobst Gutknecht, 1516). Mittelalterliches Kriminalmuseum, Rothenburg ob der Tauber.

royal – justice prevailed, enjoying a consensus among both élites and the popular classes. Cohen gives its basic axioms:

Just kings dispensed justice to all, regardless of status. Their justice derived from a law which was ancient, customary and good. The belief that the king was the guardian of the good old law, and therein lay his justice, was shared by jurists and story-tellers, theologians and simple folk alike.[12]

Furthermore, since jurisdiction (the authority to conduct trials and punish criminals) and territorial rule were closely interconnected, 'Justice was synonymous with political lordship, and doing justice meant putting to death.'[13] Not surprisingly, 'justice' serves as the basis for words for 'execution' in several European languages: *faire justice* or *justicier* in French, *Hinrichtung* in German, *giustiziare* in Italian.[14]

Criminal-justice proceedings occupied four interrelated ritual spheres: the court itself, the place outside the courthouse or town-hall, the processional route to the site(s) of execution and the execution grounds. Together these sites and routes comprised an entire topography of the city, which authorities often exploited for symbolic purposes. Unfolding across these urban spaces was a sequence of rituals that concentrated popular participation in distinct ways that

corresponded to a historic shift from one legal paradigm to another. A few words about this paradigm shift are therefore needed. Before the late Middle Ages an *accusatorial* system of criminal process predominated, in which judges had to rely on the accusations of injured parties before they could try a case; most trials were held in open-air courts and were very public occasions.[15] Under this system the trial, pronouncement of sentence and the execution 'formed a unity', according to Richard van Dülmen.[16] Older methods for determining guilt or innocence, such as the swearing of oaths (compurgation), the ordeal and the judicial duel, all of which conveyed the immanence of justice in God's will, took place in full view of crowds gathered for the purpose.

But with the advent of an *inquisitorial* criminal process in the course of the twelfth century, which gradually empowered courts to initiate investigations, make accusations, denunciations and arrests, judicial inquiries (including the use of torture) and deliberations were now conducted behind closed doors.[17] Community participation here was denied, and as a result refocused on the two rituals that could be comprehensively stage-managed by authorities: sentencing and execution. Sentencing was the criminal's last day in court and attracted a great deal of attention; where capital crimes were concerned, the appeal was even greater and so, as a result, 'authorities everywhere put great stress on a manifest and impressive pronouncement of sentence'.[18] A list of offences was read, the confession was repeated and the sentence issued, usually with the convict present. Artists drew freely upon the spectacle of sentencing, from the presence of crowds to the scenography of the town hall and its adjoining urban spaces, especially when visualizing the Passion episode of the *Ecce Homo* ('Behold the man').[19] A boisterous rendition, painted *c.* 1505–6 by a local master for the cathedral in Braunschweig, and now in that city's museum, shows Pilate presenting the captive Christ to a mob of jeering and cursing Jews (illus. 55). Beneath the parapet the Two Thieves and Barrabas (identified by inscriptions on the pavement) are shown displayed in irons, a realistic (though rare) motif which augments the punitive vocabulary of the image.[20] What was, in standard political practice, a rather solemn affair, has been rescripted here to produce something more akin to a popular ritual of degradation; the painter's apparent desire to convey the murderous hysteria of the Jews overrides his sense of judicial realism, but not by very much.

Because the community did not participate in the trial itself, the sentencing ritual was critical to the people's understanding of the crime, its circumstances, the evidence and the determination of guilt. Courts recognized that 'the indirect assent of the people lent legal

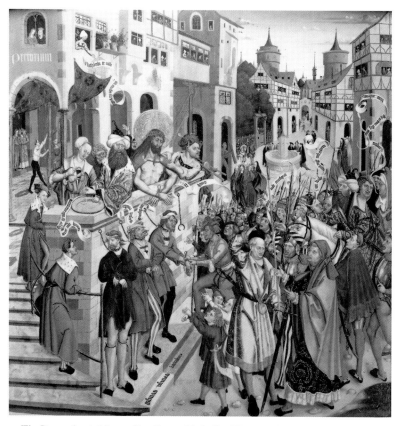

55 The Braunschweig Master, *Ecce Homo with the Two Thieves and Barrabas*, *c.* 1505–6, central panel of the altar from Braunschweig Cathedral, oil and tempera on oak panel, 174 × 174 cm. Herzog-Anton-Ulrich-Museum, Braunschweig.

validity to a sentence without which a public execution would have been problematic'.[21] Popular ratification of the sentence appears as the last sanctioned vestige of communal justice, which by the fifteenth century had been pushed aside in favour of efficient, professional trial proceedings. Ultimately the same trend began to erode communal participation in all pre-execution ceremonies; and the people's role became concentrated in the ceremony of death itself – so much so that we can speak of a division of communicative action between the three groups involved in justice rituals:

The messages of authority were conveyed largely during the pre-execution ceremonies, *amendes honorables* [public repentance] and processions. The role of the church was enacted at the foot of the gallows, and after that the popular tradition took over . . . Yet even within these demarcated spheres there was an interpenetration of usages . . . [For] executions were in essence one ceremony, different elements welded together by an interactive use of symbols.[22]

Shortly we will return to the central role of the community, where we will see how the forms of spectatorship they collectively enacted went as much beyond passive witnessing as the clergy's participation in executions went beyond rote sanctification. But first we must address the medieval view of the purpose of punishment, which turns out to be as multiple and mutable as the penalties deployed in the course of justice's performance.

Authors of medieval customaries, or books of common law, generally took it for granted that the provincial authorities who used them would grasp the rationales of criminal prosecution, and even specific capital sanctions, so there is a notable dearth of commentary on these subjects. One exception comes from Anjou, the *Coustumez, usaigez et stillez . . . ou pais d'Anjou*, written *c.* 1440. Its author enumerates the purposes of punishment as follows: to pay retribution upon the malefactor, to serve as a deterrent and warning to future transgressors, to eradicate evil from society, and to prevent future evil from afflicting it.[23] Which purposes were paramount in the minds of jurists, authorities, clergy and the people respectively?

Elemental to 'the punishment response' of practically every society that institutes criminal sanctions is retribution, a nice legalistic word meaning revenge.[24] Traditionally revenge has functioned to express outrage at transgressions, balance the tipped scales of justice, and restore personal and family honour. Old Germanic law codes (*leges barbarorum*), heavily preoccupied with honour, left plenty of room for revenge, although they also offered means to adjudicate disputes, including the use of monetary compensations. This prerogative of free, land-owning men (*liberales*), who were also men of arms, to exact retribution on those who wronged them or their kin was also a touchstone of feudal justice. As one Anglo-Saxon law code put it, the injured party could either 'buy off the spear or bear it'.[25] Up to the high Middle Ages, retribution could alone justify the use of deadly force against enemies and law breakers. But the consolidation of jurisdictions, so critical to the process of state formation, meant that the right of private vengeance, and with it private violence in general, had to be repressed. Increasingly, Europe's monarchs sought 'to impress upon their subjects, by whittling away, or even abolishing, the ancient rights of the relatives to compensation, that the State, and not the individual, was responsible for punishing the law breaker'. This was not easily accomplished; as Andrew McCall rightly remarks, 'the atavistic conviction that a personal injury should in fact be personally avenged would die hard'.[26] It can be argued that it never died at all, but was only monopolized by

the state and thus repressed elsewhere in the social body. In absolutist political theory transgressions against the sovereign's laws basically amounted to personal attacks upon the body of the sovereign himself, and only the most exquisite cruelties could avenge it. 'In every offence,' writes Michel Foucault, 'there was a *crimen majestatis* and in the least criminal a potential regicide.'[27]

We have already spoken of the deterrence effect behind executions, so less elaboration is needed here. What should be noted is how the rationale of deterrence overlaps with the imperative to prevent future crime: obviously, since authorities foreclose on the culprit's potential for future malfeasance by killing him or her, deterrent displays are inherently audience-directed. Authorities considered carefully what kind of impact the execution of certain people – at certain times, for certain crimes – would make, and footed sizeable bills to have special scaffolds erected and to pay the executioner handsomely (he earned different fees for different forms of killing).[28] The very idea of punishments enacted as a form of spectacle is predicated on the belief in their educative potential, though the 'lessons of the scaffold', as they were later known to the moralists who exploited them, could run the gamut from cautionary tales, through brutalizing threats of violent retribution, to *exempla* of damnation.

Finally, at a most basic level, we find in medieval penal rationality the desire to eliminate the criminal and, with him or her, the memory of the deed. Historians of punishment are still uncertain whether medieval jurists and judges sought for the eradication of the criminal or only of the evil deed. At first this seems a crucial distinction.[29] When, in 1474, the Bishop of Lausanne sentenced a pig to be hanged 'until death ensueth' for the murder of an infant, and ordered him to be left suspended as a warning to would-be (presumably porcine) offenders;[30] when objects like swords or cooking pots that fell from their shelves and caused damage or injury were tried for the offences;[31] or when authorities cut off the hand of a thief, or the lips of a blasphemer – were they not, in all such cases, giving tacit acknowledgement that within every evil deed there lurked, so to speak, a demon of ill-intention that must suffer extermination? Yet other, equally bizarre practices may suggest the opposite, that it is not the deed but the person of the criminal that justice pursues, even beyond death: in 1499 the executioner of Evreux was commissioned to take down the body of a suicide who had hanged herself – in order to rehang her![32]

None of these is an isolated incident. Together they suggest that neither the criminal nor the deed was regarded as a mutually exclusive target. Almost all of the aggravated penalties in the medieval repertoire,

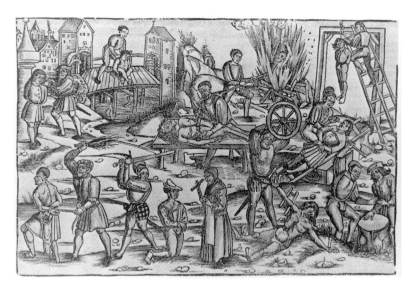

56 Various forms of capital punishment, woodcut from Ulrich Tengler, *Layenspiegel* (Augsburg: Hans Otmar, 150?). Mittelalterliches Kriminalmuseum, Rothenburg ob der Tauber.

catalogued in the woodcut made for Ulrich Tengler's law code *Der Layenspiegel*, the first published in Germany in the vernacular (illus. 56),[33] conclude with the total dissolution of the body. They thus satisfy the desire to see both deed and doer perish absolutely: burning (which was often followed by grinding the bones to powder, burying them underneath the gallows or casting them into a river), burying alive (a speciality of the sixteenth century which also abandoned the body to elemental processes), hanging and breaking with the wheel (both of which normally entailed long-term exposure until the body decomposed). Even aggravated techniques that are driven by human agency rather than elemental forces, such as disembowelling and quartering, accelerate the body's disintegration and leave natural processes to do the rest, so that, in the words of one sentencing formula, 'the memory of this shameful deed may for ever be eradicated' and 'so that the wrath of God and His punishment may be averted from the town and the land'.[34] Undoubtedly, many such attitudes towards the destruction of the criminal's body are rooted in popular beliefs, notably the widespread fears – shared by popular culture and élites – of the malevolent dead returning to terrorize the living (*revenant* in French, *Nachzehrer* in German).[35] The execution of exhumed corpses, decapitation and various forms of dismemberment, elaborate forms of body disposal, even breaking with the wheel, can all be seen as efforts to prevent the post-mortem reanimation of those most likely to torment the living:

suicides, malicious criminals, drunks, accident victims – in short, those who had died poorly or suddenly, without preparation.

Yet, just as certainly, measures such as quartering the body for display at the city's cardinal points, as was done in medieval Paris, had political significance as well. If older beliefs about death, the body and its potentialities coalesced around the rituals of punishment, they were ripe for exploitation by authorities eager to make a point about the law. That late medieval law found ways to accommodate such beliefs attests first to the extent to which they were shared by élites and the popular classes, and second to the absorptive nature of late medieval law. That the enlightened eighteenth century struggled so hard to banish them from sight attests not only to the subsequent disenfranchisement of popular culture by élites but also to the inertia of these beliefs in mental structures over the *longue durée:*

Before the execution of a malefactor it must be announced publicly at the place of execution that if one or more mischances occur during the execution, such as an ill-aimed blow, a broken rope, etc., no one shall dare, on the pain of body, belongings and death, to attack the executioner, his assistants, the condemned person or the members of the court, much less instigate a commotion about it. Therefore . . . We wish by this Our order to abolish all the improper customs the rabble believes in: namely, that if after a sword's third blow the person to be executed is still alive, or if the rope breaks, or if a female subject desires to take the convicted person in marriage, or whatever other delusions the people labour under, the convicted person is to be spared the punishment. Instead We command that the death sentence, once it is pronounced, has to be executed upon the malefactor regardless of any such matters.[36]

Every one of the 'delusions' anathematized here comprised an integral part of the popular vocabulary of justice in the late Middle Ages.

Rituals of punitive justice were ostensibly centred on the fate of the 'poor sinner under sentence of death'. A closer look, however, reveals that the body and soul of this person, his or her humanity, became a kind of projection screen, a locus of negotiation and even struggle between the three main groups involved in executions: secular authorities, the people and the Church. Each group expected the ritual of punishment to transmit a narrative of its own aspirations both to itself and to the others; and these narratives often vied for supremacy in the dramaturgy of the state executions. Late medieval spectacles of punishment, more so than in any era before or after, placed rival narratives in such a dynamic confrontation that their outcomes were never quite certain.

Before the execution ever took place, spectators were presented with an array of symbols communicating vital information about the criminal and his or her deeds.[37] We've already spoken of the sentencing ritual. In Germany the formal handing over of the convict to the executioner was also treated as spectacle: while repeating the sentence of death, the officiating judge or town clerk would hold up a wand of office, coloured white, red or black (depending on local tradition), break it with great aplomb, cast the bits down at the convict's feet and announce the condemned's now broken bond with humanity. This signal 'marked the moment of civil death for the prisoner' and made his or her social expulsion a *fait accompli*.[38] After sentencing a bell might toll, and then continue until the moment of death.[39] Clothing conveyed the convict's status at a glance: nobles might wear their livery, while infamous characters were often stripped to the waist (thus were the Two Thieves readily identified as infamous, and distinguished from the Sacred Criminal, as they shuffled off to Calvary in many scenes of the *Bearing of the Cross*).

Much else could be inferred about the crime, its aggravating or mitigating circumstances, by the manner in which the condemned was processed to the execution grounds. Noblemen might ride a cart or even be permitted to ride on horseback and thus project a chivalric image. In a deliberate inversion of this privilege, criminals with aggravated sentences would ride in a wooden cart (sometimes backwards); often the ride entailed preliminary tortures like the crude tearing away of flesh with red-hot pincers (see illus. 86). Common criminals walked mostly, but sometimes even this dignity might be withdrawn in favour of wrapping the person in an oxhide – fresh, bloody and stinking – and then dragging him, immobilized, to the gallows. The route of the procession itself could be replete with symbolism, a contemporary *via crucis* for judicial martyrs. Often a path was traced from the courthouse to the scene of the crime, and then out of town, through the city gate to the gallows (see illus. 63). Sometimes a main thoroughfare was used; in fifteenth-century Paris processions could be choreographed as a defamatory reversal of the path used by royals in their spectacular entries.[40] Thus the most prescient signs of the malefactor's fate on display were those transmitted by the body, even prior to pain. Posing and processing the criminal backwards through familiar urban spaces, immobilizing him with ropes, irons or an oxhide, dragging him supine along the ground or tied to a hurdle – all of these displacements of the body from its normal upright position were more than defamatory gestures or added pains, because they essentially animalized the culprit.[41] Such body images, presented during the procession, mediated for the

spectators the dehumanization process begun at the courthouse and concluded at the scaffold: the expulsion of the criminal from the community of the living.

Late medieval processions were surely not quite as solemn and orderly as their eighteenth-century counterparts (regulations in some German cities laid down a precise marching sequence for every member and group of the urban community), but neither were they as carnivalesque as some writers have supposed.[42] Allowing for variations from country to country, processions were for the most part carefully orchestrated, symbolically rich rites of passage in which the community played a crucial mediating role between authorities, the executioner and the condemned.

Turning now to the symbolics of judicial killing, and surveying the dizzying landscape of punitive techniques used during the late Middle Ages, we find ourselves confronted by patterns of ritual action that are obviously meaningful but remain, nevertheless, obscure. What did jurists intend, and what did audiences intuitively grasp, in the traditional sentencing formula for hanging from southern Germany and Switzerland?

This poor man shall be hanged on the high gallows by a new rope between heaven and earth, so high, that his head shall almost touch the gallows and beneath him the leaves and grass may grow. Here he shall be strangled to death by the rope so that he will die of it and be undone and his body shall remain on the gallows so that it shall be given over to the birds in the air and taken away from the earth so that furthermore neither persons nor property may be damaged by this man and others shall witness his punishment as a fright and a warning.[43]

An unused rope, the body suspended in measured relation to earth, sky, and the apparatus, exposure to the air, wind, carrion birds – what is the symbolic logic behind these specifications, and what can it tell us about the perceptual crossroads of law and belief?

A commonplace about medieval criminal law (if not all 'primitive' forms of justice) is that behind it stood a strong conviction that the penalty should mirror the crime it avenges. Then as today, appeals to the ancient authority of the *lex talionis* – punishment in kind, or 'an eye for an eye' – were an attempt to square the need for retribution with the principle of equivalence, and in this way use the penalty to illuminate the immanence of justice.[44] This is immediately perceptible in corporal punishments involving mutilation: first-time thieves might have their hands cut off, blasphemers their lips and so on. Philippe de Beaumanoir, author of a customary for the city of Beauvais, explained that 'certain crimes should be punished by different deaths, just as the

types of crime committed by criminals are in different manners', and most late medieval jurists concurred.[45] Often this resulted in an accumulation of punishments that is difficult to disentangle, but some cases reveal the logic of a rigorous system of correspondences quite clearly: for example, when the Norman arch criminal Denis Lochecome was sentenced in 1441, he was 'to be drawn as a murderer, decapitated as a traitor, quartered for various other crimes and the body hanged as an armed robber'.[46] Throughout most of Europe and across the better part of a millennium, hanging was the punishment of thieves; breaking with the wheel was inflicted on murderers, rapists and those who committed aggravated theft; arsonists, like heretics, witches and sodomites, were burned; women charged with offences against religion or morality, such as adultery or infanticide, were drowned; and decapitation was used for a wide range of offences, including manslaughter, robbery, incest, infanticide or major fraud.[47] Extraordinarily horrific torture-executions, some of which were planned to last many hours, were reserved for arch criminals, those convicted of *lèse-majesté*, regicide or the attempted assassination of a sovereign. Parricides in medieval Germany were tied up in a large cloth sack together with a cock, a serpent, a monkey and a dog, each of which symbolized a specific aspect of the offender's grotesque act.

But what does this remarkably consistent, widespread and long-surviving system of correspondences tell us about the symbolic logic of individual penalties? The answer: not much. In the case of penalties whose symbolism was geared towards defamation, jurists clearly had specific meanings in mind, for example, when the fourteenth-century commentator on the *Sachsenspiegel*, Johann von Buch, laid out the symbolic significance of each animal used in 'the sack' to punish parricides.[48] Scholars often suppose that specific forms of the death penalty survived so long because they were grounded in local customs and traditions, to wit, embedded in collective memory. 'Modes of execution could not be changed without impairing their very usefulness as tools of communication between rulers and ruled. The ritual was worthless unless people knew and understood its symbolism.'[49] But despite the scholarly consensus that symbolic vocabularies informed every detail of the judicial ritual, actual meanings remain obscure. What sense can then be made of the strange requirements expressed in the old hanging sentence quoted above? The criminologist Hans von Hentig, whose theories have coloured much post-war generalist research, makes of hanging a transmuted pagan sacrifice: the gallows is a 'sacred tree' and the hanged man a propitiatory offering to an ancient god of wind, whose 'acceptance of the sacrifice results in the gradual decomposition

of the polluted body'. Following this logic, Graeme Newman supposes that keeping the criminal's feet off the ground was a key concern, since the penalty eventually 'thrusts him into the gulf between heaven and earth', and leaves him 'to swing in the wind – to be cleaned by the elements of nature'.[50]

Is this a path towards understanding the character of late medieval penality? Unfortunately, the silence of the medieval jurists on symbolic questions has licensed, in our own time, a whole genre of 'old punishment' studies, laced with ersatz anthropology and mired in incestuous scholarship.[51] Critical historians today, however, express doubts about the validity of the approach initiated by the German school of *Volkskunde*, which seeks for the roots of medieval procedures in the sacrificial rites of the pagan Germanic peoples of Europe, and thus sees a latent sacredness, if not a vestigial form of deity propitiation, in every state-imposed death sentence. Recently, Richard Evans has exposed the ideological connections between *Volkskunde*, German nationalism and racist theories of how early punishment served, in Bernhard Rehfeldt's words, 'the eradication of the degenerate and thus the maintenance of the purity of the race'.[52] Evans points out that 'virtually all of his [Karl von Amira's] readings of the symbolic meanings of executions were purely inferential': he never delivered positive proof that any Germanic tribes actually sacrificed criminals to their gods.[53] Moreover, because whatever may have been originally pagan about these punitive rituals and their requirements had, in the later Middle Ages, already been supplanted by Christian meanings, such theories are of antiquarian rather than critical-historical interest. They obscure more than they explain.

Without denying the traditional and folkloric elements in medieval law, we can take a different tack, one which both emphasizes the function of penality in structuring social relationships and is better substantiated by the evidence. Medieval jurisprudence made considerable allowances for the social status of criminals, and consistently distinguished between honourable and disgraceful means of death. The penalties perceived by both élites and popular culture as disgraceful included hanging, breaking with the wheel, burning and every variety of dismemberment. In contrast, decapitation by sword epitomized the honourable death; unlike its vulgar opposites, it brought no stain of infamy on either the condemned or, just as important, his or her family. Petitions for clemency in capital cases very often consisted simply of an attempt to sway judges to commute a dishonouring sentence to decapitation.[54] The difference, however, lay only partly in the degree of agony or cruelty involved (though this could never have

been far from anyone's mind). Equally fearsome as excessive pain was the prospect of a punishment that kept the body immobile; vulgar penalties imposed on the victim the added ignominy of going to one's death bound and helpless. By contrast, decapitation with the sword meant that 'the condemned remained free and unbound, received the fatal stroke kneeling and thus upright, and had to show enough "honourable" self-control to remain still so that the executioner could deliver an accurate blow'.[55] Only decapitation provided the opportunity to die gloriously, courageously, fearlessly, as one dies in battle, which made it eminently suitable for both noblemen, for whom warfare was a birthright, and high-ranking patricians, for whom the appropriated aura and symbolism of warfare were cultural capital every bit as precious as its monetary counterpart.

Each mode of punishment, then, whatever its original sacrificial or cosmic symbolism, presented spectators with a powerful, precise image of the offender's place within a vast legal *ordo* which, in both learned and popular perception, encompassed every living thing in nature: insects, animals, humans of low rank, humans of high rank. And it made this impression not only by virtue of its peculiar bodily *Gestalt*, but also because of its situation in a constellation of ritual actions, words and images. Collective memory may well have preserved 'the relics of ancient beliefs . . . like fossils in the rock of usage',[56] but Christian attitudes towards the body, pain, death and justice had already transformed these vestigial beliefs into dynamic new ones that united authorities, the culprit and the people around a novel concern: the 'good death'.

The community and 'the good death'

A woodcut made for the treatise *Praxis Crimins*, printed in Paris in 1541, captures the combustible mood of the town square on a day of execution (illus. 57). Allowing for the possibility that the artist distorted the reality of the proceedings to create a simultaneous summary of penalties, he has, nevertheless, put all the social actors in their usual places, performing their typical roles. The judges and magistrates, their work now done, have withdrawn from the scene and taken up positions in first-floor windows. On the scaffold kneels a convict – identified as a person of rank by the slashed leggings that were fashionable military garb at the time – about to be decapitated, now taking a last look at the crucifix proffered by the attending friar. The headsman also wears slashed clothing (for different reasons)[57] and stands astride him, broadsword in hand. Closer to us another

57 Crowded town square on justice day (*Figura reorum plectendorum*), woodcut from Jean Milles de Souvigny (Millaeus), *Praxis Crimins* (Paris: Colinaeus, 1541), fol. 85.

executioner, not a headsman but probably only his assistant, drags a fear-struck culprit of obviously lesser rank up the ladder to the gibbet (see illus. 9). Spectators crowd in tight around the scaffold; one even shins up the platform's support to get a better look. With eyes fixed upon the actors, they wait for the decisive moment when the headsman either produces a 'master-stroke' or botches the job (the athletic skill of the executioner was always much at issue). In front of the scaffold a cart with another convict, attended by another priest, pushes its way through the crowd as a mounted herald or bailiff announces the crime and sentence. The rest is push and shove among the spectators, armed guards and mounted militia; immediately in the foreground a child, either terrified or nauseous, pushes his way out of the throng.

What did the spectators come to see? It has often been said that for ordinary people executions, though intended to be terrifying, actually offered an experience that was emotionally comforting: the reassurance that comes with seeing a bona fide sinner confess his crimes, show contrition, receive absolution, endure a painful ordeal and find redemption on the other side. If such an unfortunate wretch

can be thus saved, the reasoning goes, so can a sinner like me. Such feelings, where they existed, were undoubtedly grounded in distinctly Christian anxieties about one's own spiritual biography. Of all the popular perceptions to which authorities made the rituals of sentencing, procession and execution play, the desire to see a 'good death' was paramount. Except in cases where heinous criminals, outsiders and infamous characters of various stripes became the object of intense collective hatred (see below), the community insisted that the spectacle be edifying, not as a lesson in the majesty of the law but as a drama of Christian repentance, purification and salvation. When, in their own eyes, a community had 'paved the way to eternal life for a soul seemingly beyond redemption', the event may well have convinced spectators that redemption was possible for them as well.[58]

To make a good end, to die repentant, girded against vice, firm in the belief that one's soul would be vouchsafed in perpetuity by family, clergy, the Virgin or Christ himself – this was the ideal that overwhelmed lay religious life in the fourteenth and fifteenth centuries. With the triumph of the doctrine of purgatory, and a penitential system based on minutely calculated remissions of sins, older fears of a final judgement amidst apocalyptic chaos tended to be replaced by more immediate concerns with the individual's *hora mortis*, the hour of death, and the 'individual judgement' that followed. The drama of death 'no longer took place in the vast reaches of the beyond,' writes Philippe Ariès in *The Hour of Our Death*: 'It had come down to earth and was now enacted right in the bedroom of the sick person, around his bed.'[59] Deathbed rituals in the medieval city embroiled not only relatives and the clergymen who acted as advisers and confessors but also friends, public officials, even passers-by who might pause to involve themselves in the pre-mortem spectacles. But no amount of community involvement or clerical counsel could substitute for the dying person's own responsibility to atone for his or her sins as death neared.

To this end manuals of practical instruction in the techniques of dying well, known as the *Ars moriendi*, were penned by some of the most prominent religious authorities of the time; both Jean Gerson (1363–1429) and Johannes Geiler von Kaiserberg (1445–1510) handled the theme, though it was ultimately the treatise by Gerson, chancellor of the University of Paris, upon which the most popular booklet version was based. Illustrations suited the books to illiterate as well as literate audiences. A set of eleven engravings by the German Master E. S., made between 1450 and 1460, may have been the original designs for the better-known block-book woodcuts that filled numerous later

editions.[60] A spectacular commotion surrounds the deathbed in each of the scenes: from one to the next we witness a sequence of tenacious battles for the recumbent man's soul, enacted by demons and angels, sinners and saints; we thus share in what amounts to a series of private visions dramatizing the existential crossroads at which the dying man (*moriens*) finds himself on this very public of occasions. In the first image (illus. 58), while Christ, Mary and another saint look on, grotesque demons tempt the languishing man away from righteous behaviour and faith with visions of idolatry and what appears to be a heretical disputation. Three scenes later, as an antipode to yet another demonic exhibition of sins, the dying man is visited by the converted St Paul (struck down on the road to Damascus and blinded by a cosmic blast), St Peter (with his keys and cock), Mary Magdalene (with ointment jar) and the Penitent Thief, tied to his cross in the standard hooked-arm pose (illus. 59). All appear as exemplars and advocates of the 'perfect penance'. And as we progress through the book, their lessons and others pay off. We learn how to suffer with patience and to resist vainglory, worldly goods and things of the flesh, and in the final scene we are given a vision of such narrative precision as to belie the metaphor of the *hora mortis*: we see the moment of death itself (illus. 60). Holding a flickering taper in his hands, the dying man releases his soul into the custody of waiting angels, while at the foot of the bed demons bellow at the sight of their prize, Satan's 'legal right', being snatched away. Above them rises the crucified Christ, at once prototype of patient suffering and guarantor of salvation from sin. Like the angels he casts a gentle gaze upon the man 'crucified' by death and, by this loving gesture, models for the picture's audience the properly devotional attitude to take before the quasi-miraculous spectacle of the 'good death'.

By now it should be easy to see how the anxieties reflected in and constructed around the *Ars moriendi* flowed back and forth between the rituals of the deathbed and those of the scaffold. With such a perspective in place, it comes as no surprise that the very person who was soon to be carted off to have his bones smashed, his head sliced off, or be hanged from a gibbet, was routinely treated with the utmost dignity and respect. The entire community saw it as its responsibility to ensure that the poor sinner's conversion and repentance was complete and satisfying.[61] In part this had to do with the communal need for social and moral order; we know, for example, that the community co-operated to a considerable degree in the apprehension of offenders (this was desirable for property owners at a time when the judicial and police apparatus of the state was less effective).[62] But more than this, it was

 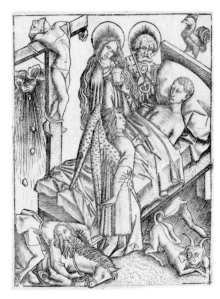

felt that the convict's opportunity for, and realization of, a 'good death' reflected well on the Christian values of the community and contributed to their upholding. Crime brought a taint of corruption and infamy upon the social body, and a proper execution held the potential to lift the miasma. In other words, the 'good death' of the offender, as Richard Evans explains in the case of murderers, 'purged the community of its blood-guilt and cancelled out the "bad death" – sudden, unprepared, and bereft of the opportunity to make peace with God and the world – of the malefactor's murdered victim'.[63] This was not achieved, as we may tend to think, simply by expelling the malefactor from the community absolutely, and banishing him or her from memory (as happened with the worst criminals). On the contrary, 'by being thus immolated as penitent and martyr, [the condemned man] achieved a posteriori his only means of social reintegration'.[64] Beyond this, a 'good death' inoculated the community from the threat of the vengeful returning dead: just as no one wanted to contemplate a sudden, unprepared death (*mors improvisa*) for themselves, the loose ends of the criminal's biography had to be tied tight, with everyone lending a hand.

To the reader imbued with 'medieval' images of a jeering mob dispensing popular justice or gloating with cruel satisfaction over the savage end of a hated criminal, my discussion in the preceding paragraphs may strike a discordant note. We are more comfortable hearing how, in the medieval 'theatre of cruelty', the vengeance of the people

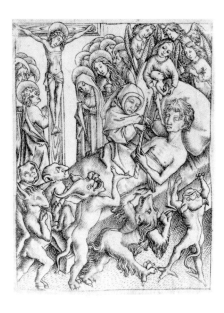

58 Master E. S., 'Temptation from Faith', engraving from the series *Ars moriendi*, 1450–60, 91 × 69 mm. Staatliche Museen zu Berlin – Preußischer Kulturbesitz (Kupferstichkabinett).

59 Master E. S., 'Good Inspiration', engraving from the series *Ars moriendi*, after 1460, approx. 91 × 69 mm. Ashmolean Museum, Oxford.

60 Master E. S., 'The Hour of Death', engraving from the series *Ars moriendi*, after 1460, approx. 91 × 69 mm. Ashmolean Museum, Oxford.

expressed itself towards the criminal; we find it easier to imagine medieval people taking an active role in settling scores with those who offended communal values; and we feel confirmed to know that often the worst punishment was exposure in the pillory, in which the criminal found himself at the mercy of a public encouraged by authorities to vent their anger by pelting him or her with rotten fruit, mud and dung.[65] All of these things certainly happened: criminals tainted with infamy, like the very wood used to build the gallows, were perceived as polluted, and they attracted the scorn and loathing of the population. Public sentiment could turn violently against a criminal who, in the course of the ceremonies, proved unremorseful, impenitent, uncooperative, questioned the sentence or cursed the judges: 'without the subjective consent of the culprit, a dignified execution was next to impossible',[66] and this led to hard feelings. A convict's refusal to play his or her allotted role might even be seen as a bad omen; it endangered everyone.

But, barring such unforeseen circumstances, popular sentiment sided with the condemned and urged him or her on to make a good repentance. Atonement rituals often included an *amende honorable*, or public acknowledgement of guilt, and a proclamation of repentance; although the ritual was designed mainly for citizens, culprits of all kinds were sentenced to perform it, and many did so upon the very ground where they committed their crimes.[67] Addressing the crowd in this way, felons might recount their life stories, implore the judges for

mercy, or ask the spectators for their prayers. Finally, on the way to the place of execution, or on the scaffold itself, the criminal was given an opportunity to confess his sins to an attending priest or friar, who provided spiritual solace, implored repentance, heard confession and focused the condemned person's mind on the salvation which awaited. The Dutch historian Johan Huizinga tells us that Franciscan friars often assisted the condemned along the way towards execution;[68] and in addition to the spiritual services offered by the clergy, members of other 'charitable associations' in German lands performed the pious task of supporting a victim's head when the torture of being dragged to the place of execution on an oxhide or wooden sledge threatened the victim with violent jolts.[69] An illustration painted for the *Luzerner Chronik* in 1513 by Diebold Schilling shows two clerics attending to the already broken murderer Duckeli; one holds a small crucifix (illus. 45). Though clearly institutionalized in northern Europe, these practices are best documented in Renaissance Italy, where they became the special province of 'comforting societies', lay confraternities dedicated to the spiritual and physical care of prisoners before and after their execution (their members were called *confortatori*).[70]

Often missed by historians of punishment is the institutional backdrop to the late medieval practices of spiritual comfort and confession on the scaffold. Prior to the fourteenth century, it was commonplace for condemned criminals to be *denied* the opportunity to confess their sins. As Esther Cohen points out, this had the effect of translating the ritualized expulsion of the criminal 'from the physical to the metaphysical plane'.

In an age very much preoccupied with the economy of the afterworld, sentencing a criminal to die unconfessed and unshriven meant eternal damnation and banishment from the community of the faithful. The eternally restless soul was symbolically represented by the unburied, exposed body, whose grisly remains were eventually dumped under the gallows . . . In a religion that had always kept its dead as an integral part of the community of the living, the exclusion of criminals' souls from this shared destiny was perhaps the harshest penalty of them all.[71]

In 1312 Clement V, continuing the papal promotion of a penitential system based on indulgences, forbade the practice of denying confession to prisoners. Evidently, though, the practice persisted. And no less a personality than Jean Gerson, chancellor at the University of Paris, was motivated to lead a campaign against it. Calling the denial of confession a 'great harshness and cruelty', Gerson did not hesitate to remind the then-king, Charles VI, that Christ himself had died a criminal for the sake of everyone, guilty and innocent alike. For

Gerson, confession 'identified the dying criminal with other Christians attempting to achieve a good death. The recurrent theme of Christ dying among criminals imbued the death of late medieval malefactors with a sense of validity.'[72] Tellingly, Gerson's colleague, Pierre de Craon, placed a stone cross near the infamous gallows of Montfaucon, not only symbolizing but also facilitating the ritual enactment of a soteriological connection between Christ's saving death and the penitent culprit's confession. Long before modern humanitarianism, then, an observable process of 'rehumanizing' criminals was set in motion to accompany the growth of lay piety in the late Middle Ages.

In the city of Strasbourg Johannes Geiler von Kaiserberg went still further, demanding that communion itself not be denied to criminals. No longer was the idea of the *corpus Christi* residing in the belly of a hanged culprit to arouse revulsion and horror; on the contrary, writes Cohen, criminals now were to be 'reintegrated into the mystical body of Christ by virtue of their penitence, thus earning the right to his sacramental body'.[73] Because Christ's death redeems any individual who *voluntarily* chooses to bear the pains He also suffered – as the condemned criminal does by virtue of his confession and repentance – the theological scandal of believing the *corpus Christi* to be 'still . . . in the gullet [of the convict and] . . . delivered to the gallows' could be made to disappear.[74] And this, as the Netherlandish mystic Jan Ruysbroeck contended, was precisely the lesson to be learned from Christ's decision to die between the Two Thieves.[75] The salvific promise of Christ's self-abasing death on the Cross was nowhere more fully realized than in the redemption of the criminal who confessed, atoned and suffered his pains steadfastly. Only the martyr-saints of yesteryear could attain the ideal of *imitatio Christi* with greater purity.

Henceforth secular punitive justice was sanctioned by the late medieval Church to punish only the criminal's body, not his soul, though it targetted the former more violently than ever before. Yet this newly invigorated official regard for the spiritual destiny of the evil-doer is only a part of what the campaign represents historically. As importantly, at a popular level, it succeeded in making it obligatory for Christian *audiences* to experience the spectacle of punitive death through the magnifying lens of 'penitential vision'. Henceforth spectators would look with horror upon the spectacle of an unconfessed death; and conversely, it ensured that these same audiences would look with satisfaction – perhaps even a kind of cultic pleasure – upon the spectacle of the criminal assimilated to the suffering Christ at the moment of his grossest abjection. 'He died like a Christ merrily and willingly,' wrote one contemporary chronicler, in admiration for a

convict who displayed steadfastnesss in the face of ultimate pain.[76] In the eyes of pious witnesses bent on procuring the intercession of the dead martyr-criminal once the latter reached heaven, the drama of judicial killing, climaxing in the executioner's successful *coup de grâce*, and continuing on to the funeral and burial, took on the aura and power of a salvific spectacle: the body in pain as both redeemed and redeeming to all who gazed upon it.

Pain and spectatorship

The medievalist Caroline Walker Bynum, whose work has brilliantly illuminated the late medieval conception of Christ's humanity, concluded that saints and mystics typically discovered 'the core of what it is to be human' in His suffering during the Passion.[77] Did the religious consciousness of the late Middle Ages uncover the very foundation of human community in the shared realization that we can, and do, all suffer? In an age when there was often nothing to alleviate sickness and injury, when death rates were extremely high and when physical suffering was seen and accepted as part of fate, could pain have provided an element of cultural cohesion, in a way that we cannot help but misunderstand from the vantage point of a culture bent on pain's elimination? Were physical pain and suffering the basis for an intersubjective form of Christian *communitas* in the later Middle Ages?

A second medievalist, Esther Cohen, has begun to write a history of pain as a culturally constructed experience (as distinct from the biological facts of pain, which appear to change little through human history),[78] and her work confirms some of Bynum's ideas. She singles out the late Middle Ages as an epoch uniquely committed to the pursuit of pain as a positive force in human affairs, and calls the special attitude it generated *philopassianism*, in order to distinguish it from impassivity (the ability to tolerate pain while experiencing it) and impassibility (the transcendence of pain-sensitivity).[79]

A third medievalist, Richard Kieckhefer, writing on the fourteenth-century mystic's fierce devotion to the Passion, configures the logic of penitential suffering in the following terms:

In their devotion to the passion, the saints bowed to the recognition that what God demands in particular is suffering. They viewed suffering as the specific means God has chosen both for Christ's redemptive work and for the sanctification of those who imitate Christ. Atonement came not from charitable works, nor from prayer, nor from enlightenment, but from pain. If God's wrath was appeased by suffering, this meant that suffering was somehow pleasing to God . . . Catherine of Siena might insist that it is not suffering per

se that God delights in but rather the love revealed by suffering. Nonetheless, God seemed to attach more weight to love manifested in suffering than to love displayed in other ways.[80]

For the 'spiritual athletes' like Catherine of Siena and Heinrich Suso, *imitatio Christi* was the leitmotif of the era's penitential striving. Harnessing the materiality of their flesh to the pursuit of mystical union with God, they imitated Christ not in His life but in His suffering.

For ordinary people, however, the religious imperative to suffering typically comprised something less extravagant: not a pursuit of penitential affliction as a spiritual vocation, but rather the cultivation of an attitude of humility and gratitude in the face of the sufferings of Christ, the Virgin and the martyrs. Religious consciousness was, in this sense, a *mode of response* to the suffering of these paradigmatic Others, one that ennobled itself and transformed into a species of suffering by seeking conformity with the thing to which it responded. Medieval authors called it 'compassion' (*compassio*) and placed great emphasis on its powers. When the Franciscan Minster General Bonaventure addressed the subject of Mary's suffering on Calvary, he asserted that the depth of her loving compassion for her son 'transformed her into the likeness of Christ'. Similarly, St Francis's biographer explains that it was 'tender compassion that transformed him into an image of the Crucified'. Both manifested in their lives a mystical principle of the first order, expressed in the Parisian canon Hugh of Saint-Victor's (d. 1141) formula (quoted approvingly by Bonaventure): 'The power of love transforms the lover into an image of the beloved.'[81] *Compassio*, by its nature, gravitates towards its object, suffering (*passio*), conforms to it and then fuses with it. Mary's emotional suffering as an eyewitness to her son's spectacular torture-execution was seen by medieval authors to rival, or even surpass, the physical agonies endured by Christ, since it grew naturally out of a perfect maternal love. Francis, who preached the ideal of *imitatio Christi* and became, physically, a living image of the crucified with the appearance of the stigmata, cultivated his brand of compassion through ardent meditation on Christ's suffering (see Chapter 7); and many other mystics carried physical stigmata, miraculous or self-inflicted, as the visible proof of their devotion to the Passion. But the key point here is that both Francis and Mary *modelled* compassion, as a species of suffering, for *all* Christians. At the highest level of affectivity and empathy, they demonstrated the mystical identity between *compassio* and *passio*, exemplifying the capacity for human love to fuse with divine love, each revealed to the other through suffering.

Compassion also provided the currency of collective emotional experience in the theatre of public punishments, where pain was spectacle. The penitential element in the death ritual cast a spell of fascination over its audiences; and this kind of intense absorption frequently erupted into collective displays of pity at the place of execution. A convict who played his part in this sequential drama of repentance, confession, absolution and communion evoked the strongest feelings of compassionate identification from spectators. He might also promise to intercede on behalf of all those injured in this life once he arrived in heaven, purified of his sins.[82] In some places it was also part of the drama of repentance for the executioner to ask the convict to forgive him for what he was about to do. At the execution of one Messire Mansart du Bois, who was put to death during the 'Burgundian Terror' in Paris in 1411, the crowd was overcome with emotion when, in response to the headsman's solicitation, the condemned man went one better and actually begged his executioner to embrace him. One chronicler wrote, 'There was a great multitude of people, who nearly all wept hot tears.'[83]

The popular identification of the condemned as a martyr could therefore be deepened by the dying person's performance. The more elaborate accounts we have of eighteenth-century executions vividly convey the crowd's compassionate immersion in the sufferings of the prisoner who, no less than his supporters, saw his death as a kind of martyrdom. In Caen, on 22 March 1760, a large crowd assembled at the Place de Saint-Saveur to see the grenadier Jean Corbelet broken with the wheel for the murder of a fellow soldier. After being fastened down he 'began to sing the Salve Regina, exhorting the crowd to join in with him':

After being struck . . . the condemned man himself started to intone the Veni Creator. At the end of the first verse the public sang the second, then the condemned man the third, and so on to the end . . . He then requested the executioner to ask the public to say the Miserere for him in Latin, while he recited it in French. Father Meritte, the priest, then intoned the Parce Domini . . . The public repeated it. Then the priest and condemned man together, in a strong manly voice, recited the second verse. About halfway through the Miserere the condemned man's voice began to fade.[84]

By orchestrating his own funeral hymns, Corbelet played his role as the holy victim 'with such exaggeration that he . . . adopted an actor's pose and turned the festival of deterrence . . . into an edifying ceremony of death and farewell, whose expressiveness exceeded all other funeral processions'. Richard van Dülmen concludes that the condemned 'might become an object of envy for others and be

celebrated as heroic or as a martyr'.[85] Compassionate identification with the sufferings of the convict could be even stronger in the case of executions involving rebels or rioters, who would have then been regarded not only as fellow Christians, but also as colleagues, 'one of us'.[86] Collective empathy tended to side with the repentant criminal, even – or *especially* – if he was first a murderer.

In line with these attitudes is a long tradition of votive imagery that projects, visually, the punished culprit's worthiness of redemption. On the title page of Jacob Issickemer's miracle book for the popular Bavarian pilgrimage shrine at Altötting, the *Büchlein der Zuflucht der Maria in Altern-Ötting*, the printer used a woodcut which shows the demolished victim of the wheel (*Geräderter*), still entwined with the apparatus, propped up before the altar (illus. 61). Surrounded by other afflicted supplicants offering *ex votos* to the apparition of the Virgin and Child, appearing here as the 'woman clothed with the sun' of Revelations (12: 1–17), the lifeless figure appeals for Mary's mercy, protection and intercession, even as he visibly wastes away (a dog even sniffs for falling bodily detritus!). More direct still is the promise of salvation held out to the famous robber Lips Tullian in an engraving made for the title-page of the criminal's biography (illus. 62).[87] Tullian, who was executed in Dresden on 8 March 1715, appears in the image as

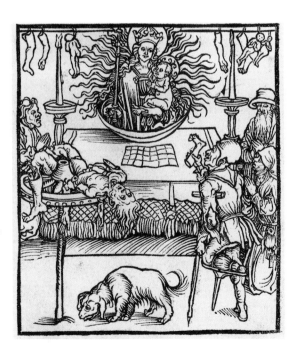

61 'The Virgin of Altötting Receiving Offerings from Pilgrims', woodcut from the title page of Jacob Issickemer, *Büchlein der Zuflucht der Maria in Altern-Ötting* (Nuremberg: Caspar Hochfeder, 1497). New York, Pierpont Morgan Library, PML 36051.

62 'Lips Tullian
Redeemed by Justice',
engraving from the title
page of *Des bekannten
Diebes, Mörders und
Räubers Lips Tullians,
und seiner Complicen
Leben und Übelthaten...*
(Dresden, 1716). Staats-
und Universitäts-
bibliothek, Göttingen.

Hier ist Kosmophilus mit Fesseln angethan,
Fängt seine Gottesfurcht, mit Reü und Thränen an.
Iustitia tritt auff, hat Galgen Rad und Stahl
Gott spricht. Theophile komm in des Himmels Saal!

the prisoner-in-irons, abjectly awaiting justice; yet the clouds part to
reveal a sunburst and a merciful God, whose representative on earth,
an allegorical figure of Justice, reassures the sinner that redemption
awaits beyond pain. In the words of the caption:

> Here the worldling now all bound in fetters lies
> starts to fear his God, his tears flow from his eyes.
> Justice comes along, with gallows, wheel and sword:
> God tells the pious man to enter Heaven's door.[88]

Contemporaries reported 'more than 20,000 people, 144 carriages, and
some 300 horses' in attendance at Tullian's spectacular death.[89] The
display of compassion was considerable enough for one élite moralist
to wonder aloud why such evildoers aroused 'compassion and pity . . .
utterly contrary to their conduct, and many spectators were moved to
tears'.[90]

But how did compassion and compassionate vision colour, or even
determine, what pious audiences actually *saw* during the infliction of
the penalty itself, when the body convulsed with pain? What did they
look for in the climax of the person's struggle against extinction? What
did a real-life 'martyrdom' look like?

Given the difficulties of sorting out, let alone reconstructing, the subjective experiences of people in the past, we will assume a set of ideal conditions, beginning with the smooth unfolding of the penitential drama prior to execution. I think we can say that two related beliefs came into play during the decisive moments, and that together they produced a baseline 'horizon of expections' for spectators. The first is a belief in the instrumentality of pain, the second in the reality of purgatory. One of the woodcuts designed by Wolfgang Katzheimer for the municipal law code, *Bambergerische Halsgerichtsordnung*, depicting a judicial procession out of the prison, expresses in a neat formula current ideas about the efficacy of pain (illus. 63).[91] Though they appear in the banderole above the heads of all the participants, the words are effectively being addressed to the convict by the friar attending him with a crucifix:

Wo du gedult hast in der pein
So wirt sie dir gar nützlich sein
Darumb gib dich willig darein

(If you bear your pain patiently,
It shall be useful to you.
Therefore give yourself to it willingly.)[92]

The ascetic belief in the 'usefulness' of the body's pain to the ascent of the soul are writ so large across the face of Christian history that we need not pause here to review its premises or trace its divergent streams. However, the later Middle Ages did leave its distinctive stamp on this history with a die cast in the twelfth century: the conception of purgatory as an intermediary otherworld where sinners were purified of sins incurred on earth.[93] Souls who had paid the price in purgatory could be assured of mercy on the great 'Law Day'.[94] Likewise, souls who had already been purified by their immense sufferings on earth could bypass the flames of purgatory and find a special place in 'Abraham's bosom', that longed-for place of refreshment (*refrigerium*) reserved for heaven-bound souls.[95] The logic of purgatory conjoined with the penitential system based on indulgences, allowing sinners to *calculate* their own spiritual debits and credits. Thus the late Middle Ages was perhaps singularly attuned to the purgative profit in pain, and acculturated to thinking of spiritual progress as an ever-changing balance sheet. As they watched a man broken with the wheel, many spectators undoubtedly wondered how many of the pains of purgatory were now being accounted for here, in the hour of this poor, repentant sinner's death. How could a soul so thoroughly cleansed by bodily affliction not be swept up directly into 'Abraham's bosom'? As a species

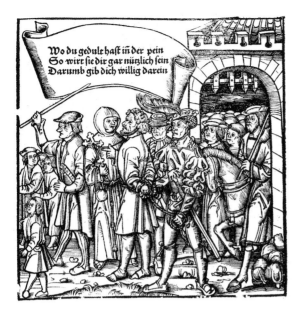

Wo du gedult haſt in der pein
So wirt ſie dir gar nützlich ſein
Darumb gib dich willig darein

63 Wolfgang Katzheimer,
'A Judicial Procession',
woodcut from
*Bambergerische
Halsgerichtsordnung*
(Mainz: Johann Schaffer,
1531), fol. xviii verso.
Newberry Library,
Chicago.

of the 'good death', executions, it must be remembered, provided the single occasion when a Christian could know the exact moment of his or her death, and thus prepare for grace up until the final blow. Its opposite, sudden, unprepared death (*mors improvisa*), inspired horror.

Furthermore, if the condemned was by any chance innocent, the soul, provided that it had no other stain upon it, could enter into 'immediate beatitude'. The doctrine of 'immediate beatitude' appears to have had wide currency at this time, having received canonical form first at the Church Council of Lyons in 1274, and later at the Council of Florence in 1439. A text known as the *Profession of Faith of Michael Paleologue*, expressed the idea this way:

> . . . if they die truly repenting in charity before making satisfaction by worthy fruits for what they have done or omitted to do, their souls are purged after death . . . But the souls of those who after holy baptism have acquired no stain at all, and those who having incurred the stain are cleansed either while still in the body or after death as described above, are received immediately into heaven, and clearly see God himself.[96]

Here we see the 'high' thinking of theologians in accord with the 'low' perceptions of judicial spectators. To see a soul 'cleansed' while 'still in the body', released and finally carried off to heaven, beyond the clutches of Satan and his demons, was an edifying sight to say the least. For ordinary people, it may have been tantamount to a miracle. The popular hunger for miracles (*miracula*) and 'signs' (*signa*) formed one

of the crucial psychological strata of the era's collective religious mentality;[97] and it is provocative to imagine how the spectacular *image* of the suffering sinner tapped into these powerful devotional longings, sweeping an entire audience into collective sobbing.

Far from being a damned wretch, the prisoner who accepts being sacrificed becomes, in the eyes of the public, a holy victim whose suffering and death make him into an intercessor for all, someone who can placate God's wrath; at the moment of death, he has the power to save, through a communion based on Grace.[98]

These factors made the spectacle of the body in pain both dreadful and fascinating, abject and glorious – neither feeling, one suspects, existed without the other. Where suffering was nobly endured, Foucault writes:

one could decipher crime and innocence, the past and future, the here below and the eternal. It was a moment of truth that all the spectators questioned: each word, each cry, the duration of the agony, the resisting body, the life that clung desperately to it, all this constituted a sign.[99]

The signs of the body in pain were not, therefore, simply a 'shameful side effect' to be tolerated for the sake of justice; they were instead the focal point of comprehension which gave the spectacle its religious meaning. 'The bodies of martyrs were repulsive to look upon after their tortures,' comments Umberto Eco on the old monastic distinction between the soul and the body's exterior, 'yet they shone with a brilliant interior beauty.'[100] Perhaps more effectively than any rationale devised by jurists, such conceptions gave popular licence to judges and magistrates to pose as the agents of cathartic punishment, and placed the state's monopoly on legal violence practically above contestation. In the era of humanitarianism's prehistory, as it were, compassionate vision learned to invert the abject sufferings of the prisoner and see them as glorious and Christ-like. The image of each penitent sinner could enter, in the mind's eye, into a macrocosmic economy of pain, a community of suffering anxiously geared towards redemption. The reeking gallows, splashed with the potent blood of martyrs, was its cult station, and the demolished body of the criminal its living cult image.

5 The Wheel: Symbol, Image, Screen

The torture of the wheel consists in this: under the arms of the condemned man timbers are placed on the ground, and the executioner or a criminal breaks his arms with a wooden wheel, then breaks both his legs, and then with the same wheel breaks the man's back. Thus broken and shattered, the man is raised on the wheel and set atop a large beam upright in the ground – there the wretch is left, breathing with difficulty. Such a death is very cruel: some unfortunate wretches have been known to live for two or three days afterwards, thus adding to the suffering and pain of this terrible spectacle.

ANTONIO DE BEATIS, travelogue of Cardinal Luigi of Aragon (1517–18)[1]

'Shapeless flesh': The wheel and judicial killing

After hanging, breaking the body with the wheel was the most common form of aggravated execution from the early Middle Ages to the beginning of the eighteenth century.[2] Among the penalties which the early modern state deployed for their deterrent effects, the wheel demonstrated a peculiar longevity well into the nineteenth century, when other forms became intolerable.[3] The frequency of its use will probably remain a matter of debate among historians for some time; while some go so far as to declare it practically a daily occurrence in parts of Europe,[4] others give a more modest accounting. In the records published by Richard van Dülmen for the city of Nuremberg, we find that between 1503 and 1743 only 55 out of a total of 939 executions were performed with the wheel. However, the ratio of wheelings to total executions in those German cities for which records exist appears to have been much greater in the late Middle Ages than in the following centuries. Its heydey was most likely the second half of the fifteenth century through to about 1600, when execution rates overall began to decline in Germany and most of Europe.[5] As an emblem of state-sponsored death, the wheel has all but passed from the West's collective imagination, replaced first by that spectacular mechanical marvel of

'instantaneous' death and political terror, the guillotine, then by an unfathomable machinery of mass murder, the Nazi gas chambers. The wheel never found a home in the New World and antebellum America, where hanging was the preferred form of public execution.[6]

Judging from the numerous depictions of the procedure which survive from this period, the method for breaking a man with the wheel was fairly standardized, though the procedure and its incidentals could vary. Here I reproduce two illustrations from diverse sources: the first is a miniature by the Swiss illuminator Diebold Schilling, one of several execution images included in the lavish *Luzerner Chronik* of 1509–13 (illus. 46);[7] the second is a broadsheet relating the punishment of a murderer in Mainz, published by the Magdeburg *Briefmaler* Leonhard Gerhart in 1572 (illus. 64). Both corroborate written descriptions like the one penned by Antonio de Beatis for the travelogue of Cardinal Luigi of Aragon (in the epigraph at the start of this chapter). First the victim was stretched out and secured with ropes staked into the ground; alternatively, the performance could take place upon the 'raven's stone' (*Rabenstein*), an elevated masonry platform covered with earth or grass, erected outside the city walls.[8] Wooden slats were then placed under the wrists, elbows, ankles, knees and hips. Occasionally, as in Gerhart's woodcut, we see the slats pre-assembled into a gridwork, over which the body is lain. Once the victim was immobilized, the executioner would begin fracturing the bones of the arms and legs, aiming his blows between the slats with a large wooden cartwheel, sometimes fitted with iron treads or a cutting blade. Some law codes stipulated that the wheel, like the hanging rope, be *unused*,[9] but the reasons for this remain obscure. Outside Germany, in Latin and Gallic Europe, an iron rod or mace sometimes replaced the wheel as a bludgeon.[10]

Law codes made some attempt to calibrate the number of blows required to bring the condemned man 'from life to death' (*vom Leben zum Tod*); and hangmen's bills, dating from a slightly later period, reveal that there were two standard procedures for breaking the body. Sentencing formulas could speak of breaking 'from below' or breaking 'from above', and could add to either of these the stipulation 'alive'. 'From below' was surely the cruellest: the executioner began with blows to the shin and thigh bones, working his way up to the chest, where a severe blow to the heart could be delivered as the *coup de grâce*. Normally eight blows were delivered to the body – one for each major bone of the arms and legs – or the number could correspond to the number of offences. Some records indicate a high number of blows. Judicial mercy generally dictated when and how soon the suffering criminal would be finished off. In St Gallen in 1596 a murderer and robber had

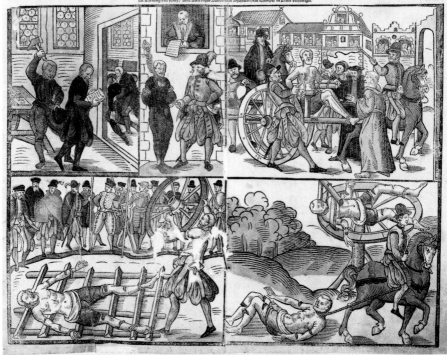

64 Leonhard Gerhart, *Murder in Halle (Saxony) and the Punishment of the Culprit in Mainz, 30 July 1572*, woodcut broadsheet, 490 × 390 mm. Zentralbibliothek, Zürich.

each of his four limbs broken twice with the wheel; after begging the executioner to end his torments, he was killed with a knife.[11] 'From above' signalled a milder form, since it generally meant that the convict was to be put to death before the breaking commenced. Strangulation appears to have been the commonest method used, and it is perhaps significant that Diebold Schilling makes a distinction between the two victims already laid out on the wheel based on the fact that the neck of one is entangled in a kind of miniature gallows attached to the wheel; Gerhart's woodcut also shows this feature, but we can see in the previous scene that the man suffered the penalty while alive. Strangling the victim beforehand *in secret* became more common in the self-consciously 'civilized' eighteenth century, as authorities sought ways to balance the conflicting aims of minimizing the actual pain of the convict, while still providing a terrifying spectacle for the populace who watched.[12]

What those who watched actually saw is still difficult to fathom. According to a broadsheet published in Hamburg on 12 June 1607, the torture transformed the victim 'into a sort of huge screaming puppet

writing in rivulets of blood, a puppet with four tentacles, like a sea monster of raw, slimy and shapeless flesh [*formlos Fleisch*] mixed with splinters of smashed bones'.[13] Normally the punishment did not end here. Once the breaking was complete, all four of the demolished limbs were 'braided' between the spokes of another large wagon-wheel and the whole bloody mess hoisted high upon a pole 'so that the birds may fly below and above the wheel', as one chronicler put it.[14] If not already granted by the judges or the executioner, death came slowly, sometimes, tragically, not for several days. In Bergkessel in 1581 a man punished with the wheel reportedly lived for nine days and was every day 'strengthened with good drink' (*mit gutem Getränk gestärkt*), suggesting that his prolonged death inspired a merciful offering of liquor for pain-relief.[15] Long-term exposure on the wheel, the final result of which was the total excarnation and dissolution of the body, constituted an aggravation of the sentence itself, first and foremost because it denied the executed person proper burial. Juridically, exposure was justified as a further deterrent.

Specific forms of violence can be both the bearers of past meanings and the repository of new ones; this is doubly true for the many varied modes of corporal and capital punishment. Much of the previous chapter was devoted to portraying the interlocking pieces of the late medieval judicial world – its procedures and rituals, its actors and audiences, its techniques and symbols, its spaces and sights – as a public sphere where secular authorities, the Church and the people engaged one another and the celestial powers in communicative action. Out of that portrayal emerged a sense of how the techniques established by custom, endorsed by jurists and enacted by executioners *meant* something beyond their overt social function as instruments of control, or their ideological value as assertions of legal authority. Then as today, penal sanctions condensed for society's members (albeit in different ways for different groups) legal concepts like retribution, restitution or justice, social values like vengeance, deterrence or the restoration of order, or moral-religious concepts like mercy and redemption (though invariably these concepts become entangled). And while such concepts and values may inform all criminal sanctions equally, other meanings were fused with the specific modes of punishment in the judicial repertoire and seem to have survived in the passage from sacrifice to legal ritual, reappearing in the collective imagination, so to speak, long after their origins had become obscured. The punishment of the wheel exemplifies this entanglement of mode and memory and the mutable nature of each.

In a 1937 study of the pre-Christian symbolism of the cross, the art historian Edgar Wind framed this notion in terms of the latest anthropological and psychological thinking about ritual, sacrifice, symbol and memory:

the survival of ritual in legal punishments is obvious in the ancient forms of execution. To break a man on the wheel, to crucify or quarter him, are cruelties of such shrewd invention that even the cauldron of abnormal psychology does not produce sufficient mixtures to account for them. These cruelties were invented for a purpose, and the psychologist who would want us to believe that they were always meant to satisfy a 'disinterested pleasure' conceives of human nature on too simple a scheme. The very shape of the wheel and the cross, the very act of quartering, point to ideas of a cosmic order and would be senseless but for a victim sacrificed for a cosmic purpose.[16]

These remarks echo the ideas of scholars like Karl von Amira and his student Hans von Hentig, already mentioned in Chapter 4. For them the wheel used to smash the bones of the condemned in the Middle Ages was a symbolic hangover from the pre-Christian past: an archetypal representation of the sun. This made medieval penal ritual, in their eyes, a transmuted form of pagan sacrifice to the sun god.[17] Amira and Hentig sought support for this theory in the classical myth of Ixion, the impudent mortal whom, for his attempt to seduce the goddess Hera, Zeus had ordered bound to a fiery wheel that would roll ceaselessly through the sky. To be sure, wheels and fire are found together in diverse cosmologies and myths. And in the classical world Ixion's wheel did indeed become a sun symbol (like the 'shameless stone' of Sisyphus, next to whom he is always placed in Tartarus).[18] Thus the medieval punishment of the wheel, like crucifixion, appeared to these scholars to have its origins in the sacrifices of pagan saturnalia, or feasts of renewal. It was precisely in such festivals, as Wind argues (here following the ideas of Sir James Frazer), that a common criminal took the place of the Divine King, a great *taboo* being whose traditional self-sacrifice fructified the earth. As the bearer of taboo, then, the medieval criminal battered with the wheel – no longer a sacrificial substitute but now merely a judicial victim turned scapegoat – died to propitiate a cosmic order.

Enticing though these theories are, there are precious few facts to support them. Only by conflating the archaeological evidence surrounding the ancient Greek torture-wheel (*trochos*), which scholars have persistently associated with the Ixion myth, can this notion fly. The scholar Ervin Roos put to rest the notion that the *trochos* had anything in common with Ixion's wheel, for whereas classical literary and iconographic sources always depict Ixion strapped to the circular

face of the wheel, the victim of the ancient torture-wheel, as we will see, was affixed convexly around the rim (see illus. 66).[19] Neither involves the breaking of limbs or their entanglement in the spokes of the wheel, the hallmarks of the medieval procedure. When we search for plausible origins for the medieval use of the wheel, one can be found, but it is less than cosmic in significance. The earliest medieval account known is that of Gregory of Tours, who wrote in the sixth century of a wheel-based punishment of apparently Frankish origins. He described nothing so elaborate as the *trochos* or Ixion's flaming wheel. Instead he reports how the condemned was tied over deep tracks in the ground and run over by a heavily laden wagon.[20]

It is unclear how this mundane penalty became the time-honoured judicial spectacle we know from numerous written and visual sources; but by the fourteenth century at the latest only the wheel itself remained, used as both bludgeon and display apparatus. Its patent dissimilarity with the ancient devices, actual and mythical, forces us to view sceptically any notion linking the medieval wheel to pagan punishment or sacrifice. And without such a tenable archaeological connection, the idea of an embedded cosmic symbolism linking the wheel and the sun and spanning the millennia dissolves into wishful thinking. To overcome this problem, Wind had to attribute the long-term transmission of cosmic symbols to what amounts to a psychological reification: 'the anonymous being, the social community, who employs . . . [the consciousness of the individual person] as a particularly suitable instrument to register and express its ancient memories'.[21] Surely he was unaware of the degree to which such ideas were already compromised by the close connection between German nationalism and the discipline of *Volkskunde*, which valorized the beliefs and rites of the Nordic tribesmen of the Dark Ages – preparing the way, as Richard Evans notes, for Himmler's attempt to institute sun worship as an authentically Germanic religion in place of 'the alien, Jewish religion of Christianity'.[22] In their zeal to redeem past penal practices like the wheel from the censure of liberal thought, which viewed them as barbaric, scholars like Amira and Hentig emphasized a uniform, sacrificial logic for all the old penalties. They naturalized, and thereby legitimized, an alleged 'instinct' for racial purity among ancient Germans, a line of thought which merged with early eugenics research and, ultimately, the Nazi quest for a *Judenrein* Europe.[23]

Despite the fact that a pernicious racist ideology informed one prominent answer to the question of what the penalty of the wheel meant in the Middle Ages, we do not need to throw out the baby with the bathwater. But if we can, as I think we should, throw out the

impossible wish of arriving at an *original* meaning for the wheel, a firmer interpretative ground can be found in the Middle Ages itself. Sometimes a wheel is just a wheel, but medieval visual culture was freighted with rotary symbols, some arcane, others, as I hope to show, demonstrably familiar to both educated and uneducated viewers alike. Medieval saints' lives and the iconography of sin provide a fertile starting point for our investigation of the wheel as symbol and visual schema; each leads us back to the *macabre* themes of mutability, impermanence and inversion, and this, we find, turns us back once again to the crucifixion of the Two Thieves. In the final section of this chapter I examine a regionally distinct treatment of the Thieves' punishment in which the *inversion* of the broken, 'crucified' body serves as a perceptual 'screen' in a double sense: *through* it can be read the phenomenology of pain peculiar to the wheel, and *upon* it was projected an image of a hated religious minority within Christendom's borders, the Jews.

From hagiography to the macabre

Medieval hagiography provides a tantalizing starting context for depictions of the wheel as an instrument of torture. A puzzling multiplicity of interpretations weaves through medieval saints' lives anyway, and the changing modes in which martyrs who died 'on the wheel' are depicted defies easy categorization. One of the most beloved medieval saints, Catherine of Alexandria, appears often with a spike-studded wheel as her attribute, a patently different device from the wagon-wheel used to break real criminals. In the *Golden Legend*'s account of her passion her persecutor, the emperor Maxentius, orders constructed for her execution a device consisting of

four wheels, studded with iron saws and sharp nails, and by this horrible device the virgin should be cut to pieces, that the sight of so dreadful a death might deter the other Christians. It was further ordered that two of the wheels should revolve in one direction, and two be driven in the opposite direction, so that grinding and drawing her at once, they might crush and devour her.[24]

Of crucial importance to the fate of Catherine, a princess and paragon of wisdom, is the theme of ensuing supernatural intervention, which shatters 'the monstrous mill', killing 4,000 pagans with its explosive force, and compels her tormentors to kill her off by a more noble method, decapitation.

Other saints' passions do not spare them their encounter with the wheel – or some form of it. Two fifth-century martyrs, Savinus and

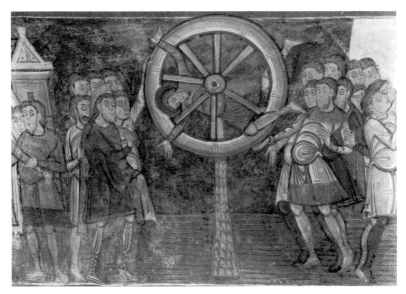

65 *Saints Savinus and Cyprian Tortured on the Wheel*, wall painting from the crypt of the church at Saint-Savin-sur-Gartempe, French (Poitiers), early 12th century.

Cyprian, appear intertwined upon large wagon-wheels in the murals adorning the crypt of the Romanesque church dedicated to them at Saint-Savin-sur-Gartempe (illus. 65). Only one in a series of scenes set in two, long horizontal friezes, the wheel torture occurs amidst other harrowing moments of violent punishment: one in which henchmen tear the flesh from the saints' bodies with hooks, another in which they are thrown to wild beasts.[25] Curious from our perspective, though, is the pinwheel-like appearance of the apparatus and the action of its operators, who seem merely to be rotating the wheels on their axes, as if the spinning motion alone were the key to the torture. Does this conception have anything to do with the medieval use of the wheel? The bodies are woven around the spokes of the wheel, but the absence of any obvious wounds or dislocations fails to convey the kind of demolition we have seen elsewhere. Was the artist bereft of a judicial source on which to model his tortures, has he copied it incorrectly from a manuscript model,[26] or was he somehow attempting to distinguish an 'ancient' form of the wheel from that which he knew to be currently in use?

Five centuries later we find the same 'fractureless' conjoining of saint and wheel in an Italian engraving by Antonio Tempesta, designed for a Counter-Reformation martyrology authored by the Jesuit Antonio Gallonio (illus. 66).[27] This book, a visual encyclopedia of the tortures inflicted on early Christian martyrs by pagan 'tyrant kings', was the

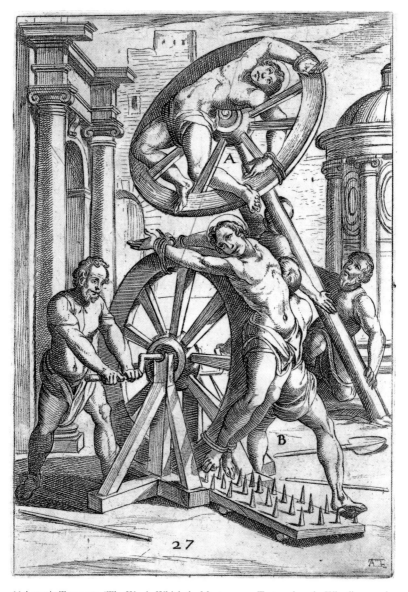

66 Antonio Tempesta, 'The Way in Which the Martyrs were Tortured on the Wheel', engraving from Antonio Gallonio, *De SS. Martyrum cruciatibus...* (Paris: Claudius Cramoisy, 1660). Rijksmuseum, Amsterdam.

most widely published specimen of a grisly devotional genre with exponents on both sides of the confessional divide.[28] Leafing through its 47 plates, one encounters an outrageous omnibus of ordeals, stage-managed by dispassionate executioners. The plate illustrated here shows two wheel-based contraptions: the first a bloodless and fracture-less approximation of the medieval wheel, in which the limbs are

interwoven with the spokes; the second a variation on the spiked rotary deployed to 'crush and devour' Catherine – a device that will grind the young martyr stretched around its rim over a rolling bed of spikes. Pictured on the next page are further variations: a martyr strapped to a spike-studded wheel and his companion about to be scorched upon a large rotisserie!

Implausible as they may appear, Gallonio and Tempesta's three variations are apparently well-informed reconstructions of the Greek and Roman torture-wheel, attested in numerous antique sources and mentioned briefly above. What is misunderstood here, however, is the fact the *trochos* was not a killing-machine per se, but principally an instrument of torture in the strict sense of the word – used for extracting confessions – though it was sometimes also used for the corporal punishment of slaves.[29] With it the production of pain centred upon the stretching and dislocating of the limbs, especially the shoulders, as was also the case with the early modern 'ladder rack'. Supplementary features came later: whipping, burning with torches (also a feature of the European rack) and rolling over spikes all gave the rotary movement of the ancient wheel, which was itself never integral to the torture, new purposes.[30] Thus apart from these minor misunderstandings, the Jesuits are guilty only of anachronism; they juxtapose these ancient gadgets with the image of the broken body interwoven in the spokes, a medieval speciality that is not traceable earlier than the sixth century.

To find a judicially accurate depiction of the wheel in a hagiographical context, we must turn to an iconographic rarity, one found, to my knowledge, only in the art of the fifteenth century, with its ingrained taste for the literal, its insistence on raw physicality and its penchant for the macabre. An altar-panel by a Hungarian or Austrian master in the circle of the so-called Master of the Martyrdom of the Apostles, painted *c*. 1480, depicts the wheel in a Passion sequence devoted to the three pilgrim saints Felix, Regula and Exuperantius (illus. 47).[31] Unflinchingly the painter displays the body of Felix, helplessly splayed out, undergoing the ordeal; from above we see the ropes, secured in the ground with stakes, that stretch his limbs over the pre-assembled grids and encircle his neck, immobilizing the body against the template.

So suspenseful is the physical and psychological confrontation between the pitiable victim and the pitiless executioner – outfitted in trademark rogue haberdashery! – we nearly miss the repulsive spectacle above the heads of the spectators. There we see Felix's sister Regula and, hovering above their tormentors, their elderly servant

Exuperantius, wretchedly contorted around their wheels, one facing up, the other down. Despite what the medieval viewer would have assumed about their heaven-granted impassibility, the artist shows the two broken saints languishing in unspeakable misery but refusing to die (in the visual sequence the three survive the wheel, regain their bodily integrity only to be decapitated in the following panel, and then make their way, heads in hands, to a resting place which became the site of their church in Zürich). As a final touch here, the artist has included a small stick, such as that used with tourniquets, with which the cords securing Exuperantius have been tightened.[32] Every obsessive detail of the butchery and display is given the authority of an eyewitness account. The devotional gaze can rove from the perilous *psychomachia* between executioner and victim to the hideous spectacle of the broken bodies displayed on the wheel – that is, from the frozen moment before the blow to the timeless abjection of the already broken. With this contrast the painter, an accomplished judicial voyeur, encourages the pious spectator to meditate upon the saints' miraculous endurance of pain, which was among the highest of *imitanda* and *admiranda* which concretized a saint's virtue.[33]

By the twelfth century, and then up to the Renaissance, the image of the wheel had become an iconographic commonplace in the allegorical guise of Fortune's wheel (*rota Fortunae*). It was the sixth-century scholar and statesman Boethius who first granted Fortuna, the discredited Roman goddess, her medieval currency, and accommodated the fatalism she embodied to a Christian idea of Providence. According to Ernst Kitzinger, Boethius 'more clearly and graphically than earlier writers visualized her with a wheel as an instrument which she turns capriciously and on which man ascends and descends'.[34] Around the eleventh century the allegory was first rendered as an image, in which the vicissitudes of temporal power are represented by four figures stationed around the wheel (whose clockwise motion is implied), and accompanied by inscriptions: there is one figure ascending (*Regnabo*), a royal figure atop the summit (*Regno*), another one descending (*Regnavi*) and one thrust down beneath (*Sum sine regno*).[35] Eventually the personification herself is added, taking up a position either astride the wheel, from where she turns it, or inside the wheel, implying that she too will turn.[36] Wheels of Fortune appear as the theme of ornamental stained-glass windows ('rose windows') in several twelfth- and thirteenth-century churches,[37] and on the unique mosaic floor in Turin, where it is closely associated with the circular image of the world map (*mappamundi*).

In these and subsequent representations the wheel symbolized, in Marcia Kupfer's words, 'the dual aspect of temporality itself, change and repetition . . . the cosmic action of time (the yearly round of months and attendant signs of the zodiac) and its moral effects (the transience of power, riches, honors, or youth)'.[38] Thematizing the impermanence and instability of things, the vanity of earthly pursuits and the sinfulness of a fallen humanity, the image of the rotating wheel became a crucial element in the medieval iconography of sin, whose intellectual source was the monastic literature of the *macabre*. Representative of the pessimism of this genre is Bernard of Cluny's mid-twelfth-century poem *De contemptu mundi* ('On Contempt for the World'), where the *mundus* is compared to a revolving wheel, continually unstable.[39] Iconographically, a compartmentalized circle often served to express what Jean Delumeau calls 'the conspiratorial solidarity of the vices'.[40] We find it in Hieronymus Bosch's *Seven Deadly Sins* panel, where the artist created a pithy scenography of the vices, each confined to its own section of the circle and overseen by the eye of God at its epicentre.

It is within this pessimistic, moralizing tradition of the *macabre* that the woodcut illustrated here, made in the second half of the fifteenth century by the Netherlandish artist known only as the Master of the Banderolles, should be understood (illus. 67). Amidst the unfurling speech-scrolls the wheel is slowly being turned counter-clockwise by a blindfolded Fortuna (that she is a mere agent of Providence is shown in the fact that her crankshaft is really controlled by Christ in heaven, who pulls the strings behind the curtain of appearances). At the wheel's zenith sits a king, at its nadir a beggar; on the sides one figure rises as his opposite falls. To complement the wheel's message the artist has opened a tomb to reveal a rotting corpse or *transi* figure (the leit-motif of the later Middle Age's obsession with death's immanence). The recumbent figure utters its own admonition to the living. Next to this we see Death itself (or himself), visualized as a grinning skeleton, shooting arrows at a tree, ostensibly the 'Tree of Life', whose foliage brims with tiny personages arranged in three tiers, representing the three estates. There is both an eclecticism in the combination of motifs here and a clever visual-rhetorical parallel between the Wheel of Fortune and the Tree of Life that resolves that eclecticism. Both are circular forms elevated on tall supports, but while the turning wheel is mounted on a sturdy column set solidly upon the ground, the top-heavy tree is perched precariously on a wooden boat bobbing in the water; its roots are gnawed by rodents to emphasize its instability. With the structure of the earthly hierarchy in the tree thus undermined,

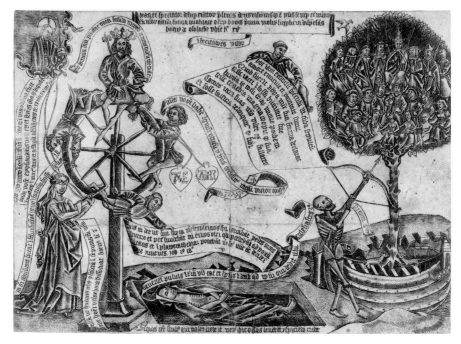

67 The Master of the Banderolles (Netherlandish), *Wheel of Fortune and Death below the Tree of Life*, woodcut, second half of the 15th century, 225 × 312 mm. British Museum, London.

its members become ready targets for the archer of Death, whose aim was, as the fear-instilling sermons of the *danse macabre* taught, indiscriminate. Even at the pinnacle of power, wealth and health, a sinful humanity must always be ready to be plummeted into misery, despair and death. Thus the two circular forms express the impermanence of earthly things in contrasting but mutually reinforcing ways.

My evocation of the Wheel of Fortune in this context begs an obvious question, which I shall now put rather crudely: as the medieval executioner battered the body of the condemned man, did the ordinary wagon-wheel he wielded appear to ordinary spectators as a *macabre* symbol of life's misfortunes? Even though the wheel-as-weapon was probably not made to turn as it was brought down on the body, would there have been any doubt, judging from the position of the condemned *under* the wheel, where Fortune had deposited the 'poor sinner' at the hour of death? Precisely this sense of the vanquished man, broken and ground asunder by Fortune's wheel, appears to have guided the designer of a popular broadsheet, now in Vienna, that attacks the Roman Church, the Pope and its priesthood as false, tyrannical and ill-fated (illus. 71).[41] Visually anchored by an allegorical wheel held by a Lady Fortune who doubles as a personification of Patience

(*Gedultikeyt*), the woodcut also includes personifications of Virtues and Vices, and animal imagery derived from the legends of Reinecke Fuchs (a.k.a. Reynard the Fox), Isengrim the Wolf and Braun the Bear. Here Reynard, the medieval trickster and folk hero, plays the role of Pope and Antichrist and is seated in mock majesty at the apex of Fortune's wheel; he is flanked by a treacherous 'Dominican wolf' and a 'Franciscan bear', who are in turn flanked by personifications of Arrogance and Envy on horseback. Counselling patience in the face of Rome's oppression – equated with the Antichrist's reign – and promising a 'Secret Revelation' (*Geheimen Offenbarung*) that will over-throw it, the broadsheet uses the *rota* to explode the vain pretensions of universal papal power, showing that its days are numbered. 'Constancy' (*Stetikeit*) plays the role of the vanquished, sprawled out upon the lower rim of the wheel and clutching at its spoke. Although we know that Fortune's wheel will eventually turn to overthrow Vice and redeem Virtue, the body of Constancy, overwhelmed by the monstrous device, is distorted, emaciated and weakened to the point of death. The message of patience and hope addressed to the viewer must therefore struggle against the undeniable concreteness of the body's vertical subjection. Will this wheel ever turn at all? Oddly, it has no mechanical axis, but is supported entirely by the figures of Patience (Fortune), Love and Humility (personified as a Samaritan monk and a Beguine). While the two kneeling figures attempt to effect its rotation, Fortune herself, blindfolded and aloof, grasps the upper spokes with two hands and stands motionless. In fact, she strikes the same pose as the medieval executioner who brings the torture-wheel down on a supine, immobilized body!

In the light of these transpositions and intersections, one suspects that as the image of Fortune's wheel was further ensconced in the late medieval iconography of sin, and thus became more familiar, its visual assimilability to the torture-wheel and its workings must have become unavoidable. That the woodcutter, perhaps a Hussite, had a popular audience in mind underscores this point and helps us draw out the possible implications: in everyday experience, the body of the con-demned criminal broken with the wheel, braided into its spokes and then displayed upon it became fused with a multivalent symbol of fate, and produced a spectacle at once repulsive, forbidding, antagonistic and yet dimly hopeful.

There is, finally, a striking schematic correspondence between the four paradigmatic positions in which figures were traditionally arrayed around Fortune's wheel and the canonical arrangement of the Calvary image! To see this, imagine a *rota* laid over any standard rendition of

Calvary like a palimpsest: Christ, soaring above everyone else, is crucified at the wheel's zenith, while his Old Testament opposite, Adam, lies buried at its nadir; the Good Thief ascends towards heaven on one side, while his opposite, the Bad Thief, plummets towards hell on the other. In other words, the descent forced upon the *misfortunate* man by the wheel's rotation evokes the powerful imagery of the Bad Thief's inversion and 'uncrowning', which some artists developed into the terrifying arched-back and broken-back postures for the Bad Thief (discussed below). The pain of the Cross is merely a foretaste of those infernal torments that await him as the archetypal, impenitent sinner (some artists reinforce the Bad Thief's infernal destination by showing the furnaces of hell blazing behind him).[42] In this context, then, the wheel is more than an allegory: it is at once an instrument of the sovereign's justice (breaker of bones), an agent of providence (destroyer of vanity), a schema with two absolute and two intermediate positions (key to the vertical logic of salvation and damnation) and a moral compass for the spectator's immanent confrontation with Death.

Arched back – broken back

A strange and powerful innovation in the iconography of the Two Thieves appeared in Austrian art, notably in the region of Steiermark, during the first century of Calvary's development.[43] Once developed, it appears to have been transmitted to Germany through Bavaria – not surprisingly, given the close dynastic and cultural ties between the two regions.[44] It also appears later in the work of a cosmopolitan painter whose journeyman's days took him to Austria and then, most likely, through Bavaria as well – one of central Germany's greatest practitioners of the judicial *macabre*, Lucas Cranach the Elder (see illus. 2). I am speaking, of course, about the notorious image of the Thief bent backwards over the *patibulum* of the cross, inverted, in what I call the broken-back posture.

In the church of the upper Austrian town of Halstatt is a mid-fifteenth-century *Calvary*, part of an altarpiece that sets colourful and exotic characters against a gold ground patterned with shooting foliage (illus. 68). An oversized crucifix dominates the upper portion of the panel, symmetrically dividing the cast of characters below into two spatial enclaves. Under Christ's right hand appears the Good Thief, characterized by a clean-shaven youthfulness and the upwards turn of his head (another sign of his immanent redemption is the way the dripping blood approaches his parted lips).[45] Though his arms are immobilized, hooked around the *patibulum* and tied at the wrist, his

legs flex backwards, as if to avoid the chopping thrusts of a boyish executioner wielding a hatchet. Vastly different is the painfully yogic posture of the Bad Thief, slung backwards over the *patibulum*. Given that his legs are also free to move, we might imagine that he has squirmed over the top of his cross on his own accord, writhing to escape the hatchet blows coming from the dark-skinned, turbaned executioner below. Note that the entire manoeuvre begins with the same hooking of arms and tying of hands, though it ends in something quite different. If the figure were not arched over in this way, he would face in the opposite direction, a spatial device which increasingly replaced the motif of the downcast head as a sign of those who die in 'blind' disregard of Christ's divinity. Inverted bodily and thus no longer fully human, the Thief's *vision* is also animalized and debased. As we'll see shortly, this aggressive dehumanizing gesture, seen as a kind of specular disempowering of the punished Thief, may have taken on a special cultural urgency in the popular piety of this region at this time.

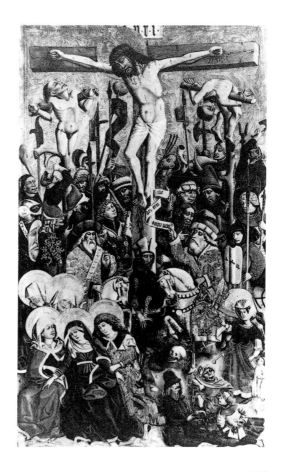

68 Upper Austrian Master, *Hallstatt Altar*, mid-15th century, painted panel from an altarpiece, Parish Church, Hallstatt, Austria.

173

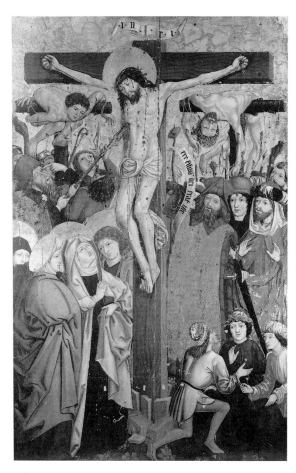

69 Tirolean Master, *Calvary*, central panel from the *Brixener Altar*, 1450–75, 181.5 × 120.5 cm. Tiroler Landesmuseum Ferdinandeum, Innsbruck.

Inversion is the key motif in several other arched-back Thieves in the corpus of late Gothic Austrian painting, and our next example comes from the Tyrol region, the so-called *Brixener Altar*, painted in the third quarter of the fifteenth century and now in Innsbruck (illus. 69).[46] All of the Tyrolean master's figures are conceived in bold, monumental terms and display a facility with anatomy, making the *Halstatt Altar* appear, by contrast, like a fussy manuscript miniature. Bewhiskered, as his counterpart on the *Halstatt Altar*, the Bad Thief here is similarly arched over the *patibulum*; but whereas the posture in the *Halstatt Altar* seemed like so much acrobatic clowning, the Tyrolean artist's command of anatomy lends his figure a quality of athleticism – like a pole-vaulter clearing the bar. This perception cannot last long, however, and the reality of punishment forces itself upon the viewer; a grotesque dislocation of the left shoulder to facilitate the arm's leverage over the crossbar; bloody wounds, inflicted

systematically across legs and arms; ropes to anchor the right arm and leg to a common point half-way down the *stipes*. A shock of horror greets the spectator who realizes that now the figure is immobilized in this awful position: wrist and ankle are tied to the stake at the point of furthest extension for both limbs; while unyieldingly the *patibulum* is shoved up into the lumbar region of the back, flattening the abdomen and pinching the lower ribcage. With the detachment of the right arm from the crossbar, the painter effectively cancels whatever remained of the hooked-arm pose in the Halstatt Master's version. Thus the new prototype becomes a figural repository for a *surplus* of pain, one capable of eliciting a surplus of horror. Perceptually, the ugly 'disarray' of the broken, half-inverted body cannot be escaped. His counterpart is shown crunched over the *patibulum*, folded at the waist as if in a forced squat. What the Bad Thief suffers in aggressive extension, the Good Thief suffers in compression. Furthermore, practically every limb of the Good Thief is bent and twisted around the cross: the left leg is hooked around the front of the *stipes*, and the two arms, one obscenely broken to effect the manoeuvre, spiral around the crossbar away from the body.

Two fifteenth-century Bavarian works will suffice to show the iconographic commonalities with these Austrian exemplars. Earlier,

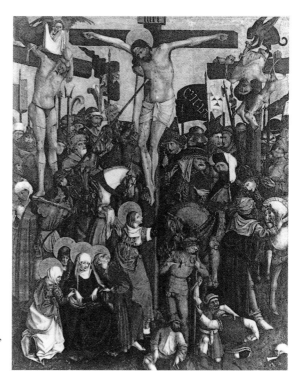

70 Upper Bavarian Master in the circle of Rueland Frueauf, *Calvary*, 1470s, painted panel from an altarpiece, Church of St Leonhard bei Wasserburg.

175

in Chapter 3, I introduced a panel by the Master of the Munich Domkreuzigung, now in the Frauenkirche (see illus. 43), and it is enough here to point to the posture of the Impenitent Thief, which may be derived from the same source as the Penitent Thief in the *Brixener Altar*; the upper body is folded forwards over the *patibulum* and the broken arms are entwined ferociously around it in opposite directions (illus. 78). Improvising, the artist has proceeded by modifying both the hooked-arm pose, in which the *patibulum* normally presses against the back or shoulder-blades, *and* the arched-back pose, in which the figure is normally made to bend backwards. Other visible signs of the criminal's infamy, like the blistery sores which pockmark the body, prove the character's deservingness to be subject to the harshest tortures imaginable.

In upper Bavaria the Austrian model for the inverted, arched-back Thief appears in an altar painted for the church of St Leonhard bei Wasserburg sometime in the 1470s, by a painter in the circle of Rueland Frueauf (illus. 70).[47] Again the contrast between the Two Thieves hinges on a naked *Gestalt*: the Good Thief, characterized as an older man by a downy white beard, hangs straight up and down from the cross, immersed in tragic gloom, his left shoulder dislocated to effect an impossible torsioning of his arm. Meanwhile, the conformation of his counterpart, yet another adaptation of the infamous bearded convict first seen in the *Halstatt Altar*, strikes a more discordant note: are we witnessing a *crucifixion* at all? With even greater malice, the Bavarian painter has clamped the body down tight against the cross – so tightly, in fact, that the ligatures begin to carve into the flesh of the arms. More appalling still are the leg wounds, the swelling of which has deformed the legs into gnarled stumps. We are made witnesses to the moment of death in a body seething with pain: the dying man's soul escapes not from the mouth, but from the exposed guts of his demolished body, only to be captured by a winged demon which crouches, succubus-like, upon the convict's disjointed pelvis. The soul of the elderly Good Thief, in poignant contrast, is flown to safety by a beautiful angel, who nestles it like a newborn infant in a pure white cloth.

With these morbid manipulations late medieval art gave birth to one of its most terrifyingly 'Gothic' and spectacularly squalid images: the crucified Thief, bent so severely over the cross that his back is broken. It is an ambivalent bit of praise indeed that credits Lucas Cranach the Elder with the 'genius' of having carried this image to its final solution. In the Berlin woodcut of *c.* 1510 (see illus. 2) Cranach does away with the last residue of the hooked-arm type (still discernible in the Thief

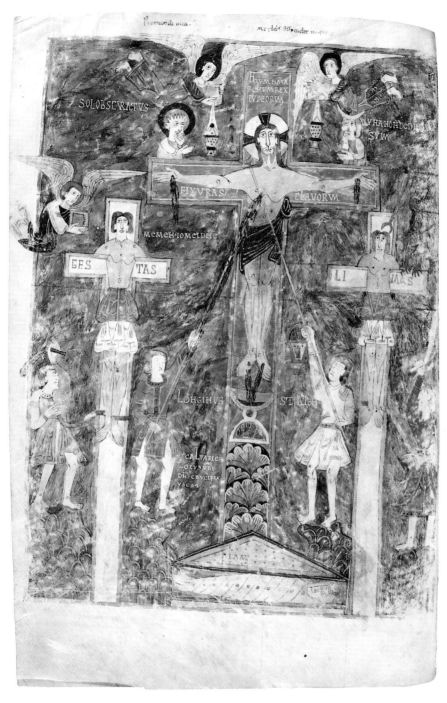

38 'Crucifixion', Kingdom of Léon, probably Tábara monastery, AD 975, illuminated page from Beatus of Lièbana's commentaries on the Apocalypse, tempera on parchment, 40 × 26 cm. Girona, Museu de la Catedral, ACG Ms. 1, fol. 16v.

39 Robert Campin (The Master of Flémalle), *Thief on a Cross*, fragment of an altar wing, *c*. 1428–30, oil on oak, 133 × 92.5 cm. Städelsches Kunstinstitut, Frankfurt.

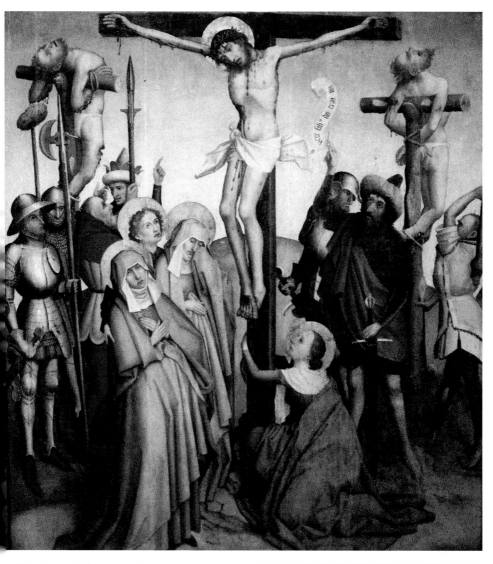

40 The Master of the Sterzinger Altarwings,
Crucifixion, exterior of a *Flügelaltar*, mid-15th
century, painted pine panel, 156.5 × 142 cm.
Staatliche Kunsthalle, Karlsruhe.

41 Detail of illus. 40, showing the legs of
the Thief on Christ's left and an executioner
with a club.

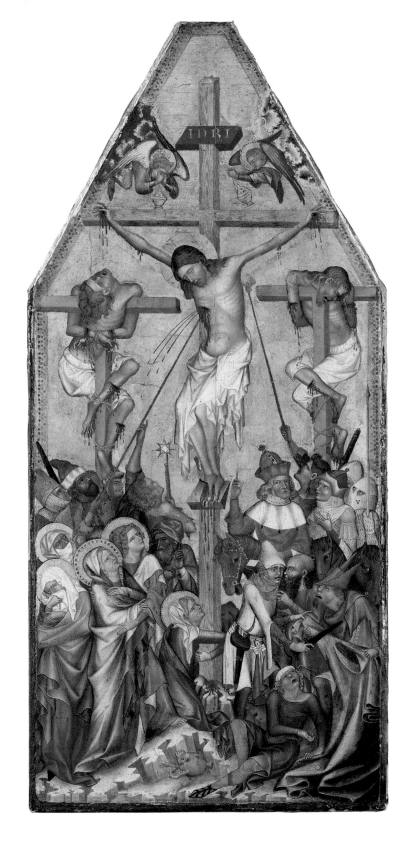

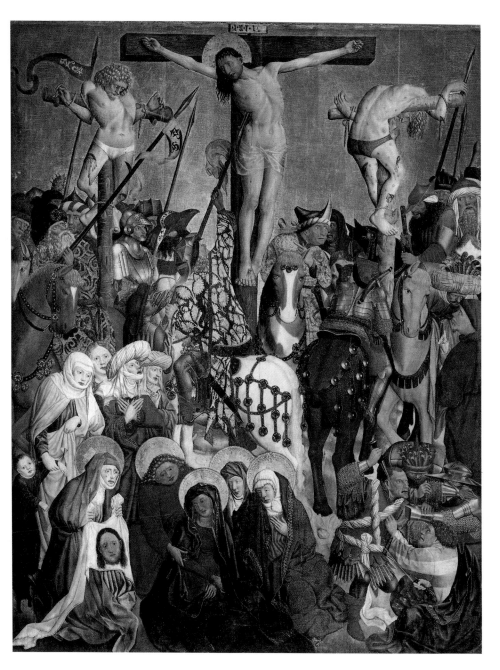

42 Bohemian Master, *Calvary*, central panel of an altarpiece (the so-called 'Kaufmann Crucifixion'), *c.* 1360, painted panel transferred to canvas over panel, 67 × 29.5 cm. Staatliche Museen zu Berlin – Preußischer Kulturbesitz (Gemäldegalerie) (OPPOSITE).

43 The Master of the Munich Domkreuzigung, *Calvary*, Upper Bavarian, mid-15th century, painted panel. Frauenkirche, Munich (ABOVE).

44 Mutilated criminal elevated on a wheel, from the so-called *Book of Numquam*, tempera on parchment, 13th/14th century. Cathedral Library, Soest.

45 Diebold Schilling, Setting up the wheel with the murderer Duckeli in 1492, fol. 218v. from *Luzerner Chronik* (1509–13), 20 × 12.6 cm. Zentralbibliothek, Lucerne.

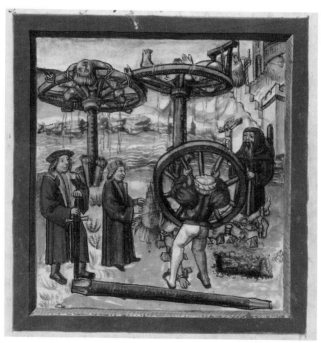

46 Diebold Schilling, Execution by wheel with mutilated criminals on elevated wheels, fol. 280r. from *Luzerner Chronik* (1509–13), 17.6 × 18.6 cm. Zentral-bibliothek, Lucerne.

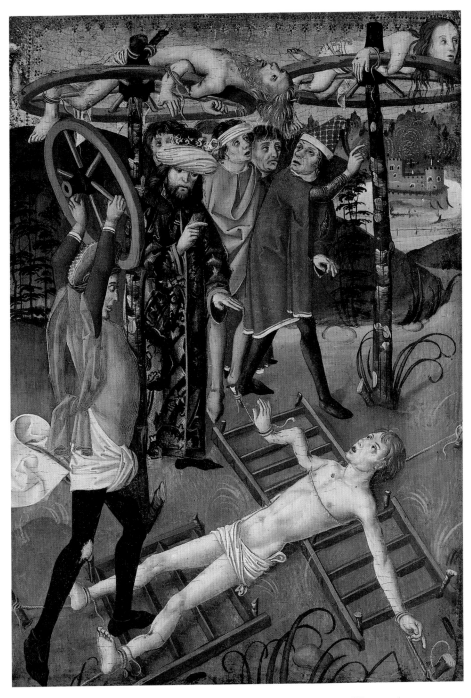

47 Circle of the Master of the Martyrdom of the Apostles, *Saints Felix, Regula and Exuperantius Broken with the Wheel*, Austrian or Hungarian, *c.* 1480, tempera on pine panel, 72.5 × 50.5 cm. Keresztény Múzeum, Esztergom, Hungary.

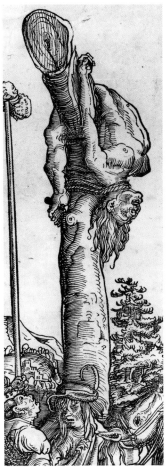

78 Detail of illus. 43, showing the Thief on Christ's left.

79 Detail of illus. 2, showing the Thief on Christ's right.

at St Leonhard's), and snaps the body in two (illus. 79); worse still, in his zeal to fix the upper body flat against the *stipes*, he creates an abominable combination of crucifixion and garrotting that, to my knowledge, has no corollary in the history of punishment or its visual record (another artist who used the arched-back motif and strangled his Thief with ropes is the painter Rueland Frueauf the Younger, who hailed from Salzburg [illus. 72]).[48] Finally, on the opposite side of the *stipes*, the figure's feet are shown nailed down, while the hands are affixed to the *patibulum* in an inverted manner. By immobilizing the figure with such a terrifying combination of technical means, Cranach forces the figure to bend – literally – to the will of the apparatus. His strategy for visualizing pain leaves no room for the kind of agonized,

thrashing gestures most artists used to convey the Thief's pitiable sufferings. By completely erasing any trace of the punished body's resistance to the apparatus, Cranach makes pain coterminous with the technique for producing it.

Before leaving the woodcut to resume our case study, we would do well to ask why the torments detailed above are inflicted upon the Thief stationed at Christ's right side, the space traditionally reserved for the Good Thief. Did Cranach intend for us to read the figure in terms of the traditional antithesis at all? If he has indeed placed the Bad Thief on Christ's right, we are forced to reconsider the theory that the spatial codes of left and right were 'normative' or, as Panofsky put it, 'universally accepted symbolism'.[49] Did Cranach cast aside as so much dead wood the traditional spatial codes of left and right? Or did he, for some reason we cannot yet surmise, endeavour to show worse abuses heaped on the body of the redeemed Thief than on his damned opposite?

The Bad Thief as the punished Jew in medieval south Germany

What cultural factors may have compelled the provincial painters of Austria and south Germany to develop the species of the crucified Thief arching or broken backwards over the cross? To what attitudes, ideas, institutions, practices or local narratives might it correspond? If the aesthetic impact – and cultural value – of realist imagery does in fact depend on a 'continuity' between the world constructed by the image and the world for which it was made, and in which it does its work (to paraphrase Leon Wieseltier), then the first place one would be inclined to look to find connections with the judicial violence of the image is the judicial violence of everyday life. Of course, in a nutshell that describes the idea behind this book. However, to ask the question baldly, does the broken, inverted Thief refer to a judicial practice specific to this region, would be to sell short the cultural logic of late medieval realism. As historical investigators, we will surely identify no specific penal procedures to which this motif can be shown to refer *in its entirety*. On the other hand, it seems that oblique and coded references abound. They are never carried over from reality to image *en bloc*, but crop up piecemeal, as quotidian overlays upon the still-exotic, 'historical' punishment of the cross.

With this said, it may be useful to recall briefly how the imagery of the Two Thieves coded its references to the wheel. First, where wounds appear on the arms of the Thieves as well as their legs, we typically see them distributed evenly over the four limbs, one for each major bone (see, for example, illus. 42, 52). Second, the pivotal works

by the Sterzing (see illus. 40) and Kempten Masters (see illus. 50) conveyed graphically the perception of 'flesh mixed with splinters of smashed bones' in their depictions of the wounds themselves. Third, in the arched-back postures prevalent in Austrian and Bavarian art, surveyed above, we can see an approximation of the position of the broken body elevated on the wheel (see illus. 68, 69, 70); conversely, in Diebold Schilling's miniature for the *Luzerner Chronik* we even see the head of one victim hanging back over the rim of the wheel – that is, inverted in the manner of the Austro-Bavarian Thief (see illus. 46). Fourth, the depiction of limbs twisted and sometimes knotted around the *patibulum* and *stipes* resembles the 'braiding' of the limbs recorded in the historical sources that depict the torture of the wheel (this point needs no further elaboration). Fifth and finally, we see in many Calvary images the executioners, the so-called 'men with clubs' (*tortores*), breaking the limbs of the Thieves *while they are still alive*, albeit suspended upon their crosses and not laid out on the ground (see illus. 41). Compared to other types for the punished Thief, then, the Austro-Bavarian figures contain a more thoroughgoing set of visual references to the physical effects of the wheel, coded and condensed in the historicized language of a 'Roman' crucifixion.

But why does this happen when and where it did? Should we look to a particular historical event or process, a change in the dynamics of judicial or state power, the repression of a particular social or religious group, or some endogenous cultural factor, to explain the peculiar density of penal references found in south German and Austrian Passion imagery? The explanation I'd like to develop requires that we link each of these spheres in a totality. And the key to this linkage is precisely that visual feature which is most insistent, and unique, in the image of the Bad Thief in Austro-Bavarian art: the inversion of the body upon the apparatus. Let us begin there.

In the Middle Ages and early modern period a special mode of hanging, in which the victim was suspended by the feet instead of the neck, was known as the 'Jewish execution'.[50] A number of variations existed. In its most prevalent form two dogs, likewise inverted, were strung up on either side of the condemned. A woodcut from the *Schweizer Chronik*, printed in Lucerne in 1586, depicts such an execution (illus. 80). In judicial practice the two components, inversion and hanging with dogs, appear to have had multiple purposes and rationales. Before the executioner's work commenced at all, judges routinely threatened Jewish offenders with the added infamy and pain such treatment would bring them as a way of pressuring them into a pre-mortem conversion. In Basel, on 24 June 1434, two German Jews

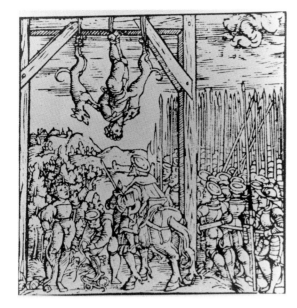

80 'A Jew Hung Upside-
down between Two Dogs',
woodcut from *Schweizer
Chronik* (Lucerne: Hans
Stumpff, 1548; reprinted
by Johann Stumpff).
Mittealterliches
Kriminalmuseum,
Rothenburg ob der
Tauber.

were arrested as thieves, tortured and made to confess their crimes;
afterwards, as they prepared their defence, they were, according to an
eyewitness account, 'urged repeatedly to turn Christian, so as not to
die like beasts'. Of the two men only one accepted the bargain, and was
beheaded for his good sense; the second 'was condemned to be hanged
by the feet with a dog beside him'.[51] Thus, when actually carried
out, inverted hanging carried a double message: it not only evoked
the horror of the sinner who dies 'in blind unbelief', unconverted, un-
repentant and unshriven; it also assimilated the judicial victim to
the realm of the non-human.[52] For this reason, Jews were eventually
hanged on separate gallows altogether, or a special place, known as the
'Jews' pinnacle' was reserved for them. Ferdinand III's *Landesordnung*
for Austria even stipulated, 'In order to distinguish him from the
Christian, the Jew is to be hanged on a special beam extending from
the gallows.'[53] The only comparable degradation for Christians was
the punishment of the sack, reserved for parricides (and later female
infanticides), in which the condemned was bound together and drowned
in a sack with various animals, each symbolizing a different aspect of the
criminal's degeneracy.

Inversion on the gallows and the identification of the malefactor
with animal life therefore went hand in hand; both applied rigorously
to Jews, but their infliction was not exclusive to them. Homicidal
animals, especially pigs (with which Jews were defamingly associated),
were also hung by their rear legs,[54] and Christians guilty of particularly

blasphemous crimes, like arch traitors, might be liable to the 'Jewish execution' or something like it. Conversely, the 'Jewish execution' was not the only penal technique associated with Jewish offenders; the blasphemous character of the Jewish criminal could be signified in other ways. For example, a special 'Jews' hat' (*Judenhüter*), filled with boiling pitch, was to be worn by those Jews broken with the wheel, as well as by those nailed to the gallows in a viciously ironic and literal reference to Christ's crucifixion as 'King of the Jews', a practice which turned, as Rudolf Glanz remarks, 'the obloquy suffered by Christ . . . back upon the Jews in the person of a crucified Jewish criminal'.[55] So there can be no talk of a closed equation between inversion in medieval judicial practice and actual Jewish criminality; nor is it accurate to assume that the execution of all Jewish criminals involved inversion. But there can be little doubt that the dehumanization brought upon the condemned person through inversion, no less than the forced juxtaposition of punished humans with punished animals, was overwhelmingly associated with the execution of Jews.

Supposing now there is a vital homology between our iconographic motif of the broken-back, upside-down Bad Thief and the form – and function – of the 'Jewish execution', why should we find its expression localized in south Germany and Austria? After all, hostility towards Jews, especially Jewish recalcitrance in accepting conversion, permeated Christian communities all across Europe; and equally widespread was the custom of hanging Jewish criminals upside-down.[56] Did this region of the German empire have a particularly antagonistic attitude towards its Jewish populations? And if that was the case, what would it explain iconographically?

The historian Lionel Rothkrug's wide-ranging studies of the regional differentiation in the distribution of pilgrimage shrines throughout Germany in the two centuries leading up to the Reformation provides some decisive clues.[57] Here I can summarize only one relevant strand of his richly woven narrative. Throughout the thirteenth century, Bavaria had been home to an especially fervent type of pilgrimage piety. Beginning *c.* 1300, however, big-time political rivalries began to accelerate the organic growth of this form of folk religion. At this time Pope Boniface VIII inaugurated a far-ranging effort to consolidate a European-wide system of *indulgences* (certifications for 'release-time' from purgatory) 'as a source for popular acclaim of papal supremacy in public affairs'. In response the south German nobility, fiercely loyal to the emperor, began to encourage 'associational forms of worship' like pilgrimage as a way of countering papal claims to universal spiritual authority. According to Rothkrug, this set in motion a 'process of

cultural differentiation' which intensified the contrast between the corporate piety of the south and the predominantly private piety of the north (this split ultimately defined important confessional divisions between Protestant and Catholic Germany). As a weapon against the papacy, then, the south German aristocracy's emphasis on the corporate character of folk piety provided a popular base for church territorialization, integrated 'religious life more closely with territorial identity' and kindled patriotic sentiments at a popular level.[58] As a result, Bavaria became the epicentre for a rapid proliferation of local pilgrimage shrines, some dedicated to Mary, others to local saints, some to Christ himself. The most important of these, the tremendously popular shrine to the Virgin at Altötting (see illus. 61), doubled as the 'central shrine dedicated to the *Heiligen Römischen Reich deutscher Nation*'.[59]

As pilgrimage piety in the south was increasingly shaped by the imperial élites and the *ministeriales* (a quasi-noble class of civil servants that actually outnumbered the old nobility), it became imbued with that class's militant piety and crusading ideology. Their insistence on warlike personae for both Christ *and* Mary – an expression of aristocratic religious ideology that recurred throughout the Middle Ages – agitated a widespread craze for crusade at the popular level. This, in turn, helped incite the earliest mass pogroms in Germany, carried out by veritable popular armies of *Judenschläger* (Jew killers) headed by noblemen. Of course this phenomenon was not entirely novel. Crusading armies since the late eleventh century had slaughtered local Jewish communities – the unbelievers at home – as a prelude to engaging the infidel abroad; and the fourteenth century in general witnessed an intensification of hostility towards Jews, mostly out of suspicions about the Jewish role in bringing about the plague.[60] What is remarkable here is how killing became integral to pilgrimage itself, and nowhere more so than in south Germany. Nowhere more than here, writes Rothkrug, did 'wide-ranging grass-roots movements annihilate entire populations of Jews'.[61]

By the mid-fourteenth century a pattern emerged: fanatical mobs like those led by the Franconian nobleman Rindfleisch or the so-called *Armleders* (named for the leather patches worn on their sleeves), marched into Jewish communities, exterminated the inhabitants and established shrines on the sites of razed synagogues. Where urban populations performed pogroms against their Jews, the resulting shrines were dedicated to Mary, now worshipped as the 'conquering' Virgin (*Siegerin aller Gottes Schlachten*, or Lady Victor of All God's Battles).[62] Numerous municipalities within the Holy Roman Empire

saw the transformation of their Jewish quarters (*Judengasse*) and the conversion of synagogues into Marian shrines accomplished through similar violences; yet the largest concentration of the phenomenon is to be found in Bavaria.[63] Of course the elimination of Jewish communities also meant the cancelling of debts to Jewish creditors and the confiscation of properties, and claims to the property rights of slain or expelled Jews provided an important touchstone for imperial Jewry legislation.[64] For every city 'cleansed' of 'hideous Jewish superstitions' (in the words of a prayer for consecrating a church on the site of a destroyed synagogue), another victory was won by the militant Virgin, whose persecution at the hands of the Jews made her their natural sworn enemy.[65] In the countryside, by contrast, sites of massacres were transformed into shrines to the suffering Christ: 'Country folk slaughtered Jews for Christ; urban populations massacred them for Mary.'[66]

Into the fifteenth century this pattern developed in response to new and ever deeper crises. The worst of these, the calamitous fall of Constantinople to the Turks in 1453, brought the heathen to the gates of Europe and resulted in an 'unprecedented public agitation for crusades'.[67] 'The wish to repel the Turk intensified crusading zeal throughout south Germany, and led people to promote unusual forms of peregrination to enlist celestial forces in their holy war.'[68] Again, Rothkrug's survey of shrines shows Austria, Bohemia, but especially Bavaria to be 'the chief centre where churches and shrines dedicated to the Virgin continued for centuries to symbolize the spirit of pogrom and crusade.'[69] In these regions pilgrimage processions continued to include the slaughter of Jews into the sixteenth century.

Against this backdrop of a militant, *institutionalized* anti-Judaism, manipulated by patriotic élites and integrated into a defining ritual of late medieval folk culture – pilgrimage – the explosive violence of the inverted, arched- or broken-back Thief must have found a deep resonance. Though I want to be cautious about stretching my evidence too far, I want to pose the question directly: did Bavarian painters who developed this particular theme for the Impenitent Thief deliberately cast the figure into the role of the archetypal, punished Jew? What would it mean, in terms of response, for the biblical Thief, 'crucified' on Calvary, to play such a topical role? To focus my interpretation, I will sketch out a few observations about the iconography of the Impenitent Thief in general, and the Austro-Bavarian broken-back Thief in particular.

The first observation takes us back to a typological tradition within the history of the Crucifixion image, namely, the opposition of Ecclesia

(the New Church) and Synagoga (the Old Synagogue), and their correlation, as antithetical figures, with the many other figures and symbols that were split across the right and left 'hands' of the crucified Saviour. Ecclesia made her first appearance in Carolingian art, where she was associated with the chalice, symbolizing the eucharistic 'cup of salvation' of the Psalms.[70] Like so much of the symbolism that accrued to the 'expanded' Crucifixion image in the following centuries, she was eventually paired with an antithetical rival, and between them the historic *altercatio* between Christianity and Judaism was enacted allegorically. From the mid-ninth century onwards, Synagoga is shown being divested of the symbols of her sovereignty, notably her crown, as a symbol of her defeat at the Crucifixion. In the Romanesque tympanum of St Gilles-du-Gard, for example, an aggressive angel knocks the crown from her head as Synagoga careens off balance; and we recall that the pulpit carved by the Pisanos for Siena Cathedral also depicted an angel rudely bouncing Synagoga off Mount Calvary, as if her right to witness the events had suddenly expired (see illus. 19). Elsewhere the related themes of squandered privilege, uncrowning and enforced exile were emphasized by having Synagoga mouth the Lamentations of Jeremiah (5: 16-17): 'The crown is fallen from our head: woe unto us, that have sinned! For this our heart is faint; for these things our eyes are dim.'

Like other paired opposites – Sol (sun) and Luna (moon), or Longinus and Stephaton – the two allegories were fitted into normative spatial positions *vis-à-vis* the Cross: a crowned, triumphant Ecclesia on the right, collecting the blood which geysered from the lance-wound; while an uncrowned and blindfolded Synagoga, clutching her broken lance or the Tablets of Law (or both), is shown grieving on the left. But with the advent of the narrative Calvary image and its novel demand for realistic spatial settings, peopled with flesh-and-blood characters (see Chapter 1), the allegorical figures lost their place. The flesh-and-blood Thieves, whose symbolic antithesis was long established in the same iconographic tradition, were henceforth enlisted to do double duty, as it were, their antithesis slowly augmented to include the symbolism of New and Old Covenants.

It is therefore not difficult to see the Bad Thieves of late medieval art, punished, despised and rejected beyond redemption, as an embodiment of the Old Synagogue and hence of Judaism in general. Through them, inversion serves as a figurative uncrowning, a demonstration of Jewish self-exile and blindness. One supposes that the image could only have gained in intensity in periods which saw feelings of hostility towards Jews mount. Hostile unbelief was also, as we recall, a central theme of the scriptural traditions surrounding the Bad

Thief's crime. It was the core idea in Luke's dialogue; it carried over, in various inventive ways, into the visual tradition as the Bad Thief's wilful refusal to gaze upon Christ; and finally it was, I suspect, imbued with a polemical assertion of the Synagogue's blindness to Paul's 'message of the Cross'. Indeed, Judaism's refusal to recognize its *own* God, its conspiracy to commit *deicide* (a term invented by Christians for polemical purposes), and its wilfulness in perpetuating its own exile and suffering formed the longest-running themes of late antique and medieval Christian writings, providing something like a baseline rationale for actual and symbolic violence against Jews in Western nations into our own era.[71]

It may have been for these reasons, and as a dramatically convincing expression of the theme of Jewish blindness, that artists like the Bavarian author of an altar panel in Esztergom, Hungary (illus. 73), the Master of the Munich Domkreuzigung (see illus. 43), and others strove to produce a kind of *enforced* occlusion of the Thief's vision of Christ by either turning the flanking cross in the opposite direction or immobilizing the figure in such a way as to make the gaze impossible. The problem of Jewish 'blindness' is even more starkly confronted in the Austro-Bavarian tradition's motif of inversion, where Jewish 'vision' is shown to also be inverted, perverted, diabolical and dangerous. And what the artist, together with his audience, perceives as dangerous – Jewish ocular contact with the crucified Saviour – he suppresses and punishes with all the means at his disposal.

The charged relationship between human vision and the sacramental *corpus Christi*, both in and outside the image, has a history, and it is possible to find regional inflections that once again point to the imperilled situation of Jews in south Germany and Austria. In 1311–12 the Church Council at Vienne gave official sanction to the Feast of Corpus Christi, first celebrated in the city of Liège in 1246. Devoted to the cultic veneration of the sacramental body of Christ in the Eucharist (the host), the feast spawned new liturgical practices, dramatic forms, iconographic formulas and especially processions as it spread into the German diocese towards the century's end.[72] Perhaps the most decisive liturgical change that followed in the wake of the feast's popularization was the *elevatio* ceremony, in which the priest raised and displayed the consecrated host for the congregation during Mass. The ceremony's *visual* component can hardly be underestimated, even though its importance was augmented in other ways: bells were rung, incense was burned, backdrops and candles deployed to make the 'visual theophany' in the Mass as dramatic and multi-sensory as possible.[73] But so potent was the mere *sight* of the consecrated host in

popular perception that this kind of 'ocular communion' made the actual ingestion of the host superfluous for most churchgoers. Gazing upon the host activated its salvific powers for a variety of other purposes; from it one could be protected against sudden death, and those too sick to swallow the wafer were encouraged to gaze upon it, a practice called *Augenkommunion*. These perceptions and practices are especially well attested in south Germany.[74]

The increasing importance of the *elevatio* ceremony fortified not only the belief in the salvific powers of the host but also the perception that the gaze constituted a form of communion, a quasi-physical act of 'touching' the body of Christ that activated the powers it contained. And this had dire consequences for Europe's Jews. Rothkrug explains:

The novel public exposure of the Host, making it suddenly visible and more available to entire populations, created anxiety everywhere over its possible desecration, particularly by Jews . . . Rindfleisch and his supporters set out on their murderous expedition, spurred on by reports that Jews has 'stabbed, hammered and pierced' the Eucharist, and then had thrown the Lord's body into a river, with entire stretches of the stream turning red from His blood.[75]

Accusations of Jewish host desecration, like the allegations of the murder of Christians for Jewish 'blood rituals', span the late Middle Ages and are not a peculiar feature of German anti-Judaism (though it is noteworthy that the south German cult of the *schöne Maria* developed in the midst of several widely publicized ritual murder and host desecration trials).[76] Of particular relevance here is the preponderance of shrines dedicated to the miraculous 'bleeding host'. From the fourteenth century onwards, many of these occupied sites of alleged host profanation or ritual murder by Jews, and shrines like Wilsnack developed into major centres of regional and transregional pilgrimage.[77] And almost all of the rural south German shrines dedicated to Christ, founded in the aftermath of pogroms, were sites of supposed host desecration. A survey of places of alleged host desecration conducted by the Jesuit scholar Peter Browe revealed that, of 47 accusations made between 1220 and 1514, massacres accompanied 22 instances, and all but two of these occurred in Germany or were incited by Germans; of these, sixteen occurred in Bavarian south Germany and Austria. Rothkrug concludes, 'The accusation is almost a uniquely German phenomenon, overwhelmingly confined to Bavarian south Germany and Austria.'[78]

My inference from all of this is that in shrines where the *corpus Christi* was exposed and offered to communicants, pilgrims, even if

they weren't involved in pogroms, would have felt some of this anxiety about Jewish desecration when gazing upon the host. The tacit privileging of what we might call ocular communion over direct physical access to the Host through ingestion may also have fuelled Christian paranoia about the nefarious magical opportunities now open to the host-desecrating Jews. And this anxiety, I suggest, may have extended to the altar-painter's re-creation of Christ's historic self-oblation on Calvary, which normally served as a cultic and pictorial backdrop to the liturgical re-enactment of that same sacrifice. If Jews had to be barred from the church to prevent them violating the host physically, or profaning it with the quasi-tangible 'rays' emitted by the 'evil eye', all the more reason to show the unrepentant Thief, the blind, punished Jew, either forcibly restrained against ocular contact with the body of Christ *or inverted*, in order to inscribe upon his sinful body the painful consequences of his disbelief, and to demonstrate the upside-down, bestial nature of Jewish perception. For the painter to remove the Thief from eye contact with Christ condemns him to die as an animal and 'a Jew'.

The Thief's atrocious death agony could thereby become a screen upon which anxious Bavarian and Austrian pilgrims to important shrines might project some of their pogromist fury *while* piously worshipping the crucified Christ and anticipating the theophany in the sacrament. Whether the depiction of a 'Jewish execution' on Calvary functioned psychologically to gratify, or to further aggravate, such hostilities, or whether the half-imaginary punishment of the painter's *mise-en-scène* defused or ignited actual violence against Jews, cannot be known. Certainly the 'Jewish execution' itself excited extraordinary hostilities towards the condemned: 'Whenever a Jew rejected conversion and persisted in reviling the Church and its symbols, that authority was forthwith invoked to inflict upon him tortures of so vindictive a kind that it could no longer pose as an agent of purely cathartic punishment.'[79] Was it likewise for the painter who 'authorized' a particular visualization of the events on Calvary? Within the frames of the Passion altarpiece, did the painter makes a pre-emptive strike, so to speak, against the sacrilegious Jews by embodying them in the horrific image of the punished Thief? Was there such a thing as a 'pogromist pilgrim', for whose imaginative journey to Calvary a purifying path had first to be cut through Jewish bodies? Was the spectacle of the broken, upside-down Impenitent Thief a comfort, or a provocation?

Conclusion

In these explorations I have tried first to lay to rest certain myths about the wheel's purpose, origins and meaning. Doubtless the survey is far from complete, and perhaps I have inadvertently created new myths. In assessing the wheel's meaning for medieval people, I have steered interpretation away from the dubious claim that Germanic pagan sacrifice had implanted a cosmic symbolism inside the form and function of the wheel, a symbolism that somehow remained in force throughout the Middle Ages. Instead I have pointed first to the multiplicity of forms and appearances of 'the wheel' in medieval hagiography and its associated pictorial traditions, and second to the allegory of Fortune's wheel, which I believe furnished the medieval imagination with a more suggestive set of symbolic associations for the wheel when seen as a judicial weapon. Would it be going too far to say that, in popular perception, the rotary allegorization of misfortune made complete sense only when juxtaposed with its concrete, judicial analogue? Symbolic homologies and collective perceptions about them never remain fixed for long.

I have also attempted a more layered reading of one notoriously violent interpretation of the Bad Thief's crucifixion: the broken-back motif found predominantly in Austria and south Germany. To speak of painters consciously encouraging their audiences to partake in atrocities, real or imagined, will strike some readers as an extreme position for interpretation to take. No doubt it will also trouble those who wish to idealize all artists as the worthy members of a great transhistorical confraternity (to paraphrase the art historian Meyer Schapiro), committed by vocation to the moral-spiritual goal of giving visible form to truth and thereby advancing the cause of humanity. Admittedly the inverted Thieves of late medieval Austria and Bavaria, and their coincidence with the region's distinctively virulent outbreaks of crusading anti-Judaism, represent something of a unique case in both cultural-historical and art-historical terms. Uniquely ferocious, but not anomalous. For despite the antagonistic extremes of violence they project, these artists do not exceed the tacit understanding, common to all 'dialects' in the language of late medieval realism, about what kinds of mayhem may be inflicted upon human bodies subject to this 'ancient' penalty.

Paradoxically, even these stranger permutations had to maintain, perforce, a resemblance to crucifixion, a penalty for which neither artist nor audience could ever have had firsthand experience. We

have seen that the arched-back form of crucifixion, reserved for the Thieves, seems to have satisfied this need for an alternative that was both invested with an air of historical authority *and* familiar for the multiple ways it encoded the procedures and effects of the wheel. But what were, exactly, the parallels that existed between crucifixion and the punishment of the wheel that made these kinds of imaginative assimilations not only possible but also desirable and effective as realist devices? Having examined the techniques and procedures of the wheel, its judicial applications and symbolic associations, we can now turn to the question of the *phenomenological* parallels between the wheel and crucifixion.

6 The Cross and the Wheel

> But what sort of life is a lingering death? Can anyone be found who would prefer wasting away in pain, dying limb by limb, or letting out his life drop by drop, rather than expiring once and for all? Can any man be found willing to be fastened to the accursed tree [*infelix lignum*], long sickly, already deformed, swelling with ugly tumours on chest and shoulders, and draw the breath of life amid long drawn-out agony? I think he would have many excuses for dying even before mounting the cross.
>
> SENECA, *Epistle* 101.14

Crucifixion by any other name

In ancient Roman law crucifixion was the supreme penalty, the *summo supplicio*,[1] and evidence from the third century CE suggests that its use was widespread and frequent throughout the empire. Yet within the space of a century, several fourth-century Church historians tell us, the penalty fell into desuetude, as Christian emperors from Constantine onwards realized the confusion that would result when slaves and enemies of the state were made to resemble the Saviour as they endured this 'most wretched of deaths', to use Josephus's knowing phrase.[2] Once declared obsolete by Christian authorities, its disuse as a penal sanction became one of the great, unspoken commitments of a civilization that has otherwise given free reign to its penal ingenuity. There is one famous instance in which a form of crucifixion was inflicted on a high-profile criminal in medieval Europe: in 1127 Louis the Fat sentenced a man named Bertholdo to be crucified for the murder of Charles le Bon, Count of Flanders, although its implementation was different from the procedures of Roman crucifixion as we understand them today, and evidently derived from the infamous form of punishment reserved for Jews and occasionally meted out to those guilty of *lèse-majesté*.[3] Thus, of all the penal methods represented in the bloody religious art of the Middle Ages and early modern period – from decapitation to disemboweling, boiling in oil to breaking with the

wheel, burning, hanging, flaying, sawing in two, impaling and dismemberment – crucifixion stood at the greatest temporal remove from the lived experience of Europeans. Even flaying and sawing in two, which were both ancient penalties and not a regular part of the medieval executioner's repertoire, did not disappear entirely in the sixteenth century.[4] Upon what authority, then, could late medieval painters render the physical effects of crucifixion with such stunning – and horrifying – specificity?

In earlier chapters we explored the peculiar logic of late medieval devotional culture, emphasizing the myriad impulses it gave to painters to conceive of the Passion as an omnitemporal experience or a 'perpetual event', one in which the 'historic' deaths of the Two Thieves could be framed most compellingly in terms of judicial procedures familiar to everyone. Painters, patrons and ordinary people shared an understanding of the importance of exercising the faculty of imagination in repeated visions of Christ's Passion, the centrepiece of devotional meditation; they also shared a living experience as spectators in the theatre of public punishment. By appealing to these shared experiences, artists could, with confidence and even a measure of authority, assimilate the (pictorial) image of the Thief's crucifixion to the (spectacular) image presented in the rituals of justice. And the punishments they chose to *simulate* crucifixion were the ones that most nearly approximated its effects: hanging and breaking with the wheel.

Hanging and breaking with the wheel. How can we say which was the more decisive as a judicial source for late medieval 'crucifixion realism'? Readers know that I've given the wheel the greater share of consideration; but it would be a mistake to be absolute about this, for certain auxiliary motifs in the iconography of the Thieves are, in fact, better explained in terms of hanging and its procedures. The motif of the executioner hauling the distraught Thief up the ladder backwards, which we saw in the middle Rhenish Passion altar now in Frankfurt (see illus. 5, 9), is a prime instance in which an artist evoked a procedure specific to hanging, and others will become apparent in this chapter. My reading of the Thief imagery in Chapters 3 and 5, however, tells me that the wheel provided a much more fruitful source, especially for the Flemish and German painters who are the prime focus of this study. When Samuel Edgerton, the first art historian to approach the relationships between art and punishment, first ventured a hunch about the judicial sources for the Two Thieves, he offered this qualification: 'In Italy where "breaking on the wheel" was not in common practice, public hanging provided the only comparable source for Crucifixion realism.'[5] Of course, his observation, which goes a long

way towards simplifying the problem of judicial sources in Italian art, only steers us towards a greater complexity when we turn to the art of Germany, where both punishments were employed concurrently.

Breaking with the wheel and crucifixion: to be sure, important differences separate these two historically distant forms of punishment – the organization of their techniques, the structure of their apparatuses, their effects upon the body and thus their means of producing pain and causing death. It also goes without saying that the two penalties were employed, and became meaningful, within quite different legal systems and under vastly different cultural circumstances. Nevertheless, I'd like to suggest that the two penalties share a great deal in common. To make these commonalities available to perception is no easy task; historical reconstruction cannot extend to the experience of witnessing these horrendous tortures, and most readers will be justifiably glad this is so. And yet that is precisely what we need to apprehend: not the juridical concept or sacred symbolism embedded within each penalty, but rather their *phenomenological* properties, the visible features that spectators could perceive as unique to that penalty. These cues to sensible experience, revealed in the unfolding of a deadly dynamic between executioner, victim, apparatus and weapon, are the keys to each penalty's peculiar power to elicit a response.

Ancient sources on crucifixion are instrumental if we want to grasp this phenomenological relationship ourselves. They show us that crucifixion, as practised by the Romans, was remarkably similar to the wheel in four key respects: both involved some kind of torture before and sometimes after the body was affixed to the apparatus; both involved exposure to the elements and thus produced a pain intensified by its prolongation; both left the executioner a certain procedural latitude in affixing the body to the apparatus (we have seen how artists play the executioner's role by arranging limbs according to their 'expressive' inclinations); and both brought about a dire and irrevocable social disgrace, a form of legal infamy, upon the condemned and also his family. Each of these effects will be unearthed in turn. What we find is that the medieval artist's contemporizing solutions for presenting the Thief on the cross – wounded and writhing in pain, dislocated or immobilized – were remarkably consistent with what ancient texts tell us about crucifixion. Surely, though, it would be a mistake to consider the textual source material I will call upon here as any kind of direct influence for medieval artists. Painters, in my view, applied themselves to exploiting the surface *simulations* which existed between the two punishments, developing their most horrific effects out of a kind of

synthetic intuition of the concrete parallels that could be drawn between them. These parallels, I suggest, made the medieval spectator's *experience* of the wheel a kind of living *Döppelganger* to the dead memory of Roman crucifixion.

'The most wretched of deaths'

> I'll give a talent to the first man to charge my cross and take it, on the condition that his legs and arms are double-nailed. When this is attended to he can claim the money from me cash down.[6]

The cheeky gallows humour expressed by the Roman slave in the writings of Plautus (*c.* 250–184 BCE) is one of the rare examples of ancient writers finding room for jest on the subject of crucifixion. Most approached it as one would an unspeakable family secret. Therefore we have been left with few detailed descriptions of crucifixion or the procedures surrounding it outside the Passion narratives of the Gospels, which are, as we have noted, infuriatingly sparse.

A remarkable multiplicity of terms existed in antiquity to describe the penalty, further testimony to its shameful, taboo nature. The Old Testament refers to the cross as 'a sign of shame' (Hebrews 12.2); Latin writers call it the 'infamous stake' (*infamis stipes*), the 'criminal' or 'barren wood' (*infelix lignum*), and the 'terrible cross' (*maxuma mala crux*) among other appellations. Cicero (d. 43 BCE) considered crucifixion the 'most horrendous torture' (*crudelissimum taeterimumque supplicium*). Even the word 'cross' (crux) itself aroused fear and loathing; it was apparently used as an abusive taunt among the lower classes from the third century onwards.[7] And when it came to the belief – the 'pernicious superstition' (*exitiabilis superstitio*) is how Tacitus mockingly put it – that a man whom the Romans had nailed to the 'fatal wood of the cross' (*crucis ligna feralia*)[8] as a state criminal was in fact the Son of God, this was nothing but folly and madness! 'What drunken old woman,' asks one writer, 'telling stories to lull a small child to sleep, would not feel ashamed of muttering such preposterous things?'[9]

According to classical sources, crucifixion was a mode of execution belonging to 'barbarian' peoples: the Egyptians, the Indians, the Assyrians, the Scythians, the Taurians, the Celts (and later the Germani and Britanni, who may have adopted it from the Romans and combined it with their own forms of punishment), the Numidians and Carthaginians, from whom the Romans probably learned it.[10] It was also known among the Jews of the Hellenistic Hasmonean period.[11] However, most books on the subject, following the evidence in Herodotus, attribute its

invention to the Persians, whose customs also included stoning, drowning, strangulation, boiling in oil and impalement.[12] Thus it may have been from their arch rivals the Persians that the Greeks learned it, though it never became – according to their own authors – a typically Greek penalty.[13] Evidence from the third century CE suggests that crucifixion was widespread as a penalty in the Roman empire, even though the negative attitudes towards it, which marked the preceding centuries, had not diminished.[14]

In the collected works of the jurist Julius Paulus called the *Sententiae* (300), Roman law constructed a hierarchy of punishments, beginning with decapitation (*decollatio*), then burning (*crematio*), and with crucifixion (*crux*) at the head. Other aggravated punishments such as being thrown to wild beasts (*damnatio ad bestias* or *bestiis obici*) often rivalled crucifixion because they could also serve as spectacular entertainments. As far as spectacle goes, however, crucifixion's advantage was that it could be carried out almost anywhere, whereas the *bestiis obici* required a city arena.[15] Crimes punishable with the cross included inciting rebellion, desertion, betrayal of state secrets, murder, prophecy about the welfare of rulers, 'nocturnal impiety' (*sacra impia nocturna*), involvement in the *ars magica* and the falsification of wills.[16] As this list shows, crucifixion had a significant political dimension. Martin Hengel explains: 'Crucifixion was already . . . the punishment for serious crimes against the state and for high treason among the Persians, to some degree in Greece and above all among the Carthaginians. That is, it was a religious-political punishment, with the emphasis falling on the political side.' Because of its severity and its spectacular nature, it was employed as a means of wearing down the resistance of cities under siege, of 'breaking the will of conquered peoples and of bringing mutinous troops or unruly provinces under control'.[17] Like the wheel and other exceedingly brutal sanctions promoted by medieval jurists, crucifixion was considered by the Romans to be the supreme deterrent and was, as a rule, carried out publicly. In many ways, then, it emblemized the ruthlessness of Roman imperial state power.[18]

But most of all, crucifixion was regarded by Roman writers as a punishment for slaves, and its first uses among the Romans may have been in this area of penal law.[19] It is no coincidence that Plautus, the first to give literary evidence of Roman crucifixions, also described the life of slaves more vividly than any other writer. According to him, crucifixion had been carried out upon slaves 'from time immemorial'.[20] The famous revolt led by Spartacus ended in the crucifixion of more than 7,000 escaped slaves, whose bodies lined the Appian Way.

81 'Alexamene worships his god!', anti-Christian graffito from the Palatine, Rome, early 3rd century.

Little wonder, then, why crucifixion as a literary motif became such an effective polemical weapon against Christianity in the hands of Roman writers – and graffitists! An extraordinary document of the mockery heaped on Christian belief is a blasphemous caricature of the Crucified with the head of an ass, inscribed upon the walls of the Palatine in Rome, in what was formerly a barracks (*paedagogium*), in the early third century (illus. 81). Astride the cross stands a man who is either praying or cursing the splayed hybrid, and beneath them both are scrawled the words, 'Alexamene worships his god!'[21] The taboo nature of the cross, its aesthetic repulsiveness and the real social disgrace it brought upon its victims (discussed below) were apparently well understood by all the classes. The negative reaction to Paul's preaching among intellectuals in Roman society was, for this

reason, practically inevitable, and the contemptuous attitude towards crucifixion itself continued into the anti-Christian polemics of late antiquity.[22]

Cross and wheel: Duration and variability

Now it is time to bring together the strands of our separate reconstructions – of ancient crucifixion and the medieval punishment of the wheel – in the phenomenological relationship that, I have argued, made the latter such a compelling model for the former in the late medieval imagination. There are two key parallels I want to establish. The first can be introduced by this passage from Elaine Scarry's excellent book, *The Body in Pain*:

> The cross is unusual among weapons: its hurt of the body does not occur in one explosive moment of contact; it is not there and gone but there against the body for a long time. The identification is steady. More important, the cross, unlike many weapons, has only one end: there is not a handle and blade but only the blade, not a handle and lash but only the lash. Though like any other weapon it requires an executioner, the executioner's position is not recorded in the structure of the weapon itself. The fact of bodily pain is not here memorialized as the projected facility of another's power . . .[23]

In this analysis Scarry's first critical observation, that pain's locus is in the prolonged 'identification' of the body and the apparatus, corresponds precisely to the emphasis Seneca (d. 65 CE) gave in his grisly evocation of the crucifixion victim's inexorable suffering (see the epigraph for this chapter). Pain's prolongation, its duration, makes the unspeakable pain of wounding the unimaginable pain of living out its gruelling aftermath. Upon the cross the condemned wages a battle against his own body, rising up against the forces of gravity and the pain of his perforated members in order to expel air and alleviate cramping, only to fall back down again from exhaustion. 'The whole agony was thus spent in an alternation of sagging and then of straightening the body, of asphyxia and of respiration,' according to the surgeon Pierre Barbet.[24] So we find that all three writers agree: it is, in a word, *time* that inflicts the worst agonies upon the crucified. Roman as well as medieval European jurists drew a distinction between modes of punishment in which natural forces (such as fire, water, wild beasts) were unleashed upon the malefactor and those which are the direct outcome of human agency (such as decapitation). Natural forces do not kill instantaneously, but partake of their sister element, time. It is surely no coincidence that Roman law reserved punishments in the first category for the lowest elements in Roman society (*humiliores*), and those in the second for upper-class offenders (*honestiores*); the

social distinction between honour and dishonour in death remained in force throughout the Middle Ages and early modern periods. Indeed, not until our own era did 'instantaneous' death cease to be the sole preserve of élites.

Furthermore, in crucifixion the duration of suffering could be, and apparently often was, manipulated by those ordering or carrying out the sentence. Some kind of torture normally initiated the execution of the sentence, and the extent and severity of it could actually shorten the time it took for the victim to expire on the cross by diminishing his physical resistance. That flagellation – the norm in Roman practice – caused blood to flow in streams, as it may have in Jesus's case, and that this may have reduced the time it took for death to claim its victim (recall that Jesus expired rather quickly, three hours according to Barbet),[25] even made it possible for contemporaries to view such preliminary bloodletting as an expression of mercy! Alternatively, when ropes were used as a different method of fastening, there was no haemorrhaging, resulting in a longer time of survival. For these very reasons, when hanging finally replaced crucifixion in the course of the fourth century, Christian writers recognized it as an essentially more humane punishment, although death was still far from instantaneous. 'But hanging is a lesser penalty than the cross,' according to Isidore of Seville (d. 636), 'for the gallows kills the victim immediately, whereas the cross tortures for a long time those who are affixed to it.'[26]

Breaking with the wheel, which normally entailed exposure to the elements after the demolition itself, often depended on duration to extract the maximum amount of physical agony. Like crucifixion, the time involved in the ensuing display of the body could probably be managed, by an experienced and knowledgeable executioner, through careful attention to the effects of the blows; it could also be minimized or eliminated altogether, as when mercy dictated that the *coup de grâce* be delivered before exposure, or before breaking itself. Furthermore, the nature of the wheel's *secondary* contact with the body, to use Scarry's terms, is like that of the cross, continuous and deadly; medieval painters made much of the opportunity to present the Two Thieves grotesquely deformed around the beams of their crosses, an arrangement that approximated, in some rather specific ways, the braiding of limbs into the spokes of the wheel.

By contrast, the gallows, as the main apparatus for hanging, never make direct contact with the body. Prior to the modern era, when the method of dropping the body through a trap door to snap the neck was developed, hanging victims died of slow strangulation. A series of sketches in the upper portion of a drawing by Antonio Pisanello,

82 Pisanello, *Study of Hanged Men*, *c.* 1437, pen over metalpoint, 283 × 193 mm. British Museum, London.

completed *c.* 1437, appears to show the stages through which the hanging victim slowly succumbed to gravity's pull (illus. 82).[27] In doing so the drawing also reveals, intentionally or not, what may have been central to the spectatorial fascination – and anxiety – surrounding hangings: namely, the difficulty spectators would have had in gauging the precise moment of death as they watched.[28] A similar anxiety may

have infected those who observed or attended the condemned as they languished in their final hours upon the cross, and on the wheel.

More explicit about the grotesque effects of hanging on the entire body are the representations in a German 'defaming picture' (*Schandbild*) from the sixteenth century, now in the criminal justice museum in Rothenburg (illus. 75). Intended to dishonour malefactors who had managed to elude arrest and escape actual punishment, such broadsides not only visualized the punishments that would have been inflicted on the person had they been caught, but also vicariously harm that person both by depicting the insulting treatment (detailed accounts of their offences accompany the images) *and* by enacting their tortures magically, *in effigie*.[29] Alongside several lifeless figures hanged upon a dead tree and a gallows, an executioner has just given a fourth *Gehenkter* the fatal shove from the ladder, whereupon the dying man, far from dead, kicks futilely into the air.

A second element which made crucifixion for Cicero 'the most horrendous torture' is the element of variability. Recall the multiplicity of terms used by classical writers to refer to the penalty; this not only bears testimony to its taboo nature among the Roman cultural élite, but also offers a striking linguistic parallel to the multiplicity of techniques that executioners, who were usually soldiers, could employ when carrying out the execution. In Martin Hengel's studied opinion, crucifixion 'was a punishment in which the caprice and sadism of the executioners were given full rein'. Seneca describes this gruesome variability in his *Dialogues*: 'I see crosses there, not just of one kind but made in many different ways: some have their victims with head down to the ground; some impale their private parts; others stretch out their arms on the gibbet.'[30] And Josephus, in his description of the fate of Jewish fugitives in the aftermath of Titus's siege of Jerusalem, notes with horror the sadism of the soldiers, who, 'out of the rage and hatred they bore the prisoners, nailed those they caught, *in different postures*, to the crosses, by way of jest, and their number was so great that there was not enough room for the crosses and not enough crosses for the bodies'.[31]

The element of variability foils any attempt to reconstruct archaeologically a normative procedure for crucifixion, even for the Roman empire, where its use was systematic. It is also a feature of the penalty that can be inferred neither from the apparatus alone nor from the earliest surviving visual representations in Christian art, which are so burdened theologically as to make them, in this regard, archaeologically useless.

And yet, despite several centuries' visual misrepresentation and the theological standardization of Christ's Crucifixion, we find artists in

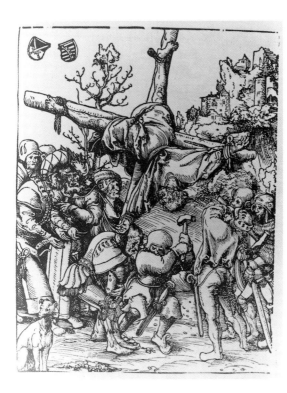

83 Lucas Cranach the Elder, *Martyrdom of Peter*, c. 1512, woodcut, 163 × 126 mm.

84 Hans von Geismar, *Crucifixion of Bartholomew*, panel from the *Bartholomew Altar*, 1500, mixed media on oak, 155 × 88 cm. Niedersächsisches Landesmuseum, Hannover.

the later Middle Ages returning to the idea of variability, and not only in the iconography of the Two Thieves. Crucifixions appear prominently in medieval saints' lives like the *Golden Legend*; the Apostles Peter, Andrew, Philip and Bartholomew all suffered a form of it, and the diversity writ large in the textual traditions was directly translated into images. In the *Golden Legend* Peter, the 'Prince of the Apostles', taunted his persecutors with the self-abasing demand, 'Crucify me head downwards, for I am not worthy to die as my Master died', and numerous artists obliged him as eagerly as the truculent Nero.[32] In the fifteenth century Massacio, Hans Holbein the Elder and Michael Wolgemut each envisioned Peter's inverted crucifixion literally (the *quattrocento* master even uselessly equipped the cross with a footrest); but Cranach the Elder, in a woodcut series of c. 1512, shows the saint bound diagonally to a timber cross with ropes (Massacio used nails), cartwheeling across the picture space as knaves position and stake the apparatus into the ground (illus. 83).[33] In 1500 Hans von Geismar, a master from Göttingen, painted a *Crucifixion of Bartholomew*, the second in a four-panel cycle of the apostle's legend, for the Marktkirche in Einbeck, in lower Saxony (illus. 84).[34] Here too we find the Apostle inverted; what is more, Geismar has apparently appropriated

the arched-back type for the crucified Bad Thief, so prevalent in Austrian and Bavarian painting of the preceding century (see Chapter 5). But his cue for this may have come from the *Golden Legend* itself, where Jacobus relates the opinion of St Dorotheus, who believed that Bartholomew 'preached the faith in the Indes, and . . . died at Albana, a city of greater Armenia, being crucified with his head down'.[35]

No detailed correlation of textual sources and iconographic precedents is needed here to illustrate my basic point: namely, that artists did not have to look far in order to discover the existence of *alternative* modes of crucifixion in the ancient world. The legends and imagery of the crucified Apostles alone would have convinced painters and beholders that the same penalty Jesus suffered in Jerusalem, under Pontius Pilate, during the reign of Tiberius, could be carried out in diverse ways, even by the Romans.

So too could the procedure of breaking a man with the wheel. Although caprice, sadism and 'improvisation' were patently *not* part of the carefully prepared judicial scripts in the Middle Ages, it is hard to imagine – in both senses – how the procedure of breaking a person's limbs, braiding them between the spokes of a wheel and hoisting the resulting amalgam of body and apparatus upon a pole could possibly produce the same results twice. Given the penchant among medieval spectators for 'reading' the gestural language of the punished body, we can only assume that the variables produced by the wheel – and thus its variability in general – were apprehended and remarked upon. Such a basis in experience, combined with a mental disposition to look at these things *at all*, would have, I think, enabled medieval artists and their audiences to infer far more about the possibilities and limitations of Roman crucifixion than we can today, even with the archaeological data at our disposal. That some scholars have discerned in the early imagery of the Two Thieves a 'kernel of historical truth' with regard to the diversity of methods once used points to the *visual* tradition as possibly the great, unacknowledged repository of ancient memories of an obsolete penalty.

The body of infamy

After the introduction of universal Roman citizenship by Caracalla, the class bases of Roman penal law became fully transparent.[36] While the aggravated penalties of *crux*, *ignis* and *bestii obici* were meted out almost always to criminals from the lower class (*humiliores*), *decollatio* emerged as the honourable punishment, reserved for upper-class citizens (*honestiores*), who could suffer it with no loss of status (it remained

the preferred form of execution for upper-class offenders through the Middle Ages). The bands of highwaymen and notorious robbers (*famosi latrones*) who terrorized the countryside in the Roman provinces were, once caught, often crucified collectively (Roman jurists thought it wise to do this at the scene of the crime); this way they would also be exposed to the contempt of the people, who were generally grateful when their governors dealt mercilessly with such outlaws. Thus not only did crucifixion serve as a means of protecting the populace against violent criminals, but because 'the robbers often drew their recruits from runaway slaves, abhorrence of the criminal was often combined here with disgust at the punishment meted out to slaves'.[37] Furthermore, in all but the rarest cases, to be crucified meant being denied a proper burial. In brief, the penalty brought the utmost disgrace and humiliation, the worst public shame, upon those who suffered it.[38] It infected its victims with the ineradicable taint of *infamy*. None of this was lost on theological giants like Paul and Augustine.

In the Middle Ages the concept of infamy (*Unehrlichkeit*) was no less important for the structuring of criminal justice than it was in antiquity. Infamy had a double character in the period with which we are concerned: on the one hand, it expressed a magical fear of contagion from 'polluted' persons and objects; on the other, it formed, in Bronislaw Geremek's words, a powerful 'mechanism of social exclusion',[39] in which certain social groups and occupations were identified as honest or noble, over and against others which were viewed as dishonest or vulgar. Infamy's opposite, honour (*Ehre*), was 'an almost tangible yet abstract set of socially defined qualities that marked people as belonging to a particular station in life through the attitudes and behaviour patterns they manifested'.[40] Thus not only were there entire classes of social undesirables who led lives of *de facto* infamy because of the 'impure' nature of their occupations (tanners, butchers, knackers, barbers, prostitutes, pimps, cleaners of public latrines, gravediggers, executioners, usurers, Jews, and also many types of entertainers) or because of disease (lepers, syphilitics); other marginal groups, such as beggars, vagabonds, heretics and various non-believers, were thought to be similarly tainted. These people were society's deviants, their culture its underworld.

Infamy also clung to the apparatus of punishment, particularly the scaffold and gallows. In later centuries these were always located in a designated space outside the city walls: the city of Nuremberg, for example, maintained both a *Rabenstein* and a *Hochgericht* (gallows), within a quarter-mile of the city gate.[41] So threatening was the miasma that surrounded them that scandal and disorder ensued whenever a

new gallows had to be built. In some instances groups of artisans refused even to touch the construction materials or go near the site. When legal coercion failed, authorities in Germany struck upon the idea of involving all groups and individuals equally; hence everyone and no one became tainted. Magistrates also presided over a ceremony in which the building site was temporarily declared 'honest' and all involved still honourable.[42]

Few depictions of the medieval *Hochgericht* convey its infamy and horror as fiendishly as Urs Graf's pen drawing of 1512, now in Vienna (illus. 85). Before an idyllic landscape a Swiss mercenary (*Reisläufer* or *Eidgenosse*) stands astride his captured arch rival, a German *Landsknecht*, whose neck is bared in anticipation of the stroke. Just beyond the two men lies a haunted precinct of gibbets and wheels, each armature

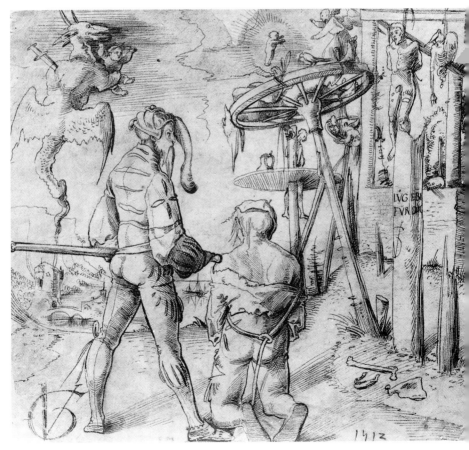

85 Urs Graf, *Place of Execution*, 1512, pen drawing, 22 × 24 cm. Staatliches Graphisches Sammlung Albertina, Vienna.

adorned with dead, dying or decaying bodies. There may well be an element of personal malice in the depiction of a German soldier subjected thus and readied for execution: though trained as a goldsmith and admitted into the Basel guild as a respected master in 1512, the impetuous and petulant Graf – described by one of his modern admirers as 'a cutthroat, a swindler, a bully and a lecher' – sought a life of adventure and brigandage in the mercenary corps, leaving first in 1511 and then sporadically throughout the ensuing decade.[43] Is the drawing Graf's personal *Schandbild* against the Germans or a gloating memento of glory days knee deep in blood? Looking again, we see that the visual vendetta carries over into the inscription Graf has included on the ruined post above his 'VG' monogram: '*Luog ebe für dich*', roughly translatable as 'Look out for yourself!'[44] Provoking us to imagine the same brutal end for ourselves, Graf sinks us deep into an abject scenography of death, where angels and devils hover over the gallows and vie for souls (it seems the soul of the man expiring on the wheel will go to heaven). Graf makes the stench of death palpable by locating our experience of it in a particular *place*.

Thus when medieval writers and artists characterized Calvary as a 'shameful place' and meditated on Christ's humiliating death as a criminal, fastened to the 'terrible cross' and exposed to public ridicule, they had only to conceive the event in terms of the dishonouring effects the punishments of their own time had upon the criminal: 'Disgrace became an independent system of punishment . . . due largely to the evolution of a corporative society in which honour played a central role.'[45] Public dishonouring, for example, was the main function of penalties meted out in the pillory, called the 'stake' or 'platform of shame', depending on its design. Offenders were sometimes made to wear ludicrous animal 'masks of shame' (*Schandmaske*), or wooden yokes called 'fiddles' (*Geige* or *Fidel*), to aggravate the pain of public exposure. In fact, public recognition that the nature of the crime conferred a stain of infamy on the perpetrator was, in itself, dishonouring.[46]

But the worst forms of disgrace were manifest in the brutal and vulgar modes of punishment, like hanging and breaking with the wheel. Several unexpected features of these punishments, not merely the pain they caused, made them dreaded carriers of the virus of infamy. Firstly, punishments in which the convicts 'went to their death bound and helpless', thereby denied the freedom of bodily movement, were, according to Richard Evans, dishonourable by definition.[47] Secondly, any physical branding or torture, such as that inflicted on criminals en route to the place of execution (*Richtplatz* or *Richtstätte*), conferred the invisible stigma of infamy in addition to visible wounds.

86 Lucas Mayer, *Torture and Execution of the Murderer Franz Seubold at Gräfenberg, 22 September 1589*, woodcut broadsheet, 410 × 320 mm. Germanisches Nationalmuseum, Nuremburg.

Third, and perhaps most important, both hanging and the wheel brought the condemned person into sustained contact with the polluting touch of the executioner and his equipment; the wheel, the rope and the gallows all radiated their own degrading miasmas (offenders who were decapitated, by contrast, touched nothing but the purifying edge of the executioner's [*Scharfrichter*] broadsword, a weapon which gleamed with the lustre of chivalry). Sentences stipulating that a malefactor be dragged to the scaffold wrapped inside an oxhide worsened the degradation not only because was he pulled along the ground by a 'brute beast', immobilized, defenceless and unable to walk upright through the streets to his own funeral, but also because the hide itself, being fresh, polluted the criminal with its bloodiness, filthiness and stench.[48] Finally, as noted earlier, it was the fate of criminals who were hanged from the gallows or displayed publicly on the wheel to be denied proper Christian burial, despite the protestations of family members, whose honour was also impaired by judicial harshness on this issue. In the words of an eighteenth-century encyclopedist, 'For, though no more bodily pain is inflicted hereby, yet the shame done to the body by the denial of burial is accounted an increase in the punishment.'[49]

From this perspective, breaking with the wheel conferred the worst stigma imaginable upon those who suffered it and its attendant torments. It was the culmination of a series of degradations that began, as a broadsheet detailing the execution of Franz Seubold at

214

Gräfenberg on 22 September 1589 makes plain, with the procession to the gallows, during which the convict's flesh was torn from the body with red-hot pincers (illus. 86). Upon the *Rabenstein* the victim's body is immobilized on the ground, then the unspeakable pain of the fracturing blows themselves, then the display of the mangled body (grotesquely welded to the apparatus), exposure to the elements, a prolonged death, excarnation by birds and, finally, the total disintegration of the unburied body – all evoked in the broadsheet by the not-so-distant 'gallows mountain'. No other medieval punishment combined such a ruthless assault on the human body with a thoroughgoing attempt to annihilate the victim's social status. Only in the virtual world depicted by the *Schandbild*, where the wheel victim is also splattered with the dung of an ass (see illus. 75), could the insult and degradation be any worse. In these respects the wheel re-created the conditions of total defamation that pertained in Roman crucifixion.

Conclusion

Much inappropriate blame has been heaped upon medieval artists, usually by historians of a positivist bent, for their failure to render accurately the technical details of Roman crucifixion, details that have until recently proved elusive to archaeological research.[50] Such unreasonable demands aroused the ire of the philologist F. P. Pickering, who expressed his intolerance with these barbed words:

Doubts about the reality of the artists' Crucifixion scenes tend nowadays to be . . . crudely expressed, as doubts concerning physiological and mechanical properties: whether it 'could have happened' or 'could have been done' thus. One can (with distaste) read modern investigations of connoisseurs of Christian art who happen to have physicians or an anatomist among their friends and advisors. They are always eager to point to the 'footrest,' which though not attested in historical sources, 'will have been necessary.' Such scholars are however still looking for that reality which . . . art refuses to depict.[51]

Abiding by what archaeological data he or she can gather to explain the appearance of Crucifixion imagery, the medievalist will never, in Pickering's jaded view, 'make his [sic] knowledge contemporary with the works he studies'.[52] The real sources of the painter's information belong 'to a different system of history', by which he means the undisputed authority of biblical sources. For medieval people the Crucifixion was 'biblically true', which is to say, *historically* true in the first degree. 'The reality of the Crucifixion is a painfully reconstructed "historical" reality which the Christian world owes to the

biblical researches of the Fathers of the Church.' Only by understanding how medieval authors forged their imagery out of the Old Testament by a process of 'translation of ancient prophecies, metaphors, similes and symbols of the Crucifixion into "history"' can we ever explain late medieval depictions of Christ's Crucifixion. 'The "reality" of the artists is also – and was first – the reality of the authors.'[53]

Art historians are justifiably piqued by such assertions, as if all late medieval artists confined their image-forming activities to the faithful reproduction of motifs found in devotional literature! Pickering is right about one thing, however, that 'behind the apparently so realistic depiction of a gruesome ritual [there was] a reality strange, not only to us, but to the medieval (and later) artists themselves'.[54] The actual procedures of Roman crucifixion would have appeared strange to the medieval artists if they could have seen them. But what was not strange to them was a judicial reality which extracted from its victims a surplus of pain and suffering equal to anything the Romans could have dreamed up. For us this reality is indeed strange, separated as we are from the spectacularization of real death not only by a great historical distance but also by a criminal-justice system that kills in well-policed secrecy. The preceding review of statements made by Jewish, Greek and Roman historians on the subject of crucifixion is therefore necessary only for us, to bring our experience closer to that of the Middle Ages. Furthermore, although Pickering is right that these ancient accounts of crucifixion – its meaning, applications, techniques and effects – have little or no evidentiary value for the iconographic development of *the Crucifixion*, the same may not be confidently said about the punishment of the Two Thieves. Pickering himself admits as much.[55]

Medieval people clearly understood that the canonical image of Jesus's crucifixion was not the only way the penalty had been, or could ever be, inflicted. We've already seen how various narrators of the Passion story, both writers and artists, were capable of thinking beyond the Bible and beyond the canonical interpretation of Christ's punishment. Popular Gospel harmonies like the *Meditations on the Life of Christ*, whose exegetical technique Pickering was so instrumental in elucidating, recognized the validity of two distinct procedures for affixing the body to the Cross (*erecto cruce* and *jacente cruce*), and artists explored these alternatives as well. With the punishment of the Two Thieves, and then the Apostles, the possibilities contained in the iconographic tradition multiplied. Though many artists contented themselves with faithfully reproducing the models furnished by tradition, others cast their nets beyond the pictorial tradition and into the sea of living reality, where there existed not only the (relatively rare) mock

crucifixions designed to avenge the Jewish murderers of Christ but also commonly seen spectacles which approximated many of crucifixion's effects on the body. What resulted was a stunning array of torments that enlarged the spectator's conception of what crucifixion was, or could be. Freed from the obligation to concretize a theological position or fulfil a biblical prophecy, as they were with the figure of Christ, artists saw fit to reinvent the procedures and techniques of 'crucifixion', and to reimagine the physical effects of this ancient procedure.

7 Dysmas and Gestas: Model and Anti-model

What could he know of forgiveness,
A thief whom Judea nailed to a cross?
For us those days are lost.
During his last undertaking,

Death by crucifixion,
He learned from the taunts of the crowd
That the man who was dying beside him
Was God. And blindly he said:

Remember me when thou comest
Into thy kingdom, and from the terrible cross
The unimaginable voice
Which one day will judge us all

Promised him Paradise. Nothing more was said
Between them before the end came,
but history will not let the memory
Of their last afternoon die.

O friends, the innocence of this friend
Of Jesus! That simplicity which made him,
From the disgrace of punishment, ask for
And be granted Paradise

Was what drove him time
And again to sin and to bloody crime.

JORGE LUIS BORGES, from 'Luke 23'[1]

First fruit

The Bohemian panel painting of *c.* 1360, now in Berlin, appeared earlier in our explorations as a key transitional monument in the history of the northern European Calvary featuring the Two Thieves (see illus. 42). Within its frame one can discover threads connecting every theme in this book. Consider again the contrasting body images it offers to the gaze. Christ languishes in canonical cruciformity, his body a gentle S-curve supported by the make-believe footrest; the Thieves, meanwhile, are twisted violently around their crosses. Bloody

gashes appear on every limb exposed to view; shoulders are racked over the crossbars; arms are cantilevered behind bodies and held fast with ropes; legs are broken, hooked and tied down around the vertical beams of the crosses. The immobilized bodies entwine and almost fuse with the punishing apparatus. And atop these agonized tangles of limbs, we see the heads of the two men craning backwards and forwards respectively – the critical difference between the two figures and the primary cue for grasping the antithetical nature of the souls within.

We are witness to the horrific climax of the tragedy on Calvary, a triple execution bathed in blood. With Christ's head slung over in death and the Thieves broken and bleeding, Longinus raises his lance to pierce Christ's side: from the Holy Body comes the miraculous double stream of sacramental liquid described in the Gospel of John (19: 34), blood oozing down the stomach and water squirting out over the heads of the mourners. Addressing the viewer of the panel the Good Centurion points upwards towards Christ, his stern gaze compelling us to fill in the missing words, 'Truly this was the Son of God.'

Amidst the tragic gloom, the silent flow of tears and the spectacular release of blood and water, it is hard to overlook how the haemorrhaging wounds in Christ's hands seem to drizzle and drip upon the heads of the Two Thieves. From his privileged position, and with his head tilted back, the Good Thief appears to catch the Holy Blood in his open mouth (illus. 87). The message is clear and literal and powerful: the tortured criminal hanging on the 'tree of shame' next to the Saviour, and suffering 'in the same condemnation', partakes of the life-giving sacrament from its source in the body of Christ. With access to the narrative codes, we know the Thief has already been promised Paradise. Yet the torture proceeds. At the moment of death Christ, playing his double role as sacrifice and priest, dispenses a primitive eucharistic meal to the dying criminal, ratifying the promise of Paradise.

Compact in its sacramental associations, the meaning of the Bohemian panel's literal assimilation of the criminal to the dying God is not exhausted until we recognize an aspect of its political significance as well. For the mystical identity between the two sufferers also reflects, in the mirror of sacred history, the necessity of penitence, confession and communion for all condemned prisoners. This at a moment when the practice of denying these spiritual opportunities to executed persons was first coming under fire from the Roman Church (see Chapter 4). In this detail the Bohemian master deftly historicizes Christ's priestly role in dispensing the Blessed Sacrament, and legitimizes the contrite sinner's worthiness to receive it.

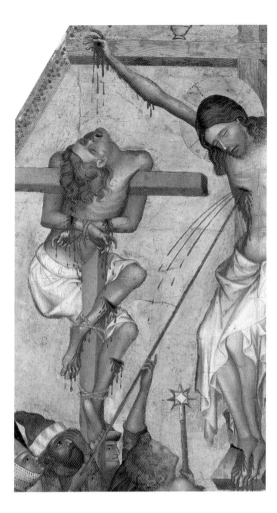

87 Detail of illus. 42, showing the Thief on Christ's right.

From a less *theological* point of view the image says still something more: there is a salvific potency in the freshly spilt blood of executed criminals who die pure. We saw in Chapters 2 and 4 that blood drinking by epileptics for curative purposes, embedded in long-term mental horizons, was a practice localized at executions and more or less permitted by authorities. Here its patron saint, so to speak, is the Good Thief, St Dysmas, whose legend cast him in an archetypal role as as the first 'fruit' of redemption, a lifelong sinner converted and saved. For medieval theologians, Dysmas's beatitude hinged first on his conversion in Christ's very presence and second, perhaps more importantly, on the 'baptism' he received in the fountain of water miraculously released from Christ's side.[2] For the painter it is quite simply a baptism in blood.

The Good Thief's execution on Calvary beside Jesus made him the first New Testament figure to follow Christ. For suffering patiently and obediently, for his literal realization of the ideal of *imitatio Christi*, he is rewarded with the crown of martyrdom. The spectacle of his death, his 'immediate beatitude', was therefore consummately edifying: a beautiful death, redeemed and redeeming, not *despite* but *because of* the abjection that accompanied it. To the *philopassianic* late Middle Ages he served as a powerful inspiration for penitents. One could only wish to die so thoroughly cleansed of sin as the man in the image.

We have already seen how a similar wish obtained, individually and collectively, in the theatre of public punishments. Confessed and penitent convicts became, in the eyes of the people, the living counterparts of the historical martyrs and, consequently, the objects of a quasi-cultic veneration. Popular perception cast them in the psychological terms of its affective devotions to the Passion, and geared their final moments towards the procurement of intercessionary prayers for all. Like his condemned counterparts in the Middle Ages, then, the Good Thief's worthiness for redemption resided in part in the purity of his self-examination, confession and repentance (Scholastic writers called the correct motivation 'contrition', to distinguish it from 'attrition', a repentance borne of fear of punishment), but only in part. His worthiness also sprang directly from his fleshly pains. As both spectacle and image, the demolished body of the Penitent Thief constituted a sign of this soul's lightning progress through purgation and towards redemption. Within the purview of a Christian 'piety of pain', his torments were both abject and redemptive, fearful and enviable, unbearable and fascinating.

For the Bad Thief, who in stubborn blindness turns away from Christ and dies in despair, unregenerate and damned, this surplus of earthly pain is something else: a foretaste of eternal torments. The same violent death transforms one Thief into a likeness of the Crucified, and hence a figure worthy of compassion, admiration and veneration; the other is marked as an everyday scapegoat, worthy of mockery and scorn. Together, then, the two figures, though marginal in the Passion narrative, become central in the medieval economy of response: they become antithetical models for a culture tuned to pain's instrumentality in the pursuit of redemption. Suffering and dying on either side of Christ, the Two Thieves thematize a kind of *existential crossroads*, one that every Christian had to face at the *hora mortis*, the hour of death. Each figure enacts a diametrically opposed conclusion to a spiritual biography as it were. Each therefore serves as the locus of a form of anxiety peculiar to the penitential culture of the late Middle

Ages. Their opposition stretches open the dangerous gulf between pain's 'world-making' and its 'world-destroying' potentialities (to adapt Elaine Scarry's terms).

Late medieval painters differentiated the Thieves from one another to facilitate this kind of identification. On Calvary one never appears without the other. The Bad Thief haunts the spectacle of redemption as a fearful *exemplum* of despair, a soul poised on the brink of annihilation.[3] Hence his presence preserves within these images a powerful element of *antagonism* that I believe is key to understanding the capacity of these images to guide and shape response. Antagonistic challenges to the viewer of the Passion appear frequently in the imagery and literature of the late Middle Ages, and painters invented new ways to agitate the beholder towards internal feelings of guilt, the bedrock also of the Church's disciplinary system of sacramental confession and penance.[4]

Much of the credit for acculturating lay people to the escalating demands of this system belongs to the Franciscans, the avant-garde of the universal call to penance. This chapter accordingly returns us to what the historian of religion Heiko Oberman calls the 'Franciscan Middle Ages'. Not only did Franciscan modes of visual meditation, devotion to the Passion and its distinctly participatory, personalized spirituality, shape the devotional attitudes of which I've spoken though-out this book; their religious ideology may have been the earliest to encourage veneration of the Penitent Thief, St Dysmas, whose cult is well attested in later centuries. Following the lead of his biographers, notably Bonaventure, painters working for Franciscan patrons cast Francis into the role of the Penitent Thief, one of several *alter egos* that demonstrated the saint's amazing capacity for compassionate identification with the suffering of Christ. In Franciscan ideology, conversion marks the beginning of the penitent's path towards reconciliation and self-understanding. It established the crucial link between the personal histories of Christ, Francis, Dysmas and other penitents like Mary Magdalene and St Peter. Among them, however, Dysmas's history stands out, for it was in his *image* that the Bonaventuran path from conversion to purgation, illumination and perfection – in short, the attainment of a 'perfect penance' – could be most immediately grasped by the penitent spectator. That Dysmas served as a patron saint of both the good death and criminals under sanction of death, and that his *example* was customarily invoked by those whose task it was to comfort the prisoner as the blows fell upon his body, suggests that his *image*, too, was never far from the minds of spectators in the penal theatre.

St Dysmas and the Franciscan connection

Between 1314 and 1329 the Bishop of Assisi, Teobaldo Pontano, had built a beautiful chapel dedicated to St Mary Magdalene as part of the mother house of the Franciscan order, the Basilica of San Francesco.[5] Devotion to Magdalene formed an integral part of the order's religious programme, and the chapel's decorators presented her in a variety of roles: in one image she receives homage from Teobaldo (pictured as a humble friar); elsewhere she communes with angels, held aloft above a rocky landscape. As a model penitent and practitioner of the contemplative life, the figure of Magdalene furnished Franciscan writers and painters with a kind of *alter ego*, one among several, for their founder (more on this below). So Francis may be seen taking up her privileged place of abasement beneath the Cross in Cimabue's Crucifixion in the upper church, as well as in numerous other frescoes, altar-pieces and painted crosses.[6] Franciscan writers drew frequent parallels between the legends of the two saints, giving their mystical identification a concrete, vocational basis.

An important part of the fresco programme was a series of at least five standing portraits of penitential figures, some set in pairs. There is St Mary of Egypt (with whom Magdalene was often either contrasted or confused), St Paul opposite King David, and, paired with Longinus, the Good Thief (illus. 88). All of the figures interact as if they were singing a contemporary *lauda* (hymn) from Perugia.[7] A beautiful young man, the figure of the Thief, leans on a cross and lovingly clasps his hands around it. He is dressed in a long robe and is, like the others, brilliantly nimbed to signify his sanctity. Interesting is the fact that he stands opposite Longinus, the Roman soldier whose blindness (or eye disease) was healed by the trickle of blood that flowed down his lance from Christ's wound (another tradition tells how, after the miracle, he became a Christian, was baptized by the Apostles, preached in Caesarea and was martyred).[8] Evidently, by pairing the two the iconographic planners of the chapel wanted to evoke the two key redemptive miracles associated with the Crucifixion, both of which centre on the conversion of an archetypal heathen, a robber and a soldier-executioner. Dysmas comes to penitence in a flash of recognition, out of inner goodness; Longinus through the transformative somatic experience of healing. Each of them opens his eyes to Christ and achieves beatitude through his conformity (*conformitas*) with Christ, the first in terms of physical suffering, the second in terms of preaching and martyrdom. Thus both figures were rewarded by the Church with beatification and the title *sanctus* (Blessed).

88 *The Good Thief as Penitent*,
fresco from the Magdalene Chapel,
Basilica of San Francesco, Assisi,
1314–29.

Although the designation *sanctus* denotes a *de facto* papal recognition
of their holiness, their exemplary lives as saints and their worthiness
to be venerated, neither Dysmas nor Longinus was ever canonized (an
elaborate legal process that requires proof of at least two miracles).
Nevertheless, evidence for a cult of Sanctus Latro is widespread and
may date to the discovery of the three crosses on Golgotha by the
emperor Constantine's mother, Helena (d. *c.* 328-30) in the fourth
century (the church established by Helena in Rome to house the relic
of the True Cross and soil from Calvary, S. Croce in Gerusalemme,
also houses a portion of the Good Thief's cross).[9] Louis Réau reports
that Dysmas's cult developed mainly in southern Italy, where he is
the patron saint of Gallipoli (in the province of Tarente); also that a
chapel was consecrated for him in Valencia.[10] Though no clear evidence
exists for a Dysmas cult in the empire before the sixteenth century,
Austria (especially the city of Graz) and Bavaria became the centre of a
flourishing cult sponsored by Jesuits and local confraternities in the
Baroque era.[11]

We have made many references to Dysmas's pre-eminence in the Passion narrative of Luke, and his biography enjoyed a colourful embroidering in the apocryphal gospels and the medieval hagiography that fed from them (see Introduction). Medieval writings about and devotions to the 'Seven Words', the last words spoken by Christ on the Cross before his death, also afford him pride of place, since the second 'word' enshrines Christ's promise of Paradise that is addressed to him alone (see illus. 4). But the textual traditions are overwhelmed by the astounding richness of the visual record in the centuries that concern us (though it is another thing to say that any of it constitutes evidence for an organized cult). If an early cult of the Good Thief ever enjoyed the backing of a Church-sanctioned group, clerical or lay, it was surely among the Franciscans, where Dysmas assumed a significant place among other model penitents.

By the time Teobaldo undertook his building campaign, a century after the friars had made their decision to expand into other countries, over 1,400 Franciscan convents were scattered across the face of Latin Christendom.[12] As part of a movement that was both Church reform and popular religious revival, the mendicant friars (*mendicus* in Latin means 'beggar', denoting their vow of poverty) preached prayer, penance and forgiveness of sins to the masses; through preaching (in the vernacular), they thought they would move a sinful humanity to confession. 'As the seed is planted in preaching, the fruit is harvested in confession,' wrote Humbert of Romans.[13] It is, of course, no historical accident that this was the emphasis of a group which rose so quickly from dissident beginnings to become one of the Church's most powerful propagandists. Five years after the determined and charismatic Francis received papal approval for his group (1210), the Fourth Lateran Council put into practical terms the rehabilitation of the Church's penitential system by mandating yearly confession for all Christians. Thus the Franciscans were among the avant-garde 'in major new developments in both the theory and practice of the sacrament of penance'.[14]

In Chapter 1 I stressed the centrality of the Passion to Francis's 'personalistic form of mysticism', and the importance of Passion-based devotions to the religious programme that Franciscan preachers, writers and artists transmitted to the laity in the three centuries or so following his death in 1226. In Franciscan thought, compassionate meditations on the Passion were to lead the individual to a heightened awareness of his or her own sinfulness and, from there, directly to penance. In this way everyone could enact his or her own *conformitas* to Christ along the lines established by Francis himself, who exemplified

the ideal of *imitatio Christi*. Indeed, so perfectly did Francis conform his life to Christ's, so ideally did he realize the three monastic ideals of poverty, chastity and obedience, that his first biographers, Thomas of Celano and Bonaventure, were aroused to think of him as a second Christ. Their writings contain seeds that in the early fourteenth century grew into a full-fledged cult of *Franciscus alter Christus*, Francis the second Christ.

And above all, what focused the cult of the *alter Christus* was the legend of the stigmatization during Francis's retreat on Mount Alverna on 17 September 1224. While fasting and ardently praying that he might experience the sufferings of the Crucified, blood marks appeared spontaneously on his hands and feet and on his side, stigmata corresponding to the Five Wounds of Christ In this trend-setting miracle, *meditatio* became *imitatio*, its proof made manifest in the (self-) marking of the ecstatic's body with the visible signs of holiness. In the *Meditations* the Pseudo-Bonaventure proclaims, 'Do you believe that the Blessed Francis would have attained such abundance of virtue . . .if not by familiar conversation and contemplation of his Lord Jesus? With such ardour did he change himself that had become almost one with Him. . . '[15] The friar's account rings with the imperative towards compassionate love of God that was to become the hallmark of a spirituality in thrall to Franciscan theology and affective devotions. It is the same imperative expressed in Bonaventure's mystical formula, 'The power of love transforms the lover into an image of the beloved' (see Chapter 4). The stigmatization completed and cemented the identification of Francis with his beloved, the Crucified.

Franciscan iconography made ample use of this image of mystical fusion. A diptych painted in the north Italian city of Rimini in the first quarter of the fourteenth century, now in Munich, juxtaposes on one of its panels the stigmatization of Francis with the Passion of Christ (illus. 89).[16] In the panel's lower register the painter depicts the crucified seraph, from whose body luminous streams of blood are transmitted, with laser-guided precision, to Francis's members. Fully receptive to this vision, which at once 'liquefies' him with intense joy and shatters him with terrible pain, Francis kneels in the mountain landscape in a pose Jean-Claude Schmitt has called 'the matrix of all mystical gestures'.[17] Above this, in the middle register, we see the *Flagellation* and the *Carrying of the Cross*, two critical scenes of the Passion for Franciscans, who actively encouraged devotion to the Stations of the Cross; and above that a *Calvary* scene that comprises fully half of the panel's area and includes the Thieves. The image abounds with Franciscan motifs: there is Magdalene weeping at the base

89 Rimini School, *Crucifixion, Flagellation, the Carrying of the Cross and the Stigmatization of St Francis*, right wing of a diptych, first quarter of the 14th century, painted chestnut panel with gold ground, 64 × 30 cm. Alte Pinakothek, Munich.

of the Cross, Mary stricken with sorrow, visualized as a sword which pierces her heart,[18] and Longinus, who raises his lance towards Christ's side. This last detail informs the conception of the whole panel. Using the *coup de lance* as the narrative focus of the event, the iconographic programme gives a 'historical' account of the Five Wounds which are being transferred to Francis in the corresponding scene below. Indeed,

the diagonal line of the lance parallels the seraph's rays, suggesting that Mount Alverna, as the *loca sancta* of Francis's ecstasy, has become a new Calvary.

The tendency to trace parallels and establish mystical identities between historically distant figures does not belong exclusively to the Francis cult, but it does find its most literal expressions there in the complementary conceptions of Francis as the penitent Magdalene and as the *alter Christus*. There is, however, one mystical identity left to consider, as tantalizing as it is comparatively unexplored by scholars, namely, Francis as the Penitent Thief. In Utrecht there is preserved a panel by the thirteenth-century painter Guido da Siena (illus. 90). Probably developed from Byzantine models, the theme, relatively rare in Passion iconography, is known as the *Ascent of the Cross*, and has been analysed most recently by Anne Derbes, who posits a Franciscan origin for the panel.[19] Across the groundline, which our gaze meets practically head-on, Mary accompanies Christ to the Cross; clinging to him as he mounts the ladder, she turns back in horror as she is confronted by a wicked child who makes the threatening gesture of drawing his finger across his throat. There is such a clamorous quality to the goings-on – executioners preparing the apparatus, Jews cursing the prisoner and the executioners, soldiers watching, etc. – that one can easily miss the naked, blindfolded and shackled figure of an elderly man seated upon the ground in the lower right corner. Derbes believes

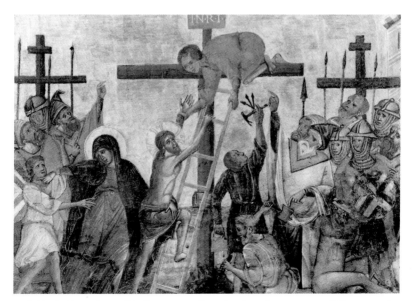

90 Guido da Siena, *Ascent of the Cross, c.* 1275–80, painted panel, 33 × 44.5 cm. Rijksmuseum het Catharijnconvent, Utrecht.

this represents one of the Thieves. His nakedness, she argues, under-scores Christ's abasement and reinforces the Franciscan insistence on His nudity in their accounts of the Passion.[20] But that is not the limit of the motif's significance. Franciscan Passion literature consis-tently highlighted the presence of the Thieves. In *Mystical Opuscula* Bonaventure used the fact of Christ's criminal companionship on the way to Calvary and during the Crucifixion to fix attention on the 'utterly degrading . . . [and] bitterly cruel' experience of the Passion:

He was hung on a tree like a robber and thief. Under the Old Law, such punishment was reserved for the worst and most atrocious of criminals, and for robbers and thieves. [. . .] Mount Calvary, a most infamous and loathsome place, strewn with the bones and bodies of many dead . . . was where the death sentence was carried out; here the vilest of men were beheaded and their bodies strung up . . . [Christ] was hanged as a thief among thieves, and in the central place as a prince of thieves. This is why Isaiah says that He *was reputed with the wicked*.[21]

This theme is elaborated by the Pseudo-Bonaventure in the *Meditations*, where the Thieves are mentioned no less than seven times in the account of the Passion.[22] Likewise, the Franciscan author of the *Meditatio pauperis in solitudine* (*c.* 1282) reminds us that Christ was 'hung up in the place of evil, between two thieves no less slandered by those very evil ones'.[23] All told, the presence of the Thief in the Utrecht panel, in Derbes's estimation, 'parallels the thieves' promi-nence for Bonaventure and Pseudo-Bonaventure and thus reinforces the likelihood of the panel's Franciscan origins'.[24]

In their efforts to cement the *alter Christus* theme, Franciscan writers were no less explicit in associating the gentle Francis with criminals, and placing him in the company of thieves. Thomas of Celano (d. 1260) writes that Francis was 'led like a robber' through Assisi;[25] and elsewhere it was reported that Francis's last wish was to be buried with the remains of criminals at the Colle d'Inferno (though his companions disobeyed and buried him in the church of San Giorgio).[26] So the question naturally presents itself: did Guido and his patrons configure yet another role for the *Poverello* of Assisi, that of the Penitent Thief? Derbes cautiously thinks so. In the account of Francis's death in the *Scripta Leonis*, she explains, Francis sits 'naked, on the bare earth' before dying, recalling the chapter in Isaiah (in general a favourite starting point for Franciscan metaphors), in which God divests Judah and Jerusalem of all worldly goods, exchanging, among numerous other things, 'the rich gown, [for] a sackcloth skirt' (3: 24). 'Just as Francis was compared by Bonaventure with a thief, here the thief may evoke Francis.'[27]

Does it go without saying that the blindfolded figure in Guido's panel should be identified as Dysmas? Is it one of the Thieves at all? Rare are the appearances of one Thief without the other in any part of the standard Passion sequence. Without doubt he is a prisoner, and by implication one of the Thieves, but why the Good Thief? Turned away from Christ, the figure's position suggests the Impenitent Thief's metaphorical 'blindness' to Jesus's divinity; yet at the same time, blindfolds are seen on both convicts in numerous other works (see illus. 77, 98). Nor are his old age and beard stabile signs of distinction; many artists, north and south, used age differences to distinguish the Thieves, yet some have characterized the Good Thief as older, while others paint him younger. Still, I agree with Derbes and think the motif works in a way that is compatible with Franciscan thought and devotion. For the patrons of Guido's unusual image, if their intent was to visualize the humility of Francis's Christ-like death in terms of a historical personage *present* at the Crucifixion, the figure of the elderly prisoner, shackled and blindfolded and suffering all of this with patience, would have provided a screen upon which the labile image of Francis could be projected. In an image where Christ's ascent could be mistakenly construed in triumphal terms, the naked figure on the ground, anchored in the picture's corner, reflected back on to Christ the Franciscan preoccupation with His 'utterly degrading' punishment among Thieves.

Picturing the antithesis

Like many other works under discussion in these pages, Guido da Siena's *Ascent of the Cross* confounds the iconographer's pursuit of a consistent symbolic language, a universally recognized schema for organizing signs. Roland Barthes recognized in the effort to seek binary oppositions – dualisms, antitheses – in every wrinkle of experience a peculiar habit of the Western mind; whether as cause or consequence, our look back upon the Middle Ages seems to confirm our own preoccupations with opposites, models and anti-models. Overwhelmingly, the textual and visual traditions out of which late medieval Passion imagery was forged draw attention to the antithetical nature of the Two Thieves. Yet as we have seen throughout, for almost every auxiliary motif, every 'sign of otherness', that seems to declare the oppositions of good and evil, penitent and impenitent, we can find competing interpretations, if not outright reversals, in other works. Are there any consistently reliable signs of difference, any hard symbolic 'rules' exempt from complications? The cultic interest in the spiritual travails

of the Good Thief surely depended on making such a polarization of opposites as legible as possible.

Iconographers have placed great faith in the symbolism of the Thieves' positions on the right and left of Christ (see Introduction). Erwin Panofsky, the progenitor of iconography as a discipline within art history, went so far as to call their diametrical placement a 'universally accepted symbolism', a rule which took precedence over other symbolic considerations in interpretation.[28] Indeed, parallels with other image types suggest its ubiquity: in the Last Judgement, in both Eastern and Western art, it is the right hand (*dextra*) of Christ which ushers the blessed on to their just rewards in Heaven, while it is the left (*sinistra*) which castigates the wicked and pushes them into Hell. Most of the visual evidence in these pages follows the supposedly iron-clad rule, so we may be tempted to follow the lead of symbolic anthropology and see the polarity of right and left as a far-reaching collective representation of sacred and profane realms.[29] But in the later Middle Ages, when the number of auxiliary motifs used to express the opposing natures of the Thieves began to multiply, the spatial diametry of right and left became only one sign among many. For the late medieval painter, who often sought ways of displaying his inventiveness within the parameters of tradition, the rule practically invited its own violation. And enough examples of clear-cut reversals can be found to caution iconographers away from enforcing Panofsky's rule (see illus. 2, 34).[30]

There is, however, one auxiliary motif that stands out for its unparalleled consistency and legibility: the image of the dying man's soul, pictured as a tiny naked human or *homunculus*, departing from his body and pursued by either demons or angels. Given its non-scriptural status, the consistency of treatment and the uniformity of message this motif generated are impressive, but not surprising: for medieval viewers, who certainly knew their angels from their demons and understood where each carried souls in their custody, the motif allowed no mistaken meanings.

Unknown in Carolingian and Ottonian art, the developed theme makes its first surviving appearance against the turbulent blue background of the page from the Beatus Apocalypse in Girona, which, we recall, bore the date 975 in its colophon (see illus. 38). A more primitive rendition has survived in a Merovingian (pre-Carolingian) manuscript containing the Pauline letters, dating to the late eighth century and now in Würzburg.[31] Even though the demonic role is played here by two black birds who peck at the Bad Thief as so much carrion, the manuscript strongly suggests a Western European, rather than Byzantine, source for the motif in the Girona Beatus. There we see

perched on the *patibulum* of the Thief to Christ's left a grinning brown demon, poised to reap his soul harvest with crescent-shaped pitchfork (illus. 92). On the opposite side a book-toting angel (designed as a counterpart to the two angels swinging censers above Christ's head) hovers patiently by the Thief on Christ's right, waiting to escort the penitent's soul to heaven (illus. 91). However perplexed we may be by the inscription that identifies the damned soul as *Limacs* (Dysmas) and his heaven-bound opposite as *Gestas* (see Chapter 2), everything we need to know about the outcome of this dramatic *psychostasis* is communicated visually and legibly (the asymmetry of redemption is reinforced by an inscription to the right of Gestas's head, *Memento mei Dne*, 'Remember me Lord' [Luke 23: 42]).

In the English *Book of Hours of Elizabeth the Queen*, a lavish prayer-book produced in the early fifteenth century, a shaggy, bird-footed demon hauls off the soul of the Bad Thief like a sack of booty and buzzes towards the picture's edge on spiny webbed wings (illus. 76).[32]

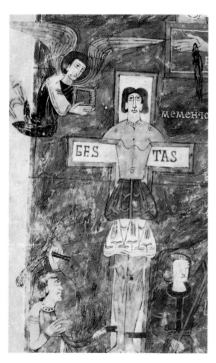
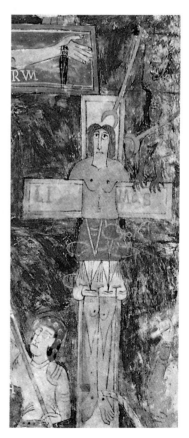

91, 92 Details of illus. 38, showing an angel and a demon claiming the dying Thieves' souls.

Edifying as the sight of the Good Thief's soul – kneeling, praying, gently held by angels – may be, miraculous as is the restoration of Longinus's sight, nothing compels attention like the Bad Thief's horrified soul, which turns back with a pained expression to utter one last pitiable cry for rescue. Indeed, so delightfully weird are the diableries concocted in these and countless other images, we might find ourselves cheering the loathsome beasts as they snatch and claw at their prey.

Little naked figures representing souls appear frequently in medieval art, particularly in monumental scenes of the Last Judgement, where resurrected souls are enfleshed in generic bodies and then carried off like warm biscuits in the angelic cloth of 'Abraham's bosom' or coralled into gaping hell-mouths by demon technicians. A significant parallel can also be found in the homunculus Christ with the Cross, often seen gliding upon shafts of divine light towards the Virgin in scenes of the Annunciation. It is unclear, though, whether the homunculus motif is of learned or popular origin, whether it grew from indigenous roots (as the Würzburg Pauline letters implies) or was adapted from an Eastern prototype.[33] Tantalizing is the fact that the same early Apocrypha that contained the first embellishments of the Thieves' opposed types also gave literary form to the supervisible battle for souls. In the middle of the countervailing speeches by Gestas and Dysmas in the *Gospel of Nicodemus*, the latter humbly assesses the 'terrible judgement' in which he finds himself, and entreats Christ to 'give not power unto the enemy to swallow me up and be inheritor of my soul, as of his that hangeth on the left; for I see how the devil taketh his soul rejoicing, and his flesh vanisheth away'.[34]

From the strict vantage point of iconography, it is unfortunate that we cannot regard this apocryphal source as a basis for the Girona Beatus illustration, with its mixed-up identifying labels. However, from the vantage point of cultural history, this incongruity may reinforce our suspicion that the visual motif of the struggle for souls, rooted in popular conceptions about the fate of the soul after death, constituted *in itself* a kind of 'universally accepted symbolism' whose signifying power overrode other symbols. For the viewer tuned to the devastating, existential uncertainty of the struggle, and aware of its cosmic implications (every victory for God diminished Satan's empire and vice versa), the capture of the fleeing soul was a matter of mortal seriousness. In all likelihood the motif was a cue for response that was accessible to all viewers, learned and otherwise. It allowed the painters of Calvary in the later Middle Ages to put narrative emphasis where their viewers perhaps wanted it most: at the moment of death. The

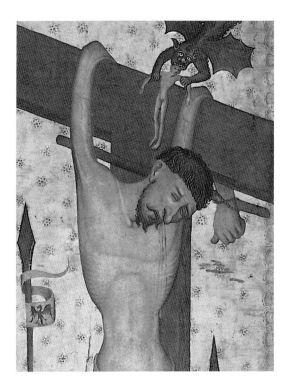

93 Detail of illus. 77, showing the upper body of the Thief on Christ's left.

French surrealist writer Georges Bataille doubted we could ever truly *see* death itself; like the sun, death's explosive power made it, practically speaking, beyond human vision.[35] Yet the painter insists that we can witness the event, that death's moment can be present before our perception, and that the sight should either edify or terrify us, depending on its outcome.

The homunculus theme may have been introduced into late medieval northern art through *quattrocento* painting.[36] It can be seen in numerous German, Austrian and Netherlandish examples. And, as late medieval altar painters worked to make these supervisible realities jibe with their increasingly naturalistic scenographies of the Passion, the soul figures themselves grew correspondingly subject to the bumps and bruises of physical existence. Some fifteenth-century painters express the soul's departure from the body with brutal anatomical specificity. In the central panel of an iconographically complex altarpiece, formerly in the (Franciscan) Barfüßerkirche in Göttingen, and now in the museum in Hannover (illus. 77), a black demon swoops down to perform a daring aerial abduction of the Bad Thief's soul (the Good Thief has not yet expired). Even though the soul figure offers no visible resistance, the violation visited upon the Thief's ransacked

body materializes in the form of a nosebleed (illus. 93). Thus does the German master configure the soul's 'departure' from the body as a kind of primitive craniectomy that wreaks havoc on the body's viscera. Elsewhere, in a popular German woodcut made a few decades later, the same operation of drawing the homunculus out of the head is performed on the Good Thief (illus. 94). Here, however, there is no adverse effect upon the body; rather, it is the Bad Thief's soul whose departure and capture are marked by violence: the body vomits up the evil spirit, as one sees so often in contemporary images of exorcisms. Equally literal is the demonic abduction in the so-called *Rehlingen Altar*, painted by Ulrich Apt the Younger of Augsburg (illus. 95). The Bad Thief's soul is yanked from his mouth and carried off, arms pulled back over its head as if crucified.

Of considerable historic importance is the *Rehlinger Altar*'s date of 1517. Painted on the eve of the Reformation, this is one of the last northern works to include the departing souls. In general, as the fifteenth century wore on, fewer and fewer representations of even those Crucifixions that purport to show the hour of death make use of

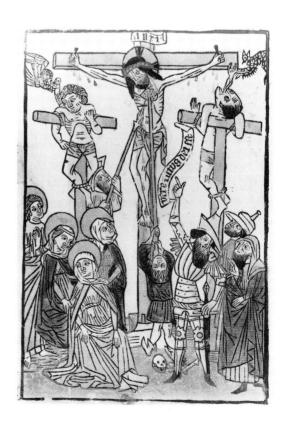

94 *Crucifixion*, German, second third of the 15th century, woodcut, 264 × 178 mm. Staatliches Graphisches Sammlung Albertina, Vienna.

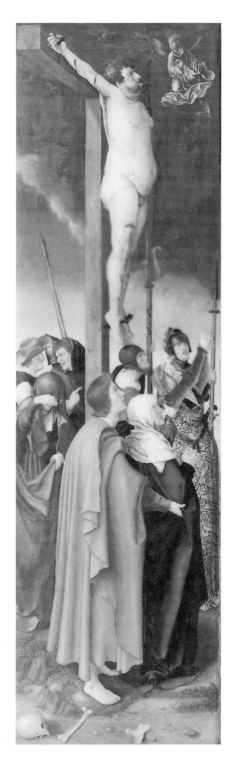
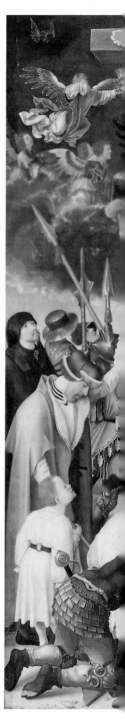

95 Ulrich Apt the
Younger, *Calvary
Triptych* (the so-called
Rehlinger Altar), 1517,
central panel
166 × 112 cm,
each wing 170 × 51 cm.
Staatsgalerie, Augsburg.

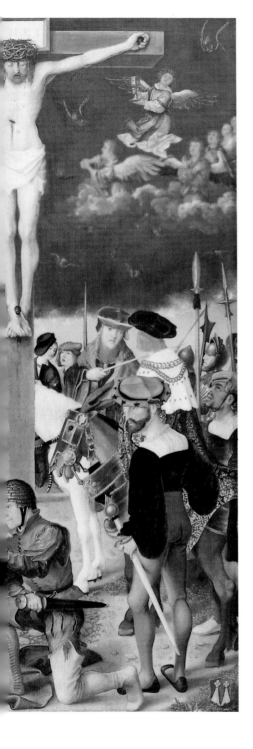
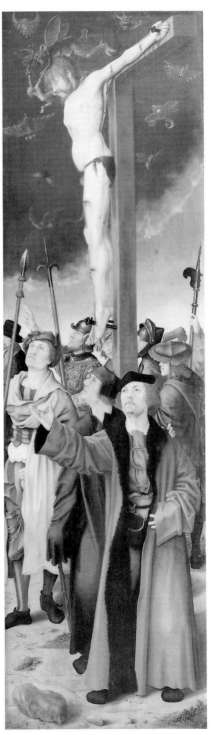

the motifs. Most of Apt's German contemporaries – for example, Dürer (see illus. 112), Cranach (see illus. 1) and Altdorfer (see illus. 107) – had, following their most influential fifteenth-century predecessors in both the Low Countries (the Limbourgs, Jan van Eyck, Hans Memling) and Italy (Antonello da Messina, Fra Angelico, Mantegna [see illus. 103]), abandoned the motif as anti-naturalistic. And Protestant iconography, for reasons we will examine in Chapter 8, would eschew them entirely except when it sought to criticize them.[37] What, then, prompted Ulrich Apt to reassemble against this awesome dark sky, above the heads of spectators so compellingly real, such a panoply of invisible beings – sweet angels and pestiferous devils? Perhaps we should not take it for granted that the painter took it for granted that the viewer would recognize the Good from the Bad Thief by their placement on right or left. The remaining signs of difference are ambiguous: the black and white bikinis worn by the Bad and Good Thieves, respectively, may have sufficed for some viewers to distinguish them, but the corpulence of the Good Thief might have led others to mistake him for his opposite. Everything considered, then, it is the drama in the sky which alone denotes the antithesis without ambiguity. The Good Thief, here as in the *Barfüßaltar* (see illus. 77), is the last to die: overlooked by all the spectators, the corpulent man (with a brutish innocence that recalls Borges's poem) exchanges gazes with a single angel who hovers before him. And as the penitent commends his soul to God, the angel prepares her robe as a 'place of refreshment' for the emerging spirit. But we are still far from explaining why this motif, which most other painters chose to exclude, remained the pivotal sign of difference for this painter.

A related work by Hans Burgkmair, an *Altar of the Crucifixion*, signed and dated 1519, and bearing the crest of the prominent Peutinger family, can illuminate this problem (illus. 96).[38] Burgkmair was a contemporary and acquaintance of Dürer, occupying the same leading position in Augsburg as the latter did in Nuremberg. His art perhaps best exemplifies the position of the prosperous Swabian town – both imperial free city and episcopal seat – as a 'dissemination point' for Italian Renaissance ideas in southern Germany.[39] Like Ulrich Apt, Burgkmair places his Thieves on the inner wings of the triptych and unifies the composition by stretching the landscape across all three panels; he also crucifies his Thieves with nails. Unlike Apt, however, he places the central cross at a slightly oblique angle, thereby avoiding the static isolation and remoteness of Apt's Christ; he also turns the cross of the Bad Thief away from us entirely, a move presaged in south German works of the preceding half-century (see illus. 43).

238

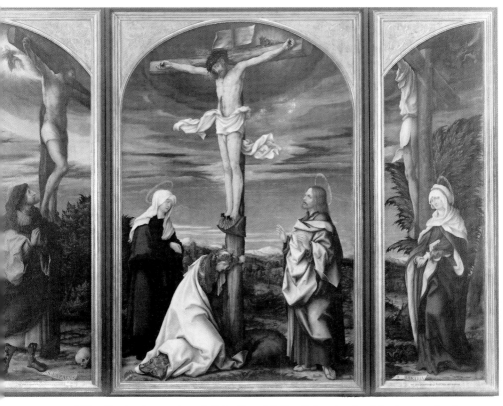

96 Hans Burgkmair, central panel of the *Altar of the Crucifixion*, signed and dated 1519, painted pine, 179 × 166 cm. Alte Pinakothek, Munich.

But the outstanding difference between the two works is the way Burgkmair has reduced the throng at Calvary to only a few key figures: Mary, John the Apostle and Mary Magdalene mourning in the centre, Lazarus on the left wing and his sister Martha on the right. Their isolation speaks to a different conception of the Crucifixion altogether: rather than the suspended moment in a temporal drama that defined the late medieval Calvary, Burgkmair draws upon the three-figure type of the Crucifixion – especially popular in the graphic arts – in which the grief and despair expressed by Mary and John are abstracted from narrative considerations. In this patently *devotional* image, then, they are joined by the weeping Magdalene, who clutches at the base of the Cross. Together the three mourners model a properly compassionate response to Christ's sufferings for the emulation and edification of the pious beholder.[40] By maintaining the Two Thieves, however, Burgkmair has hybridized the two prevailing types of image, the historiated Calvary and the devotional Crucifixion, into a monumental

239

vision of human suffering, compassion and penitence, windswept with tragic gloom. And above the heads of the Thieves the claimants of the dying men's souls take flight with their prizes.

Though similar in format and roughly comparable in size, the approaches taken to visualizing the fate of the Thieves' souls by the two Augsburg painters, Burgkmair and Apt, illuminate their diverging conceptions of the Crucifixion theme and its possibilities on the eve of the Reformation. Burgkmair departs from the didactic bombast and spectacular triumphalism of the *Rehlinger Altar* to better plumb the depths of the relationship between penitential suffering and redemption. Just as Apt used very literal soul-departures in the upper portion of the wings to harmonize with the angelic flutterings in the central panel, thus amplifying the heavenly din, so Burgkmair interpreted the motif metaphorically, in order to turn down the volume and trigger a different kind of emotional response. Our gaze is subtly directed by the compositional shifts towards the left, where it meets the praying figure of Lazarus, who radiates pious feeling from beneath the cross of the Penitent Thief. As the first soul resurrected from death by Christ (John 11: 1-44), Lazarus's unbiblical presence at the Crucifixion offers embodied proof of the transhistorical saving power of the Cross; by placing him directly astride the cross of the Good Thief, Burgkmair fuses the promise of a general resurrection at the end of time with the promise of redemption for the penitent sinner at the hour of death. Together Lazarus and the Good Thief thematize the twin glories of the soul judged worthy at death and imbued with grace for eternity. Without the radiant ascension of the Good Thief in the distance, the image would exude a troubling melancholy incompatible with Burgkmair's pious aims.

Rooted in popular beliefs, but undoubtedly sanctioned by theologians, the motif of the departing soul was an essential part of the iconography of penance and dying in medieval art. It makes its appearance across a range of subjects both religious and profane, from the Last Judgement, the Death of the Virgin and the Crucifixion, to the *Ars moriendi* (see illus. 60) and its offshoots. Against its gradual abandonment by realist painters on both sides of the Alps, and its outright avoidance by Protestant painters, the motif returns with a vengeance in works expressly made for Catholic *popular* audiences: for example, Gaudenzio Ferrari's *Calvary* fresco in the church of Santa Maria delle Grazie at the Sacro Monte in Varallo.[41] Indeed, we may be justified in calling it a 'Catholic' motif, and in doing so recognize the degree to which the supervisible struggle for souls between angels and demons could be read as an allegory for the confessional struggle

between Catholics and Protestants. At Varallo their appearance may be as determinedly anti-Lutheran as the Sacro Monte itself ultimately became. Even Lutheran propaganda found a use for them as motifs of a proven popular resonance and legibility (see illus. 116). But the same antithesis undergirds each new use of the theme, even as the theological terms that once defined it were liquidated by reformers after 1517: the Two Thieves as model and anti-model of the good death.

Donors and penitential identities

Departing soul figures furnished the beholder of Calvary's punitive spectacle with pre-eminently legible signs of spiritual difference; they functioned not to satisfy a morbid curiosity about who is redeemed and who is damned, but to attract and repel the desire for identification. Of course in the religious imagination this goes beyond the pursuit of models for external imitation. Identification and identity formation are processes that embroil subjectivity in a dialectic of absence and presence. Before identification with an other can occur, before an empathic conformity of one life to another can be enacted, part of what is already present in the self must be displaced, made absent. But also, the very thing that is *a priori* absent must also be displaced from its ontology in space and time in order to be constituted as a presence in the ego life of the desiring subject. Mystical spirituality understands this process and enshrines it at its heart. Contemplation, wrote Hugh of Saint-Victor (d. 1141), is 'an easy and clear-sighted penetration of the soul into that which is seen'.[42] The result, the exultation of the soul in its object of love, depends upon the soul's capacity to transform itself by a kind of empathic self-displacement into its object. Creator and created, prototype and image, master and epigone, lover and beloved are all transformed in the dialectics of identification – a fusionary process outside of which none of these terms exists independently.

The medieval religious who sought to become present at the Passion, walk the *via crucis* with Christ, bear personal witness to every incidental detail of these sacred events, and experience feelings of guilt, remorse, penitence and joy at rebirth – who undertook to 'penetrate' with the soul that which is physically absent but accessible to the mind's eye – whoever pursued these spiritual goals had to perform, to some degree, a set of temporal and spatial *displacements* that went beyond the metaphoric.[43] Images, we have seen, played a unique role in facilitating these kinds of imaginative experiences because they also held the potential to thematize and record those experiences for others to see, and follow. Arguably, every religious image could facilitate such

imaginative displacements, but those that included an image of the picture's donor were the first to explicitly thematize their enactment and its consequences.

Franciscan religious ideology not only formalized the devotional imperative of being 'present' at biblical events as their mysteries unfolded; it appears also to have established the precedent of showing the ideal, compassionate beholder of the image visible *in the image* as its benefactor. In Cimabue's fresco in the mother church at Assisi (*c.* 1290), Francis kneels on the hill of Calvary and leans against the Cross, just as Mary Magdalene would in countless later images. The saint's abased presence on Calvary signifies not only a literal realization of his extraordinary meditative powers but also the extraordinary depth of his penitence, which Franciscan authors construed as the emotional engine behind his radical brand of mysticism. When Francis and Mary Magdalene abase themselves at the ground-zero of sacrificial suffering, they model a form of penitential identification matchlessly. As a contemporary paradigm of compassionate suffering, Francis was also therefore the model of imaginative displacement – his alleged power to identify provided his biographers with the framework for their subsequent grafting of *alter ego*s on to him.

In subsequent decades, when Franciscans appeared on Calvary, kneeling in adoration of the Crucified, they most likely had wished to be portrayed as penitents – although they now appear off to the side, not in direct contact with the Cross (illus. 97).[44] Does the worshipper's proximity to the Cross signify the depth and extent of penitential identification with Christ? Did proximity to the crosses of Dysmas or Gesmas serve in any analogous way to assist – or challenge – the contemporary person in the fashioning of his or her own penitential identity? How did such placements and displacements, presences and absences, identifications and misidentifications, look from outside the altarpiece – that is, from the physical space of beholding in the chapel, or the church? How else could painters and sculptors thematize the positionality of the spectator? By examining several works in which the donor, immersed in visionary experience and displaced into sacred history, is juxtaposed with those antithetical models of penitence, the Two Thieves, we can, I believe, better understand the peculiarly *penitential* function of the late medieval Calvary and bring together the divergent streams of this chapter. Did artists concern themselves with assisting viewers in the self-fashioning of their own, penitential identities? Given the powerful part played by both penance, as a sacramental institution, and penitence, as a mode of thought and action, in late medieval religious and social life, how did artists and their work aid

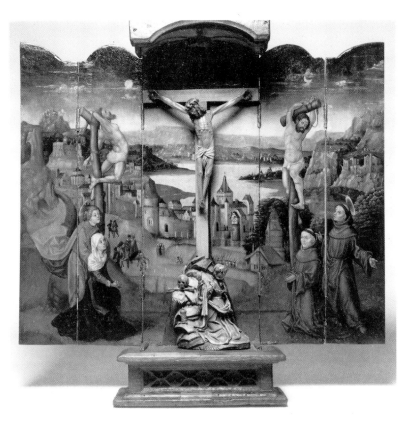

97 *Crucifixion Polyptych*: crucifix (Lower Rhenish, carved ash and fruit-wood) and painting (Netherlandish, oil on panel, *c.* 1520, 52.7 × 54 cm). Martin D'Arcy Gallery of Art, Loyola University Museum of Mediaeval, Renaissance and Baroque Art, Chicago.

and abet the workings of a special mode of 'penitential vision'? How did the expanded Crucifixion image with the Two Thieves play to the existential anxieties that gave penance and confession its over-whelming urgency in late medieval life?

A work by Robert Campin, whose monumental *Thief on the Cross* in Frankfurt we discussed earlier (see illus. 39), is a provocative starting point. Early in his career, *c.* 1410, Campin completed work on a trip-tych depicting the *Entombment of Christ*, once known as the *Seilern Triptych* after its former owner, and now in London (illus. 74).[45] Panofsky observed that the central panel represents not a Gothic *Entombment*, strictly speaking, but a hybridized *Entombment/Lamentation*.[46] The Lamentation over the dead body of Christ, a theme known in Byzantium as the *threnos*, was well known in trecento art but had been broached in the north only a century earlier by the Parisian illuminator Jean Pucelle. Lacking the authority of the Gospels but nourished by its

243

liturgical analogues in the services for Good Friday, the *Lamentation* was an abstraction from narrative action that hinged on Mary's sorrow and love for her dead son.[47] In line with this tradition, and coupled with the grieving farewells at the tomb, Campin's image rivets attention on the emotional affliction of the actors around the *corpus Christi*. On the left edge of the central panel there is an angel holding the Holy Lance. As the only actor not completely focused on the dead body of Christ, she projects a worried glance diagonally across the frame's divide, cueing us to the presence of the donor on the wing, a still-unidentified bourgeois gentleman, kneeling in prayer with a little dog. This is merely one of several devices that help us connect the spaces of the central panel and wings, but it is, I think, the most important. Together with the man's posture and gaze, the angel's mournful, *specular* acknowledgement of his proximity to the tomb establishes decisively his presence as a witness to the scene.

From these observations alone, however, it would be impossible to infer any specifically penitential meaning for the donor of the triptych or the conditions of its beholding. As a rule, fifteenth-century artists in the Netherlands showed their patrons engaged in meditation with a cool and confident mien; their visions rarely overwhelm them with sorrow or joy. Nevertheless, there is something about Campin's two-tiered composition, the way it juxtaposes the worshipper in the foreground with the immediate aftermath of the Crucifixion and Deposition in the middle distance, that imbues the donor's otherwise steady gaze with an air of anxiety. To get at this, let us first notice that there are two 'paths' connecting the donor's space and the abandoned site of Calvary, one metaphorical, the other literal. The first is the blank banderolle that spirals upwards from the donor's mouth and terminates at the base of a large ladder leaning against the Cross. Medieval devotional writers frequently used the ladder as a metaphor for spiritual ascent, a measured progress out of corporeal entrapments towards a pure vision of Christ in spirit.[48] Visually, the ladder carries the donor's prayer upwards. And yet the ladder's meaning is hardly exhausted by the workings of metaphor and index, for moments ago the pious company of Jesus had used it as a quite practical tool for removing the dead body from the Cross. Traditionally the ladder ranks among the *Arma Christi*, but here, for now, we see no angels bearing it aloft; it remains among the abandoned penal apparatus of Calvary and therefore partakes of its double nature as sacred weaponry: obloquy as well as glory. To those penitents who would truly follow Christ in his suffering, the ladder issues a macabre invitation to ascend the Cross and hang in the company of thieves.

The second path between the two spatial enclaves in the picture is a literal one: a dirt road, bordered by a fence, winding through the terrain between Calvary and the foreground. Art historian Barbara Lane sees the path in terms of a liturgical passage for the donor, who moves from Good Friday's veneration of the Cross, the Adoratio Crucis, down to the ceremonies of the Depositio and Elevatio, Holy Week rites that were often performed on side altars and involved the symbolic 'burying' of the *corpus Christi* in a receptacle on the altar, later to be 'resurrected' on Easter morning. These rites, according to Lane, are thematized by the scenes of the middle and right panels (*Entombment* and *Resurrection* respectively), of which the donor now has a privileged view.[49] Lane intimates that the path should therefore be read as a kind of private pilgrimage route, leading from one Station of the Cross to the next, one privileged view to another. Another scholar, Matthew Botvinick, sensing that Campin's scenic setting is 'charged with a latent narrative of journey and arrival', considers that the image functioned as a catalyst for the 'performance of fictive pilgrimages'.[50]

But both scholars may be glossing over the element of penitential anxiety that obtained whenever the devout was brought face to face with death and the tomb, especially the sepulchre of Jesus, whose sufferings were – are – the bitter consequence of human sins, *this man's sins*. When Bonaventure urged the penitent towards compassion for Christ's suffering, he deliberately provoked those hard of heart: 'And you, lost man, the cause of all this confusion and sorrow, how is it that you do not break down and weep?'[51] For the penitent, the vision of Christ's Passion was also a revelation of one's own guilt (*culpa*), so affective identification with his suffering entailed a harsh self-recrimination and called forth endless self-accusations. Into the Reformation this antagonistic streak recurred in popular devotional texts and images:

O mortal man, behold my wounds; was there ever found such pain to equal mine. You are the cause of my suffering, I suffer because of your sins; what do you do through my wounds! I am dying here for your sake alone – you should mark that well and full; turn away from your wicked opinion, time and tide will soon expire.[52]

Is the crystalline vision granted to the donor in Campin's painting recognition that the penitent's spiritual pilgrimage is at an end, or does the privileged view inside and outside the picture carry with it the penitent's burden to suffer for Christ's sake? Having literally followed Jesus along the path of the *via crucis* and witnessed the climax at the 'place of skulls', the man has reached the last Station of the Cross as the conclusion of a spiritual pilgrimage. Having passed through the

existential crossroads of Calvary, he has turned down the path towards salvation, but he is only half-way there. Behind him the Thieves hang, frozen in agony and abandoned, looming over the miniature landscape. Whereas many other artists who envisioned Calvary abandoned after the Deposition emptied all three crosses of their victims, Campin prolongs the display of the corpses. For the penitent beholder outside the frame, they serve as macabre admonitions that we must gird ourselves against sin – and despair – as life's pilgrimage reaches its end.

For German and Austrian painters, by and large, the visibly cool confrontation between the pilgrim and the tomb characteristic of Flemish 'bourgeois realism' could not convey the throbbing intensity of compassionate vision and identification. An Austrian work from the 1490s, the riveting *Lamentation* altarpiece by Thomas von Villach now in Klagenfurt, heats up the penitential mysticism to create an entirely different mood within the votive image (illus. 98).[53] Thomas was the leading master in Kärnten and a pre-eminent representative of the so-called 'soft style' (*weicher Stil*), a mixed bag of influences ranging from the Netherlands (the Nicodemus figure) to the southern Tyrol (the Thieves) and *trecento* Italy (the St John).[54] His workshop, undoubtedly

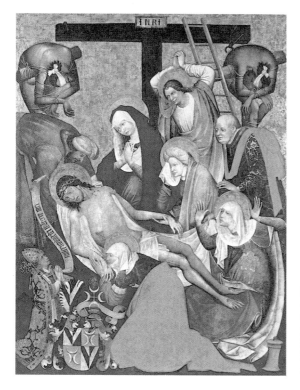

98 Thomas von Villach, *Lamentation for Christ*, 1490s, painted panel, 160 × 123 cm. Landesmuseum für Kärnten, Klagenfurt, Austria.

a large one, executed both altar-panels and wall-paintings for an impressive roster of patrons.

Here we find him working for a man who reigned as the abbot and bishop of St Paul's Stiftskirche between 1488 and 1498, Sigismund Jöbstl von Jöbstlberg; we see him kneeling in the lower left corner, dressed in liturgical vestments, holding a bishop's crozier and wearing a mitre. Considering that Jöbstlberg appears only with his family's coat of arms and not those of his office, it may be that the panel, like Campin's triptych, was commissioned as an epitaph for a family chapel where masses were sung in commemoration of the dead man. And just as Campin showed the presence of his donor being noticed by an actor (the lance-holding angel) within the Passion drama, so Villach shows Jöbstlberg's participation in the drama likewise acknowledged, this time by no less a person than the dead Christ! Lifeless the narrative may require him to be, but for all intents and purposes Villach has made sure that, with tilted head and open eyes, Christ can still meet Jöbstlberg's ardent gaze half-way. And compositionally the painter has seen to it that almost every living actor arrayed around the body will turn their attention in the abbot's direction, helping the beholder to do the same. His physical marginality translates into a symbolic centrality; the painting is as much about Jöbstlberg's piety as it is about Mary's compassion or Christ's death. From his clasped hands flies a banderolle reading *misericordia dei miserere mei*.

In Villach's complicated semiotics of absence and presence, then, it is the rhetoric of compassion that rings loudest, however much it violates the mundane coherency of space and time. A psychological realism, founded on the shared experience of suffering, gives this work an affective power that does not simply overwhelm but draws beholders in, offering them opportunities to discern parallels between suffering and sin, physical and mental pain – to wit, the ravages inflicted upon Lord Jesus's tender body and those etched on the faces of his extended family, from John and the Three Marys to Jöbstlberg himself.

So heavily is the play of meanings dependent on human interaction, in particular the ricochet of exchanged gazes across the panel, one cannot overlook the absolute way in which the Two Thieves are barred from the intersubjective drama on Calvary. Their exclusion is premised, first, on the narrative moment itself. As long as Christ remained hanging on the Cross, artists could conjure up numerous roles for the Thieves to play; but once Nicodemus, Joseph of Arimathaea and company lay hands on the *corpus Christi* and begin to arrange for Christ's burial – from which point onwards His body is handled with exquisite care –

99 Hans Baldung Grien,
Lamentation for Christ,
1514, woodcut. National
Gallery of Art,
Washington, DC.

the ignominy of the Thieves' punishment, their disgrace of being strung up, broken, and abandoned to rot and disintegrate like wasted animal carcasses, finds a powerful new counterpoint. Not until Christ's body is painstakingly removed from the Cross, lowered into tender hands, cradled and wept over by his mother, carried in silent procession and laid gently in the tomb do we realize the absolute nature of the Thieves' abjection. Villach portrays them crunched over their horizontal beams (bent forwards rather than back), wounded on legs and arms, criss-crossed by a network of ropes, handcuffed and blindfolded, a brutal treatment that separates them utterly from the affective human interactions that fill the lower part of the painting. In a word, Villach's presentation animalizes the men. To be immobilized and suspended, half inverted, butchered and abandoned to the elements – these related elements of punitive justice were, we recall from Chapter 6, the most taboo, the most feared strands of the so-called 'vulgar' sanctions. They were unbearable to contemplate because they raised the spectre of an irreversible expulsion not only from the community of the living but from the dead as well.

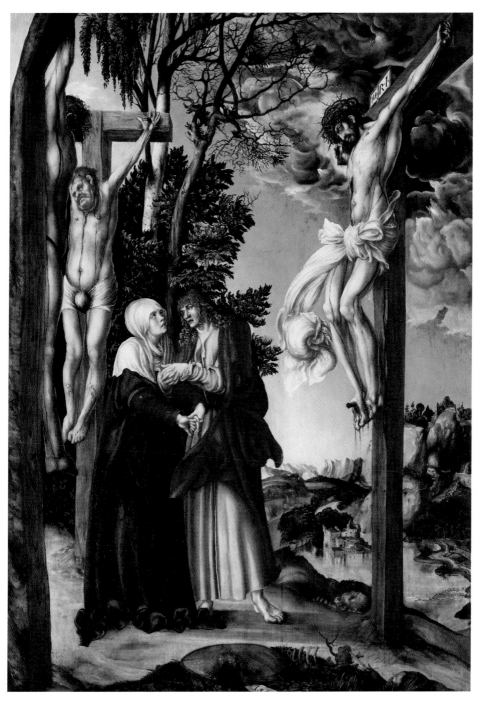

100 Lucas Cranach the Elder, *Lamentation Beneath the Cross*, dated 1503, pine panel, 138 × 99 cm. Alte Pinakothek, Munich.

101 Peter Paul Rubens, *Christ and the Penitent Sinners*, *c*. 1618, oil on oak panel, 147.4 × 130.2 cm. Alte Pinakothek, Munich.

102 Bramantino (Bartolommeo Suardi), *Crucifixion*, *c*. 1515, oil on canvas, 372.4 × 269.9 cm.
Pinacoteca di Brera, Milan.

103 Andrea Mantegna,
Calvary, central
predella panel of the
San Zeno Altarpiece,
1457–9, painted poplar,
67 × 93 cm. Musée du
Louvre, Paris.

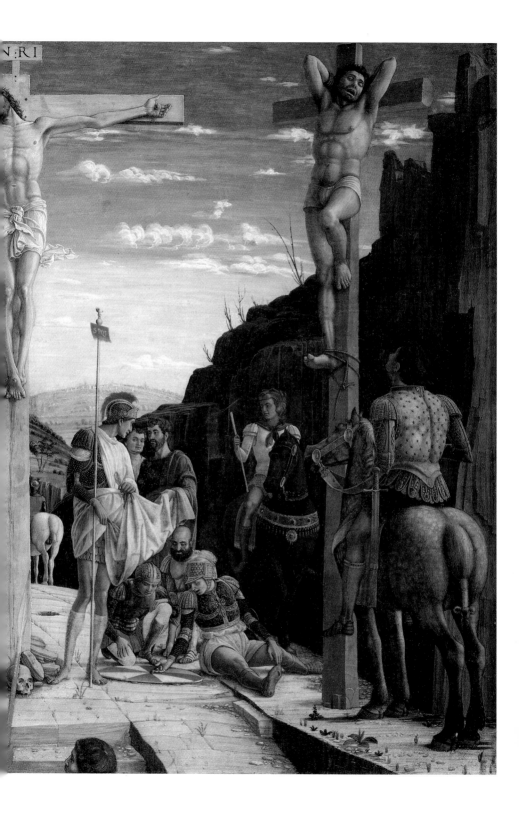

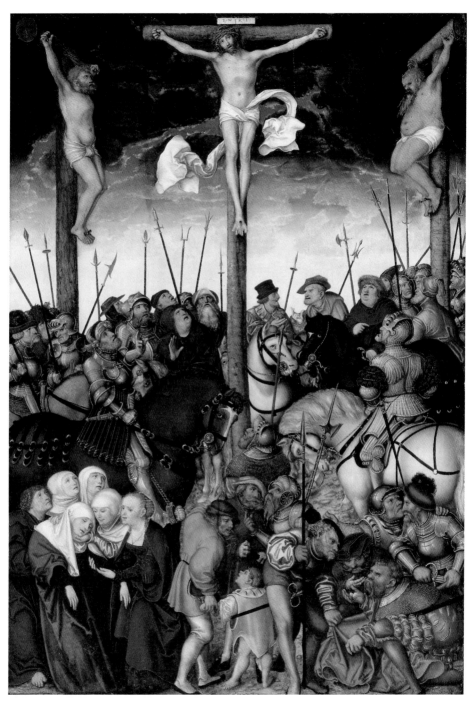

104 Lucas Cranach the Elder, *Calvary*, dated 1538, oil on panel, 121.1 × 82.6 cm. Art Institute of Chicago.

105 Balthasar Berger, *Calvary*, 1532, oil on spruce panel, 113 × 92 cm. Staatsgalerie, Stuttgart.

106 Andy Warhol, *Orange Disaster*, 1963, silkscreen ink on synthetic polymer paint on canvas, 269.2 × 208.3 cm. Solomon R. Guggenheim Museum.

By Villach's time numerous other painters had used the Thieves in the Deposition and Lamentation, where their inclusion found an easy rationale in the mountain scenography of Calvary. We see them in renditions of the theme by the Limbourg brothers, Israhel van Meckenem, Cranach, Altdorfer, Matthias Gerung, Jacob van Utrecht, Daniele da Volterra and Jacopino del Conte among many others. Early in the sixteenth century the Strasbourg painter Hans Baldung Grien experimented with the motif by cropping from his *Lamentation* imagery all but the Thieves' bloodied feet lashed against the *stipes*. He does it in the altar panel preserved in Berlin, and in a woodcut from about the same time (illus. 99).[55] Perhaps because they border on invisibility, the fragmented bodies cast a nightmarish pall over these scenes. Like other German artists of his generation, Baldung displays the demolished corpses on Calvary to fill our nostrils with the putrid smell of human carrion. His unmatched sensibility for the macabre evidently led him to the conclusion that, in terms of the contagion of horror the Thieves' discarded bodies were capable of spreading, less could be more.

Decentred visions

A group of masters associated with the so-called 'Danube School' of German painting exhibit a shared interest in locating the beholder on Calvary, *vis-à-vis* the three crosses, in a bold new way. Their work signals a final shift in the thematization of what I've been calling 'penitential vision' before the Reformation. Again Cranach leads the way. Consider first one of his most daring works, made at a relatively early point in his career, the overpowering *Lamentation beneath the Cross* preserved in Munich, inscribed with the date 1503 (illus. 100).[56] There is no mistaking the ground on which Mary and John stand: it is a place of execution, strewn with bones, among them a still-decomposing head – possibly meant to depict the skull of Adam – facing up, its mouth stretched open as if screaming (see illus. 1). Portentous clouds fill the sky behind the crucified; a shivering gust of wind blows up from the flooded valley, rattling the branches of a dead tree and puffing up the dead Christ's loincloth with a muscular tumescence.[57] Cranach paints the racked limbs of the three prisoners, the fractures and distension of the Thieves' shins, the engorged puncture wounds in Christ's feet, the welts around his eyes, the crimson streams of blood that run alongside blackened veins erupting beneath the skin – all of this done from a seeming wealth of experience that is as much the executioner's as the anatomist's. Cranach's turbulent brush makes the

natural environment seethe with vitality, but when it comes to patho-physiological details the brush slows, and expression stands down to admit precision.

Few viewers will be held so much in thrall by these surface dissections that they will miss the new compositional arrangement, the shift in perspective from frontal to oblique. As early as the 1440s Jacopo Bellini ventured an oblique perspective on Calvary's main event (the drawing is now in the British Museum); and later, at the century's end, Dürer applied the device to a devotional *Crucifixion* in his altarpiece of the *Seven Sorrows of the Virgin*.[58] However, Cranach has gone one better than his Italian predecessor and German rival by pivoting our perspective around almost a full 90 degrees away from the canonical frontality that had defined the image's 1,000-year history! As a de-centring of the beholder, the gesture opens up new avenues for interpretation and sparks new modalities of feeling. The Cross no longer functions as an element of visual stasis, but rises up along the right edge of the frame as an overpowering presence in a space we now seem to inhabit. Barely contained by the painting's upper right corner, Christ's left arm, nailed against the giant wooden beam, thrusts out above us; likewise the crossarm of the Bad Thief's cross juts clear out of the picture and over our heads. The vertical beam of this cross Cranach shoves right up against the picture plane and, by implication, against the body of the spectator. A creepy feeling descends on us as we see what the painter is up to: Cranach has taken an illusionistic devotional image of extraordinary emotional power and framed it not as a view through a rationally composed Albertian window (see Chapter 8), but through the infamous apparatus of punishment. Again we find ourselves at a kind of existential crossroads. Our vision is simultaneously privileged – in that we can take in all the positive models of patient suffering, including Dysmas, identified by his white linen cloth – and debased, since we have been fixed in place beneath the damning left hand of Christ and brought into an almost unbearable proximity with the bleeding, turgid corpse of the damned sinner, identified by his lascivious black bikini. As penitents we stand to the side, barred from a (visual) communion that is Mary and John's alone. In other words, Cranach effects our imaginative displacement to Calvary, backs us into an uncomfortably tight corner and then levels at us a devastating indictment. His is an art of antagonism. Like a schoolmaster brandishing a birch over our heads as we recite the catechism, Cranach foists upon us a captivating, sidelong vision of a redemption from which we are, for our own penitential interval, excluded.

Thus does Cranach thematize 'penitential vision' more powerfully than any of his predecessors, or successors. Joseph Leo Koerner intuits the relationship between guilt and perception when he notes the way Cranach manipulates our vision so that 'everything we see before us appear[s] colored by a subjective state within us'.[59] Yet I think Cranach was intent on going further than this by specifying what that subjective state should be. Calculatingly, he uses the pivoted perspective to place the monumental figures of Mary and John at the painting's visual centre.[60] Standing in the chilly winds of Cranach's Germanic Calvary, isolated in a narrow space in front of the Cross, threatened by the grim presence of the suspended corpses and scattered bones, Mary and John wring their hands in grief. As we look across this desolate space towards their spiritual pain, and see flanking them Christ and Dysmas in abjection, the promises of Paradise seem temporarily foreclosed. Whatever narrative repletion we may desire has stalled in gloom and horror. Under such conditions of narrative suspension, the questions Cranach seems intent on asking – Where do we stand? With whom do we identify? – swing like a wrecking ball through our fragile vanities. The painter reminds us we are all sinners and reserves a place for us in the company of those who refuse and abuse Christ on the 'sinister' left. The only proper response is to stand guilty as charged and repent.

Two works associated with the prominent Regensburg master Albrecht Altdorfer, who was about twelve years Cranach's junior and heir to his poetic treatment of landscape, attest to the impact made by the older painter's break with the canonical arrangement of Calvary. Their precise relationship to Cranach and to one another is, however, something of an art-historical puzzle. In 1518 Altdorfer was at the monastery of Sankt Florian, near Linz in Austria, where he worked on a large Passion altarpiece and a number of scenes from the life of St Sebastian. In the extraordinary *Crucifixion* panel we see that Cranach's severe angle of view has been softened, so once again Christ's cross is visible through the section of space between the Thieves (illus. 107).[61] With a different theme comes a different sense of temporality: though Altdorfer maintains enough of Cranach's atmospheric portents to suggest the old topos of the event's cosmic disruptiveness, life none the less goes on. Expressive of this uninterrupted flow of time is the brown-skinned man, perhaps an executioner, who ambles back up on to the execution ground with an axe in hand and fresh-cut logs. Nor are the Jews thwarted from their disputation with a Roman solider. In fact we are long past the Passion's climax, which occurs in the action packed *Carrying of the Cross* preceding our panel in the altar's cycle.

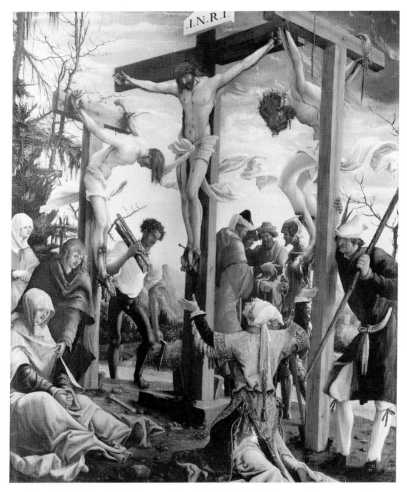

107 Albrecht Altdorfer, *Crucifixion*, panel from the *Sankt Florian Altar*, 1518, spruce, 112 × 94 cm. Monastery of Sankt Florian, near Linz, Austria.

There is more to say about the Sankt Florian altar, but first an introduction to the second work, a pen and ink drawing, dated 1511 and signed with the monogram 'J. S.' (illus. 108). Once attributed on stylistic grounds to another Danube painter, Wolf Huber, the drawing is almost certainly a copy after a lost original by Altdorfer, whose earliest design for a different Passion sequence has left only one or two other traces.[62] Clearly the composition is closely affiliated with both Cranach's Munich panel and the Florian Altar, but this is no place to review the scholarly arguments about the drawing's authorship and dating. If we accept the inscribed date of 1511 as original, then we can regard the drawing as an important document of the developmental work Altdorfer did for the Florian Altar before 1510.[63] We may also regard it

as an intermediary between the two master paintings by Cranach and Altdorfer and examine its arrangement in that light. As in Cranach, the spectator's position has been pivoted around to the left of Christ (though not so severely), so as soon as we look up we find ourselves 'under' the splayed body of the Bad Thief, whose arm thrusts out above our heads. Further, the *stipes* of his cross is pressed up against the picture's edge as in the Munich painting, only here Master J. S. puts us on the opposite side of the Bad Thief's cross – this gives us a broader view across his more open composition. Cranach's swirling phallic loincloth reappears – without quite as much lift – but that is where obvious borrowings cease. Whereas Cranach shifted attention towards Mary, J. S. and Altdorfer have us once again looking at expanded Crucifixions, as Bellini had first done in the 1440s.

With such an oblique view, our pseudo-Altdorfer has opened up new scenographic possibilities for conveying the judicial reality of the Crucifixion.[64] In a startlingly new way he transposes the biblical execution grounds of Golgotha on to the contemporary topography of penal justice. In the sixteenth century this meant the *Richtstätte* outside the city walls. Practically every theatrical detail conveys this. Buildings and

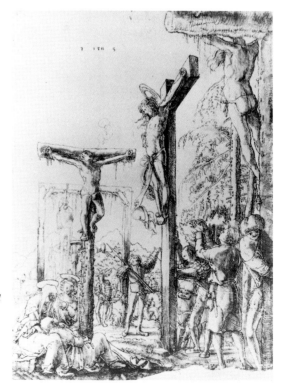

108 Master J. S., *Calvary with Executed Criminals and Mercenaries*, dated 1511, pen and ink drawing, 21.9 × 15.5 cm. Staatliche Museen zu Berlin – Preußischer Kulturbesitz (Kupferstichkabinett).

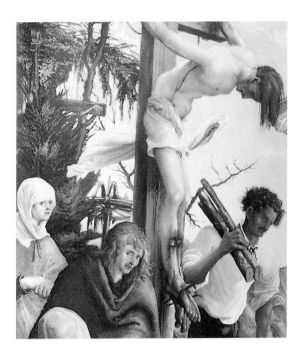

forest are unmistakably Germanic; the 'Roman' soldiers who adjust and secure the Cross upright appear in the contemporary dress of the German mercenaries, or *Landsknecht*.[65] Apart from the Three Marys and the St John figure praying with upraised hands, there are no characters in the plain biblical garb typical of northern Passion imagery.

Rising behind Dysmas, its contours diffused by the thick air, are an ordinary wooden gallows and, beyond this, a raised wheel. These penal apparitions anticipate by only a few years similar juxtapositions in the Cambridge drawing of *c*. 1525, attributed to Wolf Huber (see illus. 6). There the biblical trope of Christ's death among Thieves was modified by juxtaposing Jesus's 'Roman' crucifixion with two vulgar medieval punishments, hanging (or possibly suicide) and breaking with the wheel, and casting it in the emotional terms of a Cranachian *Lamentation Beneath the Cross* (see Introduction). However, unlike Huber, who dispensed entirely with the convention of showing the Thieves crucified, J. S. maintains the 'historical' integrity of the Calvary group, but insists none the less on exploiting the anachronistic juxtaposition of crucifixion with these other punishments for the sake of experiential immediacy. Noting this juxtaposition in the drawing, we now see a detail in Altdorfer's Florian panel that might otherwise elude notice: the erected wheel in the middle distance, its location – almost directly behind the cross of the Good Thief – reiterated from the drawing. In

the painting this takes on an added charge, since the wheel is visible only by looking directly past the hideously fractured shins of the Good Thief (illus. 109). Is it any wonder that Altdorfer insisted that the wheel standing empty in the earlier work should, in the finished painting, hold as its bounty a rotting body with its knees stuck up in the air?

Conclusion

In the long era between the Fourth Lateran Council of 1215, which mandated yearly confession for all Christians, and the Reformation, when the penitential system of the Church came under attack, the call to penance was the energizing force of lay spirituality and clerical efforts to guide it. Penance for sin stood as the universal means by which ordinary people could conform to the suffering Christ and partake of His grace. For saints, mystics and ordinary Christians alike, penitence meant more than repentance or participation in the sacrament of penance. 'Penitence,' writes André Vauchez, 'was a condition, virtually a way of life.'[66]

Churchmen, who in theory and practice pushed for a more rigorous application of the penitential system in the life of the laity, founded their arguments on the belief that the sacrament of confession and penance relieved the soul of its burden of sin and provided spiritual consolation. But when we consider the astounding inroads made by the fifteenth century's religious dissent and reform movements (Waldensians, Lollards, Cathars, Hussites) and the eventual explosion of evangelism in the sixteenth century, we are easily led to believe, as the reformers themselves did, that the Church's penitential system overwhelmed people with guilt and provided too little comfort in exchange.[67] 'Indeed,' writes historian Thomas Tentler, 'sacramental confession can become an additional source of guilt, which may arise not only because one has sinned but also because one has not been able to meet adequately the requirements for forgiveness.'[68] In the agitated years following his mother's death in 1514, Albrecht Dürer bore witness to his own great spiritual suffering (*grossen Angsten*), and wrote of the relief he finally found in Martin Luther, 'this Christian man who helped me out of great distress'.[69] A similar despair touched many.

Yet on the eve of the Reformation there still existed only one acknowledged route for the alleviation of sin's burden and its concomitant guilt: the clerically administered and controlled sacraments of confession and penance. And of the Catholic saints who modelled penitence for the laity, Dysmas was among the most dynamic and compelling. The beneficiary of many colourful legends, the saint's

actualization of the 'perfect penance' was coterminous with the spectacle of his death; tortured and forced to suffer bitter pain, he dies the archetypal Good Death and becomes its patron saint. Also, almost everywhere he appears in art before the seventeenth century, he is paired with an opposite who fascinates by actualizing the horror of the Bad Death. As he dies unregenerate, embodying despair, the Impenitent Thief negatively illuminates God's joy in seeing a fallen sinner converted and redeemed:

It is certain that he who falls can rise again and not only rise again but also rise again better than he was when he fell. Many have fallen and have arisen better than they were before they fell, even better than they would have been had they not fallen, because they were permitted to fall for the very purpose that they might be taught by their mishap and ruin and be made better.[70]

As moral opposites, real-life thieves served precisely these functions in the interlocking spheres of criminal justice, where the penitent and confessed Good Death was as edifying to spectators as the impenitent Bad Death was horrific. And it was, not surprisingly, Dysmas, the model penitent and patron saint of criminals under sanction of death, who in spirit presided over the collective effort to secure the confession and penance of the condemned prisoner. When, for example, members of the Italian confraternity of San Giovanni Decollato, established in Renaissance Rome for the spiritual care of prisoners, visited the condemned man (*giustiziati*) in his cell the evening before a scheduled execution, they routinely encouraged him to identify with the Good Thief. Their exhortations continued up to the moment of death itself: after the night's vigil, the condemned was accompanied to the scaffold by his *confortatori*, who held small devotional images, or in northern countries a crucifix, before his eyes (see illus. 45). The brothers then reminded him that God had granted him pardon, and requested that he repeat Christ's last words, '*In manus tuas Domine commendo spiritum meum*', then, '*Giesù e Maria di nuovo ve dono il Cuore e l'anima mia*' and finally, to be repeated three times, '*Giesù Giesù Giesù*'.[71] By commending one's soul to God and identifying with the Good Thief, one prepared to make a good end.

Similar promises of salvation, couched in the antithetical terms of Luke's Gospel, were held out elsewhere by comforting clerics to condemned prisoners, male and female, through the early modern period. On 16 August 1715, the infanticide Marie Hausmann was to be executed in Nördlingen. As reported in the edifying Lutheran tract, *Blessed Last Hours of Executed Persons*, on the morning of her execution Hausmann's pastor greeted her with Christ's own words to Dysmas:

'Verily, I say unto thee, today thou shalt be with me in Paradise.'[72] Thus Dysmas's story, apparently because it so vividly illustrates the sacramental efficacy of confession and penance, seems to have lived on in the minds of not only Catholics, for whom he was *sanctus*, but also Protestants, who apparently imagined him in stricter, historical terms as the first converted sinner to 'decide' in favour of faith over and against the efficacy of works. We will examine the visual implications of this Protestant conception of Dysmas in the following chapter.

Even for ordinary deaths, as we have seen, Dysmas might be invoked as a model of penitence and the bearer of intercessionary prayers. Recall his appearance alongside Mary Magdalene, Peter and Paul in the *Ars moriendi* engraving by the Master E. S. (see illus. 59). His 'perfect penance' and hence his perfect death, whose outcome was certain to whomever knew his life story (but hardly apparent in the pain-racked figure rising above the foot of the bed), were intended to inspire and comfort the dying Everyman (*Moriens*) of the series. In pain he stands as a penitent witness to God's mercy, as expressed in the famous hymn known as the *Dies irae*, penned by an Italian, most likely Franciscan, poet of the mid-thirteenth century:

> Guilty, now I pour my moaning,
> All my shame with anguish owning;
> Spare, O God, thy suppliant groaning!
>
> Through the sinful Mary [Magdalene] shriven,
> Through the dying thief forgiven,
> Thou to me a hope hast given.[73]

Later, under the impetus of the Counter-Reformation and Jesuit sponsorship, Dysmas reappears frequently among the converted sinners.[74] In a group portrait by Peter Paul Rubens of *c.* 1618, Christ receives ardent tributes from Magdalene, St Peter, King David and a swarthy St Dysmas, who hugs his cross with strong arms and gazes dreamily into the eyes of his beloved Saviour (illus. 101). For the viewer outside the picture, Dysmas's compassionate gaze condenses all the milestones in the penitent's spiritual biography, and thus the pilgrimage of his life: remorse, conversion, repentance and purgation. By fixing our gaze along the same trajectory, we are to seek a convergence – an identification – of two narratives of self and of human salvation, both modelled on the same prototype.

8 Image and Spectacle in the Era of Art

> Consideration of the behaviour of people in the sixteenth
> century, and of their code of behaviour, casts the observer back
> and forth between the impressions 'That's still utterly medieval'
> and 'That's exactly the way we feel today.' And precisely this
> apparent contradiction clearly corresponds to reality.
>
> NORBERT ELIAS, *The Civilizing Process* (1939)[1]

The crisis of the image

At the onset of the sixteenth century, the belief in the 'living presence'
of holy persons in the cult image was, for all but a few sceptical minds,
a fixture of mental life. Sacred images, like relics, contined to lure
thousands of pilgrims to shrines across Europe; they continued to be
lavishly indulgenced by papal decree; they continued to weep, bleed,
punish blasphemers, heal, rescue and perform other miracles; and
these miracles continued to produce waves of mass religious enthu-
siasm and a crusading spirit that, in some parts of Europe, erupted
into violence (see Chapter 5). Nevertheless, within a half-century's
time another type of violence, Protestant iconoclasm (the destruction
or removal of images), would negate the authority and power of the
old cult images, transform the visual environment of northern Euro-
pean sanctuaries and impinge upon the visual habits Christians had
acquired over the course of centuries.

Already before the Reformation, the quasi-magical premises of
the *imago* had been worn thin by perennial battles over 'idols in the
church' (most of which focused on the Church's liturgical centrepiece,
the high altar). In response, cautious clerics had already begun curbing
the lavishness of the image's liturgical display; and already some artists
had learned to modify its outward form, as, for example, when sculp-
tors deprived their altar figures of the gold and bright colours that
had been criticized as worldly, or when they turned to relief carving,
as the Landshut master Hans Leinberger increasingly did, to avoid
the 'idolatry' commonly associated with three-dimensional sculpture

110 Hans Leinberger, *Crucifixion*, signed and dated 1516, carved pearwood, 21.9 × 15.2 cm. Bayerisches Nationalmuseum, Munich.

(illus. 110). Already, in short, the status of sacred images *as representations* was being highlighted, their former powers bracketed – as much in response to, as a pre-emptive move against, the critics of the image. Such was the prehistory of the cult image's sixteenth-century reform: an uneasy balance between fear of idolatry and tolerance of popular forms of veneration, an ambivalent attitude towards devotion, visuality, materiality and their proper relation.[2] Once the institutions that had sponsored and authorized images came under strenuous attack by Protestant reformers, the inner contradictions of the cult image could no longer withstand criticism and the idols came down.

Alone the controversy over sacred images would not have brought to a close this long era in which the cult image reigned. The 'crisis of the image', which, according to Hans Belting, entailed a liquidation of old concepts about images and their powers, actually occurred on two fronts (and in some places simultaneously). On one hand, we have the most radical and violent stage on which the crisis of the image was played out: Protestant 'applied art criticism', which ranged in severity from the assaults on images first led in 1522 in Wittenberg by Andreas Bodenstein von Karlstadt, Luther's deputy and rival, to the more

moderate position taken by Luther, who, for a mixture of theological and political reasons, confined himself to inveighing against images that were wrongly 'set in God's place', that is, in men's hearts. Though the two men disagreed about the means, each worked doggedly to dismantle the metaphysics of the image. On the other hand, we have a quieter change, the evolution of new patterns of patronage, and the emergence of private bourgeois art consumption as a defining force in the art markets of Europe. To be sure, the increasing vulnerability of religious art commissioned and designed for public display in churches drove patrons to find alternative ways to exhibit their piety, charity and civic spirit, for when the 'temples' were 'cleansed' of images, precious investments and patrimonies were lost. Another side of this was the growing popularity of private picture cabinets comprising portraits, mythological subjects and secular themes of often unabashed sexuality. The change here is still confined to élites, but their demand ensured that the profane classicism associated with Renaissance humanism in Italy would finally – Dürer's prescient achievements notwithstanding – penetrate Germany by the 1520s.

Yet it turns out that the newly circulating secular imagery, which included subjects that were easy targets for moralistic condemnation, were largely unaffected by the *Bildersturm* raging through northern Europe. Why was this so? Belting's answer is as concise as it is provocative: 'Images, which had lost their function in the church, took on a new role in representing art.' Secular art represented values that had less and less to do with religion and therefore posed far less of a threat to spiritual life. Broadly speaking, this happened because, despite the zest of reformers, they could not prevent religious life in general from shrinking and becoming, in effect, but one sphere of life among others. Images were inevitably released from their embeddedness in religion:

Art was either admitted to this area or remained excluded from it, but it ceased to be a religious phenomenon in itself. Within the realm of art, images symbolize the new, secularized demands of culture and aesthetic experience. In this way a unified concept of the image was given up, but the loss was obscured by the label 'art,' which now was generally applied.[3]

And like the 'sphere' of religion, attitudes towards images were at once expanding and contracting.

People did not experience two kinds of images but images with a double face, depending on whether they were seen as receptacles of the holy or as expressions of art. This double view of the image persisted, even when applied to a single work. Although in the Catholic world no verdict was pronounced against the veneration of images, yet even there the holy image could not escape its metamorphosis into the work of art.[4]

These changes reflect the changing mental world of the bourgeoisie, also expanding and contracting. 'It is the central dialectic of this process,' remarks Klaus Theweleit, echoing Norbert Elias, 'that the powerfully expanding world of medieval Europe stands opposed to an increasingly self-confining individual.'[5] In the sixteenth century, we might say, profane iconophilia was to the newly discovered territories of pleasure what religious iconophobia was to the rediscovered virtues of the ascetic life. Sensibilities were being pulled in conflicting directions.

Belting's 'crisis' theory of the image sweeps away one of the central tropes about Renaissance art in older scholarship: namely, its progressive conquest of optical reality as a defining symptom of cultural modernity. Instead he envisions art's emergence in functional terms, as a destabilization of concepts and practices that had surrounded the sacred image for centuries. The process of change was undoubtedly gradual – in so far as we can chart it all – and involved beholding as well as making. At different levels of culture and according to different time-spans, that affective devotional 'horizon of expectations' about which I've been writing in this book was being slowly eroded. The mode of response which made the pursuit of a *literal* presence of the holy person in the cult image not only a possibility but an obligation, and which attributed a salvific potency to the vision of things holy, succumbed to pressure not only from a theology antagonistic to it but from art itself. As we'll see, in Italy, where the artist-theorists of the Renaissance began to claim for esteemed painters like Andrea Mantegna the same freedom of 'invention' (*inventio*) and 'imagination' (*fantasia*) previously reserved for poets, beholders were likewise thrust into new situations. Beholding grew into an increasingly intellectually demanding task, a labour of interpretation that now sought for the artist's *idea* as it was embodied in the work. Belting again:

The painter now became a poet and as such had the claim of poetic freedom, including that of interpreting religious truths. The religious subject, in the end, could only be invented by the artist, since it could not actually be seen, like the objects in a still life or landscape. The new presence *of* the work succeeds the former presence of the sacred *in* the work.[6]

These insights prompt a number of questions specific to our study. Did narrative painting's complex scenography of the sacred, its literality and its affective potency, undergo the same aesthetic transformations and perceptual shifts as the plainly cultic and patently 'devotional' images (*Andachtsbilder*) of the Middle Ages? How did Crucifixion imagery weather the two-sided crisis of the image, and what happened, in particular, when the Two Thieves were transformed into art? How much of their capacity to comfort and antagonize, to edify and horrify,

to polarize Christian subjectivity and thematize the *Angst* of peniten-
tial experience – how much of this multi-faceted tradition remained
intact, what was transformed, what negated? In the hands of some
sixteenth-century painters, Thief imagery lost nothing of its outward
brutality and squalor. But the Protestant critique of images soon
rendered problematic several key aspects of the Thieves' image and
Calvary in general. Auxiliary motifs that, in the Middle Ages, gave
Dysmas and Gestas compelling roles to play as model and anti-
model disappear, leaving us with perfunctory figures absorbed into
the surrounding *staffage*, or bloodless allegories that served as blank
screens for the projection of theological ideas or political polemics
(see illus. 116).

The crisis of the image occurred during a time of general crisis in
Europe, and in German-speaking central Europe in particular: the
failed attempts at reform by the Holy Roman Emperor and the death in
1519 of Maximilian I, 'The Last Knight of Europe'; the catastrophic
uprising and defeat of the German peasants in 1525–6; the rebellion of
the imperial knights; the forward march of the Inquisition and the
intensification of witch-hunting; the advance of the Turks into Austria
in 1529; the deepening of apocalyptic desires, the proliferation of
portents, 'monstrous' misbirths, celestial apparitions and fears of the
Antichrist's arrival; and the nagging spiritual doubt that exploded
into sustained dissent among religious reformers and radicals, ending
in a permanent confessional divide and a disorienting intra-Christian
war for souls, fraught with casualties. The geopolitical vistas of Europe
were rapidly expanding with the discovery and exploration of the
New World; at the same time, the loss of consensus, and the quickening
disruption of traditional ways of life, helped bring about a contrac-
tion of subjectivity into the bordered spaces of the self-regulated,
increasingly 'civilized' individual.

Also caught up in a dialectic of expansion and contraction were
Europe's criminal-justice regimes. In Chapter 4, I painted a picture
of the relatively uncontested nature of punitive rituals in their 'para-
digmatic', late medieval phase; at the same time I provided a glimpse
of the direction penality would begin to take in the era of rapid
state-formation after 1500. The spectacle of punishment veered more
sharply towards repression once jurists proclaimed deterrence as the
chief rationale behind state executions. Realizing this authoritarian
goal in practice meant punishing more harshly and, up to about 1600,
more frequently as well. It also meant repressing the positive ways in
which spectators had learned to identify with, and *see*, the sufferings
of the convict. Once abstract assertions of law and order began to

dominate the judicial spectacle, the sacral associations of punishment were gradually eroded, the sense of the body's magical instrumentality met with growing élite disapproval, and the empathic, devotional immediacy of the criminal's edifying pseudo-martyrdom, the 'good death', gave way to scapegoating and *Schadenfreude*.

Lutheran theology and social policy contributed significantly, though indirectly, to the transformation of the religious element in executions. In the new environment of disciplined piety, moral instruction and ordered social life Protestant authorities struggled to create, judicial spectatorship more readily served the repressive interests of élites, and concessions to popular culture and folk piety grew fewer and fewer. But the results were not always what reformers wished for. By attacking the intercessionary powers of saints and the Virgin – folk culture's mechanisms for finding redress of grievances, problems and woes – reformers may have, in a curious way, driven popular culture back upon the very magical perceptions and para-religious practices that authorities would rather have seen repressed. Belief in the curative potency of the freshly spilt blood of executed persons, particularly for those suffering from epilepsy, is a compelling example. Richard Evans argues that the apparent prevalence in Protestant areas of blood drinking by epileptics at the scaffold is not an accident of available documentation, but can be interpreted as the result of a half-century's attacks by Protestants on the magical efficacy of transubstantiation:

The criminal on the scaffold took over in Protestant folk culture the role which continued to be played by the statue of Christ on the cross, the figure of the Virgin carried in procession, or the relic of the saint preserved in the church . . . The blood and body of the executed criminal constituted a lesser but still symbolically potent version of the Communion service, which Protestant theology had robbed of many of the aspects and connotations for which popular, magico-religious culture still found a use.[7]

To be sure, the transfer of popular energies from altar to scaffold took time. In the first half of the century these changes were at best nascent. But they challenge us to look for early signs of change and, with caution, ask how the two developments, the crisis of the image and the crisis of judicial spectatorship, were connected. Did the antithetical imagery of the Two Thieves continue to serve the same psychological function, could it convey the same messages about sin and punishment, pain and purgation, abjection and redemption, in the new milieu of religious controversy? Did their symbolic charge, as it were, wax or wane? Did the Good Thief become, like his real-life counterpart under sanction of death, the unintended beneficiary of

the reformer's efforts to repress cultic worship of the Virgin and other saints? Or was his cultic appeal suppressed along with that of other saints? Should we view as accidental the fact that the very artist who introduced some of the most hideous 'Gothic' refinements in the torture of the Thieves – Lucas Cranach of Wittenberg – also assumed the leading role in developing the new Lutheran iconography, and in radically altering their role in the process?

There is obviously more in these questions than one chapter can address. I hope what emerges from the following pages will be as much a case study of Belting's 'crisis' thesis as an extension of it into the specific problematics of Passion (i.e. narrative) imagery.[8] For, taken together, the transformation of the image into art, and the polarization of attitudes towards what remained viable for religion in the sacred image have important consequences for the study of spectatorship beyond the interlocking spheres of art and religion. Once the entrenched medieval paradigm of compassionate spectatorship began to succumb to the introduction of new mediations between spectator and the scaffold, vision, it seems, underwent a kind of reconditioning. Our most important question is, did the new conception of the *narrative* image as art pave the perceptual way for the spectatorial transformations that were politically mandated by the early modern state in the theatre of public punishments?

Spectatorial distance and the painter's fantasia

Amidst a flurry of negotiations concerning his future employment with the Marchese Lodovico Gonzaga in Mantua, the northern Italian painter Andrea Mantegna, only 26 years old, pursued to completion his work on a magnificent altarpiece for the monastery church of San Zeno in Verona. His patron there was the humanist ecclesiastic Gregorio Correr, who hailed from one of the wealthiest and most powerful patrician families of Venice.[9] Having received the monastery *in commendam* in 1443, and taken over its governance two years later, Gregorio embarked on an ambitious rebuilding campaign that included the commissioning of an altarpiece from the widely admired Mantegna. Set within an architectural framework of consummately 'modern' – that is, classicizing as opposed to Gothic – structure and adornment, the altarpiece embodies the confident, humanist-inspired aesthetic enterprise of the middle *quattrocento* in northern Italy, and stands as an important document of the distinctive relationship between the artist and patron that prevailed there before 1500.[10]

Though small in relation to the upper panels of the altar, which

depict the Virgin and Child enthroned and flanked by saints, the central predella panel depicting *Calvary* (now in the Louvre thanks to Napoleon's pilfering), has been called 'one of the grand Crucifixions in Italian art' (illus. 103).[11] Indeed, the panoramic conception of the landscape and sky, the crisp atmosphere that obscures nothing save the furthest distances, the majestic verticality of the Cross and the expansiveness of Christ's outstretched arms, all lend the image a deceptively monumental appearance (photographs tempt us to believe this is a huge wall-painting, when in fact it measures only about 60 × 90 cm). A consideration of how the painter achieves this effect can serve as a useful starting point for our analysis. In the 1950s the art historian Millard Meiss pointed out that Mantegna's *Calvary* was a 'plateau type' of composition, wherein two elevated spaces, separated by a virtual geographical distance, are shown at different levels; the one that is higher on the picture's physical surface is to be read, contrary to perception, as being lower in the virtual space of the image. Meiss traced the composition back through two north Italian copies to a lost *Crucifixion* by Jan van Eyck, and regarded the new design for Golgotha's mountain setting as a turning point in the history of form.[12]

However closely affiliated with Jan's work, Mantegna fashions the *sacro monte* of his San Zeno altarpiece into the setting for an awesome spectacle. The artist's inventiveness is everywhere in evidence. By fixing our eye-level just above the head of the soldier standing on the steps that lead up to the platform, we too are encouraged to ascend towards the place where the Cross, like a cosmic lightning rod, connects the terrestrial orb with the heavens. To enhance this effect, the artist has gently swelled the platform's architecture of well-worn stones, whose age is marked by diagonal fissures and bored holes. Downwards the hill slopes as our eye moves backwards into depth, guided in its path by the soldiers who depart the scene to join the crowds along the road connecting the two mountaintops. For the throngs who have completed their spectating, and the soldiers who have concluded their stage management of the event, daily life has already resumed. These details, incidental though they seem, condense Mantegna's conception of the Passion and further establish his debt to Flemish naturalism. Whatever cosmic disturbances (earthquakes, eclipses) may have occurred at the moment of Christ's death, they have left no trace; but for the few signs of sanctity Mantegna admits into his scrupulously naturalistic scene (the gleaming haloes, for instance), this is, the painter tells us, an ordinary Roman execution. 'Never before,' writes Meiss about the Flemish inspiration behind Mantegna's panel, 'was the event immersed so deeply in the flow of time.'[13]

Nevertheless, this is an Italian picture. The attraction Mantegna evidently felt towards certain aspects of Flemish art – its crystalline perfection, its fidelity to optical reality, its tender emotion and depth of piety – did not override his determination to apply the Albertian principles of rational design, perspective, symmetry and proportion that were still the exclusive province of *quattrocento* naturalism. How did such a rational, mathematical approach to locating and describing bodies in space condition the beholder to look at the fascinating bodies of the three crucified men? Without labouring the old contrast between north and south, it bears repeating that, whereas painters like Jan van Eyck used light to unify the diversity of materials within a given space, thereby situating figures in their surroundings by virtue of a perceptual process, Mantegna and other Italian artists used mathematical co-ordinates to plot their figures perspectively in space. Light in much Italian painting tends not to unify the diversity of material surfaces and forms in a picture, but instead to separate three-dimensional entities so as to emphasize their emplotment in a spatial system. Each of Mantegna's figures seems carved in stone rather than modelled in paint (an aspect of Mantegna's aesthetic that escapes none of his admirers).

Furthermore, the lapidary design of the musculature in the Thieves' torsos hints at a likely source in classical statuary. This may seem like a scholar's footnote, but it is actually a critical point, for capable as Mantegna is in conveying the three-dimensional *presence* of his figures in space, his quest for a rational *design* diverts his concern away from the physiological effects of crucifixion, particularly the interaction of body and apparatus. The Good Thief's position and mode of suspension (with ropes) seem implausible; his arms are thrown back over his shoulders in a way that allows for no sign of strain; buoyed up magically by the ropes around his ankles, the body does not sag in abject misery but reposes, it seems, in a gentle *contrapposto* (illus. 111). As the light rakes across the three figures from the right, the torso reveals itself as a careful study in heroic anatomy, mediated by classical art. And for reasons unclear, Mantegna has erased any signs of damage to the Good Thief's legs. His pained expression is altogether unconvincing. Like- wise in the Bad Thief, an underwhelming figure whose arms are also thrown languidly back over his head, a gesture more expressive of subjective torment than of gravity-enforced immobility (his legs are bloodied but unbroken).

Such artificiality is perhaps inevitable from an artistic sensibility that 'records, analyzes, and set into its exact relationship in a universal mathematical structure virtually every facet of human experience'.[14]

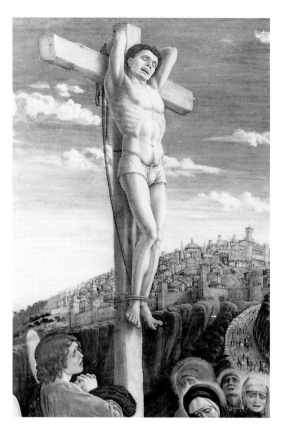

In the hands of Mantegna, north Italian realism turned decisively to
the principles of rational design extolled by humanists like Brunelleschi,
Filarete, Leonbattista Alberti and Brunelleschi's biographer, Manetti.
For these writers, as for Leonardo at the century's end, art demanded
that its practitioners combine rational knowledge (*scientia*) with a
thoroughgoing *mimesis* of nature along the lines established by classical
art.[15] Imitation of appearance, no matter how skilful, was not enough;
if the visual arts were ever to be admitted into the ranks of the *artes
liberales* and enjoy the respectability accorded to poets, the formation
of images had to occur through the artist's intellectual faculties.

The foundational poetic faculty to which painters aspired, *inventio*
(or in Italian, *inventione*), was not applied to any painter before 1400. In
fact, most *quattrocento* patrons took it for granted that 'subject matter
and meaning were too important to be left to the painter or sculptor.'[16]
As a rule, notably in the case of novel or complicated subjects, artists
were presented with preformulated literary descriptions to be used as
the basis for a painting or cycle of paintings. Only in rare instances
were the powers of iconographic invention legitimately claimed for

a painter or – at the risk of causing outrage – claimed by the painter himself. Mantegna was one such case (of the former). Writing with some irritation at the disregard Giovanni Bellini had shown the *inventioni* sent to him for a work commissioned by Isabella d'Este, Lorenzo di Pavia, Isabella's agent, praised Bellini's sense of colour but noted that 'in *invencione* no one can rival Mantegna, who is truly the most excellent'. Other authors turned in similar verdicts on the quality of Mantegna's *inventione* and *concepto*: to wit, the intellectual sophistication of his works.[17]

Evidently Mantegna enjoyed this status throughout most of his long career. Giovanni Santi's account of contemporary artists, written as part of his *Cronaca rimata* in the early 1490s, added to the chorus of praise by explicitly associating the term *fantasia* with Mantegna's art.[18] Rooted in Greek and Roman poetic theory, *fantasia* was conceived by humanists as an image-forming faculty that approximated poetic inspiration even if it could never rival it. In a famous passage from his *Libro dell'arte* (*The Craftsman's Handbook*) of *c.* 1390–1400, Cennino Cennini argues that painting

deserves to be placed in the next rank to science and to be crowned with poetry. The justice lies in this: that the poet is free to compose and bind together or not as he pleases, according to his will. In the same way the painter is given freedom to compose a figure standing, sitting, half-man, half-horse as it pleases him, following his *fantasia*.[19]

Cennini was certainly ahead of his time – it would take half a century before the concept of *fantasia* was regularly applied to the visual arts. Not until Alberti's elaboration of these ideas (*c.* 1435) was a credible case made for elevating painting to the status of a science. How early in his career the young Mantegna laid claim to these new values is uncertain, but later he made no bones about it: in 1506 he wrote personally to Isabella, reporting that he would proceed further on his designs 'when *fantasia* comes to my aid', suggesting that, like poetic genius, the artist's capacity to form images occurs spontaneously, like a force of nature erupting within him.[20]

To what extent were Renaissance artists like Mantegna still accountable to the norms of tradition for biblical subjects? Were all devotional bets off in the process of turning *historia* into art? Was sacred narrative slowly being pushed outside the realm of the literal and towards an assimilation with the fiction status already taken for granted in pictures of mythological subjects? Or did painters and patrons have to continue making concessions to an older 'horizon of expectations', one which sought for the divine presence of Christ and

the saints in their images, even in the embellished visualizations of the late medieval Calvary image?

Recall that the crisis of the image, as Belting describes it, could only begin to occur *as such* once the old, ontological boundaries between categories of image were made permeable by an independent concept, or autonomy, of art. Classical subject matter may have been the *sine qua non* of art's newly asserted autonomy; it may have represented the thematic area where *inventio* and *fantasia* could find their freest deployment; and it may, for these reasons, have constituted the clearest sign of painting's claims upon the privileged status of poetry among the liberal arts; but it was the larger effect these strategies and values and claims had on *adjacent* areas of making and beholding that really added up to a crisis:

The new themes, which had no reality of their own in a literal sense, now affected the way images in general were seen. If what they depicted was based on fiction, the older themes (images of saints and portraits), which were taken literally, could not remain free of ambiguity ... The image became an object of reflection as soon as it invited the beholder not to take its subject matter literally but to look for the artistic idea behind the work.[21]

Mantegna's *Calvary* – with its synthesis of Albertian perspective and Flemish landscape, its juxtaposition of Gothic pathos and classicizing nudes, its mixture of 'archaeological' detail and antiquarian fantasy – sits astride rival attitudes towards the image in the early Renaissance. On one hand, the work could claim a share in the literal, both because it hewed closely to the truth of the biblical story and because it connived to convey in its plastic realism something of the literal presence of the holy personages in the picture.[22] On the other hand, Mantegna's powers of invention, because they are writ large across the image, also 'invite' the viewer, as Belting suggests in the passage above, to reflect on what is fictional, what is the product of the painter's *fantasia*. As soon as we begin to look beyond the familiar contours of the story, we begin to notice unusual motifs, expressive artifice, compositional devices and quotations, that come to signify *Mantegna's powers of imagination*. The religious truths perceived by the devout spectator, no matter how 'universal' they believed them, metaphysically speaking, to be, are *in the picture* mediated by a constellation of humanist conceits that mark the religious truth as the product of Mantegna's art. The 'truth' of the visualization is no longer validated by its metaphysical origination as dream, vision or revelation, or its moral value for the advancement of spiritual self-understanding; now the professional painter's imaginative procedure, his art, supplies its truth value.

My final question for the San Zeno panel is this: how might an aware-
ness of Mantegna's *inventio* and *fantasia* in the picture's form and
content have shaped response to the theatrically agonized bodies of the
crucified and dying men? Looking back at the late medieval Calvary
image from this moment of art's ascendance, we can better recognize
why the signifying potential of the body-in-pain rested, in large part,
on what Belting calls 'the familiar impression of simple visibility'.[23]
Vision, consummating itself in a quasi-physical contact with its object,
had but one level of mediation to surmount – the taken-for-granted
substitution of the cult image for the living presence of the saint him-
or herself. Now, in the era of art, 'simple visibility', with all that it
entails, has been disrupted. The mannered writhings of Mantegna's
classical Thieves have become signifiers of the painter's art, which
henceforth mediates the encounter between body and beholder, pain
and perception, suffering and compassion. In a word, a *distancing* is set
up between the visible source of pain in the image and the devotional
viewer whose mental horizon is set upon visually 'touching' the
object of his or her veneration and relating to it in this way. Because
with Mantegna *fantasia* is a disciplined exercise of the imagination,
constrained by decorum, ruled by *scientia*, it approaches the expressive
body, the body-in-pain, as it would any other idealized object to be
plotted in space. To abide by the rules of art, to go one better than
nature, Mantegna must remove his bodies from the flux and variability
of phenomenal experience. Instead he constructs a different kind of
spectacle, one that is twice-distanced from the viewer: first, by the
painter's mediating *invenzione*, and second by the spatial rationality
that channels all pictorial information towards a single point, the eye.
Pain's visibility, its 'incontestable reality', has suddenly been implicitly
called into question by art.

Further removed from the breathing intensity of compassionate
vision are the Two Thieves in Il Bramantino's large *Crucifixion* of
c. 1515, preserved in Milan (illus. 102). Born as Bartolommeo Suardi,
the painter trained in Urbino with Bramante (from whom he took his
name), and settled in Milan after 1509, where he developed his style
in the shadow of Leonardo's commanding personality. With his
characteristic interest in the tectonics of pictorial space, the painter
has placed Christ's cross directly opposite us, locating us as beholders
at a fixed point. The flanking crosses are related to the central one
with precisely perpendicular angles, so as to form a neat, box-like
enclosure for the principal mourning figures. The Thieves are thus
visible only in profile. In terms of gesture they recapitulate Christ's
canonical cruciformity: splayed arms nailed to the front of the *patibulum*,

upright torsos heroically withstanding gravity's pull, relaxed right legs overlapping the left ones, and so on. The result is a calculated stereoisomerism between all three figures that reinforces the static symmetry of the composition as a whole. Indeed, Bramantino can contain neither his enthusiasm for the negative spaces formed between the silhouettes of the Thieves' torsos and the contours of Christ's body, nor his artifice in filling them with allusive scenic elements whose forms also respond to the contours of the Thieves' shins and feet. Hovering above the contrasting structures, an angel and devil genuflect towards Christ with a kind of choreographed simultaneity, forgoing the dangerous aerial battles of their medieval precursors.

Thus, in their staging, spatial emplotment and idealized postures, Bramantino's Thieves are not only almost literally bloodless – as far as crucifixion victims go – but metaphorically so as well. However much this feeling can be offset by the warmth of his colour and beauty of his shading, Bramantino's striving for a consonant, geometrical arrangement, a *disegno* intelligible to the rational mind, produces its own, distinctive, distancing effect. As one expert summed up his approach, 'The extreme ideality – more properly, the near-abstractness – of description and design exaggerates the principles of *Cinquecento* classicism, denaturing them in a double sense.'[24] If the executed men in this monumental 'tragic drama' appear no less like 'mournful, structureless automata'[25] than the swooning and consoling and tear-dabbing figures beneath the crosses, this should not be explained away as the belaboured product of one individual artist's 'late' style (Bramantino died in 1530). Rather, I think, it is a predictable outcome of an overcharged application of the scientific principles of art, *perspectiva* and *disegno*, at the expense of those vagaries of phenomenal reality and intersubjective experience upon which the Crucifixion image's devotional allure had traditionally been built. Bramantino's lucid abstraction offers the beholder a virtual world that is less a space for experience than a space for viewing. Fixed and immobile, the religious truth in this vision coalesces exclusively in the eye.

These two examples will suffice to show how the signifying potential of the artist's motifs *qua* inventions affected the imagery of the crucified Thieves in north Italian Renaissance art, and how the terms of engagement between beholder and body began to change as a result. Before moving on to discuss the Reformation's contribution to the crisis of the image, we should pause to consider the implantation of Renaissance attitudes and concepts north of the Alps, and how the terms of engagement between beholder and body there were also being slowly transformed.

*

After the middle of the century, increasing numbers of Netherlandish and German artists began to see the trip to Italy as an essential rite of professional passage. Some, like Roger van der Weyden or Master Bertram of Hamburg, made the trip to Rome as a religious pilgrimage (Roger in the Jubilee year of 1450), but until the century's end, there had been no shared imperative to visit Italy to study art. Therefore unprecedented was Albrecht Dürer's decision to leave Nuremberg again in the early winter of 1494 – only a few short months after his bachelor's journey and, more inexplicably, so soon after his marriage to Agnes Frey in June – in order to work in northern Italy.[26] Dürer remained in Venice for some time, familiarizing himself with mythological subjects and classical nudes, trying his hand at various Venetian motifs and studying the art of northern Italian masters like Mantegna, whose two-page engraving *The Battle of the Sea Gods* Dürer partly traced in pen and ink. He may have also travelled to Padua and Verona.[27] These researches proved decisive in the development of his imagery, as he gradually assimilated and 'synthesized' (to use Panofsky's term) this awesome diversity of influences into a coherent pictorial system, brilliantly articulated in the *Apocalypse* woodcuts of 1498.

Somewhere in the flux of Dürer's excited processing of images and ideas, he assembled a number of Italianate motifs in the design for a large woodcut *Calvary*, made from two blocks, and now in Berlin (illus. 112).[28] Scholars have rightly questioned the extent of Dürer's involvement in the work's execution (this, one of only two surviving sheets, was not printed until after his death), but most agree that it is substantial enough, particularly in the upper half, to credit him for the basic design. Fedja Anzelewsky has pointed out that the figures of Christ and the Bad Thief are connected with an unfinished painting by Lorenzo di Credi, now in Göttingen, while the Good Thief derives from a drawing by Leonardo.[29] Mannered and posed for maximum pathos, with more than a whiff of the classical, the pose of the Good Thief is at once the most interesting and troublesome in the entire composition. So gently does the right leg bend, shifting the organic structure of the lower torso, that one can easily overlook the cruel penal technique that holds the feet down against the truncated limbs of the 'tree cross', a type then popular in southern Italy. Portrayed somewhere between pathos and sunbathing, he turns to look over his shoulder at the stiletto rays of a fiery sun, while his companion stiffens in lonely dejection under the moon's influence. These are composite creatures, demonstration pieces that signify the artist's familiarity with Italian and classical models.

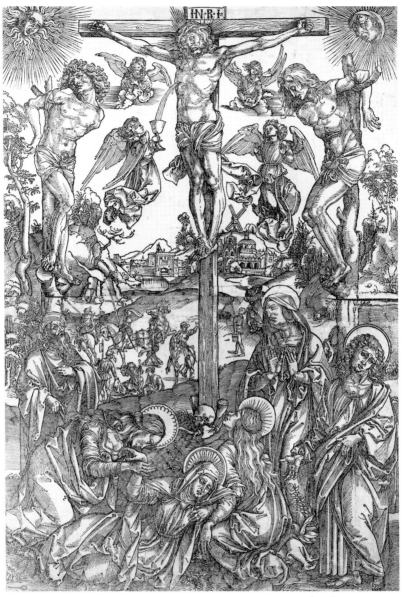

112 Albrecht Dürer(?), *The Great Calvary*, *c*. 1495, woodcut printed from two blocks, 570×389 mm. Staatliche Museen zu Berlin–Preußischer Kulturbesitz (Kupferstichkabinett).

Vaunted by humanist admirers as 'the Apelles of our age' (Apelles was the celebrated court painter to Alexander the Great), Dürer's example would indeed contribute momentously to a transformation of values, and vision, in pre-Reformation northern Europe. His accomplishment hinged on a conjoining of professional flexibility

(Nuremberg had no constraining guild system at the time), prestige, and a self-granted poetic licence that was as unique to his circumstances and personality as it was fortuitous for the development of humanist art. Yet it would be hasty to cast Dürer's promethean impact in absolute terms. Humanist ideas connecting painting to the liberal arts, and thus to the status afforded poetic invention, penetrated German élite culture along several trajectories. The situation in pre-Reformation Wittenberg, at the ducal court of Friedrich the Wise, Imperial Elector of Saxony, is an excellent case in point. Friedrich's reputation as a great territorial magnate and patron of the arts earned him the appellation the 'Maecenas of the Northern Renaissance', and at his court he assembled the leading intellectuals and artists of the day.[30] Dürer worked for him on and off throughout the Elector's life, and in the two years (1503–05) prior to securing Cranach as his salaried *Hofmaler*, Friedrich employed the famed peripatetic Venetian Jacopo de' Barbari, who was very much the outspoken partisan of painting's 'modern' claims to status. After leaving the duke's employ, de' Barbari penned an appeal to Friedrich to recognize painting as the eighth liberal art. In it he argued against the conception of painting as a mechanical art, and laid out a case for painting's unique capacity to reproduce nature, in conclusion imploring his former patron to

contemplate in these few precepts the excellence of painting which, in an inanimate nature, makes visible that which nature creates as palpable and visible. And one can deservedly seat painting among the liberal arts, as the most important of them. For when men have investigated the nature of things in their number and in their character, they still have not been able to create them. It is to this creation that painting is so suited that it deserves its freedom.[31]

There can be little doubt that, on one level, de' Barbari is preaching to the converted. As a prodigious patron of not only painting but also printmaking, wood carving, stone sculpture, monumental bronze casting and book illumination, and an obsessive collector of relics, Friedrich spared no expense in the visual adornment of the princely residence and the great Castle Church (*Schloßkirche*) in Wittenberg. And he continued to commission patently Catholic works of art well into the Reformation, even as he stepped in to act as Luther's political protector.

Friedrich's bid for a Saxon pre-eminence in the arts reveals something crucial about the fate of the image at the crossroads of medieval piety, Reformation and Renaissance. The Elector's programme of artistic patronage was as much a matter of power politics as of humanist enlightenment and his own 'deep if conventional piety'[32] – in him the

three motives were inseparable. Like his penchant for portraits of himself venerating the Virgin or St Bartholomew (his patron), the duke's relentless effort to assemble and promote his encyclopedic collection of relics for the Schloßkirche was born not strictly of the pious dream to make his residence a 'Garden of Grace' (*Gnadenhort*). It was also a key element in his aggressive political strategy aimed at the rival dynasty of Brandenburg: pilgrimages to the Saxon relic collection, publicized by the impressive catalogue, or *Heiligtumsbuch*, with woodcuts by Cranach, were prime opportunities for the sale of indulgences, and thus helped cement friendly relations with Rome. What is fascinating to note is how Friedrich's hyper-Catholic zeal for relics, their promotion and display to pilgrims, not to mention the immense political capital which accrued to his promotion of these penitential practices, only increased as the theological foundations for this kind of piety were already being undercut by theologians in the university of his very own Wittenberg. Nothing reveals more clearly the multiplicity of pressures – intellectual, religious, political – that accompanied the crisis of the image, contributing to both its expanded freedoms and its contracting monopolies on thought, behaviour and vision.

In the crucible of the Reformation

In 1529 an iconoclastic crowd in Basel wrested the large crucifix from the cathedral and marched it down to the marketplace in a mock procession. Among the insults hurled at the statue, one man is alleged to have said, 'If you are God, help yourself; if you are man, then bleed.'[33] Similarly tormented was a Christ figure that had been snatched from the *Ölberg* ensemble (Jesus suffering in the Garden of Gesthemane) of a churchyard near Ulm, taken to a local spinning bee (*Spinnstube*), and there maligned, attacked, challenged to protect itself – 'If you are Paul [sic], help yourself' – and then thrown from a window.[34] Iconoclasts enacted many such 'degradation rituals' upon sacred images, some-times under the threat of legal prosecution, throughout the diverse territories and imperial city-states that welcomed the Reformation.[35] Images were taken to bathhouses and taverns where they were splashed with beer; some were taken to the stocks and punished, decapitated, dismembered or smashed; and in Ulm in 1534 a man defecated into the mouth of a crucifix that had been removed from Our Lady's Gate.[36] Not only images but the whole material culture of late medieval Christianity came under assault in the new crusade to make churches pure (*gereinigt*). In cities like Augsburg, legalized iconoclasm generated a

programme of zealous cleansing that robbed churches of their decorations, furnishings, liturgical equipment, reliquaries and relics.[37] Even the sacrament was not beyond profanation: during the Good Friday service of 1528 at St Ulrich's in Augsburg, as the host was being lain in the sepulchre, a man approached with the words, 'Fie on you, Christ, what are you doing in that little fool's house?' and, following that, mooned the entombed *corpus Christi*.[38]

As verbal iconoclasm, the taunts described above are revealing of popular attitudes on several levels. At base, the appeal to 'help yourself', mockingly addressed to the statue of the Crucified, derives from Gospel accounts of the Passion, where the assembly of spectators and the Jewish high priests challenge him to 'Come down off that cross if you are God's son' (Matthew 27: 40; cf. Mark 15: 30-2). Likewise does the imperilled Bad Thief in Luke's dialogue 'blaspheme' Jesus with the words, 'Aren't you the Messiah? Then save yourself and us' (23: 39). Such a challenge, now hurled at the image, is like that directed against a living person, specifically a male protagonist: it is at once desacralizing *and* emasculating. More tellingly, it is an address to one who, though already degraded and vulnerable to further insult and injury, may still – perhaps – show himself potent and capable of self-defence. Again we find ourselves with an apparent contradiction that corresponds precisely to reality. Emboldened by the image's failure to protect itself, iconoclasts played the roles of the cursing mob and Bad Thief on Golgotha with all the impenitent relish their direct action inspired; yet one detects in these reports a half-hidden expectation, the glimmer of an unspoken wish, that the images would meet their challengers and prove themselves powerful once and for all!

Recent studies of iconoclasm, enriched with insights from anthropology and sociology, encourage us to see this kind of violence against images as a mode of ritual action, and to understand its cultural logic as linked in telling ways to other forms of ritual behaviour. In Lee Wandel's view, for example, the concept of a 'reformed' church, free of images, was not solely a theologian's imperative, but a pious goal that arose simultaneously among ordinary Christians who – perhaps too suddenly – discovered a powerful mode of dissent that 'no authority, secular or ecclesiastical, had sanctioned, defined, or articulated'.[39] Compelling illustrations of this are the many ways iconoclastic behaviours, such as those described above, rooted themselves in the rituals of degradation that belonged to popular culture, and specifically popular justice. Ritual forms of mockery and satire associated with Carnival were often deployed: in Zwickau in 1524, for example, an image of St Francis was bedecked with asses' ears and set upon the town fountain.[40]

In other instances, the derision heaped on cult images derived from quasi-judicial forms of image punishment, such as the 'defaming image' (*Schandbild*), which punished vicariously culprits who were beyond the reach of the law (see illus. 75). In the case of ritual iconoclasm, the culprit was the Old Church and its proxy the sacred image.[41] One can also find clear parallels with judicial punishments and the traditional forms of communal violence visited on wrongdoers: crucifixes and statues of the Virgin were decapitated and dismembered in Kempten (1525), Augsburg (1529) and Rothenburg (1525); in Königsberg a St Francis was decapitated in 1524 after being placed in the stocks, while elsewhere the cult images of the despised mendicant orders were hanged; in Münster (1534) images were mutilated along the lines of known criminal sanctions.[42] And, in apparent imitation of the dehumanizing 'Jewish execution' still current in Germany (see Chapter 5), statues were hung upside-down in Wolkenstein, in Saxony, and at the Abbey of Irrsee near Kaufbeuren, where a St Peter figure was inverted and 'disembowelled'.[43]

All of these actions followed similar ritual patterns and played to similar perceptions and expectations. In popular perception the degradation of hated images served an analogous purpose to the justice rituals considered in Chapter 4: they worked to purify the local community, the social body and the *Corpus Christianum* of elements perceived as deviant or defiling. As such they became flexible weapons against whatever afflicted a community, from rapacious landlords and wealthy, tax-exempt monasteries to the mendicant friars whose calls to penitence had finally grown too oppressive.[44] As such, iconoclasm as an historical phenomenon exposes many of the social pressures, contradictions and questions that existed within German society as the Reformation unfolded. How did leaders and those led envision their movement? Was it to be solely a revolution against the corrupt Old Church, brought about by an intellectual élite, wielding as its instrument a powerful new theology? Or was the transformation to subsume all social and political institutions as well, sweeping aside the cinctures of an outdated feudal order? Historians still debate whether the Reformation was a bona fide 'social movement', and if so, whose interests it really served.

For every person, past and present, galvanized by Luther's challenge to the old order, another has despaired that the Wittenberg reformer's brilliance limited itself, in the end, to saving souls. One need only to think of Luther's harsh reproaches to the peasant insurgents of 1525, whose military challenge to earthly tyranny many contemporaries saw, with some justification, as inspired by his own resistance to

higher authority.[45] The modern Protestant theologian Jürgen Moltmann feels the political limits of Luther's *theologia crucis* most sharply in the fact that,

while as a reformer Luther formulated [it] . . . in theoretical and practical terms against the medieval institutional church, he did not formulate it as a social criticism against feudal society . . . What he wrote to the peasants did not express the critical and liberating force of the cross, the choosing of the lowly which puts the mighty to shame . . . but instead a non-Protestant mysticism of suffering and humble submission.[46]

At the time of the Reformation, popular culture was tilted towards social change. Its readiness for a redressing of ills came as a source of tremendous energy to the early years of Luther's movement; and as we will see, Luther and other evangelical leaders sought to harness this energy for their assault on the Roman Church. Propaganda was the touchstone of this form of political 'collaboration', but Reformation propaganda was typically directed 'against the papal church and its officers, not against authority, rule or social élites'. Lutheran leaders eagerly co-opted the popular passion for dissent while, at the same time, shielding authority as such from ever becoming the focus of these passions.[47]

Where does that place the study of art and society at the time of the Reformation? Must we limit our investigation to what Panofsky called the 'underlying affinities' between 'certain types of modes of religious convictions and certain types of modes of artistic expression'?[48] How can we draw connections between transformations in iconography and the larger social processes that brought reformers and their audiences into these uneasy alliances and sometimes antagonistic relationships? Given the evangelical goal of emancipating Christian faith from its embarrassing dependence on materialist, idolatrous and magical medieval trappings, what role did reformers envision for the new iconography? What kinds of expectations on the part of beholders were targeted for elimination, and how was this to be achieved? Were concessions made to popular culture and piety, and if so, were they authentic expressions of cooperation on the part of the theologians, or cynical stop-gaps to keep the rabble in line? As we delve into iconographic change, we need to make sense of both the development of new elements and the survival of old ones; and we need to see them in terms of the social pressures that arose from this dialogue between Protestant doctrine and popular culture, whose durable 'horizon of expectations' reformers ignored at their own peril.

*

In early-sixteenth-century Germany visual experience was too multi-textured, and the appetite for religious representations too deeply embedded in cultural life, for reformers – if they wanted to make inroads with the masses – to take too hard a line against images. 'The kingdom of God is a kingdom of hearing, not of seeing,' Luther was fond of saying, but by the late 1520s he and his colleagues must have perceived the need to temper their dogmatic privileging of word over image.[49] What was needed was a transformed language of symbols to complement the new theology and the new conception of the human estate, an iconography that could express Protestant truths visually while remaining vigilant in the face of idolatry's persistent hold on human hearts. Championing the Word of God above all other objects of devotion, Lutheranism naturally constituted itself as 'a visual culture confining itself increasingly to the [printed] page';[50] neverthe-less, as the 1520s wore on and further crises ensued, Luther was clearly compelled by the reality of iconoclasm in Wittenberg and elsewhere, and the internal requirements of his theology, to develop a theory of images that gave legitimacy to certain kinds of subject matter and forms of presentation. And when it came time to concretize these new iconographical formulas in images that were to be, in Luther's view, 'neither one thing nor the other, neither good not wicked',[51] it was his friend Cranach to whom he turned.

Cranach's artistic response to Luther's thought may well predate the famous inauguration of the Reformation in Wittenberg on 31 October 1517.[52] But once established, the collaboration between theo-logian and painter bore strange fruit. Among the new themes is a group of Crucifixions depicting the converted Centurion, shown as a militant Christian soldier in fine armour, galloping past Christ and the Two Thieves on their crosses. The earliest versions date to 1536; our example, now in Aschaffenberg, is signed and dated 1539 (illus. 113).[53] This is an ascetic, stripped-down Calvary, most likely based on the minimalistic groupings found in block-books used for meditation on the 'Seven Words of the Cross' (see illus. 4). The place itself seems like the outermost point of a swollen terrestrial orb; the Calvary land-scape that once swarmed with onlookers and actors has become an eerie planetary surface, strewn with weathered stones and bones. Above the titular inscription on the head of the Cross (INRI), which appears as if written across the opening of a book, are the words of Christ's dying prayer, *Vater in dein hent befil ich mein gaist* ('Father, into thy hands I commend my spirit') (Luke 23: 46); the second inscription consists of the words addressed by the rider, *Warlich disser mensch ist Gotes son gewest* ('Truly, this man was the Son of God') (Mark 15: 39). Unlike the

113 Lucas Cranach
the Elder and workshop,
*Crucifixion with
Centurion* (version 1),
dated 1539, limewood
panel, 51.5 × 34 cm.
Staatsgalerie,
Aschaffenberg.

unfurling banderolles frozen against patterned gold grounds in many late medieval altarpieces, the graphic character of the inscriptions here is also irreproachably legible and austere. In keeping with Luther's wish to see the Word of God made accessible to all believers, they are rendered not in Latin but in the vernacular German.

Compared to the late medieval Calvary, dense with dramatic action, arresting anecdote and empathic emotionalism, there is little of interest to detain our gaze. A stereotyped Christ with stereotyped wind-tossed loincloth strikes the canonical pose but falls flat as a compelling leading man. Even the Thieves, whose hideous treatments by a younger Cranach may be counted among the *pièces de résistance* of Gothic horror, are fairly bland, their punishment uniform and predictable, their antithesis reduced to a simple turn of the head. And so, as our eyes scan this evacuated space, we are thrown back on the inscriptions and are beholden to the Word. Luther expressed a desire to see scriptural 'mottoes' added to pictures so that 'one can have God's work and word

always and everywhere before one's eyes'.[54] He regarded as indispensable for the salvation of every person the cultivation of a personal response to Scripture, and hence raised this *interpretative task* to the level of an existential imperative.[55]

It is one of the oft-repeated truths of art history that for Lutherans the painted image was first and foremost an illustration of a text, a physical object (vainly) aspiring to the metaphysical status of the Word. Narrative depictions of biblical scenes may have been a 'permissible alternative to the prohibited cult image', but even they had to be controlled by harnessing their pictorial structure to the sequential logic of the printed page.[56] However, the first significant ventures into the new iconography by Cranach were not recognizable as *historia*. Rather, they were developed as diagrammatic allegories, collections of motifs that conveyed the thrust of Luther's teachings through their paratactic display. These allegories of 'Fall and Redemption', or, as Joseph Koerner's subtle reading recommends, 'Law and Grace' (*lex et evangelium*), were worked out in numerous drawings, paintings and printed versions around 1530 (illus. 114).[57] Eventually finding their way into every conceivable media, these assembled compositions summed up Luther's thinking on sin and forgiveness, law and grace, human will and faith, and the imperative for every Christian to place him- or herself in the role of *interpreter* of Scripture.[58]

How might the careful observance of the Word's monopoly over meaning have spurred Cranach to revise his approach, not just to the Crucifixion image in general, but to the crucified Thieves within it? Of special importance are the scriptural words 'spoken' by the Centurion in the Aschaffenberg and related panels. His theophanic motto had long been revered as a sign of triumph over pagan obstinacy to Christ's divinity; by isolating the converted heathen on Calvary in what amounts to his own portrait genre, Cranach and Luther configure his testimony into an individual statement of faith, the bedrock of Luther's doctrine of justification. And it is likewise for the other convert in the picture, the Good Thief (shown in his canonical place on Christ's right). Yet the Thief does not utter a word, and for the viewer this makes the interpretative path towards an understanding of his redemption more circuitous. Consider that Christ's dying words, which come from Luke, would have led the educated viewer straight away to the Scripture that also contains the famous dialogue between the Thieves and Christ, in which their antithetical persona are established. Within the thematic orbit of the text, the minimal gestures of the crucified, one turning towards and one away from Christ, suffice to convey the fact of one man's redemption and another's damnation. Like the Centurion, the

114 Lucas Cranach the Elder, *Allegory of Law and Grace*, c. 1530, woodcut with printed text, 223 × 324 mm.

Good Thief embodies Luther's teaching that forgiveness of sins, grace and redemption are attained through faith alone, not by works or human will.[59] But is the viewer's work complete once the Thief is recognized as an allegory of conversion?

There is, I suspect, more to it. When we recall the brutally literal and physical terms in which late medieval Christian culture, artists in particular, cast the story of the Good Thief's path to redemption, we realize how deliberately Cranach has here blocked the popular expectation that redemption was achievable, in large part, through an earthly purgatory of pain. This refutation appears all the more deliberate, given the continued existence in the 1530s – despite the Protestant challenge – of a Catholic iconography that continued to emphasize the Thief's pain. About 1532, for example, the Ulmish painter Balthasar Berger executed a dazzling *Calvary*, now in Stuttgart, that portrays the dead Christ, the miracle of the lance, the Thieves' painful torture, the capture of souls and haloes for all saintly figures (illus. 105). These assertions take on their own polemical tension when we situate Berger's work in the combative milieu of Ulm in the early 1530s, when the town council finally took decisive actions to draw up plans for the city's liturgical cleansing.[60] Next to Berger's highly energetic Thieves

– grimacing and trembling, an agonized death seizing the Bad Thief – Cranach's seem, in a word, denatured. Gone are all the expressive, Catholic signs of bodily torment – the contortions, distensions and dislocation of limbs, the fracturing of legs, bleeding, screams. And, needless to say, the soul-carrying angels and devils have been omitted.

In Lutheran iconography, then, we can no longer speak of a St Dysmas, the Penitent Thief who dies the spectacular death of a pseudo-martyr, but only a model converted heathen. Pain does not 'work' to save him, and so its visualization becomes worse than superfluous – it now threatens to create the illusion that sin can be overcome at will, mechanically, by an external action, rather than by Grace alone. It would also give the image a cultic charge, a sense of the body's enchantment, that Luther clearly wanted to avoid. As an embodiment of a theological idea, rather than a human protagonist in a tragic drama, the figure of the Good Thief in Cranach's Centurion paintings performs the double pedagogical duty demanded of all good Protestant imagery, namely, to affirm truth (doctrine) and to inoculate the viewer against falsehoods.

Prior to the 1530s, Cranach's Crucifixion panels that included the Two Thieves ranged from small devotional works with a limited number of attendant figures to larger Calvaries teeming with actors in spacious landscape settings. From the early 1530s, when Lutheran patrons once again began commissioning religious paintings and even altarpieces, the Thieves become more standardized and less compelling as dramatis personae. In part this can be explained in terms of work-shop practices, but only in part. All of the Thieves that appear in the surviving Centurion paintings (with the exception of the abject Bad Thief in the version now in Seville) manifest this 'blandness' to a degree. But is this wholly attributable to the practice of delegating certain figures to the younger, less experienced or talented painters in the atelier?

If Cranach quietened down the exuberant brushwork of his early career, it may not have been solely so his sons could better assimilate his style. The austerity of painterly execution serves a doctrinal purpose as well. Cranach seems to want to avoid both the crypto-materialist trappings writ large across Passion images like Berger's and the over-heated penitential mysticism that had informed his own works from the first years of the century (see illus. 100). In other words, Cranach, with the zeal of a convert, negates the sensualizing vigour of his earlier figures and, in the process, reformed the catholicity of his early images in general. For the Two Thieves the change is profound. Increasingly they become little more than allegories of Lutheran precepts. And as such, Cranach uses them to argue against an older, mechanico-magical

view of the body and penitential suffering, in which physical pain was seen as purgative. Now, under Luther, the Thief need not suffer physically at all; he must merely choose. Figures who once told their stories in the flesh, through an arresting language of gesture, are now obliged to hang without incident and nod their heads, simply yes or no.

Cranach's circumspection about the roles of the Two Thieves was also in force when he began to readapt the multi-figured Calvary image for Protestant patrons in the early 1530s. In Chicago we find perhaps the best example of this group of paintings, a *Calvary* dated 1538 and signed with the shop's post-1537 trademark, a winged dragon affectionately called the *Cranachschlange* (illus. 104).[61] A familiar crush of spectators greets the viewer of the event, and the principal characters well-known to medieval audiences re-enact familiar roles. Although the content of the action is not specified by mottoes, the painter leaves no mistake that his crucified Christ is addressing himself to heaven. The awestruck expressions of the group of spectators beneath the Cross, situated under Christ's outstretched right arm, suggest that He is uttering the same dying words inscribed on the Centurion pictures, though again there is no sign of physical stress or emotional turmoil. What, then, makes this a Lutheran image?

Let's begin by noting that Cranach has resuscitated the physiognomic distinction between the Two Thieves. While the bloated Bad Thief languishes uneasily and silently on his cross, eyes downcast, the younger Thief to Christ's right, seemingly oblivious to his own pain, watches Him intently, as if having just spoken himself. With this contrast, Cranach has given us a useful interpretative tool for reading his revised Calvary. Just as in an earlier version of this painting, now in Indianapolis, Cranach uses the centrally placed cross to divide the image-field into two equal halves, like the opening of a book. On one side are enemies of Luther's new Church, both 'historical' – for example, the goon squad of soldiers gambling for Christ's robe – and contemporary – a mitred bishop, a fur-capped cleric with a strong resemblance to Cardinal Albrecht of Brandenburg, and a prominently placed knight on horseback. This figure may have been intended to portray the Catholic emperor Charles V, who allegedly appears in the Indianapolis panel.[62] On the side of Christ's right hand biblical persona and contemporary public figures are set out as the friends of the cause: in the foreground there is Mary, swooning into the arms of a traditional mourning group, while between the crosses the prominent figures include a plump, black-hooded monk, who most likely portrays Luther, and two bearded aristocrats, in armour, on horseback.

115 Detail of illus. 104, showing father and son.

Though there is always a danger in trying to identify one presumed portrait on the basis of another, these aristocratic figures do bear more than a casual resemblance to the Saxon electors Johann the Steadfast, Friedrich's brother and successor, and his son Johann Friedrich, who succeeded his uncle in August 1532. If this is right, the panel reiterates the political line of the Indianapolis panel, wherein Cranach 'recognized the German princes' "conversion" to the reform policies of Martin Luther and the subsequent winning of their subjects to the new faith', and hence opposed the champions of the new orthodoxy to the feudal alliance of emperor and pope.[63] That the two electors who did the most, politically, to further Luther's cause should bear witness to Christ's sacrifice in the company of their client – in fact, flanking him protectively – not only demonstrates their acceptance of Luther's *theologia crucis*, but also asserts Lutheran territorial gains in Saxony as a *fait accompli*. Ideologically, then, the grouping projects the nascent principle of *cuius regio, eius religio* ('he who rules a territory determines its religion'), which was to be formalized at the Peace of Augsburg in 1555 as the basis for coexistence between Protestants and Catholics.[64]

The antitheses with which Cranach structures the panel would have been legible enough to the educated Lutheran viewer for whom the painting was made. But apparently not content with this pedagogical *potential*, the painter invents a motif to thematize the pedagogical *function* of the image at a strategic location inside the picture. At the very bottom

edge Cranach portrays a father and son pair, in contemporary clothing, witnessing the execution (illus. 115). Children had made perennial appearances in Cranach's Passion and martyrdom imagery since at least 1509, when he included them in several of the *Passion of Christ* woodcuts made for Friedrich the Wise. Revealing a familiarity with theories of childhood rooted in antiquity, Cranach insisted upon showing us that the children who appear in these scenes unsupervised by adults enjoy free rein for their cruellest instincts, mocking, cursing and blaspheming Christ and the martyrs as they suffer horrible tortures and death. When authority is present, however, their meaning is reversed: the children are brought for discipline, to have their wild impulses tamed by the spectacle of punishment. Elsewhere I have argued that these little 'genre' motifs reproduce a disciplinary strategy that was actually practised by parents who hoped to use the 'lessons of the scaffold' as an effective childhood inoculation against crime and sin. In these respects Cranach's child appears as a sign of hope in the new faith, and embodies the spirit of innocence Luther offered as a model to all believers in his catechisms of 1529–30. But at the same time they serve as a locus of official anxiety about future disorder. By 1538, when this panel was painted, the training of the young to create the right combination of inner faith and external discipline was a matter of intense concern to Protestant reformers.[65]

On another level the child, placed explicitly on the boundary line between grace and law, also becomes a surrogate for the self-conscious beholder. From outside the painting our gaze can follow the pointing gesture made by the parental authority for the child's benefit. Again, it seems, we are in the clutches of Cranach the antagonist. He moves us once again to an existential crossroads in order to reconfirm our choice of faith. Through a child's eyes we are forced to survey the company we intend to keep by deciding one way or another. Thus the traditional antithesis of Two Thieves is further activated to argue a point of doctrine. Protestant pedagogy, denying the Good Thief salvation on the basis of his painful, penitential 'works', nevertheless uses him to model the consolation that comes with conversion and faith freely chosen.

Opposite him, we see the grossly bloated Bad Thief languishing beyond help, a victim of the Old Law in both a spiritual and a literal sense. As well as any of the allegorical figures Cranach developed, the Bad Thief embodies what Luther, after Paul, called 'carnal man': a sinner metaphorically blinded to the only possible relief for his spiritual infirmity, the legacy of Adam's expulsion from Eden. In fact, if any trace of the medieval Catholic apperception of the punished

body remains in Cranach's Protestant art, it is here, in the still-horrific spectacle of the Bad Thief, damned for his sins. One can read this strictly in terms of Luther's unique dialectical understanding of law and grace, wherein the very impossibility of human obedience to the law remains forever in force in human affairs (rather than being overcome, as in Catholic dogma, by Christ's saving death), and drives Christians ever towards Christ and the Gospels for redemption.[66]

But we must still recognize, in the face of Luther's theological ingenuity, the persistence of another, perhaps deeper, force that worked to turn carnal man towards Christ and the Gospels: fear. Consolation had to be accompanied by its opposite, and Luther himself wove the old-fashioned fear of hell into his sixty-second thesis of 1517:

The light of the Gospel illuminates those who have been crushed by the law and tells them, 'Courage! Do not be afraid.' (Is. 35: 4), 'Console my people, console them' says your God' (Is. 40: 1) . . . When the conscience of the sinner hears this good news, it comes back to life, it exults, it is full of confidence, it [no] longer fears death and, having become the friend of death, it no longer fears any punishment, not even hell.[67]

A submerged threat surely lies behind the negating promise of 'no longer' in this passage. As persistent features of Protestant preaching, the macabre motifs of the *contemptus mundi* and the horrors of hell formed a bridge with the Middle Ages, as Jean Delumeau has shown: 'The Reformers of the sixteenth century and, in their wake, all leading Protestant thinkers saw in the doctrine of justification by faith the only theology capable of reassuring sinners that we all are, and will remain so until our death.'[68] Luther's savage treatment of his opponents, critics and unbelievers (especially Jews) further attests to the room he reserved for terror and the fear of retributive punishment in his worldview. If the Good Thief here and elsewhere in Cranach's Protestant works seems, in his capacity as an allegory of Lutheran choice, less compelling than his medieval counterparts, Cranach's Bad Thief retains some of the spectacular immediacy that links him to the real-life horrors of alienated death in the theatre of public punishment.

That one side of the Thieves' story could be so visibly denatured to serve the positive ideals of Lutheran doctrine, while leaving relatively unchanged, on the other side, the grotesque terrors and fear-instilling antagonisms of late medieval 'realism' returns us to the question of the Reformation's complex social and political dimensions. Popular culture in Germany at the time of the Reformation – and Renaissance – clung tenaciously to traditional forms of piety and, in doing so, preserved its own modes of visual perception. Protestant propaganda imagery

(*Kampfbilder*), as Robert Scribner's work has so thoroughly shown, made effective use of the ritual forms and visual schema of popular culture for the task of agitating hostility towards Rome. Traditional devotional art provided a rich resource of forms and schema on which propagandists could draw. But at what price to popular piety and its attendant forms of 'folk visuality' – like the commonly held belief in the salvific properties of the sacred thing seen (*heilbringende Schau*) – were these expropriations made?

An anti-papal broadsheet, printed by the monogrammist I. W. around the middle of the century and featuring a woodcut based on the devotional Crucifixion image with three crosses, reveals something of this confrontation between popular devotion and Protestant propaganda (illus. 116). Declaring itself as 'a very beautiful drawing, in which the true and false Christs, and the Antichrist, the churches of God and the Devil, are compared through the figures of the thieves on the right and left of Christ Crucified', the broadsheet was but one, closing salvo in a long propaganda war against Rome (one that began with the Cranach workshop's woodcuts for the *Passional Christi und Antichristi* in 1521). With calculated vitriol the woodcutter metamorphoses the Bad Thief into an Antichrist-pope – readily identifiable to the unlettered by his tiara – and sees to his fitting end by hanging the culprit in abjection upon the cross at Christ's left. Demons assail the malefactor and abscond with his damnable soul as it is rudely expelled from the mouth; while at his feet appears a venom-spewing 'cleric devil' (*Kleriker-Teufel*) whose body mimics the *suppedenaeum* widely known from medieval Crucifixion iconography as a support for the feet of Christ. On the ground a demon swings an axe at the *stipes* of the pope's cross, which is already set aflame (in the text the papal Church is identified with the barren fig tree that is cut down and consumed by eternal fires). To complete the antithesis visually, the praying soul of the Good Thief is tenderly carried towards heaven by an angel, while at the base of this cross springtime shoots appear, recalling the simile of Christ's own cross as the *arbor vitae*, or Tree of Life. Further elaboration on these themes is provided by the surrounding text: the Bad Thief, we are told, stands for those who persecute the Gospels, despise Christ and cling to the Church of the Antichrist and the Devil; the Good Thief embodies the true, evangelical Church, which preaches the Gospel of Christ Crucified, penance and forgiveness of sins.[69]

There are many fascinating aspects of this propaganda piece that must unfortunately go unmentioned here, not least the conflation of pope and Antichrist, which in late medieval culture became the embodiment of a 'counterfeit holiness' and a focus of inestimable

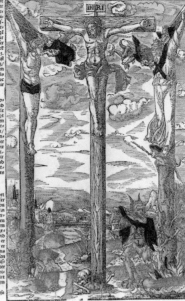

116 Monogrammist I. W., *Crucifixion with the Pope as the Bad Thief and Antichrist*, mid-16th century, woodcut broadsheet, 290 × 330 mm. Germanisches Nationalmuseum, Nuremberg.

apocalyptic dread.[70] What is of greater importance for the question at hand is the reappearance of the motif of the departing souls claimed by angels and devils. Recall that Luther and Cranach abjured the use of these figures in the visually austere, allegorically loaded 'reformed' Crucifixions of the 1530s. Reformers, with their suspicion of all Catholic superstitions, most likely saw the motif as yet another magical trapping of an oppressive Old Church, one that needed to be expunged in the name of doctrine. Yet surely they were aware of its function in the symbolic economy of medieval Passion imagery, where the soul figure furnished less educated beholders with all the visible proof needed to distinguish the fate of the Two Thieves who were, in their punishment and pain, often close to identical.

What, then, explains the woodcutter's insistence on reactivating the motif? In a word, it was audience. Reformation propaganda continually walked a tightrope between positive theological assertion and glaring negativity towards Rome (the latter coming to predominate in the waning years of Luther's life). Part of this balancing act meant drawing on the symbolic vocabulary of popular belief (here the elements of devotional culture) in the phrasing of *both* its appeals for mass support *and* its ridicule of Rome, without, however, seeming to impugn the

validity of those beliefs. Scribner's assessment of this interchange is worth quoting here:

Whether dealing with comets, conjunctions, omens, monsters, visions or prophecies [Protestant propaganda images] were ambiguous about the amount of credence to be given to such phenomena. Reformation aversion to superstition led to attempts at spiritual interpretation, but these depended enough on literal belief in such signs for the matter to remain ambivalent. Thus, evangelical propaganda did not break with pre-Reformation apocalyptic feeling, but rather exploited it. In terms of the religious emotions it aroused, the propaganda confirmed and extended these elements of popular belief.[71]

Propaganda's appeal to the magical-materialist expectations and visual habits of folk piety are revealing of the Protestant attitude towards visual experience, and the way it was targeted in the changed form and function of the Two Thieves. As we've noted throughout this book, the nature of medieval visuality made beholders highly attentive to the minutiae of the body's appearance: gestures, postures, physiognomies, facial expressions and so on.[72] Devotional imagery, because of both its moral instructiveness and its magical efficacy, served as one particularly dense locus of the look. Imagery involving pain, to which medieval spectators had more than a simple visceral reaction, indulged a deep disposition to decode the language of the body. Reformers, I have argued, connived to remove from view the positive image of the body-in-pain in part to block that mental disposition, peculiar to the Middle Ages, to attend to the surfaces of the body, to read its language of pain and to gauge the purifying potential of that pain. Where iconoclasm failed to banish the image entirely, formulators of the new imagery stripped the crucified body of its magical phenomenology and substituted for it the dry allegories of conversion and choice, true and false churches.

Conclusion

By reading the theological and pedagogical content of Lutheran imagery as a cluster of negations and antagonisms, I hoped to emphasize the intent of reformers to imbue their new iconography with the ironical function of images that argue against images. For its rhetorical effectiveness, this new anti-image demanded the efforts of a new kind of beholder who reads and interprets, rather than looks and feels. Many other artists contributed to this transformation, but I find it fascinating that it was Cranach, the painter who knew better than most the affective power of spectacularized pain, who waged the aesthetic

campaign to cleanse the figure of the Good Thief of its magical immediacy for the gaze. In line with the Protestant assault on the medieval cult of saints, Cranach purged his art of the penitential excesses of his Vienna years, and, in the process, robbed 'St Dysmas' of his redeeming pain, replacing it with the visually tepid, spiritual interpretation of an assent to faith.

Thus was the viewer distanced from the quasi-cultic appeal of his image, and disciplined away from what Luther saw as the self-deifying delusions of late medieval religion, which longed to see, with intensely compassionate eyes, the purification of the body through pain. As I intimated at the outset of this chapter, the reform of the cult image was prepared long before Lutherans or Zwinglians issued their critiques; and works made for bourgeois patrons in still-Catholic territories anticipated the critique with distancing effects of their own. An artist who would later be banished from Leipzig as a Protestant, Georg Lemberger, painted *c.* 1522 a soaring and epic *Calvary* for the Schmidburg family's epitaph in the church of St Nicholas (illus. 117). Instead of transposing the devout donors into the tumult of the envisioned event literally, Lemberger calls attention to the fictional status of his *historia* by setting it behind a sculpted baldachin towards which the kneeling donors direct their prayers. Framed like a monumental wall painting above a colonnaded dado and bands of inscription, Lemberger's Calvary is an image within an image.[73] Its composite appearance deliberately undermines the cultic function of 'simple visibility', asserting instead the primacy of the painter's artful mediations.

Other distancing effects in German art at this time arose from the growing interest in landscape. Following the lead of other Danube School painters like Altdorfer (see illus. 107) and Wolf Huber (see illus. 6), the multi-talented Nuremberg artist Augustin Hirschvogel, in a pen and ink drawing of 1533 now in Windsor Castle, located the three crosses on a barren Franconian hillside, amidst hundreds of onlookers, and gave us an oblique view of the crosses (illus. 118).[74] Hirschvogel's reputation rested primarily on his work as a cartographer – after leaving Nuremberg in 1543, he pioneered the use of triangulation in maps prepared in anticipation of the next Turkish siege of Vienna – so the panoramic conception of landscape in his drawings (no paintings by his hand survive) should not surprise us. Although the spectators in Hirschvogel's thoroughly contemporary judicial audience are close enough to the human source of pain to feel its intensity, we are set back far enough to survey the entire landscape with all its features, natural, architectural and human.

117 Georg Lemberger, *Calvary*, from the so-called *Schmidburg Epitaph*, *c.* 1522, oil on pearwood panel, 142.5 × 84.5 cm. Museum der bildenden Künste, Leipzig.

An analogous process of perceptual reconditioning, and similar terms of disengagement from the body-in-pain, arose in the Italian Renaissance, which transformed the sacred image into art. Just as the Protestant critique of images set the stage for the Thief's dissolution into spiritual allegory, humanist ideas of poetic creation, applied to the visual arts, gave theoretical backing to the professional painter's application of rational rules and knowledge (*scientia*) to the depiction of sacred subjects. This precipitated another kind of crisis in the image's cultural function – its contamination by fiction. At least for a certain class of learned viewers, the visual artist's new claims to the image-forming powers of poets, and the various aesthetic procedures for demonstrating these powers, served to convince the beholder that what the image signified was not the real presence of a Holy Person, but the latter seen through the painter's *inventio* and *fantasia*.

Just how, and by what means, these attenuations of visual experience at the hands of Protestant reformers and Renaissance artists may have conditioned perceptual and mental habits elsewhere can only be a matter of conjecture. What I have tried to draw out of both manifestations of crisis are their implications for the history of response to images on the one hand and spectacle on the other. In the late Middle Ages experiences with images and spectacle could overlap and condition one another mutually. Now, I suggest, Renaissance and Reformation art set the perceptual stage for their disengagement. The time was ripe. In the tally sheet of criminal-justice history, the period encompassing Italian and German humanism, the artistic Renaissances of south and north, and the Protestant Reformation – all of which signal for liberal historiography the advent of the modern era – was surely the bloodiest, cruellest and, in a word that retains its descriptive currency to this day, the most *medieval*. During this time the monolithic system of punishments aimed at the body, and enacted in public as spectacle, reached its apogee. But whatever repressive social-control function this system may have served at the time, it did not yet entail a disciplining of visuality; nor did it assail the psychological basis of this particular visual mode, what I have called compassionate vision. Eventually, however, this did occur, and the sixteenth century played a pivotal role in forming a bridge from the 'medieval paradigm' of the fourteenth and fifteenth centuries (as I described it in Chapter 4) to the era which saw the re-engineering of penal ceremonies by absolutist governments across Europe.

The sixteenth century is undoubtedly a transitional one in the evolution of repression, and the physical coercion embodied in its criminal-justice regimes was complemented by numerous other forms

118 Augustin Hirschvogel, *Calvary*, dated 1533, pen and ink drawing, 55.5 × 39.4 cm. Windsor Castle.

of discipline imposed upon popular culture. One important set of disciplinary measures issued from the growing fiscal pressures of the early modern state. With the rising burden of maintaining ever-larger courts, bureaucracies and armies, the early modern state instituted extensive sumptuary laws that combined social discipline with revenue-raising.[75] Other disciplinary measures were aimed at the spiritual and mental world of a ruler's subjects. In contrast to the

fragmentation of religious life in the late Middle Ages, popular culture and popular religion were subject in the sixteenth century to increasing levels of colonization and control by the combined efforts of state and church authorities. As Günther Lottes writes, 'The whole magical element in popular religion, which the late medieval Church had tolerated, canalized, and sometimes encouraged for financial reasons, was coming under attack.'[76] During the early phases of the Protestant revolution, however, this attack was muffled by the movement's calculated need to co-opt, for propaganda purposes, the anti-clerical streak and tradition of religious protest in popular culture. When reformers needed it most, they trod lightly on popular religion, but the situation changed 'when the new faith had won power at the governmental level and no longer needed to mobilize a mass following'. From that point on, reformers could afford to take a harder line against the superstitious beliefs and practices of popular religion. 'To political repression and social austerity were added religious repression and austerity.'[77]

All of these changes in the relational dynamics of power and culture coalesced around the spectacle of punishment in the sixteenth century, infusing this era in the history of penalty with a new set of contradictions, and for that reason also setting it on a course towards its own negation centuries later.

Epilogue

I would like to see a law passed that would abolish capital punishment, except for those states which insist on keeping it. Such states would then be allowed to kill criminals provided that the killing is not impersonal but personal and a public spectacle: to wit that the executioner be more or less the same size and weight as the criminal . . . and that they fight to death using no weapons, or weapons not capable of killing at a distance . . . The benefit of this law is that it might return us to moral responsibility. The killer would carry the other man's death in his psyche. The audience, in turn, would experience a sense of tragedy, since the executioners, highly trained for this, would almost always win.

NORMAN MAILER, *The Presidential Papers* (1963)[1]

And we think we are civilized!

LOUIS SEBASTIEN MERCIER, *Tableau de Paris* (1782–6)[2]

Imagine if the execution of criminals was once again to become a form of public spectacle. Millions might witness the final moments of the condemned man or woman on televisions in their homes and offices, in bars and shopping malls, indeed from one end of the global village to another. Audiences could once again observe and remark, as they once did, on the language of the punished body as it involuntarily shook with pain and sobbing. They might watch as the subject of yet another electrocution is left charred and smouldering, electrodes popping off the body; or as the subject of lethal injection trembles, the life flowing silently out of his or her body; or as the individual inside the gas chamber desperately gasps for air, and then falls silent. The pain of death, for which our public policy and laws have declared certain criminals deserving, could, in other words, once again be rendered visible, concrete, undeniably real. The body-in-pain could once again become an object of collective fascination and the focal point of a new kind of collective spectatorship.

My fictitious scenario for a future return to punishments enacted before the camera and the public gaze could make an interesting simulation game for social scientists if it weren't for the fact that reality may be catching up with fantasy. In 1991 the San Francisco public television station, KQED, sued the warden of San Quentin, Daniel Vasquez, for the right to televise the gassing of Robert Alton Harris, the first execution in the state for 24 years.[3] Though this was not the first such case,[4] it was the first to place the issue of media-assisted judicial spectatorship squarely in the public arena. The station argued that since the print media had traditionally been allowed to watch executions with the tools of its trade – paper and pen – it too should be able to bear witness with its tool, the video camera. 'Television,' proclaimed its news director, 'is the only neutral witness.'[5] Predictably, the state opposed the presence of television cameras, first on the grounds of security, claiming that 300 death-row prisoners with TVs in their cells might be incited to revolt, and second that such visual publicity constituted a danger for both the witnesses and the prison personnel who participated in the execution.

Abolitionists were divided: while most apparently opposed the idea, expressing concern for the privacy of the condemned, one group supported the idea of a broadcast since it would let people witness the atrocity of an execution for themselves. This backhanded justification contains a historical insight, one that has informed my thinking throughout these pages. Those who expressed the idea must have known that the KQED petition flew against prevailing social standards of what kinds of bodily events could be made public without offending sensibilities. After all, physical pain, like sex, elimination and sleeping, had long since been consigned to the realm of private experience, banished 'behind the scenes' of social existence. Officially, the last public executions in the United States took place in the early 1830s (though public lynchings continued);[6] after that time, reformers and abolitionists who saw public punishment as 'a spectacle at once revolting and injurious to society', succeeded in sequestering the ritual behind the walls of prisons. Televising an execution now, some abolitionists thought, would reveal the hypocrisy of a society that kills its deviants in secret. They seemed to be insisting, in concert with Albert Camus, that if a society really believed what it said about capital punishment as a deterrent, 'it would exhibit the heads'.[7]

Although the petition was ultimately denied and Harris killed away from the camera's gaze, the affair shifted the terms of debate about the death penalty, and the political uses of pain, to the post-medieval question of public sensibilities and their brutalization by open displays

of violence.[8] Those involved in the *KQED* v. *Vasquez* case took seriously the possibility that a public whose sensibilities had long ago adjusted to the privatization of pain, and the invisibility of actual punishment, might now be ready to open the penitentiary doors and have lethal punishments rendered visible once again. For making punitive rituals public once again through television means nothing less than *deprivatizing* the individual's pain of death, and allowing it to once again circulate freely in the political and social economies of violence. In this respect alone the move would have signalled – or will signal – a regression, perhaps tantamount to what Norbert Elias has termed a 'decivilizing spurt'. Would it, in other words, have signalled an impending return to the Middle Ages?

This is, on the surface, a rather glib way to focus a complicated historical question. We are still, I think, a long way from seeing a sustained *nostalgia* for medieval punishments, at least one strong enough for Umberto Eco to revise his list of the 'Ten Little Middle Ages' that float through our cultural imaginary.[9] But we also know that the trope of 'the medieval' has long been invoked – a spectre from the past always haunting the present – by modern penal reformers and abolitionists in their critique of torture and capital punishment. Up until now their refrain might be usefully translated to mean 'barbaric', 'uncivilized' or, in the language of the Eighth Amendment, 'cruel and unusual'. But now, on the threshold of a new era of public punishments, the historical moniker accrues new meanings and summons up old ghosts.

When the socialist artist John Heartfield – exiled in 1933 to Prague, the home of Germany's opposition parties – levelled his two-way indictment against Nazi political terror and the treatment of criminals in the 'Middle Ages' (his model comes from a carved oculus relief on the Tübingen Stiftskirche), he staked the rhetorical power of his image on the currency of a stereotyped 'medieval' barbarism whose emblems were the cross and the wheel (illus. 119).[10] Only one year before, blood-thirsty cries had arisen throughout Germany for the execution of Marinus van der Lubbe, the Dutch anarchist who burned down the Reichstag on 27 February 1933. Although the 'French' guillotine was the current mode for state executions, the German public let it be known this was too good for van der Lubbe, and Hitler vowed to have him hanged, even though no statute provided for it.[11] Only by issuing an emergency decree that made death penalty provisions retroactive could the Nazi leadership make good Hitler's promise. Van der Lubbe was eventually guillotined, but critics of the regime instantly recognized the dangerous precedent. 'Now nobody,' Richard Evans explains,

119 John Heartfield, *Wie in Mittelalter... so im Dritten Reich*, photomontage from *Arbeiter-Illustrierte Zeitung* (Prague), 31 May 1934.

'could be sure what the punishment for their offence would be by the time they came to trial.'[12] New opportunities now awaited the Third Reich's executioners. That Nazi propaganda had succeeded in making the threatened return of 'medieval' punishments appear like a spontaneous expression of the *Volk*'s natural instinct for racial self-defence surely did not escape Heartfield. Fighting fire with fire, he harnessed the new aesthetic procedure of photomontage to the dissident goal of piercing the veil of appearances; his juxtaposition is therefore best understood not as a generalized lament about the transhistoricity of state terror, but as a militant disruption of a Nazi-agitated, popular nostalgia for penalties of unbridled vindictiveness. It is a consummate work of political art.

In 1963 the American artist Andy Warhol made a very different kind of visual statement about state-sponsored death, one that reversed Heartfield's introjection of a new image into the mass media. Call it a unique conjuncture of iconography and artistic procedure. In the

summer of 1962 Warhol adopted the photo-silkscreen technique to the virtual exclusion of hand-painting, and turned decisively to pre-existing photographs as source material for his imagery. By the early months of the following year his studio was churning out serialized images of suicide leaps, car crashes, police attack dogs, atomic explosions – the so-called 'Death and Disaster' series, of which *Orange Disaster*, a silkscreened grid of fifteen photographs of an electric chair in an abandoned death chamber, is well known (illus. 106).[13] With no political agenda for his minimally mediated disclosures of social and political violence, Warhol was free to look upon the evacuated death chamber as but another site of impersonal death. Like fifteen stills from one of his motionless films, the serialized image concretized the camera's gaze, fulfilling his desire to think and work like a machine. Whereas Heartfield placed his faith in a reproductive medium that, true to its name, interposed a meaning *between* human beings and the world, Warhol toyed with the implications of serial images that, like commodities, communicated with one another on a new plane of reality.

If we ever witness a 'medieval' turn to punishments enacted before the public gaze, that gaze will surely be the distracted, impassive, mechanical stare presaged in Warhol's serial disasters. As the iconic presence of the electric chair in his silkscreen atomizes into smaller and smaller units, like a cell division without brakes, it provides us with a compelling premonition of how the pain of the prisoner's body might 'look' when its electronic image reaches everybody. However, unlike the judicial spectators in the Middle Ages, we will be quiet, sitting still, completely free to wonder whether we have any stake at all in the hideous death of this poor, condemned sinner. Will we be able to grasp precisely whose guilt the atrocity discloses? Or will we accept the spectacle on the condition that our responsibility is dispersed? 'The picture becomes evidence of the general human condition,' writes John Berger. 'It accuses everybody and nobody.'[14]

References

Preface

1 Primo Levi, *Survival in Auschwitz: The Nazi Assault on Humanity*, trans. S. Woolf (New York, 1969), p. 22, quoted in Sara R. Horowitz, 'But is it Good for the Jews? Spielberg's Schindler and the Aesthetics of Atrocity', in *Spielberg's Holocaust: Critical Perspectives on 'Schindler's List'*, ed. Y. Loshitzky (Bloomington, 1997), p. 121.
2 Quoted in Geoffrey H. Hartman, 'The Cinema Animal', in *ibid.*, p. 66.
3 The problem is cogently outlined by Richard J. Evans, *Rituals of Retribution: Capital Punishment in Germany, 1600–1987* (Oxford, 1996), pp. xiii–xiv; throughout what follows my debts to Evans's meticulous scholarship are considerable.

Introduction

1 See Werner Schade, *Cranach: A Family of Master Painters*, trans. H. Sebba (New York, 1980), pp. 17–19.
2 See *Lukas Cranach. Gemälde, Zeichnungen, Druckgraphik*, exh. cat. by Dieter Koepplin and Tilman Falk; Kunstmuseum, Basel (1974), cat. no. 62 and p. 169; for the borrowings from Dürer, see Johannes Jahn, *Lukas Cranach als Graphiker* (Leipzig, 1955), p. 12.
3 Throughout this book I capitalize the designations 'Two Thieves' or simply 'Thieves' as a convention when referring to the malefactors of the biblical Passion narratives.
4 For catalogue information, see *Dürer and His Time: An Exhibition from the Collection of the Print Room, State Museum Berlin, Stiftung Preussischer Kulturbesitz*, cat. essay by Fedja Anzelewsky; Smithsonian Institution, Washington DC (1965), cat. nos 63–4 (pp. 71–2).
5 The words are those of Minucius Felix's pagan character Caecilius in his dialogue with the Christian Octavius, quoted in Martin Hengel, *Crucifixion: In the Ancient World and the Folly of the Message of the Cross*, trans. J. Bowden (London, 1977), p. 3.
6 See the brilliant if flawed pair of articles by Edgar Wind, 'The Criminal-God' and 'The Crucifixion of Haman', *Journal of the Warburg and Courtauld Institutes*, I (1937–38), pp. 243–8.
7 Hengel, *Crucifixion*, p. 20; for Gnostic denials of the event's reality, p. 21.
8 Though its arguments are specious, see for its death-ritual folklore Elizabeth D. Purdum and J. Anthony Paredes, 'Rituals of Death: Capital Punishment and Human Sacrifice', in *Facing the Death Penalty: Essays on Cruel and Unusual Punishment*, ed. M. Radelet (Philadelphia, 1989), pp. 139–55.
9 *The Compact Edition of the Oxford English Dictionary* (Oxford, 1989), p. 553.
10 Arlette Farge, *Fragile Lives: Violence, Power and Solidarity in Eighteenth-century Paris*, trans. C. Shelton (Cambridge, Mass., 1993), p. 172.

11 *The Compact Edition of the Oxford English Dictionary*, p. 553.

12 This point is made by Michel Foucault in his highly influential book *Discipline and Punish: The Birth of the Prison*, trans. A. Sheridan (New York, 1979), p. 46.

13 Farge, *Fragile Lives*, p. 199.

14 For recent thinking about the Man of Sorrows and devotional art, see the essays by Bernhard Ridderbos and Michael Camille in *The Broken Body: Passion Devotion in Late Medieval Culture*, eds A. A. MacDonald, H. N. B. Ridderbos and R. M. Schlusemann (Groningen, 1998), pp. 145ff.

15 Elaine Scarry, *The Body in Pain: The Making and Unmaking of the World* (Oxford, 1985), pp. 27–59.

16 On saintly 'defiling practices' as a form of *imitatio Christi*, see Karma Lochrie, *Margery Kempe and Translations of the Flesh* (Philadelphia, 1991), pp. 38–43.

17 See Esther Cohen, 'Towards a History of European Sensibility: Pain in the Later Middle Ages', *Science in Context*, VIII/1 (1995), pp. 47–74.

18 On late medieval vision, see Bob Scribner, 'Popular Piety and Modes of Visual Perception in Late Medieval and Reformation Germany', *Journal of Religious History*, XV/4 (December 1989), especially pp. 456ff.

19 The main New Testament texts for the Crucifixion are Matthew 27: 33–50, Mark 15: 22–41, Luke 23: 33–49 and John 19: 17–37.

20 See Jürgen Moltmann, *The Crucified God: The Cross of Christ as the Foundation and Criticism of Christian Theology*, trans. R. A. Wilson and J. Bowden (New York, 1974), p. 147.

21 Gerard S. Sloyan, *The Crucifixion of Jesus: History, Myth, Faith* (Minneapolis, 1995), pp. 2–3.

22 *The Apocryphal New Testament*, trans. and ed. M. R. James (Oxford, 1924), p. 103; for a complete listing of textual sources, see Englebert Kirchbaum, *Lexikon der christlichen Ikonographie* (Freiburg im Breisgau, 1972), IV, col. 57, and (1974), VI, col. 68.

23 *The Apocryphal New Testament*, p. 140, n. 1.

24 *Ibid.*, pp. 161ff.

25 See Leopold Kretzenbacher, 'St Dismas, der rechte Schächer: Legenden, Kultstätten und Verehrungsformen in Innerösterreich', *Zeitschrift des Historischen Vereines für Steiermark*, XLII (1951), pp. 120ff.

26 *The Apocryphal New Testament*, p. 163.

27 *Ibid.*, pp. 163–4.

28 See Gertrud Schiller, *Iconography of Christian Art*, trans. J. Seligman (London, 1972), II, pp. 13–14.

29 *Gaistliche vsslegung des lebens Jhesu Christi* (Ulm: Johann Zainer, 1480–85), fol. 123 verso; for catalogue information, see *Martin Luther und die Reformation in Deutschland: Austellung zum 500. Geburtstag Martin Luthers*, exh. cat.; Germanisches Nationalmuseum, Nuremberg (Frankfurt am Main, 1983), cat. no. 495.

30 Ruth Mellinkoff, *Outcasts: Signs of Otherness in Northern European Art of the Late Middle Ages* (Berkeley, 1993), I, pp. 52–3 (costume), 133 (distorted facial features), 155–6 (red hair and ruddy skin), and 214–15 (spatial position). I address the last category of symbolism in Chapter 7. For a critical view, see Michael Camille's book review in *Art Bulletin*, LXXVII/1: 1 (March 1995), pp. 133–4.

31 See Norman Bryson, 'Art in Context', in *Studies in Historical Change*, ed. R. Cohen (Charlottesville and London, 1992), pp. 18–42.

32 See Wolfgang Pilz, *Das Triptychon als Kompositions- und Erzählsform* (Munich, 1970), cat. no. 101; for an Italian example of this motif, see Samuel Y. Edgerton,

Pictures and Punishment: Art and Criminal Prosecution during the Florentine Renaissance (Ithaca, 1985), illus. 53 and p. 190.

33 See Arthur Danto, *Beyond the Brillo Box: The Visual Arts in Post-historical Perspective* (New York, 1992), pp. 55ff.

34 See Erwin Heinzle, *Wolf Huber um 1485–1553* (Innsbruck, n.d.), p. 73.

1 *'A Shameful Place': The Rise of Calvary*

1 *The Golden Legend of Jacobus de Voragine*, trans. G. Ryan and H. Ripperger (London, 1993), p. 208.

2 Quoted in Alessandro Nova, '"Popular" Art in Renaissance Italy: Early Response to the Holy Mountain at Varallo', in *Reframing the Renaissance: Visual Culture in Europe and Latin America, 1450–1650*, ed. C. Farago (New Haven and London, 1995), p. 112.

3 George Kubler, 'Sacred Mountains in Europe and America', in *Christianity and the Renaissance: Image and Religious Imagination in the Quattrocento*, eds T. Verdon and J. Henderson (Syracuse, 1990), pp. 413–41, compares four case studies: Varallo, Granada, Braga (Portugal) and Congonhas do Campo (Brazil).

4 On this point in particular, see William Hood, 'The *Sacro Monte* of Varallo: Renaissance Art and Popular Religion', in *Monasticism and the Arts*, ed. T. G. Verdon (Syracuse, 1984), p. 295.

5 Kubler, 'Sacred Mountains in Europe and America', p. 415.

6 Nova, '"Popular" Art in Renaissance Italy', p. 116.

7 David Freedberg, *The Power of Images: Studies in the History and Theory of Response* (Chicago and London, 1989), p. 196.

8 Kubler, 'Sacred Mountains in Europe and America', p. 418.

9 *Ibid.*

10 The apt phrase is from Heiko A. Oberman, 'Fourteenth Century Religious Thought: A Premature Profile', *Speculum*, LIII/1 (January 1978), p. 81.

11 Discussed in Nova, '"Popular" Art in Renaissance Italy', p. 118.

12 *Ibid.*, pp. 116–20.

13 Quoted in *ibid.*, p. 120.

14 *Meditations on the Life of Christ: An Illustrated Manuscript of the Fourteenth Century*, eds I. Ragusa and R. B. Green (Princeton, 1961), p. 5; also quoted in Nova, '"Popular" Art in Renaissance Italy', p. 120.

15 Thomas Bestul, *Texts of the Passion: Latin Devotional Literature and Medieval Society* (Philadelphia, 1996), p. 27.

16 F. P. Pickering, *Literature and Art in the Middle Ages* (Coral Gables, FL, 1970), p. 234.

17 The *Zardino de Oration* was evidently written for young girls; quoted at length in Michael Baxandall, *Painting and Experience in Fifteenth-century Italy* (Oxford, 1988), p. 46.

18 *Ibid.*, p. 45.

19 See Frank Günter Zehnder, *Katalog der Altkölner Malerei*, Katalog des Wallraf-Richartz-Museums XI (Cologne, 1990), cat. no. 65, pp. 484–91.

20 For a similar discussion of donor imagery, see Matthew Botvinick, 'The Painting as Pilgrimage: Traces of a Subtext in the Work of Campin and His Contemporaries', *Art History*, XV/1 (March 1992), pp. 1–18.

21 Zehnder, *Katalog der Altkölner Malerei*, p. 489.

22 Hood, 'The *Sancro Monte* of Varallo', p. 305.

23 Text reprinted in C. Davis-Weyer, ed., *Early Medieval Art, 300–1150* (Toronto, 1986), p. 48.

24 Gertrud Schiller, *Iconography of Christian Art*, trans. J. Seligman (London, 1972), II, p. 3. For an excellent discussion of the Crucifixion's origins, and their theological determinations, see Peter G. Moore, 'Cross and Crucifixion in Christian Iconography: A reply to E. J. Tinsley', *Religion*, IV (Autumn 1974), pp. 104–13.

25 William Loerke, '"Real Presence" in Early Christian Art', in *Monasticism and the Arts*, ed. T. G. Verdon (Syracuse, 1984), p. 33.

26 *Ibid.*, p. 34.

27 Kurt Weitzmann, '*Loca Sancta* and the Representational Arts of Palestine', in *Studies in the Arts at Sinai* (Princeton, 1982), p. 21 [35].

28 See discussion and notes in Loerke, '"Real Presence" in Early Christian Art', pp. 36, 49–50 (ns 12–14); also Weitzmann, '*Loca Sancta* and the Representational Arts of Palestine', pp. 26–7.

29 Hans Belting, *Likeness and Presence: A History of the Image in the Era Before Art*, trans. E. Jephcott (Chicago and London, 1994), p. 134.

30 John 19: 26–7; discussed in Schiller, *Iconography of Christian Art*, p. 92.

31 Loerke, '"Real Presence" in Early Christian Art', p. 30.

32 Longinus is probably a reference to Psalm 21: 12: 'Therefore shalt thou make them turn their back, when thou shalt make ready thine arrows upon thy strings against the face of them'; the motif of piercing also comes from Zechariah 12: 10; see Schiller, *Iconography of Christian Art*, p. 93.

33 From St Augustine's *Tractatus in Johanem*. Discussed in Schiller, *Iconography of Christian Art*, p. 93; also see Belting, *Likeness and Presence*, p. 270, on the ceremony of the *zeon*, in which warm water and wine were mixed in the eucharistic chalice to commemorate the divine nature which persisted in the mortal body of Christ.

34 Schiller, *Iconography of Christian Art*, pp. 93–4.

35 Melito of Sardis (*c.* 170), quoted in Gerard S. Sloyan, *The Crucifixion of Jesus: History, Myth, Faith* (Minneapolis, 1995), pp. 123–4.

36 For essential information, see Kurt Weitzmann, *The Monastery of Saint Catherine at Mount Sinai: The Icons* (Princeton, 1976), I, cat. no. B. 36, and *idem.*, '*Loca Sancta* and the Representational Arts of Palestine', p. 26.

37 Belting, *Likeness and Presence*, pp. 269ff.

38 Kathleen Corrigan, 'Text and Image on an Icon of the Crucifixion at Mt Sinai', in *The Sacred Image: East and West*, eds R. Ousterhout and L. Brubaker (Urbana and Chicago, 1995), p. 48; see also Belting, *Likeness and Presence*, p. 120; and Anna D. Kartsonis, *Anastasis: The Making of an Image* (Princeton, 1986), pp. 40ff.

39 On the liturgical function of Passion icons in Byzantium, see Hans Belting, *The Image and Its Public in the Middle Ages: Form and Function of Early Paintings of the Passion*, trans. M. Bartusis and R. Meyer (New Rochelle, NY, 1990).

40 See Elizabeth Roth, *Der Volkreiche Kalvarienberg in Literatur und Kunst des Spätmittelalters* (Berlin, 1958), pp. 47–8.

41 See Gerhard Ruf, *Das Grab des hl. Franziskus: Die Fresken der Unterkirche von Assisi* (Freiburg im Breisgau, 1981), pp. 94–6; also Roth, *Der Volkreiche Kalvarienberg*, p. 53.

42 Catherine of Siena, in a letter to Raymond of Capua, quoted in Richard Kieckhefer, *Unquiet Souls: Fourteenth-century Saints and Their Religious Milieu* (Chicago, 1984), p. 109.

43 See Hanspeter Landolt, *German Painting. The Late Middle Ages (1350–1500)*, trans. H. Norden (Geneva, 1968), pp. 13, 18, 23ff.

44 See Roth, *Der Volkreiche Kalvarienberg*, pp. 62–3.

45 *Ibid.*, p. 55.

46 See Sydney C. Cockerell, *Burlington Magazine* (February 1927), pp. 108–11.

47 Jan Piet Filedt Kok, *The Master of the Amsterdam Cabinet, or The Housebook Master, c. 1470–1500* (Amsterdam and Princeton, 1985), pp. 264–7, dates the *Speyer Altar* between 1480 and 1485.

48 See *Alte Pinakothek Munich* (Munich, 1986), pp. 320–21.

49 From the *Lignum vitae* (*Tree of Life*), quoted in Denise Despres, *Ghostly Sights: Visual Meditation in Late Medieval Literature* (Norman, Oklahoma, 1989), pp. 26–7.

50 Erwin Panofsky, *Early Netherlandish Painting: Its Origins and Character* (New York, 1971), pp. 181–2.

51 Cf. Craig Harbison, 'Visions and Meditation in Early Flemish Painting', *Simiolus*, XV/2 (1985), pp. 87–118.

52 Little recent scholarship has been devoted to Provoost; for an introduction, see Ron Spronk, 'Jan Provoost: Art Historical and Technical Examinations', doctoral dissertation, Rijksuniversiteit Groningen, 1993, especially pp. 9–20.

53 See Martin Kemp, 'Introduction: The Altarpiece in the Renaissance: A Taxonomic Approach', in *The Altarpiece in the Renaissance*, eds P. Humphrey and M. Kemp (Cambridge, 1994), p. 18.

54 Quoted and discussed in Kieckhefer, *Unquiet Souls*, p. 104.

55 Bernd Moeller, 'Piety in Germany around 1500', in *The Reformation in Medieval Perspective*, ed. S. Ozment (Chicago, 1971), pp. 53–4.

56 Despres, *Ghostly Sights*, p. 16.

2 The Two Thieves Crucified: Bodies, Weapons and the Technologies of Pain

1 Michael Walzer, *Just and Unjust Wars: A Moral Argument with Historical Illustrations* (New York, 1977), p. 24, quoted in Elaine Scarry, *The Body in Pain: The Making and Unmaking of the World* (Oxford, 1985), p. 16.

2 On the 'three-nail type', see Elizabeth Roth, *Der Volkreiche Kalvarienberg in Literatur und Kunst des Spätmittelalters* (Berlin, 1958), pp. 26ff; and Erwin Panofsky, *Early Netherlandish Painting: Its Origins and Character* (New York, 1971), I, p. 364, n. 3.

3 Isaiah 53: 4; on the Passion tracts of both Bonaventure and the Pseudo-Bonaventure, see Thomas Bestul, *Texts of the Passion: Latin Devotional Literature and Medieval Society* (Philadelphia, 1996), pp. 43ff.

4 For catalogue information, see Irmgard Hiller and Horst Vey, *Katalog der deutschen und niederländischen Gemälde bis 1550 (mit Ausnahme der Kölner Malerei) im Wallraf-Richartz-Museum und im Kunstgewerbemuseum der Stadt Köln* (Cologne, 1969), pp. 119–20.

5 Leo Steinberg, *The Sexuality of Christ in Renaissance Art and in Modern Oblivion*, 2nd edn (Chicago and London, 1996), pp. 246–50.

6 In the *Meditations* the author allows for the stretching and nailing of Christ's body on to the Cross both while on the ground (*jacente cruce*) and after having ascended and standing on a ladder (*erecto cruce*); see *Meditations on the Life of Christ: An Illustrated Manuscript of the Fourteenth Century*, eds I. Ragusa and R. B. Green (Princeton, 1961), p. 334; also discussed in Bestul, *Texts of the Passion*, p. 50.

7 See Gertrud Schiller, *Iconography of Christian Art*, trans. J. Seligman (London, 1972), II, p. 134.

8 See Craig Harbison, 'Visions and Meditation in Early Flemish Painting', *Simiolus*, XV/2 (1985), p. 88.

9 Scarry, *The Body in Pain*, p. 16: emphasis in original.

10 *The Book of Margery Kempe*, ed. W. Butler-Bowden (New York, 1944), p. xxv, quoted and discussed in *ibid*.

11 *Adversus Judaeos*, 667 A–B, quoted in Joseph W. Hewitt, 'The Use of Nails in the Crucifixion', *Harvard Theological Review*, XXV (1932), p. 43.

12 Quoted in *ibid*.

13 F. P. Pickering, 'The Gothic Image of Christ: The Sources of Medieval Representations of the Crucifixion', in *Essays on Medieval German Literature and Iconography* (Cambridge, 1980), pp. 14–15.

14 Hewitt, 'The Use of Nails in the Crucifixion', p. 37.

15 See F. P. Pickering, *Literature and Art in the Middle Ages* (Coral Gables, FL, 1970), p. 244; Hewitt, 'The Use of Nails in the Crucifixion', p. 32, n. 4; and Schiller, *Iconography of Christian Art*, illus. 322.

16 Hewitt, 'The Use of Nails in the Crucifixion', p. 39.

17 Ampullae nos 10 and 13; see André Grabar, *Ampoules de Terre Sainte (Monza-Bobbia)* (Paris, 1958), pp. 26–7, 29.

18 Kurt Weitzmann, '*Loca Sancta* and the Representational Arts of Palestine', in *Studies in the Arts at Sinai* (Princeton, 1982), p. 27.

19 *Ibid.*, p. 26. The cross stands on a small mound of earth indicating Golgotha, but is perhaps also symbolic of Paradise; see Schiller, *Iconography of Christian Art*, p. 90.

20 For the varieties of posture, see Grabar, *Ampoules de Terre Sainte*, pls XIV, XVI (our illus. 26) and XVIII for type one; XII and XIII for type two; XXIV (our illus. 27) for type three.

21 Schiller, *Iconography of Christian Art*, p. 90; Weitzmann, '*Loca Sancta* and the Representational Arts of Palestine', p. 26, believes the third type arose out of a formal imperative to adapt an originally rectangular composition to a circular format.

22 A recent reappraisal of the skeletal remains of a crucifixion victim, discovered at Giv'at ha–Mivtar in 1968, concludes with the most plausible reconstruction: arms hooked back over the *patibulum* and bound with ropes, feet affixed to the *stipes* with iron nails; see Joseph Zias and Eliezer Sekeles, 'The Crucified Man from Giv'at ha–Mivtar: A Reappraisal', *Israel Exploration Journal*, XXV (1985), pp. 22–7.

23 Pierre Barbet, *A Doctor on Calvary: The Passion of Our Lord Jesus Christ as Described by a Surgeon*, trans. the Earl of Wicklow (New York, 1963), p. 73.

24 Kurt Weitzmann, *The Monastery of Saint Catherine at Mount Sinai: The Icons* (Princeton, 1976), I, p. 63.

25 Quoted in Schiller, *Iconography of Christian Art*, p. 98; see also John R. Martin, 'The Dead Christ on the Cross in Byzantine Art', in *Late Classical and Medieval Studies in Honor of Albert Mathias Friend, Jr*, ed. K. Weitzmann (Princeton, 1955), p. 196; and Hans Belting, *Likeness and Presence: A History of the Image in the Era Before Art*, trans. E. Jephcott (Chicago and London, 1994), p. 270.

26 Quoted and discussed in John Williams, *The Illustrated Beatus. A Corpus of the Illustrations of the Commentary on the Apocalypse, vol. II: Ninth and Tenth Centuries* (New York, 1994), pp. 51–6. See also *The Art of Medieval Spain AD 500–1200*, exh. cat.; The Metropolitan Museum of Art, New York (1993), cat. no. 80, pp. 156–7.

27 See the detailed explication of the page in Marcia Carole Cohn Growden, 'The Narrative Sequence in the Preface to the Gerona Commentaries of Beatus on the Apocalypse', doctoral dissertation, Stanford University, 1976, pp. 91–111.

28 Angers, Bibliothèque Municipale, Cod. 24, fol. 8; reproduced in Schiller, *Iconography of Christian Art*, II, no. 390. For further references, see Growden, 'The Narrative Sequence', p. 121, n. 78.

29 *Ibid.*, p. 116. For the various theories of an Ottonian transmission of Byzantine models, see Jacques Bousquet, 'A propos d'un tympans de Saint-Pons: la place des larrons dans la Crucifixion', *Cahiers de Saint-Michel-de-Cuxa*, XIII (1997), pp. 25–54.

30 See James H. Stubblebine, 'Byzantine Sources for the Iconography of Duccio's *Maestà*', *Art Bulletin*, LVII/2 (June 1975), pp. 176–85, which proposes a late-thirteenth-century manuscript prototype; for the history and civic significance of the altar, see Belting, *Likeness and Presence*, pp. 404–8.

31 See *Art and the Courts: France and England from 1259 to 1328*, exh. cat. ed. by Philippe Verdier, Peter Brieger and Marie Farquhar Montpetit; The National Gallery of Canada, Ottawa (1972), II, cat. no. 12.

32 See Roth, *Der Volkreiche Kalvarienberg*, pp. 68ff.

33 For a review of the entire iconographic programme, see Hiller and Vey, *Katalog der deutschen und niederländischen Gemälde bis 1550. . .*, pp. 142–4.

34 See Bridget Corley, *Conrad von Soest: Painter Among Merchant Princes* (London, 1996), p. 105; the independence of the rod from the cross is easier to see in the Osnabrück altar than in Conrad von Soest's *Niederwildungen Altar*. Panofsky, who also perceived its Westphalian origins, called the device an 'iron bar', and espied it in the *Crucifixion* miniatures of the so-called *Arenberg Hours* (*c.* 1435, Arenberg Coll., Nordkirchen) and John Siferwas's version from the *Sherbourne Missal* (*c.* 1400–07, British Library, Loan MS 82, p. 380); see Panofsky, *Early Netherlandish Painting*, pp. 118, 176, 404, n. 4, 427, n. 6, for numerous other citations.

35 The most up-to-date treatment is Corley, *Conrad von Soest*, pp. 183–93.

36 Charles Cuttler, *Northern Painting from Pucelle to Bruegel* (New York, 1968), p. 58.

37 Following F. P. Pickering, Corley, *Conrad von Soest*, p. 104, reads the arched body of Conrad's Christ in terms of the Old Testament symbolism of King David's harp: 'this noble bow, His holy body, bent by derision, drawn by insult, was stretched by "affixiones" on the cross for our salvation' (Gotfried of Admont).

38 Not having discerned the precedents, Corley writes apologetically, 'Conrad's actors seem to be a little muddled over their dramatic instructions, for the repenting Dismas has his soul carried away by the devil' (*ibid.*, p. 105).

39 Most likely trained in the lower Rhine or Westphalia, the artist was later active in Augsburg and is named after the panel there, originally from the city's Kloster Kasheim. On the Augsburg panel, see Theodor Musper, *Altdeutsche Malerei* (Cologne, 1970), p. 128; on the Cologne panel, see Hiller and Vey, *Katalog der deutschen und niederländischen Gemälde bis 1550. . .*, pp. 94–5. Both works are roughly the same size: 142.7 x 121.2 cm (Augsburg) versus 151 x 118 cm (Cologne).

40 Originally made for the high altar of the Marian Stiftskirche in Herrenberg. The literature on the altarpiece is large; for an overview, see Peter Beye, *Staatsgalerie Stuttgart* (Recklinghausen, 1984), p. 68.

41 Otto Benesch, *The Art of the Renaissance in Northern Europe: Its Relation to the Contemporary Spiritual and Intellectual Movements*, rev. edn (London, 1965), p. 42.

42 Reproduced in Ruth Mellinkoff, *Outcasts: Signs of Otherness in Northern European Art of the Late Middle Ages* (Berkeley, 1993), II, pl. III.41; for other Westphalian works bearing this motif, see Corley, *Conrad von Soest*, p. 105, as well as her cat. no. 10; also Alfred Stange, *Deutsche Malerei der Gotik* (Munich and Berlin, 1938), III, no. 41 and (1954), VI, nos 31, 32, 51, 63. A *Calvary* by Derick Baegart from the Propsteitkirche in Dortmund (*c.* 1470–75) also exhibits the motif; see Isolde Lübbeke, *Early German Painting: 1350–1550*, trans. M. T. Will (London, 1991), p. 127, illus. 2.

43 Corley, *Conrad von Soest*, p. 105.

44 The earliest instance of this is in the Catalonian Bible from the Abbey of Farfa (eleventh century); see Schiller, *Iconography of Christian Art*, illus. 391. In the fifteenth century the Master of the Tegernsee Tabula Magna showed an executioner at work on the legs of a Thief with a hatchet; see his *Calvary*, reproduced in *Alte Pinakothek Munich* (Munich, 1986), pp. 340–42.

45 Discussed in Pieter Spierenburg, *The Spectacle of Suffering: Executions and the Evolution of Repression* (Cambridge, 1984), p. 73.

46 Gustav Radbruch, 'Ars moriendi. Scharfrichter–Seelsorger–Armer Sünder–Volk', *Schweizerische Zeitschrift für Strafrecht*, LIX (1945), p. 493, quoted in Richard van Dülmen, *Theatre of Horror: Crime and Punishment in Early Modern Germany*, trans. E. Neu (Cambridge, 1990), p. 121.

47 See *ibid.*, p. 120, which stresses freedom from disease as the basis for the effectiveness of such relics for healing purposes.

48 Richard J. Evans, *Rituals of Retribution: Capital Punishment in Germany, 1600–1987* (Oxford, 1996), p. 95.

49 Hewitt, 'The Use of Nails in the Crucifixion', p. 42; for the passage concerning Erichtho's demonic collecting, see Lucan Pharsalia, *Dramatic Episodes of the Civil Wars*, trans. R. Graves (London, 1961), Book VI, verses 541–6 (p. 118); on the distinction between natural and demonic magic, see Richard Kieckhefer, *Magic in the Middle Ages* (Cambridge, 1990), pp. 8–17.

50 Pliny the Elder, *The Natural History of Pliny*, trans. J. Bostock and H. T. Riley (London, 1900), V, Book xxviii, ch. II (p. 293).

51 Quoted in Dülmen, *Theatre of Horror*, pp. 120–21.

52 Ann Derbes discusses the importance of the rope around Christ's neck (a standard motif in scenes of the *Way to Calvary*) in Franciscan iconography and ideology: *Picturing the Passion in Late Medieval Italy: Narrative Painting, Franciscan Ideologies, and the Levant* (Cambridge, 1996), pp. 134–5.

53 See also an upper Bavarian work from the Church of Oberbergkirchen bei Mühldorf, in which the Good Thief is totally immobilized against the *stipes* with ropes; reproduced in Stange, *Deutsche Malerei der Gotik* (Munich and Berlin, 1960), X, no. 50.

3 *The Broken Body as Spectacle*

1 William Ian Miller, *The Anatomy of Disgust* (Cambridge, Mass., 1997), p. 82.

2 See James Elkins, *The Object Stares Back: On the Nature of Seeing* (San Diego, 1996), especially pp. 101–24.

3 *Meditations on the Life of Christ: An Illustrated Manuscript of the Fourteenth Century*, eds I. Ragusa and R. B. Green (Princeton, 1961), p. 74, quoted in Thomas Bestul, *Texts of the Passion: Latin Devotional Literature and Medieval Society* (Philadelphia, 1996), p. 49.

4 From 'Sermon 62', in *Bernard of Clairvaux: Selected Works*, trans. G. R. Evans (New York, 1987), pp. 250–51; quoted and discussed in Gerard S. Sloyan, *The Crucifixion of Jesus: History, Myth, Faith* (Minneapolis, 1995), p. 135.

5 Martin Kemp, 'Introduction: The Altarpiece in the Renaissance: A Taxonomic Approach', in *The Altarpiece in the Renaissance*, eds P. Humphrey and M. Kemp (Cambridge, 1994), p. 4.

6 Leon Wieseltier, 'Close Encounters of the Nazi Kind', *New Republic* (24 January 1994), p. 42.

7 Miller, *The Anatomy of Disgust*, p. 58.

8 Julia Kristeva, *Powers of Horror: An Essay on Abjection*, trans. L. S. Roudiez (New York, 1982), p. 3: emphasis in original.

9 On the panel's reverse side is a grisaille figure of John the Baptist in a niche and under a baldachin.

10 Robert Herrlinger, 'Zur Frage der ersten anatomisch richtigen Darstellung des menschlichen Körpers in der Malerei', *Centaurus*, II (1953), p. 288.

11 Since the recognition of a connection between the Flémallesque Frankfurt fragment and the triptych in Liverpool by Martin W. Conway in 1882 ('A picture by Roger van der Weyden and one by Dierick Bouts', *Academy* [1882], pp. 212ff.), numerous scholars have used the comparison as a touchstone for reconstruction; for a survey of scholarship, the most up-to-date technical information and complete bibliography, see Jochen Sander, *Niederländische Gemälde im Städel, 1400–1550* (Mainz am Rhein, 1993), pp. 129–53.

12 Herrlinger, 'Zur Frage der ersten anatomisch richtigen Darstellung. . .', p. 286.

13 See Samuel Y. Edgerton, *Pictures and Punishment: Art and Criminal Prosecution during the Florentine Renaissance* (Ithaca, 1985), p. 157; on Leonardo's special dispensation to dissect cadavers for anatomical research, see Katharine Park, 'The Criminal and the Saintly Body: Autopsy and Dissection in Renaissance Italy', *Renaissance Quarterly*, XLVII/1 (Spring 1994), p. 16, with further references; on the evidence that Leonardo conducted studies specifically directed towards understanding the anatomical requirements and effects of crucifixion, see Lynn Picknett and Clive Prince, *Turin Shroud: In Whose Image?* (New York, 1994), p. 83.

14 See Richard J. Evans, *Rituals of Retribution: Capital Punishment in Germany, 1600–1987* (Oxford, 1996), pp. 88–9, with further bibliography; Park, however, argues that in fifteenth-century Italy what placed people at risk for being dissected was not their status as judicial victims so much as being poor foreigners without relatives nearby to claim their bodies ('The Criminal and the Saintly Body', p. 12).

15 Edgerton wrongly imputes to Herrlinger the notion that Campin 'took as his model some poor victim actually broken on the wheel in the artist's own community' (*Pictures and Punishment*, p. 136, n. 15); Lionello Puppi, *Torment in Art: Pain, Violence, Martyrdom* (New York, 1991), p. 67. n. 254, implies the same.

16 Herrlinger, 'Zur Frage der ersten anatomisch richtigen Darstellung. . .', p. 286.

17 The Crucifixion is the obverse of a panel that once belonged to a larger altarpiece; on the reverse is the *Death of the Virgin*: see Jan Lauts, *Staatliche Kunsthalle Karlsruhe: Katalog alte Meister bis 1800* (Karlsruhe, 1966), II, pp. 199–200.

18 For basic information, see Alfred Stange, *Deutsche Malerei der Gotik* (Nendeln/Liechtenstein, 1969), VIII, pp. 119–24.

19 Quoted in Pierre Barbet, *A Doctor on Calvary: The Passion of Our Lord Jesus Christ as Described by a Surgeon*, trans. the Earl of Wicklow (New York, 1963), p. 84. The procedure is also mentioned, according to the author, in Seneca and Ammianus Marcellinus.

20 *Ibid.*, pp. 82–3.

21 In the Passion narratives of the period, Christ's joints are typically pulled apart (see Psalm 22: 14), his veins burst and so on, but the key point here is that none of the nuanced litanies of specific tortures included the *breaking* of individual bones; see Bestul, *Texts of the Passion*, pp. 44–7. What is more, the evocation of dislocated joints in the literary tradition is not matched in the visual; major deformations of the body *as a whole*, like the breaking of bones, are reserved for the Thieves.

22 Formerly in the collection of Richard von Kaufmann, from whom it derives its name, *Kaufmannsche Kreuzigung*. On the importance of the panel, see Elisabeth Roth, *Der Volkreiche Kalvarienberg in Literatur und Kunst des Spätmittelalters* (Berlin, 1958), pp. 66–8, 73.

23 On Bolognese influence, see Wilhelm H. Köhler, *Masterworks of the Gemäldegalerie, Berlin* (New York, 1986), p. 46; on the multiple streams of Italian

influence in Bohemian art in general, see Roth, *Der Volkreiche Kalvarienberg*, p. 73; on the Prague missal (Vienna, Nationalbibliothek, MS Nr 1844), see Stange, *Deutsche Malerei der Gotik* (Nedeln/Liechtenstein, 1969), IX, no. 254.

24 The two painted panels (the other is an *Ascension of Christ*) were originally wings for a carved shrine in the middle, depicting the *Coronation of the Virgin*; see Lauts, *Staatliche Kunsthalle Karlsruhe*, pp. 194–5.

25 See Stange, *Deutsche Malerei der Gotik*, (Munich and Berlin, 1960), X p. 57.

26 A sixteenth-century *Crucifixion* panel, now in Prague, suggests that the Munich master's bent-forwards type may also, like the arched-back pose, have its roots in Austrian art; reproduced in Ruth Mellinkoff, *Outcasts: Signs of Otherness in Northern European Art of the Late Middle Ages* (Berkeley, 1993), II, pl. VII.28.

27 Edgerton: 'Flemish artists of the fifteenth century . . . frequently showed the two accompanying thieves . . . in attitudes clearly derived from the contemporary northern European punishment of the "wheel"' (p. 190). Of the Thief's body in a Dutch *Calvary* in Berlin, Puppi: 'This detail seems to be a recollection of manual quartering or of executions by the wheel . . . the two thieves are represented as being broken alive'; he repeats the formulation in his discussion of Rubens's *Christ Pierced with a Lance* in Munich (p. 137).

28 The phrase belongs to A. Matéjcek, *Gotische Malerei in Böhmen* (Prague, 1939), cited in Roth, *Der Volkreiche Kalvarienberg*, p. 66.

4 *Pain and Spectacle: Rituals of Punishment in Late Medieval Europe*

1 From *Wohlverdientes Todesurteil nebst einer Moralrede des Matthias Weiser* (Munich, 1771); quoted in Richard van Dülmen, *Theatre of Horror: Crime and Punishment in Early Modern Germany*, trans. E. Neu (Cambridge, 1990), p. 125.

2 Jean Delumeau, *Sin and Fear: The Emergence of a Western Guilt Culture, 13th–18th Centuries*, trans. E. Nicholson (New York, 1990), p. 97.

3 *Über die Gewohnheit, Missethäter durch Prediger zur Hinrichtung begleiten zu lassen* (Hamburg, 1784), pp. 1–15; quoted in Richard J. Evans, *Rituals of Retribution: Capital Punishment in Germany, 1600–1987* (Oxford, 1996), p. 125.

4 Anon., *Auch etwas über die Gewohnheit, Missethäter durch Prediger zur Hinrichtung begleiten zu lassen* (Hamburg, 1784), p. 33, quoted *ibid.*

5 Esther Cohen, *The Crossroads of Justice: Law and Culture in Late Medieval France* (Leiden, 1993), p. 202.

6 *Ibid.*, p. 11.

7 Harold Berman, *Law and Revolution: The Formation of the Western Legal Tradition* (Cambridge, Mass., 1983), p. 76.

8 Andrew McCall, *The Medieval Underworld* (London, 1979), p. 51.

9 See Harold Dexter Hazeltine, 'Roman and Canon Law in the Middle Ages', in *Cambridge Medieval History* (Cambridge, 1926), V, pp. 753–6.

10 *Brandenburgische halszgerichts ordnung* (Nuremberg: Jobst Gutknecht, 1516); on Albrecht's political agenda, see Steven Ozment, *The Age of Reform 1250–1550: An Intellectual and Religious History of Late Medieval and Reformation Europe* (New Haven and London, 1980), p. 251.

11 Dülmen, *Theatre of Horror*, p. 129. Despite their penchant for classical culture, humanists like Ulrich von Hutten deplored the benefits neo-Roman law imparted to the territorial and urban magnates; for the sixteenth century, see Gerald Strauss, *Law, Resistance and the State: The Opposition to Roman Law in Reformation Germany* (Princeton, 1986).

12 Cohen, *The Crossroads of Justice*, p. 202.

13 *Ibid.*, p. 181.

14 See Esther Cohen, 'Symbols of Culpability and the Universal Language of Justice: The Ritual of Public Executions in Late Medieval Europe', *History of European Ideas*, XI (1989), p. 409.

15 Evans, *Rituals of Retribution*, p. 37.

16 See Dülmen, *Theatre of Horror*, pp. 34–9.

17 See Edward Peters, *Torture* (New York, 1985), pp. 41–4.

18 Dülmen, *Theatre of Horror*, p. 37.

19 John 19: 5; see also Matthew 27: 21–5; Mark 15: 8–14; Luke 23: 17–24.

20 For catalogue information, see *Stadt im Wandel: Kunst und Kultur des Bürgertums in Norddeutschland 1150–1650*, exh. cat. ed. by Cord Meckseper; Herzog Ulrich-Anton-Museum, Braunschweig (Stuttgart, 1985), cat. no. 118; for the many inscriptions on the panel, see A. Boockmann, ed., *Die Inschriften der Stadt Braunschweig bis 1528* (Wiesbaden, 1993), pp. 199–202.

21 Dülmen, *Theatre of Horror*, p. 37.

22 Cohen, *The Crossroads of Justice*, p. 207.

23 See Esther Cohen, '"To Die a Criminal for the Public Good": The Execution Ritual in Late Medieval Paris', in *Law, Custom, and the Social Fabric in Medieval Europe: Essays in Honor of Bruce Lyon*, eds B. S. Bachrach and D. Nicholas (Kalamazoo, 1990), p. 286.

24 Susan Jacoby makes this point at the beginning of her book *Wild Justice: The Evolution of Revenge* (New York, 1983).

25 Quoted in Berman, *Law and Revolution*, p. 54.

26 McCall, *The Medieval Underworld*, p. 47.

27 Michel Foucault, *Discipline and Punish: The Birth of the Prison*, trans. A. Sheridan (New York, 1979), pp. 53–4.

28 For costs and executioner's fees, see Evans, *Rituals of Retribution*, pp. 62–3, and Cohen, *The Crossroads of Justice*, p. 160.

29 See Dülmen, *Theatre of Horror*, p. 4, for the belief that punishment was aimed primarily at the deed, not the offender.

30 E. P. Evans, *The Criminal Prosecution and Capital Punishment of Animals* (London, 1906; repr. 1987), p. 143.

31 See McCall, *The Medieval Underworld*, p. 49.

32 See Cohen, *The Crossroads of Justice*, p. 142; on the larger question of the execution of corpses, *ibid.*, pp. 134–45.

33 Tengler's *Layenspiegel* appeared in at least seventeen editions, printed by altogether eight different print shops in Augsburg and Straßburg, between 1509 and 1560. For background and extensive references, see Kristin Eldyss Sorensen Zapalac, *'In His Image and Likeness': Political Iconography and Religious Change in Regensburg, 1500–1600* (Ithaca and London, 1990), p. 195, n. 10.

34 Quoted in Dülmen, *Theatre of Horror*, p. 92.

35 See Cohen, 'Symbols of Culpability and the Universal Language of Justice', p. 412; also the excellent study by Paul Barber, *Vampires, Burial and Death* (New Haven, 1988).

36 From the *Constitutio Criminalis Theresiana*, promulgated in 1769 by Maria Theresa, the Austrian empress (1740–80), quoted in Dülmen, *Theatre of Horror*, p. 113.

37 Cohen, 'Symbols of Culpability', p. 410.

38 Richard J. Evans, *Rituals of Retribution*, p. 72.

39 *Ibid.*, p. 73.

40 Cohen, 'Symbols of Culpability', p. 410.

41 Cohen, *The Crossroads of Justice*, pp. 170–71.

42 Dülmen, *Theatre of Horror*, p. 75; Richard J. Evans, *Rituals of Retribution*, p. 75.

Evans also explains (pp. 103–7) that the 'Bakhtinian' reading of execution rituals applies better to the situations in England and France, for which, respectively, see Thomas W. Laqueur, 'Crowds, Carnival and the State in English Executions, 1604–1868', in *The First Modern Society: Essays in English History in Honour of Lawrence Stone*, eds A. L. Bier, D. Cannadine and J. M. Rosenheim (Cambridge, 1989), pp. 305–55, and Foucault, *Discipline and Punish*, pp. 59–62.

43 Quoted in Dülmen, *Theatre of Horror*, p. 96; see the closely related formula quoted in Cohen, 'Symbols of Culpability', p. 411.

44 Helen Prejean points out the error made by death-penalty advocates in their standard exegesis of Exodus (21: 22–5). Instead of *stipulating* that a principle of equivalence determine the degree of vengeance, 'the punishment is to be measured out according to the seriousness of the offense . . . *Only* an eye for an eye, *only* a life for a life is the intent of this passage' (*Dead Man Walking: An Eyewitness Account of the Death Penalty in the United States* [New York, 1993], p. 194).

45 Quoted in Cohen, *The Crossroads of Justice*, p. 158.

46 Quoted in Cohen, '"To Die a Criminal for the Public Good"', pp. 297–8; see also *idem.*, *The Crossroads of Justice*, p. 147.

47 Richard J. Evans, *Rituals of Retribution*, p. 72.

48 See Cohen, *The Crossroads of Justice*, pp. 174–5, for the full text.

49 Cohen, 'Symbols of Culpability', p. 410.

50 Hans von Hentig, *Punishment: Its Origins, Purpose and Psychology* (London, 1937), pp. 52–8; Graeme Newman, *The Punishment Response* (Philadelphia, 1978), p. 37; see also Rudolf Glanz, 'The "Jewish Execution" in Medieval Germany', *Jewish Social Studies*, v (1943), pp. 3–26, where the significant element in the hanging of a thief is that 'the earth can bear him no longer' (p. 6).

51 One can trace a line of descent from the pioneering work of the German folklorist Karl von Amira (*Die germanische Todestrafen. Untersuchungen zur Rechts- und Religionsgeschichte* (Abhandlungen der Bayerische Akademie der Wissenschaften, Philosophische-philologische und historische Klasse, 31), III (Munich, 1922), through the widely translated work of his student von Hentig, to many of today's histories of capital punishment; for its exemplary indebtedness, see Newman, *The Punishment Response*, pp. 27–51.

52 Bernhard Rehfeldt, *Todesstrafen und Bekehrungsgeschichte. Zur Rechts- und Religionsgeschichte der germanischen Hinrichtungsbräuche* (Berlin, 1942), pp. 165–6; cited and discussed in Richard J. Evans, *Rituals of Retribution*, pp. 3–7.

53 *Ibid.*, p. 7.

54 Dülmen, *Theatre of Horror*, p. 79.

55 Richard J. Evans, *Rituals of Retribution*, p. 55; on honourable and dishonourable penalties, see also Mitchell Merback, 'Lucas Cranach the Elder's *Martyrdom of the Twelve Apostles*: Punishment, Penal Themes and Spectacle in his Early Graphic Art', doctoral dissertation, University of Chicago, 1995, especially pp. 267–79.

56 Cohen, *The Crossroads of Justice*, p. 75

57 On executioners' dress in late medieval art, see Merback, 'Lucas Cranach the Elder's *Martyrdom of the Twelve Apostles*', pp. 351–6; see also Ruth Mellinkoff, *Outcasts: Signs of Otherness in Northern European Art of the Late Middle Ages* (Berkeley, 1993), I, pp. 24–8.

58 Richard J. Evans, *Rituals of Retribution*, p. 86.

59 Philippe Ariès, *The Hour of Our Death*, trans. H. Weaver (New York, 1981), p. 107.

60 See Arthur M. Hind, *An Introduction to a History of Woodcut* (New York, 1963), I, pp. 224–30, with table of major editions on pp. 224–5. For the text of the

anonymous booklet of *c*. 1430–35, see John Shinners, ed. *Medieval Popular Religion, 1000–1500: A Reader* (Peterborough, Ontario, 1997), pp. 525–35.

61 See the account in Richard J. Evans, *Rituals of Retribution*, p. 66.

62 *Ibid.*, p. 37.

63 *Ibid.*, p. 85–6.

64 Arlette Farge, *Fragile Lives: Violence, Power and Solidarity in Eighteenth-century Paris*, trans. C. Shelton (Cambridge, Mass., 1993), p. 179, which paraphrases the argument of Michel Bée, 'La Spectacle de l'exécution dans la France d'Ancien Régime', *Annales ESC*, XXXVIII/4 (July–August 1983), pp. 843–62.

65 Pieter Spierenburg, *The Spectacle of Suffering: Executions and the Evolution of Repression* (Cambridge, 1984), p. 85.

66 Dülmen, *Theatre of Horror*, p. 60.

67 Cohen, *The Crossroads of Justice*, pp. 163–4; also Dülmen, *Theatre of Horror*, p. 53.

68 Johan Huizinga, *The Waning of the Middle Ages* (Garden City, NY, 1954), p. 25.

69 C. V. Calvert, 'Introduction', in *A Hangman's Diary, Being the Journal of Master Franz Schmidt, Public Executioner of Nuremberg, 1573–1617*, ed. A. Keller, trans. C. V. Calvert and A. W. Gruner (London, 1929, repr. Montclair, NJ, 1973), p. 54.

70 See Samuel Y. Edgerton, *Pictures and Punishment: Art and Criminal Prosecution during the Florentine Renaissance* (Ithaca, 1985), pp. 165ff. The Roman group constructed its own oratory between the mid-1530s and mid-1550s, the complex decorative cycle of which has been studied by Jean S. Weisz, *Pittura e Misericordia: The Oratory of S. Giovanni Decollato in Rome* (Ann Arbor, 1982).

71 Cohen, *The Crossroads of Justice*, p. 195.

72 See *ibid.*, pp. 198–9

73 *Ibid.*, p. 200.

74 Alain de Lille, *Liber Poenitentialis*, ed. Jean Longré (Louvain, 1965), II, pp. 141–2, quoted in Esther Cohen, 'Towards a History of European Sensibility: Pain in the Later Middle Ages', *Science in Context*, XIII/1 (1995), p. 66.

75 Jan Ruysbroeck, 'De vera contemplatione', in *Opera Omnia*, trans. L. Surius (Cologne, 1552), p. 508, quoted *ibid.*, p. 65.

76 Quoted in Theodor Hampe, *Crime and Punishment in Germany: As Illustrated by the Nuremberg Malefactors' Books*, trans. M. Letts (New York, 1929), p. 78.

77 Caroline Walker Bynum, 'The Body of Christ in the Later Middle Ages: A Reply to Leo Steinberg', in *Fragmentation and Redemption: Essays on Gender and the Human Body in Medieval Religion* (New York, 1992), p. 92.

78 For a refutation of the theory that human pain sensitivity has evolved independently of changing attitudes towards the pain experience, see Daniel de Moulin, 'A Historical-phenomenological Study of Bodily Pain in Western Man', *Bulletin of the History of Medicine*, XLVIII/4 (Winter 1974), pp. 540–70.

79 Cohen, 'Towards a History of European Sensibility', pp. 47–74.

80 Richard Kieckhefer, *Unquiet Souls: Fourteenth-century Saints and Their Religious Milieu* (Chicago, 1984), p. 89; see also Karma Lochrie, *Margery Kempe and Translations of the Flesh* (Philadelphia, 1991), pp. 27–47.

81 For all three quotations, see Otto G. von Simson, '*Compassio* and *Co-redemptio* in Roger van der Weyden's *Descent from the Cross*', *Art Bulletin*, XXXV (1953), p. 13.

82 Dülmen, *Theatre of Horror*, p. 120.

83 Quoted in Huizinga, *The Waning of the Middle Ages*, pp. 11–12.

84 Quoted in Bée, 'La Spectacle de l'exécution dans la France d'Ancien Régime', pp. 850–51, English translation in Lionello Puppi, *Torment in Art: Pain, Violence, Martyrdom* (New York, 1991), p. 54.

85 Dülmen, *Theatre of Horror*, pp. 60–61.

86 On the relationship between riots and executions, see Spierenburg, *The Spectacle of Suffering*, pp. 100–09.

87 Anon., *Des bekannten Diebes, Mörders und Räubers Lips Tullians, und seiner Complicen Leben und Übelthaten* ... (Dresden, 1716), discussed in Richard J. Evans, *Rituals of Retribution*, p. 97.

88 Translation from *ibid.*

89 *Ibid.*, p. 73.

90 Quoted from O. F. Breibeck, *Ertz-Malefikanten. Wilddiebe, Räuber, Mordbanditen* (Regensburg, 1977), p. 80, translation from Dülmen, *Theatre of Horror*, p. 171, n. 4.

91 *Bambergerische halsgerichts und Rechtlich ordnung* ... (Mainz: Johann Schöffern, 1531), fol. 18v.

92 Translation from Cohen, 'Symbols of Culpability', p. 409.

93 See Jacques LeGoff, *The Birth of Purgatory*, trans. A. Goldhammer (Chicago, 1981), especially pp. 209–34.

94 Berman, *Law and Revolution*, p. 171.

95 LeGoff, *The Birth of Purgatory*, p. 6.

96 See Monika K. Hellwig, 'The Life of the World to Come', in *The Human Condition in the Jewish and Christian Traditions*, ed. F. E. Greenspahn (Hoboken, 1986), p. 215; both Edgerton (*Pictures and Punishment*, p. 16) and Dülmen (*Theatre of Horror*, p. 120) give this theological idea currency in the judicial context.

97 See Benedicta Ward, *Miracles and the Medieval Mind: Theory, Record and Event, 1000–1215* (Philadelphia, 1987), pp. 20–32.

98 Bée, 'La Spectacle de l'exécution dans la France d'Ancien Régime', p. 851, translation in Puppi, *Torment in Art*, p. 54.

99 Foucault, *Discipline and Punish*, p. 46.

100 Umberto Eco, *Art and Beauty in the Middle Ages*, trans. H. Bredin (New Haven, 1986), p. 9.

5 *The Wheel: Symbol, Image, Screen*

1 Quoted in Lionello Puppi, *Torment in Art: Pain, Violence, Martyrdom* (New York, 1991), p. 16; for the original Italian, see André Chastel, ed., *Luigi d'Aragona: un cardinale del Rinascimento in viaggio per l'Europa* (Rome, 1987), p. 209.

2 For the most reliable general accounts of the wheel, see Richard van Dülmen, *Theatre of Horror: Crime and Punishment in Early Modern Germany*, trans. E. Neu (Cambridge, 1990), pp. 92–6; Pieter Spierenburg, *The Spectacle of Suffering: Executions and the Evolution of Repression* (Cambridge, 1984), pp. 71–3; and Wolfgang Schild, *Alte Gerichtsbarkeit: Vom Gottesurteil bis zum Beginn der modernen Rechtsprechung* (Munich, 1980), pp. 202–4.

3 See Dülmen, *Theatre of Horror*, p. 85; on the deterrent effect of the wheel, p. 130.

4 For example, Robert Held, *Inquisition / Inquisicion: Torture Instruments from the Middle Ages to the Industrial Era*, exh. cat. (Florence, 1985), p. 42.

5 Dülmen, *Theatre of Horror*, pp. 83, 139–41, for statistics on several German towns; see also Richard J. Evans, *Rituals of Retribution: Capital Punishment in Germany, 1600–1987* (Oxford, 1996), p. 42; for declining rates in France after 1700, see John McManners, *Death and the Enlightenment: Changing Attitudes to Death among Christians and Unbelivers in Eighteenth-century France* (Oxford, 1981), p. 369.

6 See Lynn White Jr, 'The Legacy of the Middle Ages in the American Wild West', *Speculum*, XL (1965), pp. 191–201.

7 See also illus. 45 in Chapter 4, from the same manuscript.

8 Decapitations often took place in the marketplace, immediately in front of the town hall, whereas ignoble punishments like the wheel and hangings were generally conducted outside the town walls.

9 Dülmen, *Theatre of Horror*, p. 95; also see Hans von Hentig, *Punishment: Its Origins, Purpose and Psychology* (London, 1937), p. 49, which specifies that the wheel must have nine or ten spokes.

10 See Spierenburg, *The Spectacle of Suffering*, pp. 71–2, on Amsterdam, which explains that even when the wheel was replaced by an iron bar, the name of breaking with the wheel (*radbraken*) continued to be used.

11 Dülman, *Theatre of Horror*, p. 95.

12 *Ibid.* Spierenburg sees Maria Theresa's insistence that the magistrates of Brussels practise secret strangling (1776) as a clear sign of the 'mentality of a new age' (*The Spectacle of Suffering*, p. 73); on 'secret strangling' in the Prussian Enlightenment, see Evans, *Rituals of Retribution*, pp. 121–6.

13 *Trewlicher Bericht eynes scröcklichen Kindermords beym Hexensabath . . .*, broadsheet published in Hamburg, 12 June 1607, quoted in Held, *Inquisition*, p. 42.

14 From the chronicles of St Gallen, cited in Dülman, *Theatre of Horror*, p. 95.

15 See Franz Heinemann, *Der Richter und die Rechtsgelehrten: Justiz in früheren Zeiten* (Leipzig, 1900; repr. in facsimile, 1969), pp. 108–10.

16 Edgar Wind, 'The Criminal-God' and 'The Crucifixion of Haman', *Journal of the Warburg and Courtauld Institutes*, I (1937–8), p. 244.

17 Discussed in Evans, *Rituals of Retribution*, pp. 4–5; see Hentig, *Punishment*, pp. 50–51; and Karl von Amira, *Die germanische Todestrafen. Untersuchungen zur Rechts- und Religionsgeschichte* (Abhandlungen der Bayerische Akademie der Wissenschaften. Philosophische-philologische und historische Klasse, 31), III (Munich, 1922), pp. 204ff.

18 See Robert Graves, *The Greek Myths* (Harmondsworth, 1960), I, pp. 208, 219.

19 Erwin Roos, 'Das Rad als Folter- und Hinrichtungswerkzeug in Altertum', *Opuscula Archaeologica, Proceedings from the Swedish Institute in Rome* (Lund, 1952), pp. 87–104.

20 Spierenburg, *The Spectacle of Suffering*, p. 71; also see F. de Witt Huberts, *De Beul en z'n werk* (Amsterdam, 1937), p. 113, cited in Puppi, *Torment in Art*, p. 61, n. 41.

21 Wind, 'The Criminal-God' and 'The Crucifixion of Haman', p. 248.

22 See Evans, *Rituals of Retribution*, p. 4.

23 See *ibid.*, pp. 3–5.

24 *The Golden Legend of Jacobus de Voragine*, trans. G. Ryan and H. Ripperger (London, 1993), p. 711.

25 See Otto Demus, *Romanesque Mural Painting* (New York, 1970), p. 420 and colour plate 142; the accompanying scenes in which flesh is torn from the bodies of the saints with hooks are reproduced in Andreas Petzold, *Romanesque Art* (Englewood Cliffs, NJ, 1995), fig. 41; and in Puppi, *Torment in Art*, illus. 1.

26 Demus proposes an illustrated *vita* of the two Poitevin saints, Savinus and Cyprian, similiar to the *Vie de Saint Radegonde* (Poitiers, Bibl. de la Ville, MS 250), as an iconographic source (*Romanesque Mural Painting*, p. 422).

27 The first Italian edition was titled *Trattato degli instrumenti di martirio – usale da gentili contro Christiani* (Rome, 1591); later it was translated into Latin and published under the title *De sanctorum martyrum cruciatibus . . .* (Paris: Claudium Cramoisy, 1660); for the English translation, see *Tortures and Torments of the Christian Martyrs*, trans. A. R. Allinson (Paris, n.d.); the complete set of 47 plates from the first edition are reproduced in *The Illustrated Bartsch* (New York, 1978–), XXXV, pp. 489–544.

28 See Puppi, *Torment in Art*, pp. 55–6.

29 Roos, 'Das Rad als Folter- und Hinrichtungswenkzeug in Alterum', p. 87.

30 *Ibid.*, pp. 88, 104.

31 For basic information, Dénes Radocsay, *Gothic Panel Painting in Hungary*, trans. G. Dienes (Budapest, 1963), pp. 24–5, 51–2; on the hagiographical legend of the 'three pilgrims', see Guy Terverant, *Les Énigmes de l'art du Moyen Age* (Paris, 1938), I, pp. 15–16.

32 A similar stick was part of the equipment that went along with garrottes, or strangling-poles (see Spierenburg, *The Spectacle of Suffering*, p. 71).

33 Richard Kieckhefer, *Unquiet Souls: Fourteenth-century Saints and Their Religious Milieu* (Chicago, 1984), p. 13.

34 Ernst Kitzinger, 'World Map and Fortune's Wheel: A Medieval Mosaic Floor in Turin', in *The Art of Byzantium and the Medieval West: Selected Studies* (Bloomington and London, 1976), p. 345.

35 *Ibid.*, p. 363.

36 The drawing in the sketchbook of Villard de Honnecourt (first half of thirteenth century) is of this type; see H. R. Hahnloser, *Villard de Honnecourt* (Vienna, 1935), pl. 42 and pp. 127ff., cited in *ibid.*, p. 364, n. 133.

37 See *ibid.*, p. 363 and n. 132.

38 Marcia Kupfer, 'The Lost Wheel Map of Ambrogio Lorenzetti', *Art Bulletin*, LXXVIII/2 (June 1996), p. 305.

39 Kitzinger, 'World Map and Fortune's Wheel', p. 367.

40 Jean Delumeau, *Sin and Fear: The Emergence of a Western Guilt Culture, 13th–18th Centuries*, trans. E. Nicholson (New York, 1990), p. 238.

41 See Wolfgang Harms, 'Reinhart Fuchs als Papst und Antichrist auf dem Rad der Fortuna', in *Frühmittelalterliche Studien*, VI (1972), pp. 418–40; *Martin Luther und die Reformation in Deutschland: Austellung zum 500. Geburtstag Martin Luthers*, exh. cat.; Germanisches Nationalmuseum, Nuremberg (Frankfurt am Main, 1983), cat. no. 288, pp. 229–30; and Robert W. Scribner, *For the Sake of the Simple Folk: Popular Propaganda for the German Reformation* (Cambridge, 1981), pp. 119–21.

42 See the panel by the Master of the Parlement de Paris (Malibu, J. Paul Getty Museum), reproduced in Ruth Mellinkoff, *Outcasts: Signs of Otherness in Northern European Art of the Late Middle Ages* (Berkeley, 1993), II, pl. VI.48.

43 Both of the mid-fourteenth-century works bearing this motif are from Steiermark and are in the Landesmuseum in Graz: the *St Lambrecht Retable* and the *Judenburger Retable*. For the former, see Wolfgang Pilz, *Das Triptychon als Kompositions- und Erzählsform* (Munich, 1970), cat. no. 108; for the latter, see Alfred Stange, *Deutsche Malerei der Gotik* (Munich and Berlin, 1961), XI, no. 127.

44 Two important Bavarian examples that I do not discuss here are: a *Calvary* panel in the Berechtesgaden Schloß (see Alfred Stange, *Malerei der Donauschule* [Munich, 1964], fig. 51); and a *Calvary* by Gabriel Mälesskircher (see Stange, *Deutsche Malerei der Gotik* [Munich and Berlin, 1960], X, no. 112).

45 The theme is discussed in Chapter 7.

46 Each wing contains two scenes: *Christ before Pilate* and the *Carrying of the Cross* (left); *Ecce Homo* and the *Resurrection* (right).

47 Stange, *Deutsche Malerei der Gotik*, X, no. 106, p. 96; Otto Fischer, *Die Altdeutsche Malerei in Salzburg* (Leipzig, 1908), pp. 94–5.

48 For the symbolism of the Bad Thief's red hair, and further references, see Mellinkoff, *Outcasts*, I, pp. 155–60.

49 Erwin Panofsky, *Early Netherlandish Painting: Its Origins and Character* (New York, 1971), I, p. 417, n. 2. To interpret Cranach's apparent reversal of Good and

Bad Thieves as the result of printing a woodblock cut directly from the original drawing does not solve the riddle, since the standard positions for all other figures (see Mary and John) remain unaffected.

50 See Rudolf Glanz, 'The "Jewish Execution" in Medieval Germany', *Jewish Social Studies*, V (1943), pp. 3–26; also see Esther Cohen, 'Symbols of Culpability and the Universal Language of Justice: The Ritual of Public Executions in Late Medieval Europe', *History of European Ideas*, XI (1989), pp. 411–12, and *The Crossroads of Justice: Law and Culture in Late Medieval France* (Leiden, 1993), pp. 88–94.

51 From the diary of Andrea Gattaro of Padua, quoted in full in Glanz, 'The "Jewish Execution" in Medieval Germany', p. 4.

52 Cohen, 'Symbols of Culpability', p. 412.

53 Quoted and discussed in Glanz, 'The "Jewish Execution" in Medieval Germany', p. 12.

54 Cohen, 'Symbols of Culpability', p. 411.

55 Glanz, 'The "Jewish Execution" in Medieval Germany', p. 24.

56 Cohen, 'Symbols of Culpability', p. 411.

57 See Lionel Rothkrug, 'Popular Religion and Holy Shrines: Their Influence on the Origins of the German Reformation and Their Role in German Cultural Development', in *Religion and the People, 800–1700*, ed. J. Obelkevich (Chapel Hill, 1979), pp. 20–86, and *Religious Practices and Collective Perceptions: Hidden Homologies in the Renaissance and Reformation* (Waterloo, Ontario, 1980), pp. 62ff.

58 Rothkrug, 'Popular Religion and Holy Shrines', pp. 25–6.

59 *Ibid.*, p. 67.

60 Norman Cohn, *The Pursuit of the Millennium* (Fairlawn, NJ, 1957), pp. 68–70.

61 Rothkrug, 'Popular Religion and Holy Shrines', pp. 27–8.

62 *Ibid.*, p. 28; also Rothkrug, *Religious Practices and Collective Perceptions*, p. 63.

63 J. M. Minty, '*Judengasse* to Christian Quarter: The Phenomenon of the Converted Synagogue in the Late Medieval and Early Modern Holy Roman Empire', in *Popular Religion in Germany and Central Europe, 1400–1800*, eds B. Scribner and T. Johnson (New York, 1996), pp. 58–86, especially p. 64.

64 *Ibid.*, p. 73.

65 See *ibid.*, pp. 79–82.

66 Rothkrug, *Religious Practices and Collective Perceptions*, p. 64.

67 Rothkrug, 'Popular Religion and Holy Shrines', p. 62.

68 Rothkrug, *Religious Practices and Collective Perceptions*, p. 67.

69 Rothkrug, 'Popular Religion and Holy Shrines', p. 31.

70 Psalm 116: 13; see Gertrud Schiller, *Iconography of Christian Art*, trans. J. Seligman (London, 1972), II, pp. 105–6, 110–12.

71 See John Weiss, *Ideology of Death: Why the Holocaust Happened in Germany* (Chicago, 1997), pp. 3–19.

72 See Charles Zika, 'Hosts, Processions and Pilgrimages: Controlling the Sacred in Fifteenth-Century Germany', *Past and Present*, CXVIII (February 1988), pp. 25–64, on the processions, pp. 38ff.

73 Bob Scribner, 'Popular Piety and Modes of Visual Perception in Late Medieval and Reformation Germany', *Journal of Religious History*, XV/4 (December 1989), p. 458.

74 See Zika, 'Hosts, Processions and Pilgrimages', p. 33.

75 Rothkrug, 'Popular Religion and Holy Shrines', p. 29.

76 For the trials at Endingen (1470), Passau (1478), Regensburg (1470–76) and Freiburg im Breisgau (1504), see R. Po–chia Hsia, *The Myth of Ritual Murder: Jews and Magic in Reformation Germany* (New Haven and London, 1988).

77 On Wilsnack, see Zika, 'Hosts, Processions and Pilgrimages', pp. 48ff.

78 Rothkrug, *Religious Practices and Collective Perceptions*, pp. 63–4, which cites Peter Browe, 'Die Hostienschändung der Juden im Mittelalter', *Römische Quartalschrift*, XXXIV (1926), pp. 167–97, with a list on pp. 173–5. Rothkrug offers an important qualification, observing: 'The regional specificity of the offense points to a different conception of the Eucharist, *not* primarily to a local image of the Jew. Shrines to the bleeding Host appeared where people perceived a supposed desecration of the Eucharist to have been a *physical* reenactment of Christ's martyrdom' (pp. 64–5).

79 Glanz, 'The "Jewish Execution" in Medieval Germany', p. 11.

6 *The Cross and the Wheel*

1 The term comes from Cicero in his speech against Verres, quoted in Martin Hengel, *Crucifixion: In the Ancient World and the Folly of the Message of the Cross*, trans. J. Bowden (London, 1977), p. 33.

2 From the early fourth century, the words *crux* and *patibulum* disappear from penal law, replaced with *furca*, a type of gallows on which victims were hung and strangled: see Theodor Mommsen, *Römisches Strafrecht* (Graz, 1955), p. 921. Constantine's restriction of crucifixion may have been limited to abolishing the practice of breaking the legs of the condemned; see Gerard S. Sloyan, *The Crucifixion of Jesus: History, Myth, Faith* (Minneapolis, 1995), p. 126, with further references.

3 John Laurence, *A History of Capital Punishment* (New York, 1960), p. 15; see also Esther Cohen, *The Crossroads of Justice: Law and Culture in Late Medieval France* (Leiden, 1993), p. 174, with further references; and Lionello Puppi, *Torment in Art: Pain, Violence, Martyrdom* (New York, 1991), p. 67, n. 254. On the inverted 'crucifixion' of Jews, see Rudolf Glanz, 'The "Jewish Execution" in Medieval Germany', *Jewish Social Studies*, V (1943), p. 24.

4 See Mitchell Merback, 'Lucas Cranach the Elder's *Martyrdom of the Twelve Apostles*: Punishment, Penal Themes and Spectacle in his Early Graphic Art', doctoral dissertation, University of Chicago, 1995, pp. 238–55.

5 Samuel Y. Edgerton, *Pictures and Punishment: Art and Criminal Prosecution during the Florentine Renaissance* (Ithaca, 1985), p. 190; Puppi adduced the same connections, but couched them in even vaguer language (see *Torment in Art*, pp. 111, 137).

6 Quoted in Hengel, *Crucifixion*, p. 52; see also G. E. Duckworth, *The Nature of Roman Comedy* (Princeton, 1952), pp. 288ff. Plautus is accepted as the first writer to give evidence of Roman crucifixions.

7 For these and other references, see Hengel, *Crucifixion*, pp. 7–10; and Sloyan, *The Crucifixion of Jesus*, pp. 12–18, Cicero on p. 13.

8 From the dialogue by Minucius Felix, *Octavius*, 9.4, quoted Hengel, *Crucifixion*, p. 3.

9 From Origen's *Contra Celsum* 6.34, in which Celsus mocks Christian talk of a 'tree of life' and 'resurrection of the flesh through the wood [of the cross]': see *ibid.*, p. 8, n. 14.

10 *Ibid.*, pp. 22–3.

11 Y. Yadin, 'Pesher Nahum (4QpNahum) Reconsidered', *Israel Exploration Journal*, XXI (Jerusalem, 1971), pp. 1–12. Hengel explains that it was probably because of the excessive use made of crucifixion in the suppression of Judaea from the beginning of direct Roman rule that the penalty ultimately became taboo. This, combined with reasons stemming from the rabbinical interpretation

of Deuteronomy 21: 23, ensured that 'the cross never became a symbol of Jewish suffering . . . So a crucified messiah could not be accepted either' (*Crucifixion*, pp. 84–5).

12 See Jacques Bréhant, 'Les artistes ne devraient-ils pas repenser le thème de la Crucifixion?', *Gazette des Beaux-Arts*, LXIX (1967), p. 347.

13 Hengel, *Crucifixion*, p. 23.

14 *Ibid.*, p. 9.

15 But *bestiis obici* was not included in the *summa supplicia* as a regular form of execution, since it also depended on the chance circumstances that a popular festival had been arranged at the same time: see Mommsen, *Römisches Strafrecht*, p. 927; and Hengel, *Crucifixion*, p. 35.

16 See *ibid.*, p. 34, n. 3, for references to the *Sententiae*.

17 *Ibid.*, p. 46.

18 Mommsen, *Römisches Strafrecht*, p. 921, asserts that crucifixion lacked any religious character whatever; for the opposite view, see Edgar Wind, 'The Criminal-God' and 'The Crucifixion of Haman', *Journal of the Warburg and Courtauld Institutes*, I (1937–38), pp. 243–8.

19 Mommsen, *Römisches Strafrecht*, p. 919; Bréhant, 'Les artistes ne devraient-ils pas repenser le thème de la Crucifixion?', p. 348; Hengel, *Crucifixion*, p. 62.

20 *Ibid.*, p. 52.

21 Erich Dinkler, *Signum Crucis: Aufsätze zum Neuen Testament und zur Christlichen Archäologie* (Tübingen, 1967), pp. 150–3; see also Bréhant, 'Les artistes ne devraient-ils pas repenser le thème de la Crucifixion?', p. 354; and Gertrud Schiller, *Iconography of Christian Art*, trans. J. Seligman (London, 1972), II, p. 90. Hengel relates the satire to one of the perennial themes of anti-Jewish polemic, the accusation that Jews worshipped an ass (see *Crucifixion*, p. 19, with further references).

22 Hengel, *Crucifixion*, p. 19.

23 Elaine Scarry, *The Body in Pain: The Making and Unmaking of the World* (Oxford, 1985), p. 213.

24 Pierre Barbet, *A Doctor on Calvary: The Passion of Our Lord Jesus Christ as Described by a Surgeon*, trans. the Earl of Wicklow (New York, 1963), pp. 82–3; see my Chapter 3 for entire quotation.

25 On flagellation in Roman crucifixions, see Hengel, *Crucifixion*, pp. 28–9; on the possible timing of Jesus's death, Barbet, *A Doctor on Calvary*, p. 72.

26 *Etymologia* 5.27.34, translation from Hengel, *Crucifixion*, p. 29; for original Latin, see Mommsen, *Römisches Strafrecht*, p. 921, n. 2.

27 See *Pisanello: Le Peintre aux sept Vertus*, exh. cat.; Musée du Louvre, Paris (1996), cat. no. 151, pp. 244–5. Puppi's observation that the figures in this and a related drawing, now in New York, 'are certainly life-studies of the successive decay of the same bodies' seems to me unsupported by the images (see *Torment in Art*, p. 23; the New York drawing is his illus. 10).

28 On the indeterminancy of the moment of death in hanging, see Esther Cohen, 'Symbols of Culpability and the Universal Language of Justice: The Ritual of Public Executions in Late Medieval Europe', *History of European Ideas*, XI (1989), p. 412.

29 On 'defaming pictures' and 'image punishment,' see Wolfgang Brückner, 'Das Bildnis in rechtischen Zwangsmitteln: Zur Magieproblem der Schandgemalde', in *Festschrift für Harald Keller* (Darmstadt, 1963), pp. 11–129, and his articles 'Bildnisstrafe' and 'Bildzauber', in *Handwortenbuch zur deutschen Rechtsgeschichte*, ed. Wolfgang Stammler *et al.* (Berlin, 1964), I, col. 424–30; for Italy, see Edgerton, *Pictures and Punishment*, pp. 91–125; for the Reformation era, Robert

W. Scribner, *For the Sake of the Simple Folk: Popular Propaganda for the German Reformation* (Cambridge, 1981), pp. 78–81.

30 *Dialogue*, 6 (*De consolatione ad Marciam*), 20.3, quoted in Hengel, *Crucifixion*, p. 25.

31 Josephus, *De Bello Judaico*, 5.449–51, quoted *ibid.*, p. 26.

32 *The Golden Legend of Jacobus de Voragine*, trans. G. Ryan and H. Ripperger (London, 1993), p. 337; see also Louis Réau, *Iconographie de l'art chrétien* (Paris, 1958), III, pp. 1096–8.

33 See Merback, 'Lucas Cranach the Elder's *Martyrdom of the Twelve Apostles*', pp. 104–8, 231–3, for the comparisons cited.

34 Alfred Stange, *Deutsche Malerei der Gotik* (Munich and Berlin, 1954), VI, p. 134, and, for the whole four-panel sequence, illus. 239.

35 See *The Golden Legend*, p. 483, where the author further weighs the diversity of opinion: 'On the other hand, Saint Theodore says that he was flayed. In many other books we read only that he was beheaded. But these contradictions can be made to agree, by saying that he was first crucified, then flayed while still alive in order to increase his sufferings, and finally beheaded.'

36 See Hengel, *Crucifixion*, p. 34.

37 See *ibid.*, pp. 49–50.

38 Even so, there were evidently times when the crimes of persons of noble birth demanded that they be crucified. It may be for this reason that two types of cross were in use in the ancient world, the more common *crux humilis* and the taller *crux sublimis*. In contradiction to many medieval representations, which picture Christ's cross towering above the gathered witnesses, it is almost certain that he was condemned to die on the *crux humilis*: see Bréhant, 'Les artistes ne devraient-ils pas repenser le thème de la Crucifixion?', p. 351.

39 Bronislaw Geremek, 'Marginal Man', in *The Medieval World*, ed. J. LeGoff, trans. L. G. Cochrane (London, 1990), pp. 361ff. See also Geremek's full-length study, *The Margins of Society in Late Medieval Paris*, trans. J. Birrell (New York, 1987).

40 Richard J. Evans, *Rituals of Retribution: Capital Punishment in Germany, 1600–1987* (Oxford, 1996), p. 53.

41 C. V. Calvert, 'Introduction', in *A Hangman's Diary, Being the Journal of Master Franz Schmidt, Public Executioner of Nuremberg, 1573–1617*, ed. A. Keller, trans. C. V. Calvert and A. W. Gruner (London, 1929; reprinted Montclair, NJ, 1973), p. 49.

42 As a result of all this, the completion of each new gallows was accompanied by great festivity: see Pieter Spierenburg, *The Spectacle of Suffering: Executions and the Evolution of Repression* (Cambridge, 1984), pp. 87–8.

43 Emil Major, 'Prefatory Note', in Emil Major and Erwin Gradmann, *Urs Graf* (London, 1947), pp. 5–8.

44 See Christiane Andersson, *Urs Graf: Dirnen, Krieger, Narren* (Basel, 1978), p. 42. Thanks to Edith Welliver for help with the translation.

45 Richard van Dülmen, *Theatre of Horror: Crime and Punishment in Early Modern Germany*, trans. E. Neu (Cambridge, 1990), p. 50.

46 Evans, *Rituals of Retribution*. p. 54.

47 *Ibid.*, p. 55.

48 *Ibid.*, pp. 55–6.

49 *Zedlers Grosses Vollständiges Universal Lexicon aller Wissenschaften und Künste* (Leipzig and Halle, 1745), xl. 585: '*Straffe (peinliche)*', quoted *ibid.*, p. 56.

50 Examples of this fallacy can be found in the otherwise useful articles of Bréhant, 'Les artistes ne devraient-ils pas repenser le thème de la Crucifixion?', and

Joseph W. Hewitt, 'The Use of Nails in the Crucifixion', *Harvard Theological Review*, XXV (1932), pp. 29–45.

51 F. P. Pickering, *Literature and Art in the Middle Ages* (Coral Gables, FL, 1970), p. 235.

52 *Ibid.*, p. 225.

53 For all above quotations, *ibid.*, pp. 232–6. This attitude is shared by art historian James Marrow, whose method of study owes much to his mentor Pickering: see *Passion Iconography in Northern European Art of the Late Middle Ages and Early Renaissance* (Kortrijk, 1979).

54 *Ibid.*, p. 235.

55 *Ibid.*, p. 233. 'By comparison with the authority of the Bible, of patristic exegesis and the Liturgy (on the *Crucifixion*), the statements to be found in the Jewish, Greek and Roman historians (on *Crucifixions*) have no evidential value – *except* for the crucifixion of the *two thieves* on Golgotha' (author's own emphasis).

7 Dysmas and Gestas: Model and Anti-model

1 From *Selected Poems 1923–1967*, ed. N. T. D. Giovanni, trans. M. Strand (New York, 1972), p. 141. I thank Keith Nightenhelser for bringing this poem to my attention.

2 Louis Réau, *Iconographie de l'art chrétien* (Paris, 1958), III, pt 1, p. 386.

3 See Susan Snyder, 'The Left Hand of God: Despair in Medieval and Renaissance Tradition', *Studies in the Renaissance*, XII (1965), pp. 18–59.

4 Thomas N. Tentler, *Sin and Confession on the Eve of the Reformation* (Princeton, 1977), p. 347.

5 See Lorraine Schwartz, 'Patronage and Franciscan Iconography in the Magdalen Chapel at Assisi', *Burlington Magazine*, CXXXIII (1991), pp. 32–6. Magdalene was not among the saints designated for veneration by Francis himself; her Franciscan cult developed in the middle of the thirteenth century in response to her widespread popularity in northern countries.

6 For references, see *ibid.*, p. 33.

7 *Ibid.*, p. 33, n. 7.

8 J. C. J. Metford, *Dictionary of Christian Lore and Legend* (London, 1983), p. 162.

9 Joseph N. Tylenda, *The Pilgrim's Guide to Rome's Principal Churches* (Collegeville, Minn., 1993), pp. 69–72.

10 Réau, *Iconographie de l'art chrétien*, p. 386.

11 See Leopold Kretzenbacher, 'St Dismas, der rechte Schächer: Legenden, Kultstätten und Verehrungsformen in Innerösterreich', *Zeitschrift des Historischen Vereines für Steiermark*, XLII (1951), pp. 119–39; and Edgar Krausen, 'Der Kult des heiligen Dismas in Altbayern', *Bayerische Jahrbuch für Volkskunde* (1969), pp. 16–21.

12 Lester K. Little, *Religious Poverty and the Profit Economy in Medieval Europe* (Ithaca, 1978), p. 152. Franciscan communities were successfully established in Germany in 1221 and three years later in England.

13 Quoted *ibid.*, p. 190.

14 *Ibid.*, pp. 187–8.

15 *Meditations on the Life of Christ: An Illustrated Manuscript of the Fourteenth Century*, eds I. Ragusa and R. B. Green (Princeton, 1961), p. 3.

16 See *Alte Pinakothek Munich* (Munich, 1986), p. 430.

17 Jean-Claude Schmitt, *La raison des gestes dans l'Occident médiéval* (Paris, 1990), p. 318.

18 The Seven Sorrows of the Virgin originated in the prophecy of Simeon, repeated in Luke (2: 35): 'Yea, a sword shall pierce through thy own soul also'; the Pseudo-Bonaventure uses it in the *Meditations on the Life of Christ*, p. 340.

19 Anne Derbes, *Picturing the Passion in Late Medieval Italy: Narrative Painting, Franciscan Ideologies, and the Levant* (Cambridge, 1996), p. 154.

20 *Ibid.*

21 *Mystical Opuscula*, in *The Works of Bonaventure*, trans. J. DeVinck (Paterson, NJ, 1960), I, p. 240.

22 See *Meditations on the Life of Christ*, pp. 330–39, especially pp. 331, 339.

23 '*In iniquorum loco inter ipsos etiam latrones suspensus ab ipsis iniquis blasphematur*' implies that the slander came from the Thieves themselves; see *Meditatio pauperis in solitudine*, ed. F. M. Delorme (Florence, 1929), p. 71.

24 Derbes, *Picturing the Passion in Late Medieval Italy*, p. 154.

25 *Ibid.*, p. 134.

26 Metford, *Dictionary of Christian Lore and Legend*, p. 104.

27 Derbes, *Picturing the Passion in Late Medieval Italy*, p. 154.

28 Erwin Panofsky, *Early Netherlandish Painting: Its Origins and Character* (New York, 1971), I, p. 417, n. 2.

29 As in the 1909 essay by Robert Hertz, 'The Pre-eminence of the Right Hand: A Study in Religious Polarity', trans. R. Needham, in *Right and Left: Essays on Dual Symbolic Classification*, ed. R. Needham (Chicago and London, 1973), pp. 3–31.

30 The lightning rod for this debate is Robert Campin's *Thief on the Cross* in Frankfurt (our illus. 39); see first Panofsky, *Early Netherlandish Painting*, pp. 167–8, 417 (n. 147.2), and 424 (n. 168.1); then Julius Held's review in *Art Bulletin*, XXXVII/3 (September 1955), pp. 205–34, esp. 213–14.

31 Würzburg, Universitätsbibliothek, M. p. th. fol. 69. fol. 7 recto; see *Karl der Grosse – Werk und Wirkung*, exh. cat. by Heinrich Lübke: Aachen Rathaus and Dom (Aachen, 1965), cat. no. 448, fig. 69.

32 For essential information, see Richard Marks and Nigel Morgan, *The Golden Age of English Manuscript Painting, 1200–1500* (New York, 1981), p. 110.

33 See David M. Robb, 'The Iconography of the Annunciation in the Fourteenth and Fifteenth Centuries', *Art Bulletin*, XVIII (1936), pp. 523–6; for a critique of this view in regard to Campin's *Mérode Altarpiece*, see Cynthia Hahn, 'Joseph Will Perfect, Mary Enlighten and Christ Save Thee: The Holy Family as Marriage Model in the *Mérode Altarpiece*', *Art Bulletin*, LXVIII/1 (March 1986), p. 62; for the theory of an Eastern prototype, see Gertrud Schiller, *Iconography of Christian Art*, trans. J. Seligman (London, 1972), II, p. 116.

34 From the *Story of Joseph of Arimathaea*, in M. R. James, ed., *The Apocryphal New Testament* (Oxford, 1924), p. 163.

35 See Georges Bataille, *The Tears of Eros*, trans. P. Connor (San Francisco, 1989), pp. 204–7; for an interpretation of Bataille's theory of death's invisibility, see James Elkins, *The Object Stares Back: On the Nature of Seeing* (San Diego, New York and London, 1996), pp. 103ff.

36 Barna da Siena's *Crucifixion* scene in San Gimignano (*c.* 1350–55) appears to be the earliest extant; see Schiller, *Iconography of Christian Art*, no. 509.

37 Augsburg did not turn to Lutheranism until the period between the two Imperial Diets at Speyer in 1526 and 1529, while Luther was still under ban of the empire; see Roland H. Bainton, *The Reformation of the Sixteenth Century*, enlarged edn (Boston, 1985), pp. 148–51; on the early history of the Reformation and iconoclasm in Augsburg, see Jeffrey Chipps Smith, *German Sculpture of the Later Renaissance, c. 1520–80: Art in an Age of Uncertainty* (Princeton, 1994), pp. 39–41.

38 The outer faces of the wing panels, now detached, are in the Augsburg Staatsgalerie and the predella panel is in the Thyssen-Bornemisza Collection in Lugano; for a reconstruction, see Isolde Lübbeke, *Early German Painting: 1350–1550*, trans. M. T. Will (London, 1991), cat. no. 39.

39 Charles Cuttler, *Northern Painting from Pucelle to Bruegel* (New York, 1968), p. 401.

40 Scholars have not been able to show whether Lazarus and Martha were, like the saints on the exterior, Peutinger family patrons: see *Alte Pinakothek Munich*, p. 126.

41 Reproduced in Franco Caresio, *Il Sacro Monte di Varallo* (Biella, 1984).

42 Quoted in Umberto Eco, *Art and Beauty in the Middle Ages*, trans. H. Bredin (New Haven, 1986), p. 10.

43 For a different application of the term 'displacement', see Michael Schwartz, 'Beholding and Displacements in Renaissance Painting', in *Place and Displacement in the Renaissance*, ed. A. Vos (Binghamton, NY, 1995), pp. 231–43. Thanks to Anne Harris for bringing this article to my attention.

44 For an earlier instance, see the frescoes of the right arm of the western transept in the lower church, painted *c.* 1320–30 by followers of Giotto; see Schiller, *Iconography of Christian Art*, pp. 153–4.

45 For the most recent discussion, with comprehensive bibliography, see Albert Châtelet, *Robert Campin, Le Maître de Flémalle: La fascination du quotidien* (Anvers, 1996), cat. no. 3.

46 Panofsky, *Early Netherlandish Painting*, p. 160.

47 See Hans Belting, *The Image and Its Public in the Middle Ages: Form and Function of Early Paintings of the Passion*, trans. M. Bartusis and R. Meyer (New Rochelle, NY, 1990), pp. 109–15.

48 See Craig Harbison, 'Visions and Meditation in Early Flemish Painting', *Simiolus*, XV/2 (1985), p. 90.

49 Barbara Lane, 'Depositio et Elevatio: The Symbolism of the Seilern Triptych', *Art Bulletin*, LVII/1 (March 1975), pp. 21–30, especially p. 29; and her briefer account in *The Altar and the Altarpiece: Sacramental Themes in Early Netherlandish Painting* (New York, 1984), pp. 99–101.

50 Matthew Botvinick, 'The Painting as Pilgrimage: Traces of a Subtext in the Work of Campin and His Contemporaries', *Art History*, XV/1 (March 1992), pp. 1–18, quote on p. 8.

51 From the *Lignum vitae* (Tree of Life), quoted in Denise Despres, *Ghostly Sights: Visual Meditation in Late Medieval Literature* (Norman, Oklahoma, 1989), pp. 26–7.

52 From a devotional broadsheet printed by Wolfgang Strauch, sixteenth century; discussed in Bob Scribner, 'Popular Piety and Modes of Visual Perception in Late Medieval and Reformation Germany', *Journal of Religious History*, XV/4 (December 1989), pp. 467–9.

53 For catalogue information, Janez Höfler, *Die Tafelmalerei der Gotik in Kärnten (1420–1500)* (Klagenfurt, 1987), cat. no. 22; also see Otto Benesch, 'Eine österreichische Stiftsgalerie', *Belvedere* (1929), pp. 32ff.; Otto Demus, 'Die Tafelbilder des Thomas von Villach: Restaurierungen und Entdeckungen', *Österreichische Zeitschrift für Denkmalpflege*, V (1951), pp. 23–6.

54 *Ibid.*, p. 23; Benesch, 'Eine österreichische Stiftsgalerie', p. 33.

55 *Hans Baldung Grien. Prints and Drawings*, exh. cat. ed by James H. Marrow and Alan Shestack; National Gallery of Art, Washington, DC and Yale University Art Gallery, New Haven (Washington, DC, 1981), cat. no. 49.

56 See *Alte Pinakothek Munich*, pp. 150–52.

57 For Leo Steinberg, Cranach's depiction of 'this humblest of garments' converts Christ's erect penis 'into a fanfare of cosmic triumph'; see *The Sexuality of Christ in Renaissance Art and in Modern Oblivion*, 2nd edn (Chicago, 1996), pp. 91–4.

58 For Bellini's drawing, see Frederick Hartt, *History of Italian Renaissance Art*, 4th

edn (Englewood Cliffs, NJ, 1994), fig. 396; for Dürer's altarpiece, see *Lukas Cranach. Gemälde, Zeichnungen, Druckgraphik*, exh. cat. by Dieter Koepplin and Tilman Falk; Kunstmuseum, Basel (Basel and Stuttgart, 1974), I, pp. 115–16 and illus. 50. Cranach probably got the idea from Dürer.

59 Joseph Leo Koerner, *The Moment of Self-portraiture in German Renaissance Art* (Chicago and London, 1993), p. 375.

60 See R. Kuhn, 'Cranachs Christus am Kreuz (von 1503) als Marienklage', *Alte und moderne Kunst*, XVII (1972), pp. 12–30.

61 See Edwin Maria Landau and Max Seidel, *Altdorfer: Leidensweg, Heilsweg: Der Passionsaltar von St Florian* (Stuttgart and Zurich, 1983), pp. 18ff.

62 On the work's authorship, Franz Winzinger, *Wolf Huber. Das Gesamtwerk* (Munich, 1979), I, pp. 137–8 and II, illus. 167; and *idem., Albrecht Altdorfer: Zeichnungen* (Munich, 1952), cat. no. 127 (pp. 99–100); on the related Passion planned by Altdorfer, a *Christ on the Mount of Olives* (1509) is cat. no. 13, and the copy after his *Lamentation* (*c.* 1508–9) is no. 14. The latter draws on Cranach's Munich painting, though it actually *increases* the angle of turn past 90 degrees so we see Christ's cross obliquely from behind.

63 Winzinger, *Albrecht Altdorfer*, p. 100.

64 For a different intepretation of the oblique arrangement, see Christopher Wood, *Albrecht Altdorfer and the Origins of Landscape* (Chicago and London, 1993), pp. 184, where the turn is seen as a discouragement of idolatry.

65 On the special role of the soldiers, see J. R. Hale, *Artists and Warfare in the Renaissance* (New Haven and London, 1990), p. 227.

66 André Vauchez, *The Laity in the Middle Ages: Religious Beliefs and Devotional Practices*, ed. D. E. Bornstein, trans. M. J. Schneider (Notre-Dame and London, 1993), p. 122.

67 Lawrence G. Duggan, 'Fear and Confession on the Eve of the Reformation', *Archiv für Reformationsgeschichte*, LXXV (1984), pp. 153–75.

68 Tentler, *Sin and Confession on the Eve of the Reformation*, p. 347.

69 See Jane Campbell Hutchison, *Albrecht Dürer: A Biography* (Princeton, 1990), pp. 121–5, with quotation from a letter to Georg Spalatin on p. 125.

70 Hugh of Saint-Victor, *The Sacraments of the Christian Faith*, trans. R. J. Deferrari (Cambridge, Mass., 1951), p. 409; quoted and discussed in Snyder, 'The Left Hand of God', p. 27.

71 Discussed in Jean Weisz, *Pittura e Misericordia: The Oratory of S. Giovanni Decollato in Rome* (Ann Arbor, 1984), pp. 1–7, quotations on p. 5.

72 Richard J. Evans, *Rituals of Retribution: Capital Punishment in Germany, 1600–1987* (Oxford, 1996), p. 81.

73 The author of the *Dies irae* may possibly be St Francis's biographer, Thomas of Celano (d. 1260); for the entire hymn, see John Shinners, ed., *Medieval Popular Religion, 1000–1500: A Reader* (Peterborough, Ontario, 1997), pp. 501–3.

74 On his role in Counter-Reformation generally, see John B. Knipping, *Iconography of the Counter-Reformation in the Netherlands: Heaven on Earth* (Nieuwkoop and Leiden, 1974), pp. 315–17; on the Jesuit role in fostering the Dysmas cult in the German empire, see Krausen, 'Der Kult des heiligen Dismas in Altbayern', p. 16.

8 *Image and Spectacle in the Era of Art*

1 From *The History of Manners*, part one of Elias's *The Civilizing Process*, trans. E. Jephcott (Oxford, 1994), p. 66.

2 On this prehistory, see Bernhard Decker, 'Reform within the Cult Image: The

German Winged Altarpiece Before the Reformation', in *The Altarpiece in the Renaissance*, eds P. Humphrey and M. Kemp (Cambridge, 1994), pp. 90–105.

3 Hans Belting, *Likeness and Presence: A History of the Image in the Era Before Art*, trans. E. Jephcott (Chicago and London, 1994), p. 458.

4 *Ibid.*

5 Klaus Theweleit, *Male Fantasies, volume 1: Women, Floods, Bodies, History*, trans. S. Conway (Minneapolis, 1987), pp. 301–2.

6 Belting, *Likeness and Presence*, p. 459.

7 Richard J. Evans, *Rituals of Retribution: Capital Punishment in Germany, 1600–1987* (Oxford, 1996), pp. 96–8.

8 In Michael Camille's review of Belting's *Likeness and Presence* in *Art Bulletin*, LXXIV/3 (September 1992), pp. 514–17, the author complains with some justification that Belting 'has written a narrative story against narrative images' (p. 515).

9 See Ronald Lightbrown, *Mantegna* (Berkeley, 1986), pp. 76ff.

10 For a periodization of patronage relationships, see Bram Kempers, *Painting, Power and Patronage: The Rise of the Professional Artist in the Italian Renaissance*, trans. B. Jackson (London, 1992), pp. 12–17.

11 Frederick Hartt, *History of Italian Renaissance Art*, 4th edn (Englewood Cliffs, NJ, 1994), p. 389.

12 Millard Meiss, 'Jan van Eyck and the Italian Renaissance', in *Venezia e l'Europa: atti del XVIII Congresso Internazionale di storia dell'arte* (Venice, 1956), p. 64.

13 *Ibid.*, p. 68.

14 Hartt, *History of Italian Renaissance Art*, p. 386.

15 Martin Kemp, 'From "Mimesis" to "Fantasia": The Quattrocento Vocabulary of Creation, Inspiration and Genius in the Visual Arts', *Viator*, VIII (1977), pp. 347–98.

16 *Ibid.*, p. 358.

17 For Lorenzo di Pavia's remark, see *ibid.*, p. 359. The terms *inventione*, *concepto* and *fantasia* appear in the chronicle of Giovanni Santi.

18 *Ibid.*, p. 375.

19 Quoted in *ibid.*, p. 368. For the English edition, see Cennino Cennini, *The Craftsman's Handbook*, trans. D. V. Thompson (New York, 1954).

20 Quoted in Kemp, 'From "Mimesis" to "Fantasia"', p. 375.

21 Belting, *Likeness and Presence*, p. 472.

22 This kind of response may well have been increasingly confined to lowbrow viewers, those for whom the 'art' of the image was still solely a matter of the craftsman's skill or artifice.

23 Belting, *Likeness and Presence*, p. 474.

24 Sydney J. Freedberg, *Painting in Italy, 1500–1600* (Harmondsworth, 1970), p. 263.

25 *Ibid.*, p. 264.

26 On this early trip to northern Italy, see Jane Campbell Hutchison, *Albrecht Dürer: A Biography* (Princeton, 1990), pp. 40–47.

27 *Ibid.*, p. 45.

28 The line separating the two blocks can be discerned about the level just above the Virgin's forehead.

29 Fedja Anzelewsky, *Dürer: His Art and Life*, trans. H. Grieve (New York, 1980), p. 48, endorses the attribution to Dürer; for a more critical view, see *The Illustrated Bartsch* (New York, 1978–), X, no. 1001.405.

30 A useful summary of Friedrich's patronage is Carl C. Christensen, *Princes and Propaganda: Electoral Saxon Art of the Reformation* (Kirksville, Missouri, 1992), Chapters 1–2.

31 Quoted and discussed in Keith Moxey, 'Hieronymus Bosch and the "World Upside Down": The Case of *The Garden of Earthly Delights*', in *Visual Culture: Images and Interpretations*, eds N. Bryson, M. A. Holly and K. Moxey (Hannover and London, 1994), p. 117.

32 Christensen, *Princes and Propaganda*, p. 26.

33 See Jeffrey Chipps Smith, *German Sculpture of the Later Renaissance, c. 1520–80: Art in an Age of Uncertainty* (Princeton, 1994), p. 35.

34 Discussed in Robert W. Scribner, *Popular Culture and Popular Movements in Reformation Germany* (London, 1987), pp. 110ff.

35 For detailed, localized accounts of the iconoclastic regimes in three imperial city-states, see Lee Palmer Wandel, *Voracious Idols and Violent Hands: Iconoclasm in Reformation Zurich, Strasbourg and Basel* (Cambridge, 1995).

36 Scribner, *Popular Culture and Popular Movements in Reformation Germany*, p. 111.

37 Smith, *German Sculpture of the Later Renaissance, c.1520–80*, pp. 39–41, for a summary of the Augsburg episode.

38 Scribner, *Popular Culture and Popular Movements in Reformation Germany*, p. 110.

39 Wandel, *Voracious Idols and Violent Hands*, p. 2.

40 Scribner, *Popular Culture and Popular Movements in Reformation Germany*, p. 116.

41 *Ibid.*, p. 113; see also Belting, *Likeness and Presence*, p. 461.

42 For most of these, see Scribner, *Popular Culture and Popular Movements in Reformation Germany*, p. 115; on the Münster episode, see Martin Warnke, 'Durchbrochene Geschichte? Die Bildersturm der Wiedertäufer in Münster', in *Bildersturm. Die Zerstorung des Kunstwerks*, ed. M. Warnke (Munich, 1973), pp. 65–98.

43 Scribner, *Popular Culture and Popular Movements in Reformation Germany*, p. 115, where the connection with the 'Jewish execution' is not adduced.

44 Belting, *Likeness and Presence*, p. 460.

45 See Steven Ozment, *The Age of Reform 1250–1550: An Intellectual and Religious History of Late Medieval and Reformation Europe* (New Haven and London, 1980), pp. 272–89.

46 Jürgen Moltmann, *The Crucified God: The Cross of Christ as the Foundation and Criticism of Christian Theology*, trans. R. A. Wilson and J. Bowden (New York, 1974), p. 72.

47 See Robert W. Scribner, *For the Sake of the Simple Folk: Popular Propaganda for the German Reformation* (Cambridge, 1981), p. 94.

48 Erwin Panofsky, 'Comments on Art and Reformation', first delivered as a lecture in 1960 and reprinted in *Symbols in Transformation: Iconographic Themes at the Time of the Reformation*, exh. cat.; The Art Museum, Princeton University, Princeton (1969), p. 9.

49 Luther, quoted in Belting, *Likeness and Presence*, p. 465.

50 Andrée Hayum, *The Isenheim Altarpiece: God's Medicine and the Painter's Vision* (Princeton, 1989), p. 70.

51 Quoted in Belting, *Likeness and Presence*, p. 548.

52 The panel depicting the *Ten Commandments*, for example, was completed in the shadow of Luther's sermons on the subject, delivered in the Wittenberg Stadtkirche between June 1516 and Shrove Tuesday 1517; see Elfriede Starke, *Lukas Cranach d. Ä. Die Zehn-Gebote-Tafel* (Leipzig, 1982), pp. 9–10.

53 For a discussion of other versions, see John Oliver Hand, *German Paintings of the Fifteenth through the Seventeenth Centuries* (Washington DC, 1993), cat. no. 1961.9.69 (pp. 44–8).

54 Quoted in Belting, *Likeness and Presence*, p. 466.

55 See Joseph Leo Koerner, *The Moment of Self-portraiture in German Renaissance Art* (Chicago and London, 1993), p. 367.

56 See Hayum, *The Isenheim Altarpiece*, pp. 72–3; and Koerner, *The Moment of Self-portraiture in German Renaissance Art*, who makes a similar argument, pp. 370ff.

57 For catalogue information, see *Martin Luther und die Reformation in Deutschland: Austellung zum 500. Geburtstag Martin Luthers*, exh. cat.; Germanisches Nationalmuseum, Nuremberg (Frankfurt am Main, 1983), cat. no. 538.

58 See Koerner, *The Moment of Self-portraiture in German Renaissance Art*, pp. 370–75; Hayum, *The Isenheim Altarpiece*, pp. 82–4; also *Martin Luther und die Reformation in Deutschland*, cat. no. 538, pp. 398–400, with further bibliography.

59 Dieter Koepplin makes this point in his catalogue entry in *Martin Luther und die Reformation*, cat. no. 494, p. 371.

60 On legal iconoclasm in Ulm, see Michael Baxandall, *The Limewood Sculptors of Renaissance Germany* (New Haven, 1980), p. 74. Berger may, in fact, have already left Ulm; he is recorded there only as late as 1529.

61 For five related post-1537 Crucifixions, see Max J. Friedländer and Jakob Rosenberg, *The Paintings of Lucas Cranach* (Ithaca, 1978), pp. 144–5.

62 See Laurinda S. Dixon, 'The *Crucifixion* by Lucas Cranach the Elder: A Study in Lutheran Reform Iconography', *Perceptions*, I (December 1981), pp. 37–41, for hypothetical identifications of the portraits in the Indianapolis painting.

63 *Ibid.*, p. 40.

64 Cf. Smith, *German Sculpture of the Later Renaissance, c. 1520–80*, p. 43.

65 See Mitchell Merback, 'Lucas Cranach the Elder's *Martyrdom of the Twelve Apostles*: Punishment, Penal Themes and Spectacle in his Early Graphic Art', doctoral dissertation, University of Chicago , 1995, Ch. 7, and 'Torture and Teaching: The Reception of Lucas Cranach the Elder's *Martyrdom of the Twelve Apostles* in the Protestant Era', *Art Journal*, LVII / 1 (Spring 1998), pp. 14–23.

66 Cf. Koerner, *The Moment of Self-portraiture in German Renaissance Art*, p. 373.

67 From the sixty-second thesis of 1517, quoted in Jean Delumeau, *Sin and Fear: The Emergence of a Western Guilt Culture, 13th–18th Centuries*, trans. E. Nicholson (New York, 1990), p. 493.

68 *Ibid.*

69 Scribner, *For the Sake of the Simple Folk*, p. 100.

70 See Bernard McGinn, *Antichrist: Two Thousand Years of the Human Fascination with Evil* (San Francisco, 1994), especially pp. 143–99 on the papal Antichrist tradition.

71 Scribner, *For the Sake of the Simple Folk*, p. 147.

72 Baxandall, *The Limewood Sculptors of Renaissance Germany*, p. 152.

73 See Johannes Jahn, *Museum der bildenden Künste Leipzig* (Leipzig, 1961), p. 41.

74 Dated 1533 and inscribed with a forged Cranach monogram ('LC'); for essential information, see Edmund Schilling, *The German Drawings in the Collection of Her Majesty the Queen at Windsor Castle* (London and New York, n.d.), cat. no. 31 (pp. 26–7).

75 See Günther Lottes, 'Popular Culture and the Early Modern State in 16th Century Germany', in *Understanding Popular Culture: Europe from the Middle Ages to the Nineteenth Century*, ed. S. L. Kaplan (Berlin and New York, 1984), pp. 148–88.

76 *Ibid.*, p. 175.

77 Both quotes *ibid.*, p. 176.

1 Norman Mailer, *The Presidential Papers* (New York, 1963), p. 11
2 From the twelve-volume *Tableau de Paris* (1782–6). Mercier doubted that the polite society he knew could condone public executions and, in the same breath, extol itself for its progress in contrast to barbaric peoples in distant lands; see Arlette Farge, *Fragile Lives: Violence, Power and Solidarity in Eighteenth-century Paris*, trans. C. Shelton (Cambridge, Mass., 1993), p. 190.
3 For an overview of *KQED* v. *Vasquez*, see Wendy Lesser, *Pictures at an Execution: An Inquiry into the Subject of Murder* (Cambridge, Mass. and London, 1993), especially pp. 24–46.
4 See Hugo Adam Bedau, 'Background and Developments', in *The Death Penalty in America*, 3rd edn, ed. H. A. Bedau (Oxford and New York, 1982), p. 14.
5 David A. Kaplan, 'Live, from San Quentin . . .', *Newsweek* (1 April 1991), p. 61.
6 For two examples from 1936 and 1937, see Bedau, 'Background and Developments', p. 13.
7 Albert Camus, 'Reflections on the Guillotine', in *Resistance, Rebellion and Death*, trans. J. O'Brien (New York, 1974), pp. 180–81.
8 For recent evidence on the 'brutalizing' effect directly attributable to executions, see William J. Bowers and Glenn L. Pierce, 'Deterrence or Brutalization: What is the Effect of Executions?', *Crime and Delinquency*, XXVI/4 (October 1980), pp. 453–84.
9 See Umberto Eco's essays, 'Dreaming of the Middle Ages' and 'Living in the New Middle Ages', in *Travels in Hyperreality*, trans. W. Weaver (San Diego, New York and London, 1986), pp. 61–85.
10 The idea for the montage appears to have come from an election poster for the SPD (German Social Democratic Party); see Peter Pachnicke, 'Morally Rigorous and Visually Voracious', in *John Heartfield*, eds P. Pachnicke and K. Honnef (New York, 1992), p. 41.
11 See Richard J. Evans, *Rituals of Retribution: Capital Punishment in Germany, 1600–1987* (Oxford, 1996), pp. 621ff.
12 *Ibid.*, p. 622.
13 For the series, see Christopher Phillips, 'Desiring Machines: Notes on Commodity, Celebrity, and Death in the Early Work of Andy Warhol', in *Public Information: Desire, Disaster, Document*, exh. cat.; San Francisco Museum of Modern Art (1994), pp. 39ff.
14 John Berger, 'Photographs of Agony', in *About Looking* (New York, 1980), p. 40.

Select Bibliography

Alte Pinakothek Munich (Munich, 1986)

The Apocryphal New Testament, ed. M. R. James (Oxford, 1924)

Ariès, Philippe, *The Hour of Our Death*, trans. H. Weaver (New York, 1981)

Barbet, Pierre, *A Doctor on Calvary: The Passion of Our Lord Jesus Christ as Described by a Surgeon*, trans. the Earl of Wicklow (New York, 1963)

Baxandall, Michael, *The Limewood Sculptors of Renaissance Germany* (New Haven, 1980)

——, *Painting and Experience in Fifteenth-century Italy* (Oxford, 1988)

Belting, Hans, *The Image and Its Public in the Middle Ages: Form and Function of Early Paintings of the Passion*, trans. M. Bartusis and R. Meyer (New Rochelle, NY, 1990)

——, *Likeness and Presence: A History of the Image in the Era Before Art*, trans. E. Jephcott (Chicago and London, 1994)

Benesch, Otto, *The Art of the Renaissance in Northern Europe: Its Relation to the Contemporary Spiritual and Intellectual Movements*, rev. edn (London, 1965)

Berger, John, 'Photographs of Agony', in *About Looking* (New York, 1980), pp. 37–40

Bestul, Thomas, *Texts of the Passion: Latin Devotional Literature and Medieval Society* (Philadelphia, 1996)

Binski, Paul, *Medieval Death: Ritual and Representation* (Ithaca, 1996)

Bousquet, Jacques, 'A propos d'un des tympans de Saint-Pons: La place des larrons dans la Crucifixion', *Cahiers de Saint-Michel-de-Cuxa*, VIII (1977), pp. 25–54

Bréhant, Jacques, 'Les artistes ne devraient-ils pas repenser le thème de la Crucifixion?' *Gazette des Beaux-Arts*, LXIX (1967), pp. 347–64

Bynum, Caroline Walker, *Fragmentation and Redemption: Essays on Gender and the Human Body in Medieval Religion* (New York, 1992)

Châtelet, Albert, *Robert Campin, Le Maitre de Flémalle: La Fascination du Quotidien* (Anvers, 1996)

Cohen, Esther, 'Symbols of Culpability and the Universal Language of Justice: The Ritual of Public Executions in Late Medieval Europe', *History of European Ideas*, XI (1989), pp. 407–16

——, '"To Die a Criminal for the Public Good": The Execution Ritual in Late Medieval Paris', in *Law, Custom, and the Social Fabric in Medieval Europe: Essays in Honor of Bruce Lyon* (Studies in Medieval Culture, XXVIII), eds Bernard S. Bachrach and David Nicholas (Kalamazoo, 1990), pp. 285–304

——, *The Crossroads of Justice: Law and Culture in Late Medieval France* (Leiden, 1993)

——, 'Towards a History of European Sensibility: Pain in the Later Middle Ages', *Science in Context*, VIII / 1 (1995), pp. 47–74

Corley, Bridget, *Conrad von Soest: Painter Among Merchant Princes* (London, 1996)

Corrigan, Kathleen, 'Text and Image on an Icon of the Crucifixion at Mt Sinai', in *The Sacred Image: East and West*, eds R. Ousterhout and L. Brubaker (Urbana and Chicago, 1995), pp. 45–62

Cuttler, Charles, *Northern Painting from Pucelle to Bruegel* (New York, 1968)

Decker, Bernard, 'Reform within the Cult Image: the German Winged Altarpiece Before the Reformation', in *The Altarpiece in the Renaissance*, eds P. Humphrey and M. Kemp (Cambridge, 1994)

Delumeau, Jean, *Sin and Fear: The Emergence of a Western Guilt Culture, 13th–18th Centuries*, trans. E. Nicholson (New York, 1990)

Derbes, Anne, *Picturing the Passion in Late Medieval Italy: Narrative Painting, Franciscan Ideologies, and the Levant* (Cambridge, 1996)

Despres, Denise, *Ghostly Sights: Visual Meditation in Late Medieval Literature* (Norman, Oklahoma, 1989)

Dinkler, Erich, *Signum Crucis: Aufsätze zum Neuen Testament und zur Christlichen Archäologie* (Tübingen, 1967)

Dülmen, Richard van, *Theatre of Horror: Crime and Punishment in Early Modern Germany*, trans. E. Neu (Cambridge, 1990)

Edgerton, Samuel Y., *Pictures and Punishment: Art and Criminal Prosecution during the Florentine Renaissance* (Ithaca, 1985)

Elias, Norbert, *The Civilizing Process: The History of Manners and State Formation and Civilization*, trans. E. Jephcott (Oxford, 1994)

Evans, Richard J., *Rituals of Retribution: Capital Punishment in Germany, 1600–1987* (Oxford, 1996)

Farge, Arlette, *Fragile Lives: Violence, Power and Solidarity in Eighteenth-Century Paris*, trans. C. Shelton (Cambridge, Mass., 1993)

Filedt Kok, Jan Piet, *The Master of the Amsterdam Cabinet, or The Housebook Master, c. 1470–1500* (Amsterdam and Princeton, 1985)

Foucault, Michel, *Discipline and Punish: The Birth of the Prison*, trans. A. Sheridan (New York, 1979)

Friedländer, Max J., and Jakob Rosenberg, *The Paintings of Lucas Cranach* (Ithaca, 1978)

Garland, David, *Punishment and Modern Society: A Study in Social Theory* (Chicago, 1990)

Glanz, Rudolf, 'The "Jewish Execution" in Medieval Germany', *Jewish Social Studies*, V (1943), pp. 3–26

Goodich, Michael, *Violence and Miracle in the Fourteenth Century: Private Grief and Public Salvation* (Chicago and London, 1995)

Growden, Marcia Carole Cohn, 'The Narrative Sequence in the Preface to the Gerona Commentaries of Beatus on the Apocalypse', doctoral dissertation, Stanford University, 1976

Harbison, Craig, 'Visions and Meditation in Early Flemish Painting', *Simiolus*, XV/2 (1985), pp. 87–118

Held, Julius, 'Review of Erwin Panofsky, *Early Netherlandish Painting*', *Art Bulletin*, XXXVII, (3 September 1955), pp. 205–34

Held, Robert, *Inquisition/Inquisicion: Torture Instruments from the Middle Ages to the Industrial Era*, exh. cat. (Florence, 1985)

Hengel, Martin, *Crucifixion: In the Ancient World and the Folly of the Message of the Cross*, trans. J. Bowden (London, 1977)

Hentig, Hans von, *Punishment. Its Origins, Purpose and Psychology* (London, 1937)

Herrlinger, Robert, 'Zur Frage der ersten anatomisch richtigen Darstellung des menschlichen Körpers in der Malerei', *Centaurus*, II (1953), pp. 283–8

Hertz, Robert, 'The Pre-eminence of the Right Hand: A Study in Religious Polarity',

trans. R. Needham, in *Right and Left: Essays on Dual Symbolic Classification*, ed. R. Needham (Chicago and London, 1973), pp. 3–31

Hewitt, Joseph William, 'The Use of Nails in the Crucifixion', *Harvard Theological Review*, XXV (1932), pp. 29–45

Hinckeldey, Ch., ed., *Justiz in alter Zeit* (Rothenburg ob der Tauber, 1989)

Hood, William, 'The Sacro Monte of Varallo: Renaissance Art and Popular Religion', in *Monasticism and the Arts*, ed. T. G. Verdon (Syracuse, 1984), pp. 291–311

Huizinga, Johann, *The Waning of the Middle Ages* (Garden City, NY, 1954)

Hutchison, Jane Campbell, *Albrecht Dürer: A Biography* (Princeton, 1990)

Keller, Albrecht, ed., *A Hangman's Diary, Being the Journal of Master Franz Schmidt, Public Executioner of Nuremberg, 1573–1617*, trans. C. Calvert and A. W. Gruner (London, 1929; repr. Montclair, NJ, 1973)

Kemp, Martin, 'From "Mimesis" to "Fantasia": The Quattrocento Vocabulary of Creation, Inspiration and Genius in the Visual Arts', *Viator*, VIII (1977), pp. 347–98

——, 'Introduction: The Altarpiece in the Renaissance: A Taxonomic Approach', in *The Altarpiece in the Renaissance*, eds P. Humphrey and M. Kemp (Cambridge, 1994), p. 18

Kieckhefer, Richard, *Unquiet Souls: Fourteenth-century Saints and Their Religious Milieu* (Chicago, 1984)

Kirchbaum, Engelbert, *Lexikon der christlichen Ikonographie*, 8 vols (Freiburg im Breisgau, 1968–76)

Kitzinger, Ernst, 'World Map and Fortune's Wheel: A Medieval Mosaic Floor in Turin', in *The Art of Byzantium and the Medieval West: Selected Studies* (Bloomington and London, 1976)

Koerner, Joseph Leo, *The Moment of Self–Portraiture in German Renaissance Art* (Chicago and London, 1993)

Kretzenbacher, Leopold, 'St Dismas, der rechte Schächer: Legenden, Kultstätten und Verehrungsformen in Innerösterreich', *Zeitschrift des Historischen Vereines für Steiermark*, XLII (1951), pp. 119–39

Kristeva, Julia, *Powers of Horror: An Essay on Abjection*, trans. L. S. Roudiez (New York, 1982)

Kubler, George, 'Sacred Mountains in Europe and America', in *Christianity and the Renaissance: Image and Religious Imagination in the Quattrocento*, eds T. Verdon and J. Henderson (Syracuse, 1990), pp. 413–41

Kupfer, Marcia, 'The Lost Wheel Map of Ambrogio Lorenzetti', *Art Bulletin*, LXXVIII/2 (June 1996), pp. 286–310

Landolt, Hanspeter, *German Painting. The Late Middle Ages (1350–1500)*, trans. H. Norden (Geneva, 1968)

LeGoff, Jacques, *The Birth of Purgatory*, trans. A. Goldhammer (Chicago, 1981)

Lightbrown, Ronald, *Mantegna* (Berkeley, 1986)

Lochrie, Karma, *Margery Kempe and Translations of the Flesh* (Philadelphia, 1991)

Loerke, William, '"Real Presence" in Early Christian Art', in *Monasticism and the Arts*, ed. T. G. Verdon (Syracuse, 1984), pp. 29–51

Lübbeke, Isolde, *Early German Painting: 1350–1550*, trans. M. T. Will (London, 1991)

Lukas Cranach. Gemälde, Zeichnungen, Druckgraphik, exh. cat. by Dieter Koepplin and Tilman Falk; 2 vols (Basel and Stuttgart, 1974)

McCall, Andrew, *The Medieval Underworld* (London, 1979)

Major, Emil, and Erwin Gradmann, *Urs Graf* (London, 1947)

Marrow, James H., *Passion Iconography in Northern European Art of the Late Middle Ages and Early Renaissance* (Kortrijk, 1979)

Martin, John R., 'The Dead Christ on the Cross in Byzantine Art', in *Late Classical and Medieval Studies in Honor of Albert Mathias Friend, Jr*, ed. K. Weitzmann (Princeton, 1955), pp. 189–96

Martin Luther und die Reformation in Deutschland: Austellung zum 500. Geburtstag Martin Luthers, exh. cat., Germanisches Nationalmuseum, Nuremberg (Frankfurt am Main, 1983)

Meditations on the Life of Christ: An Illustrated Manuscript of the Fourteenth Century, eds I. Ragusa and R. B. Green (Princeton, 1961)

Mellinkoff, Ruth, *Outcasts: Signs of Otherness in Northern European Art of the Late Middle Ages*, 2 vols (Berkeley, 1993)

Merback, Mitchell, 'Lucas Cranach the Elder's *Martyrdom of the Twelve Apostles*: Punishment, Penal Themes and Spectacle in his Early Graphic Art', doctoral dissertation, University of Chicago, 1995

Miller, William Ian, *The Anatomy of Disgust* (Cambridge, Mass., 1997)

Moeller, Bernd, 'Piety in Germany around 1500', in *The Reformation in Medieval Perspective*, ed. S. Ozment (Chicago, 1971), pp. 50–75

Moltmann, Jürgen, *The Crucified God: The Cross of Christ as the Foundation and Criticism of Christian Theology*, trans. R. A. Wilson and J. Bowden (New York, 1974)

Moore, Peter G., 'Cross and Crucifixion in Christiam Iconography: A reply to E. J. Tinsky', *Religion*, IV (Autumn 1974), pp. 104–13

Newman, Graeme, *The Punishment Response* (Philadelphia, 1978)

Nova, Alessandro, '"Popular" Art in Renaissance Italy: Early Response to the Holy Mountain at Varallo', in *Reframing the Renaissance: Visual Culture in Europe and Latin America, 1450–1650*, ed. C. Farago (New Haven and London, 1995), pp. 112–26

Osten, Gert von der, and Horst Vey, *Painting and Sculpture in Germany and the Netherlands, 1500–1600* (Harmondsworth, 1969)

Pachnicke, Peter, and Klaus Honnef, eds, *John Heartfield* (New York, 1992)

Panofsky, Erwin, *Early Netherlandish Painting: Its Origins and Character*, 2 vols (New York, 1971)

Peters, Edward, *Torture* (New York, 1985)

Pickering, F. P., *Literature and Art in the Middle Ages* (Coral Gables, FL, 1970)

——, 'The Gothic Image of Christ: The Sources of Medieval Representations of the Crucifixion', in *Essays on Medieval German Literature and Iconography* (Cambridge, 1980), pp. 3–30

Pilz, Wolfgang, *Das Triptychon als Kompositions- und Erzählsform* (Munich, 1970)

Puppi, Lionello, *Torment in Art: Pain, Violence, Martyrdom* (New York, 1991)

Radelet, Michael, *Facing the Death Penalty: Essays on Cruel and Unusual Punishment* (Philadelphia, 1989)

Radocsay, Dénes, *Gothic Panel Painting in Hungary*, trans. G. Dienes (Budapest, 1963)

Réau, Louis, *Iconographie de l'art chrétien. Vol. III: Iconographie des saints* (Paris, 1958)

Roos, Erwin, 'Das Rad als Folter- und Hinrichtungswerkzeug in Altertum', *Opuscula Archaeologica, Proceedings from the Swedish Institute in Rome* (Lund, 1952), pp. 87–104

Roth, Elisabeth, *Der Volkreiche Kalvarienberg in Literatur und Kunst des Spätmittelalters* (Berlin, 1958)

Rothkrug, Lionel, 'Popular Religion and Holy Shrines: Their Influence on the Origins of the German Reformation and Their Role in German Cultural Development', in *Religion and the People, 800–1700*, ed. J. Obelkevich (Chapel Hill, 1979), pp. 20–86

——, 'Religious Practices and Collective Perceptions: Hidden Homologies in the

Renaissance and Reformation', *Historical Reflections/Réflexions Historiques*, VII/1 (Waterloo, Ontario: Department of History, University of Waterloo, 1980)

Sander, Jochen, *Niederländische Gemälde im Städel, 1400–1550* (Mainz am Rhein, 1993)

Scarry, Elaine, *The Body in Pain: The Making and Unmaking of the World* (Oxford, 1985)

Schade, Werner, *Cranach: A Family of Master Painters*, trans. H. Sebba (New York, 1980)

Schild, Wolfgang, *Alte Gerichtsbarkeit: Vom Gottesurteil bis zum Beginn der modernen Rechtsprechnung* (Munich, 1980)

Schiller, Gertrud, *Iconography of Christian Art*, trans. J. Seligman, vol. II (London, 1972)

Schwartz, Lorraine, 'Patronage and Franciscan Iconography in the Magdalen Chapel at Assisi', *Burlington Magazine*, CXXXIII (1991), pp. 32–6

Scribner, Robert W., *For the Sake of the Simple Folk: Popular Propaganda for the German Reformation* (Cambridge, 1981)

——, *Popular Culture and Popular Movements in Reformation Germany* (London, 1987)

——, 'Popular Piety and Modes of Visual Perception in Late Medieval and Reformation Germany', *Journal of Religious History*, XV/4 (December 1989), pp. 448–69

Simson, Otto G. von., '*Compassio* and *Co-redemptio* in Roger van der Weyden's Descent from the Cross', *Art Bulletin*, XXXV (1953), pp. 9–16

Sloyan, Gerard S., *The Crucifixion of Jesus: History, Myth, Faith* (Minneapolis, 1995)

Snyder, Susan, 'The Left Hand of God: Despair in Medieval and Renaissance Tradition', *Studies in the Renaissance*, XII (1965), pp. 18–59

Smith, Jeffrey Chipps, *German Sculpture of the Later Renaissance, c. 1520–80: Art in an Age of Uncertainty* (Princeton, 1994)

Spierenburg, Pieter, *The Spectacle of Suffering: Executions and the Evolution of Repression* (Cambridge, 1984)

——, *The Broken Spell: A Cultural and Anthropological History of Preindustrial Europe* (New Brunswick, 1991)

Stange, Alfred, *Deutsche Malerei der Gotik*, 11 vols (Munich and Berlin, 1936–61; repr. Nendeln/Liechtenstein, 1969)

Tentler, Thomas N., *Sin and Confession on the Eve of the Reformation* (Princeton, 1977)

Thoby, Paul, *Le Crucifix, des Origines au Concile de Trente* (Nantes, 1959)

Voragine, Jacobus de, *The Golden Legend of Jacobus de Voragine*, G. Ryan and H. Ripperger, 2 vols (London, 1941; republished in a single volume, London, New York and Toronto, 1993)

Weitzmann, Kurt, *The Monastery of Saint Catherine at Mount Sinai: The Icons*, vol. I (Princeton, 1976)

——, '*Loca Sancta* and the Representational Arts of Palestine', in *Studies in the Arts at Sinai* (Princeton, 1982), pp. 19–55

Williams, John, *The Illustrated Beatus. A Corpus of the Illustrations of the Commentary on the Apocalypse, Vol. II: The Ninth and Tenth Centuries* (New York, 1994)

Wind, Edgar, 'The Criminal-God' and 'The Crucifixion of Haman', *Journal of the Warburg and Courtauld Institutes*, I (1937–8), pp. 243–8

Zias, Joseph, and Eliezer Sekeles, 'The Crucified Man from Giv'at ha-Mivtar: A Reappraisal', *Israel Exploration Journal*, XXV (1985), pp. 22–7

Photographic Acknowledgements

The author and publishers wish to express their thanks to the following sources of illustrative material and/or permission to reproduce it:

Alinari/Art Resource, NY: 17, 19, 20, 25, 29, 39, 48, 81; Archivio della Riserva Naturale Speciale del Sacro Monte di Varallo: 10; Art Institute of Chicago (Charles H. and Mary F. S. Worceter Collection): 104 - photo © 1998, Art Institute of Chicago, all rights reserved; Art Resource, NY: 103, 111; Art Resource/Bildarchiv Foto Marburg: 107, 109; Art Resource/Giraudon: 65; Artothek: 15, 22, 100, 101; © Ashmolean Museum, Oxford: 59, 60; Augustinermuseum, Freiburg im Breisgau: 14; Bayerische Staatsgemäldesammlungen, Munich: 33, 89, 93, 96, 113; © British Museum, London: 24, 67, 82; Courtauld Gallery, London, (Princes Gate Collection): 74; Ruben de Heer: 90; Ursula Edelmann: 39, 48; Photo courtesy of the Evangelisches Pfarramt Bad Wildungen: 32, 37; Silvano Ferraris: 10; © Fitzwilliam Museum, Cambridge: 6; Germanisches Nationalmuseum, Nuremburg: 3, 4, 50, 51; Staatliche Kunsthalle, Karlsruhe: 52; Bernd-Peter Keiser: 55; Keresztény Múzeum, Esztergom: 47; Inge Kitlitschka: 75; Erich Lessing: 103, 111; The Martin D'Arcy Gallery of Art, The Loyola University Museum of Mediaeval, Renaissance and Baroque Art, Chicago (bequest of Thomas F. Flannery, Jr.): 97; Metropolitan Museum of Art, New York (Harris Brisbane Dick Fund): 1; Attila Mudrák: 73; Museo del Duomo, Monza: 26, 27; Reproduced courtesy of the Michigan-Princeton-Alexandria Expedition to Mt Sinai: 18 – © the Regents of the University of Michigan, Ann Arbor, MI; National Gallery of Art, Washington, DC (Rosenwald Collection): 97; Josep Maria Oliveras: 38; Rheinisches Bildarchiv Köln: 12, 21, 23, 31, 34, 35, 36; Royal Collection Enterprises, © Her Majesty Queen Elizabeth II: 118; Scala: 102; Solomon R. Guggenheim Museum, New York (Gift, Harry N. Abrams Family Collection, 1974): 106 – photo David Heald/© Solomon R. Guggenheim Foundation, New York; Staatliche Museen zu Berlin - Preußischer Kulturbesitz/Jörg P. Anders: 42, 87 (Gemäldegalerie), 2, 7, 8, 58, 79, 108, 112 (Kupferstichkabinett); Städelsches Kunstinstitut, Frankfurt: 5, 9; Stedelijke Musea, Bruges: 14; Stiftung Archiv der Akademie der Künste, Berlin: 119; Tiroler Landesmuseum Ferdinandeum, Innsbruck: 69; Wolf-Christian von der Mülbe: 43, 78; © The Andy Warhol Foundation for the Visual Arts, Inc/ARS, NY and DACS, London 1998: 106; and ZB Luzern (Eigentum Korporation Luzern): 45, 46.

Index

abjection 113, 157, 168, 248, 258
Adam, skull of, on Golgotha 11, 59, 84, 247
Alberti, Leonbattista 258, 275–7
Albrecht of Brandenburg 130, 292
Allegory of Law and Grace (Cranach) *114*
Altdorfer, Albrecht 13, 238, 259-63, 299
 Calvary (Sankt Florian) *107, 109*
Altötting, shrine of 153, 190
 miracle book by Jacob Issickemer *61*
amende honorable: see criminal justice
Amira, Karl von 141, 162–3
Anastasius of Sinai 55
anatomical study by artists 114–16, 120
Andachtsbilder: see devotional images
Anselm, Archbishop of Canterbury 57
anti-Christian grafitto (Rome) *81*
anti-papal imagery 170–1
Antichrist 82, 170, 270, 296–7
Antonello da Messina 238
Anzelewsky, Fedja 280
Apt, Ulrich the Younger, *Calvary Triptych*
 (Augsburg) *95*
Ariès, Philippe 144
Arma Christi 76, 97–8, 244
Armleders 190
Ars Moriendi 58, 59, 60, 144, 240, 263
art, modern concept of 268–9, 275–8, 301
Ascent of the Cross (Guido da Siena; Utrecht) *90*
Assisi, Basilica of San Francesco
 works in 60–1
 Magdalene Chapel *88,* 223
astrology 99
Augsburg 236, 283, 285, 293
Augustine, Bishop of Hippo 77
Austrian art 124, 172–5, 246–7

Bad Thief: *see* Gestas
Baldung, Hans, *Lamentation for Christ*
 (Washington) 99
Bambergerische halsgerichts und Rechtlich
 ordunung 63
Barbet, Pierre 81, 118–19, 204
Barthes, Roland 230

Bataille, Georges 234
Bavarian art *43, 70, 73,* 175–6
Baxandall, Michael 45–6
Beatis, Antonio de 158–9
Beatus Apocalypse, *Crucifixion* (Girona) *38,*
 91, 92
Beatus of Lièbana, *Commentary on the*
 Apocalypse 83
Beaumanoir, Philippe de 139–40
Bellini, Giovanni 276
Bellini, Jacopo 258, 261
Belting, Hans 52, 56, 267–9, 272
Benesch, Otto 95
Berger, Balthasar, *Calvary* (Stuttgart) *105, 115*
Berger, John 308
Berman, Harold 130
Bernard of Clairvaux (Abbott) 57, 102
Bernard of Cluny 169
Blessed Last Hours of Executed Persons 264–5
blood
 of Christ as sacrament 78, 84
 see also: Crucifixion of Christ
 of executed persons 97–8, 157, 220, 271
Boethius 168
Bohemian art 121–2, 124, 218–19
Bohemian Master, *Crucifixion* (Berlin) *42, 87*
Bonaventure 45, 57, 64, 151, 222, 226, 229, 245
Boniface VIII (Pope) 189
Book of Hours of Elizabeth the Queen (London)
 76
Book of Hours of Jeanne d'Evreux (Pucelle;
 New York) *28*
Book of Numquam 44
Borges, Jorge Luis 218, 238
Borromeo, Carlo (Archbishop) 43
Bosch, Hieronymus, *Seven Deadly Sins* 169
Botvinick, Matthew 245
Bramantino (Bartolommeo Suardi),
 Crucifixion (Milan) *102*
Brandenburgische Halsgerichtordnung (1516) *54*
Braunschweig Master, *Ecce Homo*
 (Braunschweig) *55*
Browe, Peter 194

Buch, Johann von 140
Büchlein der Zuflucht der Maria in Altern-Ötting (Jacob Issickemer) *61*
Burgkmair, Hans, *Altar of the Crucifixion* (Munich) *96*
Bynum, Caroline Walker 150
Byzantine empire 54, 56–7

Caimi, Bernardo 41, 44, 47
Calvary
 etymology 48
 as place of execution 11, 41, 84, 213, 229
 as spectacle 47–8
 see also: Crucifixion of Christ
Calvary (Altdorfer; Sankt Florian) *107, 109*
Calvary (Austrian; Hallstatt) *68*
Calvary (Bavarian; Esztergom) *73*
Calvary (Bavarian; St. Leonard bei Wasserburg) *70*
Calvary (Berger; Stuttgart) *104*
Calvary (Cranach; Berlin) *2, 79*
Calvary (Cranach; Chicago) *104, 115*
Calvary (Cranach; New York) *1*
Calvary (Duccio; Siena) *29*
Calvary (attrib. Dürer; Berlin) *112*
Calvary (Ferrari; Sacro Monte, Varallo) *10, 11*
Calvary (Frueauf; Klosterneuberg) *72*
Calvary (Hirschvogel; Windsor) *118*
Calvary (Housebook Master; Freiburg) *13*
Calvary (Kempten Master; Nuremburg) *50, 51*
Calvary (Lemberger; Leipzig) *117*
Calvary (Lorenzetti, Assisi) *20*
Calvary (Mantegna; Paris) *103, 111*
Calvary (Master of 1477; Augsburg) *33*
Calvary (Master of 1477; Cologne) *34*
Calvary (Master of Benediktbeuren; Munich) *15, 22*
Calvary (Master of Göttingen Barfüßaltar; Hannover) *77, 93*
Calvary (Master of the Munich Domkreuzigung) *43, 78*
Calvary (Provoost; Bruges) *14*
Calvary (Ratgeb; Stuttgart) *35*
Calvary (Tirolean; Innsbruck) *69*
Calvary (von Soest; Bad Wildungen) *32, 37*
Calvary ('Wehrden Altar'; Cologne) *21*
Calvary with executed criminals and mercenaries (Master J. S.; Berlin) *108*
Calvary with other scenes of the Passion (Master of Wasservass; Cologne) *12*
Calvary with riders (Master I. A. M. von Zwolle; London) *24*
Calvary Triptych (Apt; Augsburg) *95*
Campin, Robert (Master of Flémalle) 66, 113–15, 120, 243–6
 Entombment Altarpiece (London) *74*
 Thief on the Cross (Frankfurt) *39, 48*

Camus, Albert 305
capital punishment
 of animals 135, 187–8
 as deterrence 128, 135, 152, 161, 202, 270, 294
 as elimination of criminal 135–7
 as monopolization of violence 127, 134, 161
 as pagan sacrifice 140–2, 162–3
 as penitential theatre 143–6, 149, 152–3, 156–7
 as retribution 134–5, 139, 161
 dishonouring effects of 140–2, 187–9, 210–15
 forms of 56, 135–6, 139–42, 158–9, 161, 198–201
 Jesus's death as instance of 15–17
 mutilation prior to 138–9, 205
 symbolism of 139–42, 161–3, 187–9
 see also criminal justice, executions, hanging and wheel
Caracalla (Roman emperor) 210
Catherine of Alexandria 164, 167
Catherine of Siena 20, 67, 151
Celtis, Conrad 11
Cennini, Cennino, *Libro dell'arte* 276
Centurion, in the Passion 88, 287–90
Charles V (German emperor) 292
Charles VI, King of France 148
Charles le Bon (Count of Flanders) 198
Christ and the Penitent Sinners (Rubens; Munich) *101*
Christ in Limbo (Nuremburg) *3*
Christ on the Cross bound with ropes (Cologne) *23*
Christ with the Two Thieves (Santa Sabina, Rome) *25*
Christus patiens 56, 82
Christus triumphans 82
Cicero 199, 205
Cimabue 223, 242
Clement V (Pope) 148
Cohen, Esther 20, 129, 131, 148, 150
comforting societies 148, 261–2
 see also: executions and San Giovanni Decollato
compassion, as religious ideal 20, 151–2, 154, 157, 225–6, 239
Constantine (Roman emperor) 49–50, 79, 198
Constantinople 47, 82, 191
 sack of in Fourth Crusade 58
Constitutio Criminalis Carolina 130
context, problems of 28–32, 128–9
Corbelet, Jean 152
Corley, Bridget 95
Corpus Christi
 administered to convicts 149, 219

feast of 193
beliefs about 193–4
Correr, Gregorio 272
Counter-Reformation 165–6, 265
Cranach, Lucas the Elder 11–15, 172, 176,
 238, 257–9, 272, 287–95, 298–9
 Allegory of Law and Grace 114
 Calvary (Berlin) *2, 79*
 Calvary (Chicago) *104*
 Calvary (New York) *1*
 Crucifixion with Centurion (Aschaffenberg)
 113
 Lamentation Under the Cross (Munich) *100*
 Martyrdom of S. Peter 83
 Thief on the Cross (version 1; Berlin) *7*
 Thief on the Cross (version 2; Berlin) *8*
Credi, Lorenzo di 280
criminal justice
 amende honorable 133, 147–8
 community participation in 131–3, 145–53
 defamation rituals in 138, 140, 213–15
 processions 138–9, 155, 213–14
 sentencing 131–3
 and social status 141–2, 210–15
 see also capital punishment and executions
Cross and crosses
 'binding rod' used in conjunction with
 95–6
 commemorative Cross on Golgotha 49–50,
 79
 inscriptions with Thieves' names 55, 84–5,
 90, 232
 symbolism of 74–5
crucifixion
 among Romans 198, 201–205, 207, 210–11
 archaeological evidence of 80
 breaking of legs (*crurifragium*) 72, 89,
 113–21
 dishonouring effects of 210–11
 in ancient world 162, 201–202
 in hagiography 208–10
 medieval versions 198
 patho-physiology of 81, 118–20
 phenomenology of 75, 200, 204–5
 techniques of 69, 78, 80–1, 198, 204–5, 207
 see also Crucifixion of Christ
Crucifixion of Christ
 affixing to the Cross 71–2, 216
 conventions of 69–72, 215–17
 difference from that of the Thieves 72–5,
 82, 216–17
 iconographic themes of 12, 239–40,
 287–92
 nakedness of Christ associated with 71, 73
 sacramental theology of 16–17, 77–8, 219
 Scriptural sources for 13, 69, 77, 215–16,
 285

use of nails in 77, 80–2, 98
use of ropes in 71, 77–8, 80, 99, 100
see also Passion of Christ *and* crucifixion
Crucifixion (Bavarian woodcut) *94*
Crucifixion (Beatus Apocalypse; Girona) *38,
 91, 92*
Crucifixion (Bohemian; Berlin) *42, 87*
Crucifixion (Bramantino; Milan) *102*
Crucifixion (Burgkmair; Munich) *96*
Crucifixion (Florence) *14*
Crucifixion (Leinberger; Munich) *110*
Crucifixion (London) *76*
Crucifixion (Master of the Regler Altar;
 Karlsruhe) *52*
Crucifixion (Master of the Sterzing
 Altarwings; Karlsruhe) *40, 41, 49*
Crucifixion (Mount Sinai, Egypt) *18*
Crucifixion (Palestinian; Monza) *27*
Crucifixion (Pucelle; New York) *28*
Crucifixion (Pisanos; Siena) *19*
Crucifixion (Rimini school; Munich) *89*
Crucifixion and episodes from the Life of Christ
 (Palestinian; Rome) *16*
Crucifixion of S. Bartholomew (von Geismar;
 Hannover) *84*
Crucifixion polyptych (Chicago) *97*
Crucifixion with Centurion (Cranach;
 Aschaffenburg) *113*
Crucifixion with executed criminals (Huber,
 Cambridge) *6*
Crucifixion with palm cross (Palestinian;
 Monza) *26*
Crucifixion with the Pope as the Bad Thief
 (Master I. W.; Nuremburg) *116*
Crucifixion with the Two Thieves (Paris) *30*
Crucifixion with the Two Thieves (Nuremburg) *4*
crurifragium (breaking of legs): *see* crucifixion
Crusades 48, 58, 190–1
cult image 104, 266–9, 283–4, 298–9
Cuspinian, Johannes 11
customary law: *see* law
Cuttler, Charles 90

Danto, Arthur 29
death penalty: *see* capital punishment
Delumeau, Jean 126, 169, 295
Derbes, Anne 226–8
des Pres, Terrence 7
d'Este, Isabella 274
Devotio moderna 73, 75
devotional images 49, 70, 239
 see also cult images
Dies Irae 263
Dominicans 67
donor imagery 46–7, 241–8
Duccio di Buoninsegna 62, 72, 85
 Calvary (Siena) *29*

Dülmen, Richard van 152
Dürer, Albrecht 12, 104, 238, 248, 261, 268, 280–2
 Apocalypse woodcuts 12, 280
 Great Calvary (Berlin) *112*
Dysmas (the Good Thief) 23–6, 55, 67, 84–5, 218–21, 228–30
 Christ's promise of Paradise to 22, 24–5, 238, 262–3
 cult of 26, 222, 224–5
 as model penitent *88*, 220, 223, 261–3

Ecce Homo (Braunschweig Master; Braunschweig) *55*
Ecclesia, allegory of 59, 191–2
Eco, Umberto 157, 306
Edgerton, Samuel Y. 124, 199
Elias, Norbert 264, 267, 306
Ende (illuminator) 83
Entombment Altarpiece (Campin; London) 74
Evans, Richard 141, 146, 163, 306–7
executed persons
 exposure of bodies of 161
 magic ascribed to bodies of 97–8
 as martyrs 149–50, 152–3, 155–7
 spiritual comfort for 148–9, 264–5
Execution of Matthias Klostermaier in Dillingen (broadsheet) *53*
executioners
 medieval 97, 135, 137, 142, 152, 159, 170
 Roman 200
 in Passion imagery: *see* 'men with clubs'
executions
 crowds at 127, 156
 end of public executions 305
 literature for 126–7
 participation of clergy in 148–9, 152, 155, 264–5
 participation of community in 129, 142–8, 152
 staging of 127–8, 270–1
 see also: capital punishment *and* criminal justice

Ferdinand III (Austrian emperor) 188
Ferrari, Gaudenzio 42, 47, 240
 Calvary (Sacro Monte, Varallo) *10*, *11*
Flavius Josephus 16, 81, 198, 207
Fourth Lateran Council 225, 261
Fra Angelico 238
Francis of Assisi 57, 61, 151, 242
 as *alter Christus* 226–7
 images of, mocked 284–5
 as Penitent Thief 220, 228–30
 stigmatization of 151, 226
Franciscans 41–5, 148, 171, 222–30
 spirituality of 43, 57, 67, 225–6, 241–2

themes in art 226–30
 see also Sacro Monte
Frazer, Sir James 162
Friedrich the Wise (Duke of Saxony) 282–3, 293–4
Frueauf, Rueland the Younger, *Calvary* (Klosterneuberg) *72*

Gaistliche vsslegung des lebens Jhesu Christi 4
Gallonio, Antonio, *De SS. Martyrum cruciatibus . . . 66*, 165–7
gallows 97–8, 149, 157, 211–14, 261–2
Geismar, Hans von, *Crucifixion of S. Bartholomew* (Hannover) *84*
Geremek, Bronislaw 210
Gerhart, Leonhard, *Murder in Halle . . .* (broadsheet; Zürich) *64*
Gerson, Jean 144, 148–9
Gesmas: *see* Gestas
Gestas (the Bad Thief) 23–5, 55, 67, 84–5, 221–2, 262
 in role of punished Jew 191–5
Glanz, Rudolf 189
Golden Legend (*Legenda Aurea*) by Jacobus de Voragine 41, 164, 208–10
Golgotha: *see* Calvary
Gonzaga, Lodovico 278
'Good Death', the 142, 144–6, 152–3, 156, 264–5
Good Thief: *see* Dysmas
Gospels (books of the New Testament)
 Gospel of John 14, 22, 45, 52, 61, 77, 117–19, 121
 Gospel of Luke 22–3
 Gospel of Mark 22–3, 52
 Gospel of Matthew 22–3, 52
Gospel of Nicodemus (apocryphal) 23, 55
Gospel of the Infancy (apocryphal) 24
Graf, Urs, *Place of Execution* (Vienna) *85*
Gregory VII (Pope) 129–30
Gregory the Great (Pope) 49
Gregory of Tours (Bishop) 163
Groote, Geert 75
Grünewald, Matthias, *Isenheim Altarpiece* 20–1
Guido da Siena, *Ascent of the Cross* (Utrecht) *90*
guillotine 159, 306

hagiography 164–8
hanging
 as death penalty 136, 140–1, 187–8, 199–200
 in Passion imagery 28–9
 physiological effects *82*, 115, 205–7
 symbolism of 139–42
hangman: *see* executioner
Hanseatic League 90
Harris, Robert Alton 305

Hausmann, Marie 264
Heartfield, John, *Wie in Mittelalters . . . so im Dritten Reich* (Berlin) *119*
Helena (Roman empress) 224
Hengel, Martin 17, 202, 204
Hentig, Hans von 140–1, 162–3
Herrlinger, Robert 113–16, 120
Hewitt, Joseph 78, 99
Hilary, Bishop of Poitiers 77
Hirschvogel, Augustin, *Calvary* (Windsor) *118*
Hitler, Adolf 306
Holbein, Hans the Elder 208
Housebook Master, *Calvary* (Freiburg) *14*
Huber, Wolf 13, 30–1, 260, 262, 299
 Crucifixion with executed criminals (Cambridge) *6*
Hugh of Saint-Victor 241
Huizinga, Johan 148
humanism 104, 266, 272, 281–2
 see also Renaissance
Humbert of Romans 225
Humbert of Silva Candida (Cardinal) 82–3
Hussites 171, 261

Iconoclasm
 in Byzantine empire 55
 in Protestant Europe 264, 283–5
imitatio Christi 149, 151, 221, 226
'immediate beatitude', doctrine of 156
Impenitent Thief: *see* Gestas
infamy 211–13
International Style 62, 101
intervisuality 21, 32
inversion 164, 172–5, 187–9, 193
Investiture Controversy 130
Isaiah, prophecies of 22, 70
Isidore of Seville (Bishop) 205
Issickemer, Jacob 153
Ixion's wheel 162–3

James, M. R. 23
Jauss, Hans Robert 129
Jerusalem 41, 44, 46, 81
 loca sancta in 21, 43–4, 46–8, 50–1, 79
Jesuits 165, 167, 224
Jews and Judaism 186–94, 201, 211
 accusations against 194–5
 execution of *80*, 187–9, 195, 285
 pogroms against 190–1
 supposed role in Passion of Christ 117–18, 132, 189, 193, 217
Jöbstlberg, Sigismund Jöbstl von 247
John of Damascus 55
Judas Iscariot 30
judicial spectatorship 128, 142–3, 149, 152–3, 155–7, 206–7, 301–2

see also spectacle *and* visuality
Julius Paulus, *Sententiae* 206
justice 131
 allegory of 62, 154
 popular justice 146–7

Kaiserberg, Johann Geiler von 144, 149
Karl IV (Holy Roman emperor) 61, 121
Karlstadt, Andreas Bodenstein von 265
Katzheimer, Wolfgang
 Instruments of torture (woodcut) *54*
 A judicial procession (woodcut) *63*
Kempe, Margery 76
Kempis, Thomas à 75
Kempten Master, *Calvary* (Nuremburg) *50, 51*
Kieckhefer, Richard 150
Kitzinger, Ernst 168
Koerner, Joseph Leo 257, 289
KQED vs. Daniel Vasquez 305–6
Kristeva, Julia 113
Kubler, George 42
Kupfer, Marcia 169

Lactantius 77
Lamentation for Christ (Baldung; Washington) *99*
Lamentation for Christ (von Villach; Kärnten) *98*
Lamentation under the Cross (Cranach; Munich) *100*
Lane, Barbara 245
Lanzmann, Claude 7
Last Judgement, theme of in art 18, 26, 231, 233, 240
law, medieval 129–30, 134
Layenspiegel (Ulrich Tengler) *56*
Lazarus of Bethany 239–40
Leinberger, Hans, *Crucifixion* (Munich) *110*
Lemberger, Georg, *Calvary* (Leipzig) *117*
Leo III (Byzantine emperor) 55
Leonardo da Vinci 115, 278, 280
Levi, Primo 7
Limbourg brothers 238
loca sancta (Holy Places): *see* Jerusalem
Longinus 52–3, 83, 223–5, 227
Lorenzetti, Pietro, *Calvary* (Assisi) *20*
Lottes, Günther 303
Lubbe, Marinus van der 306
Lucan 98
Luigi of Aragon (Cardinal) 158–9
Luther, Martin 13, 15, 263, 267–8, 282, 285–98
Lutheranism
 iconographic themes 287–95, 298–9
 propaganda for 239, 286, 295–8
 relation to popular culture 271, 295–8, 302–3

theology 15, 271, 286–90, 289–91, 294–5
Luzerner Chronik (Schilling; Luzern) 45, 46

McCall, Andrew 134
macabre, themes in art and literature 164,
 169–72
Mailer, Norman 304
Mamluks 47
Man of Sorrows, Christ as 20
Mantegna, Andrea 272–8, 280
 Calvary (Paris) 103, 111
Margaret of Ypres 67
Martyrdom of S. Peter (Cranach) 83
Mary, Jesus's mother: see Virgin Mary, the
Mary Magdalene 145, 223, 239, 242, 263
 Chapel in church of San Francesco: see
 Assisi
Massacio 206
Master of 1477
 Calvary (Augsburg) 33
 Calvary (Cologne) 34
Master of the Banderolles, Wheel of Fortune
 and Death below the Tree of Life (London)
 67
Master of Benediktbeuren, Calvary
 (Munich) 15, 22
Master E. S., engravings for Ars Moriendi
 Good Inspiration (Oxford) 59
 The Hour of Death (Oxford) 60
 Temptation from Faith (Berlin) 58
Master of Flémalle: see Campin, Robert
Master of Göttingen Barfüßaltar, Calvary
 (Hannover) 77, 93
Master I. A. M. von Zwolle, Calvary with
 riders (London) 24
Master I. W. Crucifixion with the pope as the
 Bad Thief (Nuremburg) 116
Master J. S., Calvary with executed criminals
 and mercenaries (Berlin) 108
Master of the Martyrdom of the Apostles,
 circle of, SS. Felix, Regula and
 Exuperantius broken with the wheel
 (Esztergom) 47
Master of the Munich Domkreuzigung,
 Calvary (Munich) 43, 78
Master of the Regler Altar, Crucifixion
 (Karlsruhe) 52
Master of the Sterzing Altarwings,
 Crucifixion (Karlsruhe) 40, 41, 49
Master of Wasservass Calvary, Calvary
 (Cologne) 12
Maximilian I (German emperor) 130, 270
Mayer, Lucas, Torture and execution of
 Murderer Franz Seubold
 (Nuremburg) 86
meditation: see Passion of Christ
Meditatio pauperis in solitudine 229

Meditations on the Life of Christ 44–5, 58, 72,
 102, 226
Meiss, Millard 273
Melito of Sardis 54, 57
Mellinkoff, Ruth 27
Memling, Hans 238
'men with clubs' (tortores) 59, 61, 96, 116–21,
 187
mercenaries 212–13, 262
Mercier, Louis Sebastian 304
Miller, William Ian 101, 113
Moeller, Bernd 67
Moltmann, Jürgen 22, 80, 286
Monophysites 57
Monza (Italy), Cathedral Treasury
 ampulla no. 10, Crucifixion 27
 ampulla no. 13, Crucifixion with palm cross
 26
Mount Sinai (Egypt), Crucifixion icon 18
Muslims 66

Nazis 120, 159, 163, 306
Netze Master, Passion Altarpiece (Cologne)
 31, 36
New Testament, books of: see Gospels
Newman, Graeme 141
Nicholas of Cusa 75
Nova, Alessandro 44

Obermann, Heiko 222
Origen 118
Ottoman Turks 47–8, 191, 270, 299
Ottonians 85–7, 231

pain 69, 76, 125, 150–1, 276, 298, 304
 Christian attitudes toward 142, 149–51,
 155–7, 221–2
 and damnation 171–2, 221
 and penal techniques 89, 141–2, 160,
 185–6, 204–7, 214–15
 spiritual efficacy of 154–7, 221, 291–2, 298
 see also spectacle
Palestine, ancient 47–8, 50
 see also Jerusalem
Panofsky, Erwin 66, 94, 186, 231, 280, 286
Paracelsus 99
Passion Altarpiece (Netze Master; Cologne)
 31, 36
Passion Altarpiece (Rhenish; Frankfurt) 5, 9
Passion of Christ
 devotions to 19, 67, 150–1, 234–42
 early commemoration of 49–50
 injuries resulting from 70
 meditations on 19, 45, 199
 relics of: see Arma Christi
 scenic recreations of 41–3
 visualization of 41–7

see also pilgrimage
Paul (Apostle) 16–17, 49, 81, 145, 203, 223, 294
Pauline letters manuscript (Würzburg) 231, 233
Peace of Augsburg 293
Peasant's War in Germany 95, 270
penance 27, 145, 222, 225, 263–5
'penitential vision' 242, 245–7, 257–9
Penitent Thief: see Dysmas
philopassianism 20, 150, 221
Pickering, F. P. 45, 77, 215–16
Picture Book of the Life of Christ and the Saints (French; Paris) 30
pilgrimage 41–3, 46–8, 50–1
 mental pilgrimage 43–7, 54, 244–6
 see also Passion of Christ
 relation to Crusades and pogroms 189–91, 194–5
Pisanello, Antonio, Study of Hanged Men (London) 82
Pisano, Nicola and Giovanni, Crucifixion (Siena) 19
Place of Execution (Graf; Vienna) 85
Plautus 201–2
Pliny the Elder, Historia Naturalis 99
pogroms: see Jews and Judaism
Pontano, Tebaldo 223, 225
Prague 61
Praxis Criminalis (Jean Milles de Souvigny) 57
Protestantism: see Reformation, German and Lutheranism
Provoost, Jan, Calvary (Bruges) 14
Pseudo-Bonaventure: see Meditations on the Life of Christ
Pucelle, Jean 62, 85–8, 244
 Crucifixion (New York) 28
Puppi, Lionello 124
purgatory 144, 155–6

Rabbula Gospels (Syrian; Florence) 17
Rabenstein (raven's stone) 159, 211, 215
Radbruch, Gustav 97
Ratgeb, Jörg, Calvary (Stuttgart) 35
realism in art 101–4, 186, 216–17, 272–7
Réau, Louis 224
Reformation, German 282, 285–6, 298
 consequences for art 266–72, 297–9
 see also Iconoclasm
 see also Luther, Martin and Lutheranism
Rehfeldt, Bernard 141
Renaissance
 in Italy 269, 274–9, 301
 in northern Europe 280–3
 see also humanism
Reynard the Fox as Pope and Antichrist with Wheel of Fortune (Vienna) 71

Richtstätte: see gallows
Rimini school, Crucifixion (Munich) 89
Rindfleisch 190, 194
Roman law 198, 202
 see also law
Roos, Ervin 162
Rothkrug, Lionel 189–91, 194
Rubens, Peter Paul, Christ and the penitent sinners (Munich) 101
Ruysbroeck, Jan 149

Sacro Monte, Varallo (Italy) 10, 11, 41–5, 64, 240–1
Saint-Gilles-du-Gard 192
Saint-Savin-sur-Gartempe 65, 165
Saints Felix, Regula and Exuperantius broken with the wheel (Master of the Martyrdom of the Apostles; Esztergom) 47
Saints Savinus and Cyprian tortured on the wheel (Saint-Savin-sur-Gartempe) 65
San Giovanni Decollato, confraternity of 264
 see also executed persons
San Salvador de Tábara, monastery of 83
San Zeno monastery (Verona) 272–3
Sancta Sanctorum (Palestinian icon; Rome) 16
Sankt Florians monastery (Linz) 259–60, 262–3
Sant-Andrea, Pistoia 59
Santi, Giovanni, Cronaca rimata 276
Scarry, Elaine 20, 26, 204–5, 222
Schandbrief (letter of defamation) 75
Schapiro, Meyer 195
Schiller, Gertrud 80
Schilling, Diebold
 Execution by the wheel (Luzern) 46
 Setting up the wheel with Duckeli (Luzern) 45
Schmitt, Jean–Claude 226
Schöne Maria: see Virgin Mary, the
Schweizer Chronik (woodcut) 80
Scribner, Robert 296, 298
Scripta Leonis 229
'secret strangling' 160
Seneca 196, 204, 207
Serenus of Marseilles (Bishop) 49
Seubold, Franz 86, 214–15
'Seven Words from the Cross' 13, 26, 287
Shoah (Lanzmann) 7
Siena Cathedral, works in 58–9, 85, 192
 see also Duccio di Buoninsegna
Soest, Conrad von, Calvary (Bad Wildungen) 32, 37
soul-figures in art 231–41
Souvigny, Jean Milles de (Praxis Criminalis) 57
Spartacus 202
spectacle

and formation of sensibilities 101–2,
 128–9, 270–2, 301, 305–6
pain as 19, 75, 155–7, 298–9, 304
punishment as 19, 142–8, 202
varieties of in Middle Ages 18–19
see also capital punishment *and* executions
spectatorship: *see* judicial spectatorship *and*
 visuality
Steinberg, Leo 71
Story of Joseph of Arimathaea 23–5
Study of Hanged Men (Pisanello; London) *83*
Sultan Selim I 47
Suso, Heinrich 67
Synagogue, allegory of 59, 192–3
 see also Jews and Judaism

Tacitus 201
Tempesta, Antonio 66
Tengler, Ulrich, *Layenspiegel 56*, 136
Tentler, Thomas 263
Tertullian 77
Theodore of Studion 55
Theweleit, Klaus 267
Thief on the Cross (Campin; Frankfurt) *39, 48*
Thief on the Cross (Cranach, version 1; Berlin)
 7
Thief on the Cross (Cranach, version 2; Berlin)
 8
Thomas of Celano 229
tortores: see 'men with clubs'
torture: *see* criminal justice *and* pain
*Torture and execution of Murderer Franz
 Seubold . . .* (Mayer; Nuremburg) *87*
Tübingen Stiftskirche 306
Tullian, Lips *62*, 153–4
Turin 168
Two Thieves
 as anti–types 22, 192–3, 230–41, 264
 in apocryphal legends 23–5, 233
 scriptural sources for 22–3
 see also: Dysmas, Gestas

Ulm 283, 290

van der Weyden, Roger 66, 73, 114, 116, 280
van Eyck, Jan 66, 238, 273–4
Varallo (Italy): *see Sacro Monte*
Vauchez, André 263

vices, representations of 169–71
Villach, Thomas von, *Lamentation for Christ*
 (Kärnten) *98*
Virgin Mary, the 12–13, *61*, 151, 153, 227–8,
 239, 244, 257–9
 cult of *Schöne Maria* 190–1, 194
 shrines for 190–1
visuality 21, 192–4, 266–9, 296, 298, 308
 see also judicial spectatorship *and*
 'penitential vision'
Volkskunde, discipline of 141, 163
Voragine, Jacobus de: *see Golden Legend*
votive imagery 153–4, 243–8

Walzer, Michael 69, 76
Wandel, Lee Palmer 284
Warhol, Andy, *Orange Disaster* (New York)
 106
Wasservass Family (Cologne) 46–7
weapons
 and pain 76
 as relics and amulets 76, 97
 displayed on crosses 96–7
 see also Arma Christi
Weitzmann, Kurt 80–1
Wheel of Fortune *67, 71,* 168–72
wheel, punishment of 136, 140–1, 153,
 158–61, 164–8, 199–200
 ancient precedents 162–3, 167–8
 in hagiography 164–8
 phenomenology of 205–10
 as referent in art 122–5, 185–6, 198–200
 symbolism of 162–4
 techniques of 159–61, 171, 205, 210
Wieseltier, Leon 104, 186
Wilsnack 194
Wind, Edgar 162
Wittenberg (Germany) 11, 267, 282, 287
Wolgemut, Michael 208
wounds
 of Christ 70–1, 102, 226–7
 as generators of horror 113
 graphic depiction of 114–18
 see also Crucifixion of Christ *and* Passion of
 Christ

Zardino de Oration 45, 68
Zürich 168